THE JOY OF I.T.

Infinite Transcendence

Anthologies of Inspirational Insights,
Poetry, and Visionary Art

LALI A. LOVE

A Collaboration of Love by Contributing Artists:

Book Cover Design and Digital Artwork contribution by Aurelien Pumayana Floret, **www.pumayana.com**

Poetry of Healing and Transformation contribution by Gillian Small, *The Journey of the Soul Within* copyright @2019 Gillian Small, **www.essence-oflight.com**

Intuitive Photography Artwork contribution by Michelle Aristocrat, copyright @2019 Michelle Aristocrat, **www.michellearistocrat.com**

Visionary Artwork contribution by Autumn Skye, **www.autumnskyeart.com**

Digital Artwork by Daniel B. Holeman**, www.AwakenVisions.com**

Poetry by Lali A. Love "Fly" and "Come Home to Me" Published by Writer's Egg Magazine

Distributed by Bublish, Inc.
ISBN: 978-1-64704-212-7

Dedication

To the beautiful Souls on our majestic planet Earth, you are what all of existence desired to be, a manifestation of true immaculate perfection. With love, light, grace, and humility, we honor and celebrate you with joy. Namaste.

Insights from Author Lali A. Love

I am humbled and grateful to be able to share these contributions of distinctive, mixed media artistic expressions and my reflections. We have provided a collaboration of healing and harmony through a tapestry of inspirational insights, transformative poetry, and visionary art. We hope these creations, loving messages of positivity, and visual stimulation will elevate your feelings of joy and invigorate your senses to reach infinite transcendence.

As Lightworkers, our purpose is to embody the light, anchored in love and kindness, transcending time, and space. We are a Soul tribe, connected and awakened to our highest potentiality through transformational journeys and unique experiences. The intention of this book is to offer insightful viewpoints and artistic ingenuity, to uplift humanity by elevating the expansion of unity consciousness.

This information may come through the sharing of conscious knowledge, loving energetic frequencies, and visual illumination. One who radiates and resonates with the vibrations of light tend to provide blessings, prayers, and daily intentions. Through this practice, we are assisting and protecting Mother Earth and her inhabitants through the power of channeled light codes, kind deeds, and actions.

It is an honor to bring you this compilation of healing creativity through our sacred art. May we all aspire to our higher purpose and unique expressions of Light. Blessings of inner peace, bountiful joy, limitless love, enlightenment, clarity, and fulfillment.

"When we operate from the space of heart-centered consciousness, every Soul becomes our mirror and our teacher. We are all connected within this web of radiant life force energy called Love."
—Lali A. Love

Essence of love in purest form,
A gleaming gem of the highest norm.
A Queen crafting her masterpiece anew,
To my magnificent Mommy, I cherish you.

We are slowed down sound and light waves, a walking bundle of frequencies tuned into the cosmos. We are souls dressed up in sacred biochemical garments and our bodies are the instruments through which our souls play their music.
—Albert Einstein

———⁓⁓⁓———

The Divine Light of awareness empowers every cell in your body.
—Deepak Chopra

———⁓⁓⁓———

Art washes away from the soul the dust of everyday life.
—Pablo Picasso

———⁓⁓⁓———

Poetry is the rhythmical creation of beauty in words.
—Edgar Allen Poe

———⁓⁓⁓———

Who looks outside, dreams, who looks inside, awakes.
—Carl Jung

Reflections

ANCHORING THE LIGHT

"Although you appear in Earthly form, your Essence is pure Consciousness. You are the fearless guardian of Divine Light."
—*Rumi*

You are a powerful, beautiful, multi-dimensional being, whose purpose is to expand into the love that you have always been. Each one of us who shares our genuine Light and Love, the most powerful force in the Universe, helps uplift humanity into higher states of conscious awareness and heals the world.

Once you realize that you are the limitless representation of celestial innocence, the living embodiment of Source energy within each thought, feeling, and response, your spiritual maturity begins to develop and evolve. In this state of ascension, you are pure consciousness, a sphere of possibilities. When you discover your true nature and understand your essence, you experience a pureness of being that can stand fearlessly in any situation. With the truth of this interconnected Oneness, you gain access to the unlimited and eternal power of the self, anchored in infinite light, attracting people and circumstances that help support your daily aspirations.

When you embrace this inner knowing, you are able to quiet the negative chatter of the external world and tap into your unlimited power. In this stillness, you begin to release any need for judgement, comparison, or competition; attributes that can only create an inner turmoil, blocking your ability to connect to your higher self. This internal dialogue projects as the experience of your physical world and reality; observing the world through the lens of your perspective. Beyond that is the infinite realm of foresight and knowing, which becomes available to you with tranquility and the magic of inner silence.

You are the Universe manifesting in a human nervous system, a Divine force that transforms energy in multiple dimensions. You are part of creation, entering this existence with pure consciousness, generating frequencies of unconditional love. You are the creators, the influencers and therefore, the catalysts for evolution. If you can but realize your true power and pure potential, then the opportunities are endless in this ever-expanding Universe. May you always be blessed with the radiant life force energy, Beloved.

"Pointing to another world will never stop vice among us; shedding light over this world can alone help us."
—*Walt Whitman*

She Spread Her Wings

She spawned her wings of Golden light,
cascading through ways of time and plight.
Iridescent shimmers breaking free,
from lifetimes of dependent patriarchy.
Her body swayed, connecting with divine femininity,
releasing beliefs of how things are supposed to be.
Sparkles of radiant universal dust
illuminated her soul with such brilliant gust.
Breathing and sensing to the sounds of her own soul,
as her wings opened fluttered,
transmuting old to gold.
It was time to set her spirit free,
spreading her wings for humanity.

Gillian Small

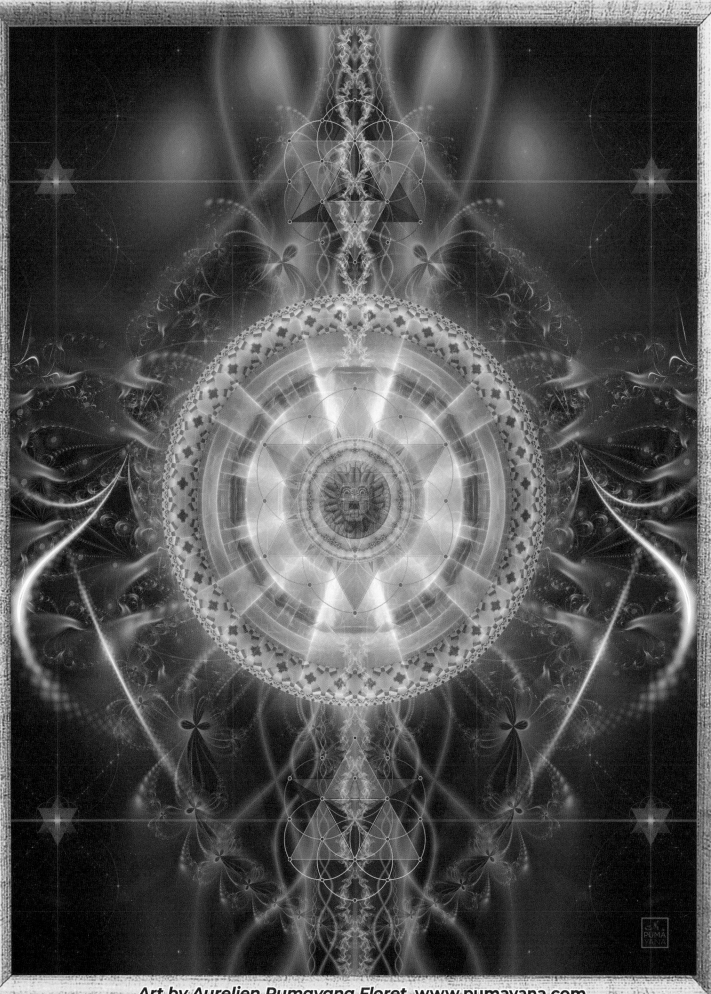

Art by Aurelien Pumayana Floret, www.pumayana.com

CONSCIOUSNESS

*"Until you make the unconscious conscious, it will
direct your life and you will call it fate."*
—Carl Jung

When we operate from a space of scarcity or un-awareness, known as unconsciousness, we identify with our egoistic narratives, mindset, and limiting perceptions. This rigid and fixed belief drives our thoughts, emotional intelligence, and behaviors stemming from an over-active and fragile ego identity. When we become aware of this reality, we begin to practice self observation and realize that we are not our thoughts. We are more than just physical matter of our perceived understanding within this third dimensional reality.

All material creations that we can see, hear, taste, smell, and touch come from the same Source energy. Consciousness is the infinite life force within the unified field that is beyond the familiarity of the five senses of our physical world. Within this existence, remains the power of boundless creativity, the conditions to manifest different experiences according to varying sensory perception. It is a fundamental element of mind, matter, and energy. It is a pre-existing, Universal presence, the notion of Oneness with the Source of all Creation. If you relinquish the belief that you are limited, a profusion of certainties will flow to you through the **A**wareness **M**anifested quantum field.

As Eckhart Tolle eloquently stated: "The beginning of freedom is the realization that you are not the thinker. The moment you start watching the thinker, a higher level of consciousness becomes activated. You then begin to realize that there is a vast realm of intelligence beyond thought, that thought is only a tiny aspect of that intelligence. You also realize that all the things that truly matter—beauty, love, creativity, joy, inner peace—arise from beyond the mind. You begin to awaken."

When authentic love is conveyed intentionally, you enable the utmost vibrational frequency of Divine's resounding expression to permeate the present moment. Now is the time to choose your highest trajectory, planting the fertile seeds of clear goal setting, anchored in the unified field of Light.

*"Pure Consciousness, which is the Heart, includes all, and
nothing is outside or apart from it. That is the ultimate Truth."*
—Ramana Maharshi

The Youniverse Within

I look up at the sky, and it's all that I see.
The cosmos of you, the universe in me.
The clouds and the stars beckon us to see,
our heritage and journey and how we came to be.
We are magnificent and brilliant making up the One.
In all that we are, connected, not undone.
We will always share a love so divine.
Between you and me,
Gaia our Mother Earth ~ messages and synchronicities ~ is our sign.
Holding us so near and so dear,
the essence of our beloved ancestors, their channelings becoming so clear.
If you pay attention, you'll be sure to believe,
you won't need to question your divinity – it's there for you to receive.
Look and gaze up at the wonders all around.
For they're the same wonders in you, it is found.
For all that we are and all that we be,
the divinity of One, birthed in You and birthed in Me.

Gillian Small

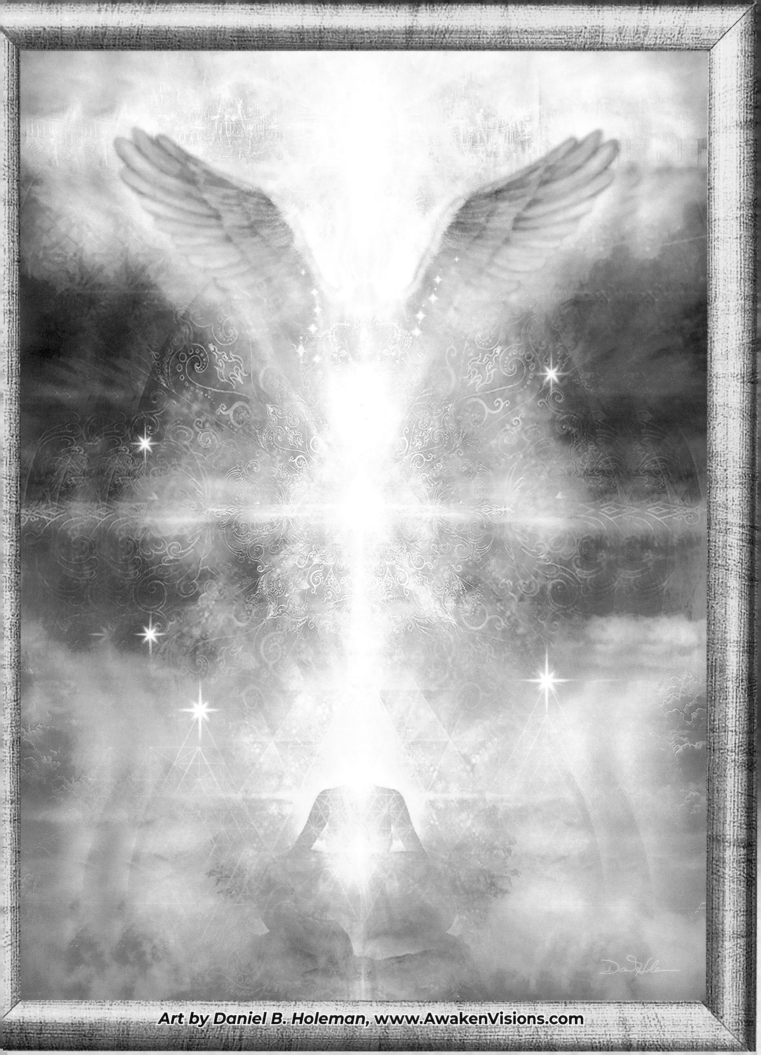

ENERGETIC BEINGS

*"If you want to understand the Universe, think in
terms of frequency, vibration, and energy."*
—Nicola Tesla

Everything is energy, and energy connects all things and carries information in a constant flow of momentum. As such, every sentient being on Earth is an infinite mystery, whether it's humans, plants, animals, bacteria, etc. The journey to enlightenment requires an awareness of this interconnectedness and a relinquishment of the personal narrative.

Your thoughts are sound waves of electrical pulses that penetrate all time and space. Your mind perceives and evaluates, creating vibrational frequencies that can change your physical world by changing your thoughts and beliefs. Your feelings are your conscious awareness of your vibration, and a manifestation of unseen, internal reality.

Beyond the mind resides the eternal unchanging spirit, with pure unlimited potential. It is a construct of your interpretations, self-talk, beliefs, and emotional reactions that create specific outcomes in the physical world. Daily systematic perceptual experience inhibits the connection to the Source, which is beyond all perception.

Your vibration equals your point of attraction for everything coming into your reality. Energy that is on the same frequency will resonate and attract. Energy that is not on the same frequency will repel. To live in harmony with this Universal Law, remember to become aware of what you are thinking and the negative self-chatter. You can change the vibration by simply acknowledging your thoughts and improving it by imagining something more pleasant that brings your heart feelings of joy.

*"You draw to you the people and events which
resonate with the energy that you are radiating.
You attract what you are, so be your best."*
—Lynda Field

The Rise

She thought she was losing her mind, hounded by nightmares of darkness.
She yearned for a sense of belonging that she could harness.
When she looked in the mirror with hope for salvation
she gazed deeply into her emerald pools of wisdom with jubilation.

She peered at the Cosmos as the answers poured in
and travelled beyond the dimensions that could be found within.
She discovered a magical realm where the light resided
the language of love was mysterious, but the feeling was akin, she had decided.

She wandered for days in pursuit of the unknown
until she realized an existence the Divine had shown.
She voyaged with her galactic compass, seeking satisfaction
as her Soul sketched her a map of what she had forgotten.

The Council spoke to her in light codes without using words
She was immediately activated to embrace her ethereal lords.
She recognized she was sent on a mission of devotion
Her journey propelled her with lessons of awakening revocation.

Light could only be grasped with the wisdom of dark passion
as her heart vibrated with the harmonic frequencies of compassion.
Relinquishing to the full power of unconditional love
intensifying her vulnerability and forgiveness for the Universe above.

She illuminated her light to eradicate the darkness
and realized she was cloaked in a warrior shield that no one could harness.
She prayed for the power of her infinite self in her classes,
as her angelic vibrations reversed and healed the masses.

She never questioned her path again.
The Light applauded her wisdom, her love and grace with an amen.
She was infinite energy, radiating bliss in space
with blessings of joy and peace, uplifting the human race.

Lali A. Love

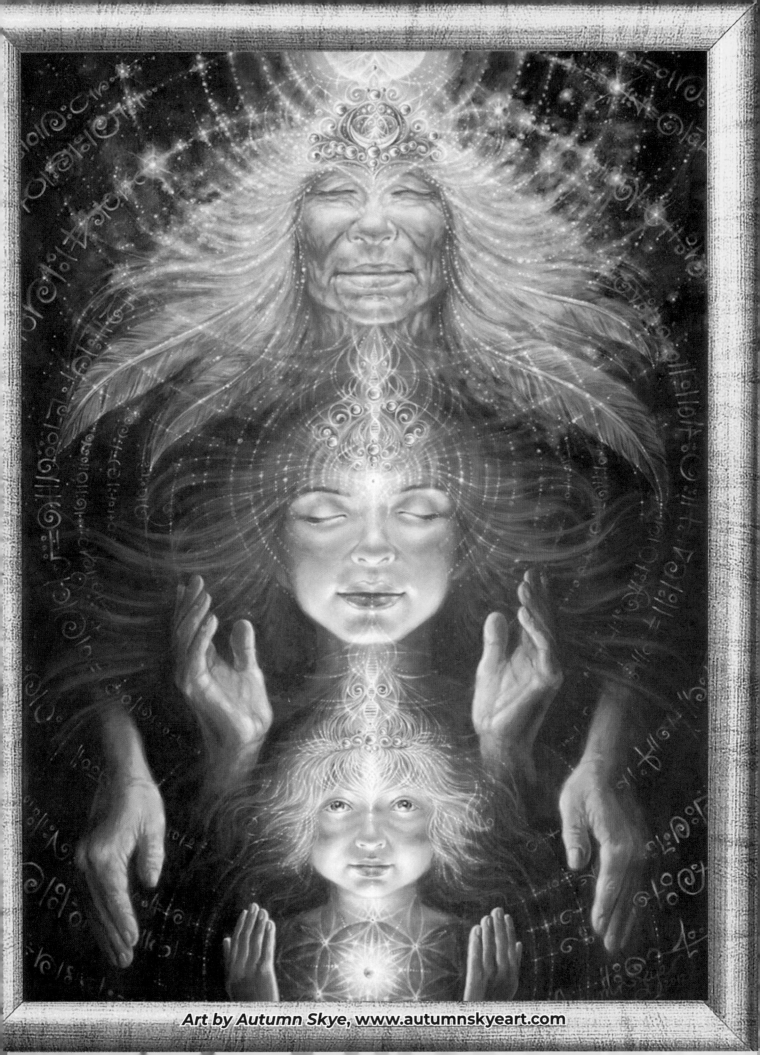

Art by Autumn Skye, www.autumnskyeart.com

THE TRUTH OF LOVE

*"Love rests on no foundation. It is an endless
ocean, with no beginning or end..."*
—Rumi

Love is the Divine force that unites us all through vibrating frequencies in this beautiful, collective state of consciousness. It is much more than an emotion; it is an eternal, energy force that transforms through every dimension of time and space. With the willingness to love without conditions and often, we are able to remember the deeper spiritual reasons why circumstances occur. Every moment of our experience is created by the Universe to ensure our highest growth.

We come into this existence with pure, unconditional love, wholeness, and connection to the Source. The one undifferentiated intelligent eternity, unpolarized, full and whole, is the macrocosm of the mystery. Love is more than feelings, words, or gifts. Love is the energy that allows all to exist. Love is what makes our hearts beat, spins the planet, and helps us breathe. Love's reach is infinite in every one of us.

The lessons we learn through this experience will enhance our Souls with divine wisdom as we transcend through endless dimensions of existence with grace and kindness. Each of us has a source of power deep within that fuels us in much bigger, profound ways. That source serves us in each and every moment, and in every choice we face.

Aligned with the truth of love, we are calm, optimistic, and whole. This true power is strength over time, it's the power of the humble warrior, the power of inner steadiness that we call upon in a time of crisis, as we share generously when others need our support.

Your capacity to love and be loved is based on your ability to realize you are deserving of love. You are worthy and love is your Divine inheritance. Let the truth of love propel you, let it be your guide; when you are low on love, remember within you it resides.

*"Love is the greatest force in the universe. It is
the heartbeat of the moral cosmos."*
—Dr. Martin Luther King Jr.

The Magician

You are the magician. Go within and listen.
What does your heart say? What do your thoughts portray?
Let go of blaming, for you have the key.
To make peace with your past and let your magic set you free.
The future you hold is still untold. Let your magic ignite all your desires in sight.
It's quite simple you see. Nothing external can jeopardize thee.
For you hold the power, the magic, my dear. To create a life simple and clear.
You are the awoken one of divinity so bright. Let go of others that hold back your flight.
Let them go dear ones with grace and love. You will reap rewards most only dream of.
Believe from the depth of your soul. You hold the key to make your magic unfold.
It's within You – believe, believe! For this is where your answer lies, trust me.

Gillian Small

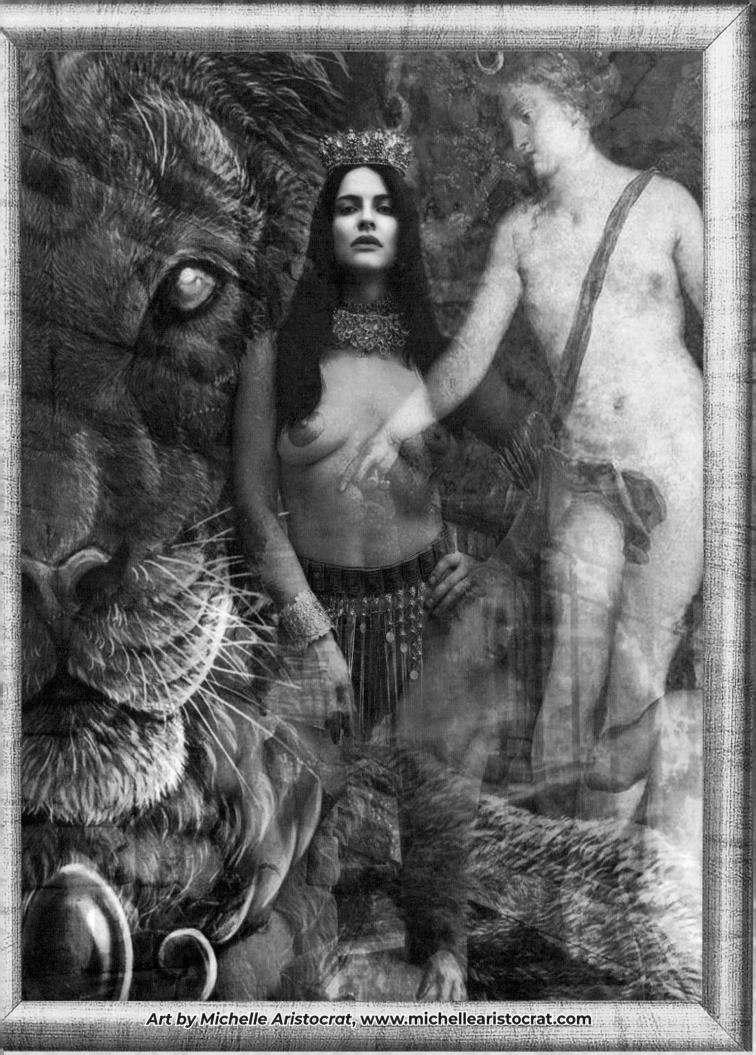

WHOLENESS

*"Wholeness is not achieved by cutting off a portion of
one's being, but by integration of the contraries."*
—Carl Jung

While the collective perception resides in the physical world of mind and matter, pure consciousness exists between your heart center field and in the gap between thoughts, which is the foundation of all creativity. Embrace your highest being and tap into the Universal mind to luxuriate in the harmony of transcendent silence and unlimited abundance of inner peace.

You are love and love is whole, without any opposition or judgement. Look within for answers and align yourself to your Truth, to your Spirit. You are infinite light, supported by an entire loving, intelligent Universe. Discover your highest purpose and your visions relentlessly and passionately. Your energy is too precious to be wasted on anything that does not serve your highest good. Your Soul is eternal and limitless.

When the mind nourishes the body with good thoughts and feelings, the body returns to its natural state of joy and serenity. From this place of bliss, you are able to reclaim the memory of who and what you really are—a spiritual being, interconnected with the ingenious power of the Universe in its entirety.

"Every Soul is whole no matter how wounded the mind is."
—Unknown

We Are the Creators

I connect my feet to Mother Earth,
Grounding in her grassy hearth.
Nature's sensations embrace my stance,
Flowing vibrations like the perfect dance.
The sun pours down on my naked skin,
Opening my arms to all within.
The glorious skies in all their mist
Blazing energies from Gaia's bliss.
And as the gates appear so far,
They shine on me like long-lost stars.
I return to the essence of who I am –
Wisdom and truth, as I rewrite my own program.
I am my God.
I am my Creator.
I am my Temple.
As all are inside me.
This is divine truth and so it shall be.

Gillian Small

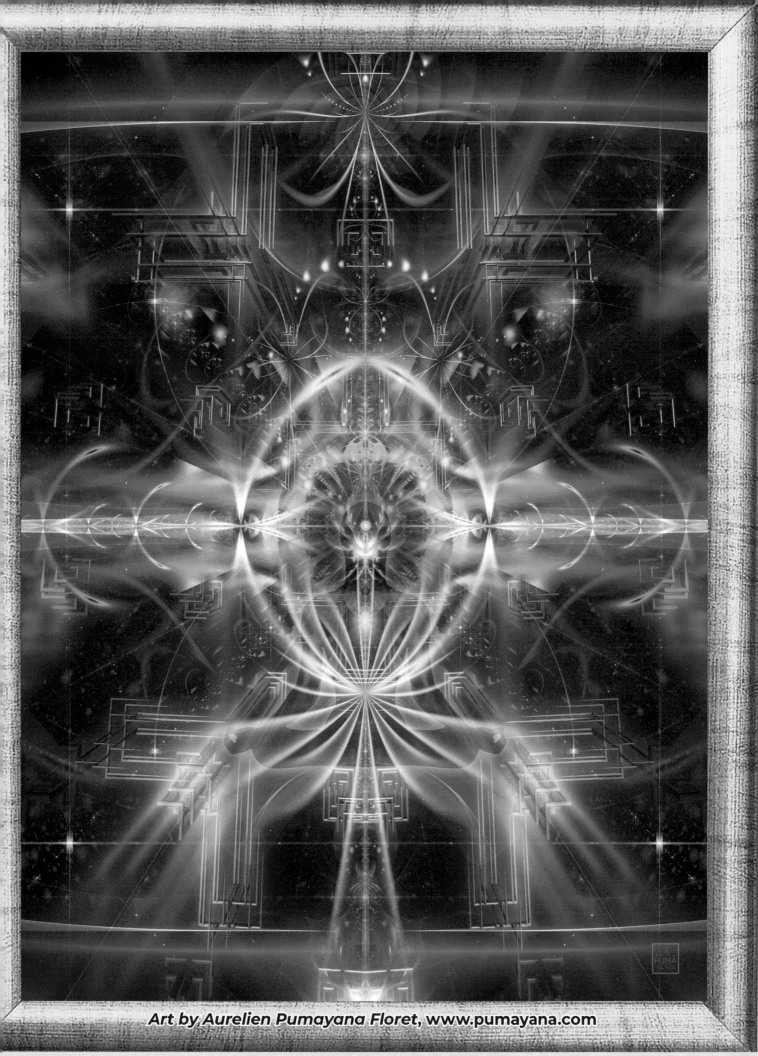

Art by Aurelien Pumayana Floret, www.pumayana.com

Consider Your Ego with Kindness

"Compassion is the wish for another being to be free from suffering; love is wanting them to have happiness."
—Dalai Lama

Are we dressing up our egos, embodying other aspects of the self, to project a façade to the outside world? When we memorize past emotional behavior such as fear, shame, anger, guilt, judgement, jealousy, blame, anxiety, or hatred, we develop a gap between our true self/state of being and our image/appearance.

The ego is the imaginary identity of our overstimulated nervous system, consisting of narratives and thoughts that we identify with, perpetuated by stress responses acquired from pain and emotional imbalance. The primary function of the nervous system is to help maintain a sense of linear order through the multidimensional nature of life.

The innocence of our being starts to fade through complicated patterns of survival and is often overwhelmed by a constant state of alertness, both of which are recorded in the memory of our cells. This causes the threat of deficiency and disappointment to become outcomes that we regularly anticipate. As such, a deep-rooted sense of separation is formed from vibrations of love that may lead to patterns of codependency and addictive behaviors.

When we choose to remove our everyday masks of expectations—the habits and emotions that block its flow within us—the Divine intelligence begins to illuminate, expanding our states of consciousness. This allows us to make space for gratitude and embrace our childlike egos gently, with compassion and kindness. Since this loving intelligence flows effortlessly through our heart center, we become the best version of our higher self. This is our birthright, beautiful Souls, and the effect is true joy, inner peace, bliss, and harmony.

"Inside you there's an artist you don't know about."
—Rumi

Loving Fearlessly

Step into the waters of life that excite
Watch the waves ebb and flow with delight.
Don't let the coolness of the ocean shore
inhibit your experience from opening the door.
Fear not the surge of the current's throw
The swell will deliver you where you're destined to go.
Will you allow it to take you seriously?
Into the depth of loving fearlessly.
Do you dare to love yourself truly?
Embracing the parts of you tending fearfully.
Be merciful, kind, and caring
To your nervous system that is flaring.
Quench your innocence with worthiness
Healing your childhood wounds with nothing less.
With compassion and respect, honor the truth
By how fiercely you choose to adore your youth.
Limitless love is pure and instinctive
Bursting from a Universal core that is distinctive.
With these auspicious streams of tears, you roam.
Creating a deluge to sweep you back home.

Lali A. Love

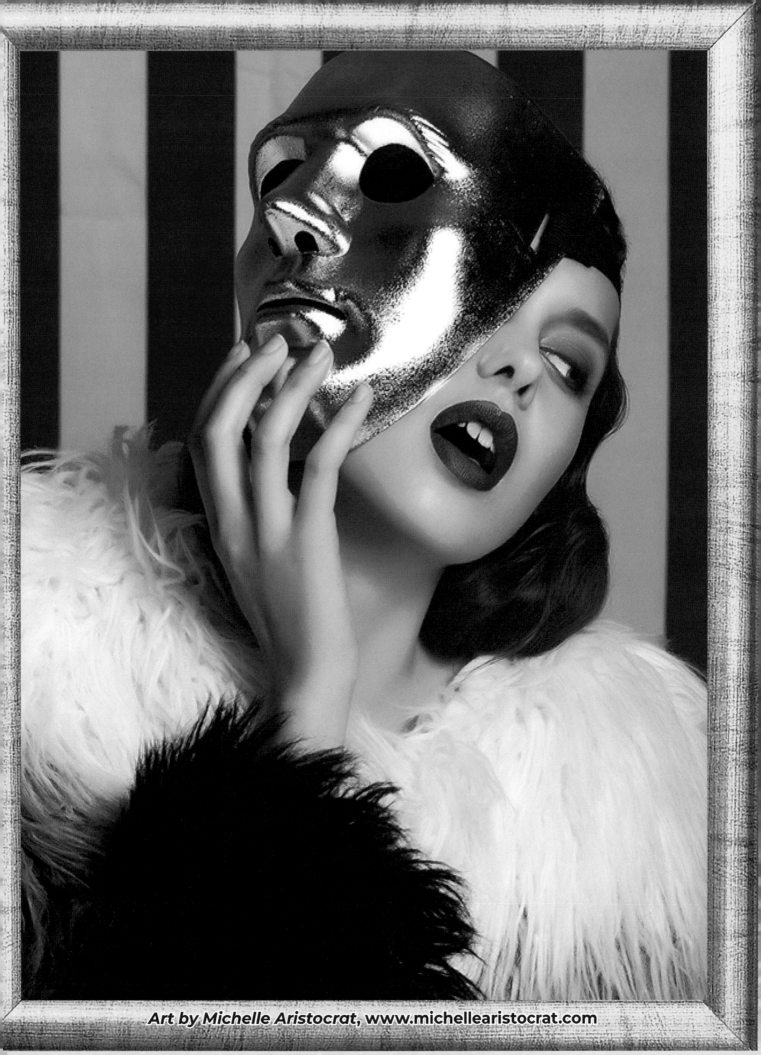

Art by Michelle Aristocrat, www.michellearistocrat.com

HEART-CENTERED AWARENESS

*"Go out into the world today and love the people you meet. Let
your presence light a new light in the hearts of people."*
—Mother Theresa

Did you know that the heart emits a vibrational frequency that has a reach of up to fifteen feet in diameter? When we practice mind, heart, and body coherence with authentic intentions, we are aligned with the energy of the Universe, which provides us with momentum to fuel our pathway. When we are reacting with Egocentric desires for instant gratification, recognition, and status gain, we emit lower frequency vibrations that we ultimately attract into our reality, where the cycle perpetuates itself.

The heart is not only a muscle or a physical pump that moves blood throughout our body as an imperative in sustaining life, but an organ capable of influencing and directing one's emotions, morality, and decision-making ability. When our heart is open, it is aligned with the unified magnetic field of energy where polarity meets duality and the place where wholeness and Divinity begins. The frequency generated from this elevated emotion carries information throughout our physical bodies.

As such, we become more intuitive, more patient, more present, more forgiving, and more knowing. These are the elevated feelings of heart-centered consciousness—love, compassion, gratitude, understanding, joy, unity, and forgiveness. These feelings infuse our core and allows us to feel whole, connected, and unified, rather than the feelings of fear and stress that divide our communities and drain individuals of vital life force energy.

"Nothing can dim the light that shines from within."
—Maya Angelou

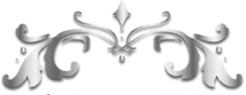

The Connection Within

Roaming and buzzing and all alone.
Searching throughout the great unknown.
Disconnected and scared. Where was her place,
was it all a disgrace?
Foundations created by beliefs of separation.
Generations that forced a cruel dilation.
Surrounded by many, yet alone in her world.
No justification for her life un-hurled.
All that had been taught through the minds of her tribe.
Conglomerates of prejudices unbeknownst dissected her pride.
Piece by piece the learnings she was taught.
No longer had relevance in this life that she sought.
And just when her purpose and meaning was about to come crumbling down.
In came her twin, her spirit, her soul-part was found.
For it's not what you think, not another "one", per say.
Yet she connected with source, her inner divine that day.
He came flying in to support her and connect on a level so deep.
He was her other half and so eager to take the big leap.
She accepted and reconnected, to herself,
the divine masculine and divine feminine reunited at last.
A reunion of ancient alchemy from her long-lost past.
And so, her search of seeking and fulfillment from external "ones" came to a halt.
For all that she needed was already within,
resurrecting and pollinating with her very own twin.
No need to look outside of oneself for happiness, peace, love, joy, protection.
The company we seek is inside on a divine connection.
Blessings for all those who are so vulnerable and open.
Thus, they shall reap the benefits of a love unspoken.
This is our time dear ones to take that journey within.
For it is in this sacred space, where true love begins.

Gillian Small

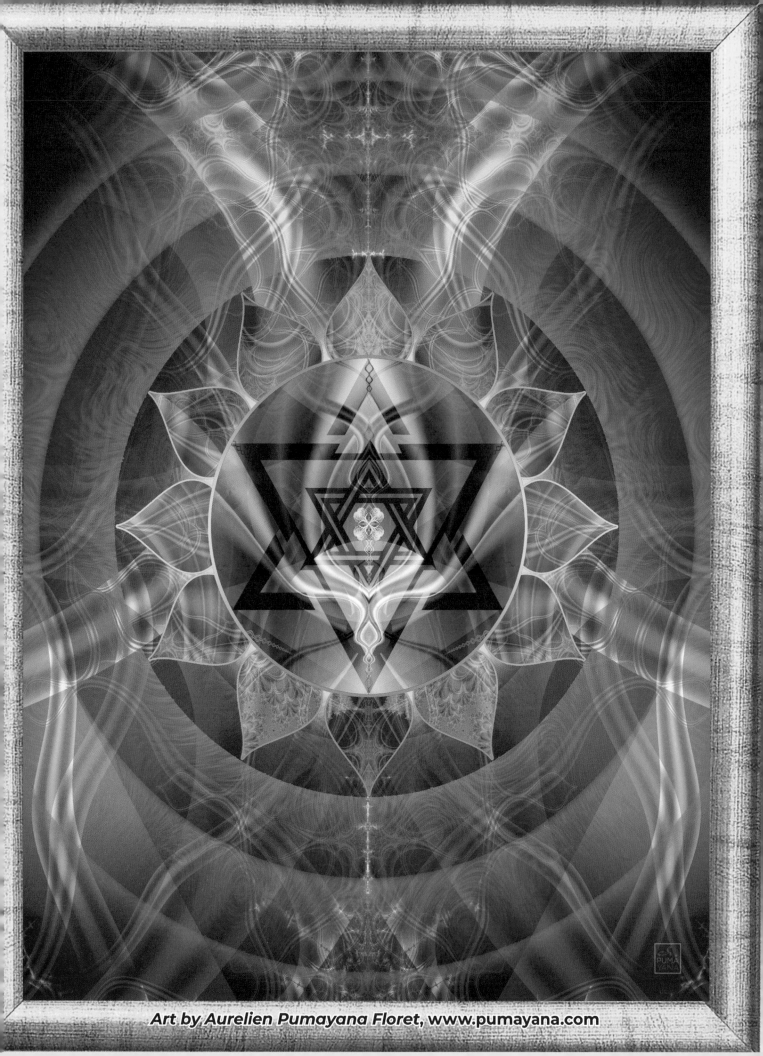

Art by Aurelien Pumayana Floret, www.pumayana.com

STATE OF BEING

"No one and nothing outside of you can give you salvation, or free you from the misery. You have to light your own lamp. You have to know the miniature universe that you yourself are."
—Banani Ray

Thoughts are the language of the brain; feelings are the vernacular of the body. How we think and how we feel creates our state of being. Daily hormones of stress cause us to unconsciously focus on the worst-case scenarios, resulting in negative thought patterns and emotional behaviors.

When we focus our attention on what's going wrong instead of what's right in our lives, we lower our vibrational state. In order to regain control of the frequencies we emit, we must learn to cultivate our state of being. We have to increase our awareness of our own thinking, speaking, and acting and be willing to self-analyse and self-adjust with gentle kindness.

In every situation, we have numerous alternatives that affect us and the people around us by the choices we make. Our conscious choice making should nourish us and everyone influenced by our actions, taking responsibility, and caring for what we value. Every action we take generates a force of energy that returns to us in kind.

By taking deep cleansing breaths, we can become aware of how we are expressively reacting to situations and assess the choices we make. The frequencies that we emit from this state of being are the vibrations that we attract back into our reality.

"You have to grow from the inside out. None can teach you; none can make you spiritual. There is no other teacher but your own soul."
—Swami Vivekananda

Currency of Life

Good thoughts, good words, good deeds,
With these karmic actions, your spiritual currency grows like weeds.
Be mindful of the electrons circling your quantum field,
For every human action has an equal and opposite impact to yield.

Good thoughts, good words, good deeds,
The Universe speaks through cause and effect, knowing where it leads.
Clearing old karmic debris from your soul's boundary,
As your greatest achievement is to realize self mastery.

Good thoughts, good words, good deeds,
With intentions and actions your choice exceeds.
Transmuting your passions within a magical realm,
Guided by a journey with awareness at your helm.

Good thoughts, good words, good deeds,
Anchoring your being with wholeness that breeds.
Aligning with the spirit of love and harmonious acceptability,
Manifesting life's treasures with honor, service, and humility.

Lali A. Love

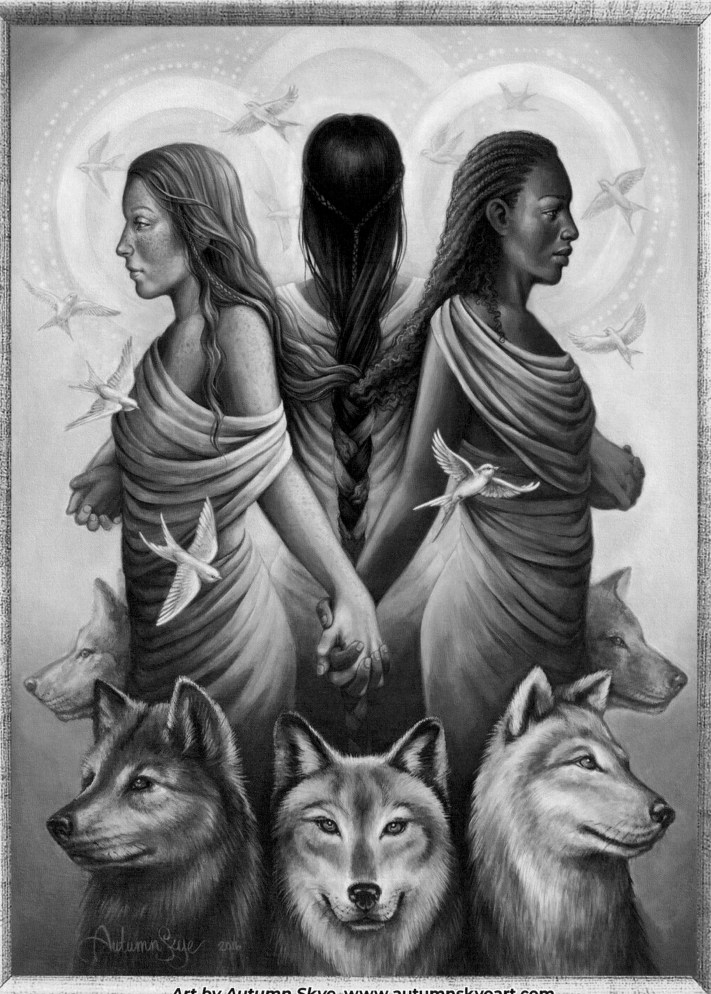

Art by Autumn Skye, www.autumnskyeart.com

BREATH OF LIFE

*"From the ashes, a fire shall be woken, a light
from the shadows shall spring."*
—J. R. R. Tolkien

Between Birth and Death, there is Breath. Awareness is the lens which the breath looks through, first thing that occurs at birth and last experience at physical mortality. Deep, conscious breathing skills can lower heart rate, boost energy, and improve stress. Focusing on breath awareness forms the universal core of meditation. With this knowledge, a simple cleansing breath easily unlocks the door to the pleasures of spiritual liberation.

In the physical body, we have two types of energies. One is known as prana and the other is known as consciousness. In every organ of the body, there are two networks supplying energy through the sympathetic and the parasympathetic nervous systems that are interconnected. In the same way, every organ is supplied with the energy of prana, meaning the original life force energy.

Prana is a Sanskrit word indicating constant motion, which commences from birth and is the energy responsible for the body's life, heat, and maintenance. Prana is not merely a philosophical concept; it is in every sense a physical substance similar to electromagnetic waves. In the physical body, there are pranic waves and a pranic field. By breathing deeply, we stimulate our respiratory system and the blood circulation, resulting in significant change in the limbic structure.

Our breath is the living example of fully awakened transcendent glory. With every inhalation, we have an opportunity to welcome a new moment with gratitude. Our breath is our tour guide into the highest vibration realm of love.

*"Life is a great tapestry. The individual is only an insignificant
thread in an immense and miraculous pattern."*
—Albert Einstein

Good Morning

Dawn dismantles the night
To divulge the energy hidden in light.
Subtle codes of electric currents
Expose fields of magnetic deterrents.
Permeating the intergalactic tones
A distinct alchemy of atoms with human bones.
Comprising of the Sun power core
A body of inner balance you can't ignore.
Meditating to achieve infinite bliss
With enthusiasm to welcome the day with a loving kiss.

Lali A. Love

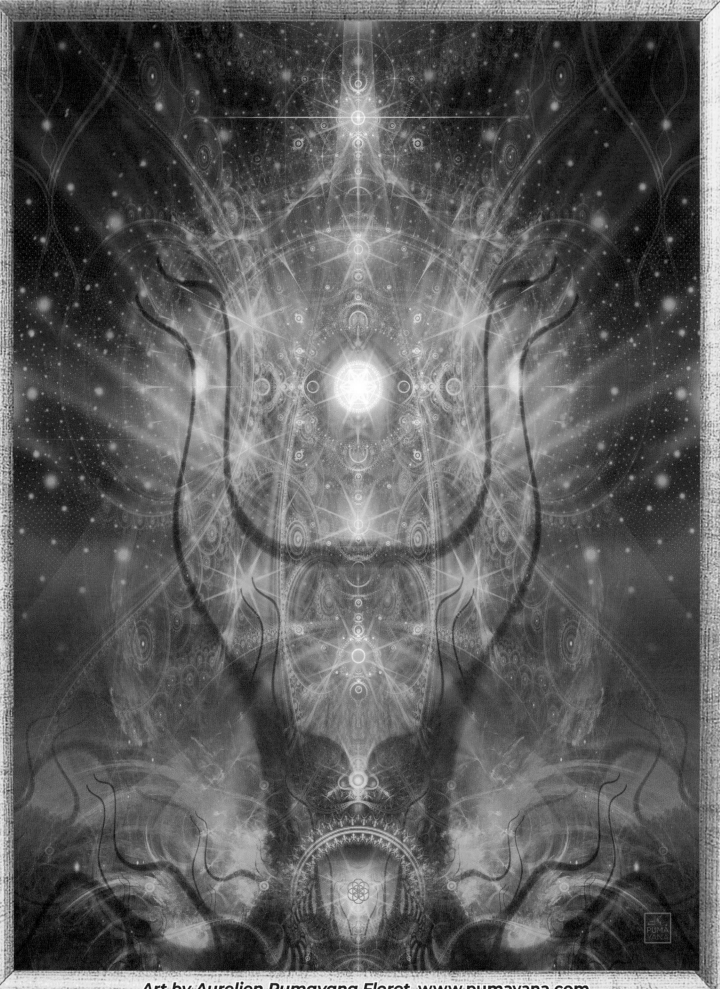

Art by Aurelien Pumayana Floret, www.pumayana.com

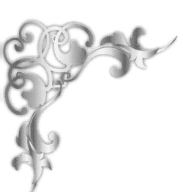
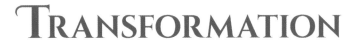

TRANSFORMATION

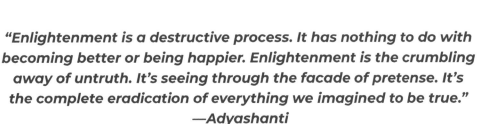

"Enlightenment is a destructive process. It has nothing to do with becoming better or being happier. Enlightenment is the crumbling away of untruth. It's seeing through the facade of pretense. It's the complete eradication of everything we imagined to be true."
—Adyashanti

Our consciousness is the ultimate basis of our being that creates all our reality. How our minds are programmed results in the experiences of our bodies, our perception, and our lives. When we elevate our state of awareness, we reinvent and transform our consciousness to our highest level of Divinity. This will influence how we think, how we emotionally react, how we perceive the world around us.

It will help us attain encouraging, loving, compassionate relationships, social interactions, behaviors, and patterns. These qualities are more conducive to the process of enlightenment, as it also provides healing for our environment and the world as we are all interconnected.

This also helps improve our biology, like our blood pressure, heart rate, immune functions, etc. For most of us, our bodies are the battleground for the conflicts we wage in our minds; by choosing to change our negative self-talk, our bodies can become the playground for bliss, creativity, harmony, and inner peace.

How do we transform our unconscious being into an expanded state of consciousness? Through the powerful alchemy of meditation and deep breathing.

May you be blessed with inner peace and an abundance of love as you journey through this loving, harmonious Universe with grace and humility.

"You've seen my descent. Now watch my rising."
—Rumi

Metamorphosis

I AM star dust plucked from the Cosmos,
Consciously transforming the realms of my bounds.
As I illuminate my divinity to heal old wounds,
I emerge with the wisdom of a thousand prophets,
So, let it be known with elation and trumpets.
I AM a collection of Souls primed by sacred flames,
But now you begin to define me with human names.
With calcium, carbon, nitrogen, and iron,
I form my vessel as a conduit for my Soul mission.
Particles, atoms, and cellular debris,
Producing a bundle of joy to fill your heart with glee.
Gifting my wholeness as my conditioning begins,
You imprint your ancestral scars and emotional casings.
Layer by layer my pureness starts to get dimmer,
Wearing masks of pain and a phony glimmer.
The parasites rejoice as they begin to feast,
But I will not be enslaved by your insatiable beast.
I remember my wholeness as I awaken and heal,
Picking up the shattered pieces of my tender heart, I start to feel.
I've been stitched together with self-realization and love,
Honing my warrior radiance from the creator above.
With loving awareness, I intensify with explosive light,
It emanates brightly through the broken fragments of my might.
As my calcified ribs grow wings of illumination,
I rise above your shadows and your delusion.
I AM magic, love, kindness, and bliss,
Spreading messages of unity that you cannot miss.
With forgiveness and compassion, I set you free,
As I AM infinite energy transmuting with glee.
Radiating at high frequencies to heal this earthly dome,
I will love you eternally as I transform back home.

Lali A. Love

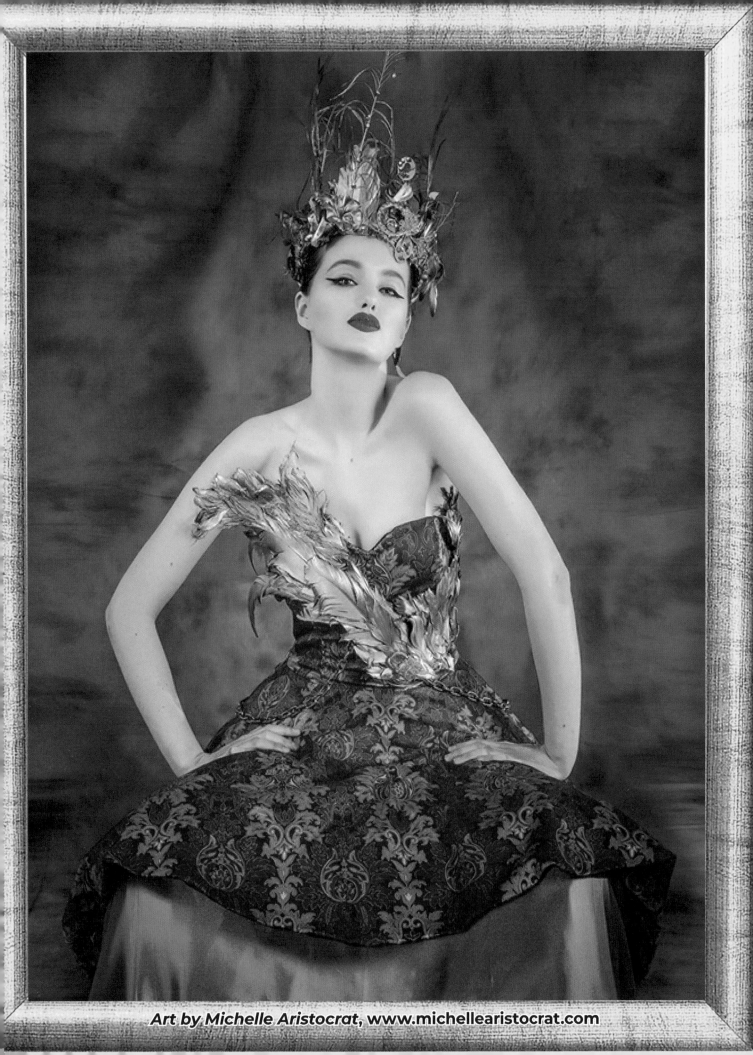

GRATITUDE

*"Acknowledging the good that you already have in
your life is the foundation for all abundance."*
—Eckhart Tolle

Did you know that daily practice of gratitude transforms deficiency into abundance? Eckhart Tolle stated this perfectly: "When you love what you already have, it fills you with enthusiasm and energy, and as a result, you end up creating more abundance with that positive energy."

When you experience genuine gratitude, the ego is overstepped to enable you to feel greater love, joy, compassion, and understanding. When you connect with this authentic inner joy, you are able to feel greater bliss and begin to emote and appreciate the miracle of life in all it's magnificence.

This practice helps remove the negative self-talk of limitations and reminds you that everything you experience is an opportunity to evolve into your higher self, a more loving and thankful being. When you feel good about the simple things in life such as the joyful humming sounds of birds, the warmth radiance of the sun on your skin, the delicious taste of coffee, or the cool breeze providing sustenance for your Soul, you begin to realize all the beauty and magic that surrounds you. With this mindset, you will attract abundance and remain in harmony with the Universe.

"Wear gratitude like a cloak and it will feed every corner of your life."
—Rumi

Time to Fly

She could hear the waves moving closer and closer. Carrying the echoes of their past voices.
Her past voices. The incessant noises.
They rose and crashed. Waves thrashing against earths bountiful
rocky cliff-side. Crashing against her beliefs that no longer had her
best interests at heart. Smashing them into the ground.
No longer to be found.
The waves ripped and tore through the templates of the past.
They could no longer rehash, that which was ready to be cast.
Her feathered wings, ripe they had always been, yet smothered in unwanted
screams. Now done with the programming that mourned her no good,
the waves teased her to spread those wings, as she so could.
Fluttering open with divine wisdom, her wings deflected the waves prism.
"How will you ever know if you can fly, if you never use your wings?"
And with an inner knowing and a gleeful sigh, she soared, she flew, way up high.

Gillian Small

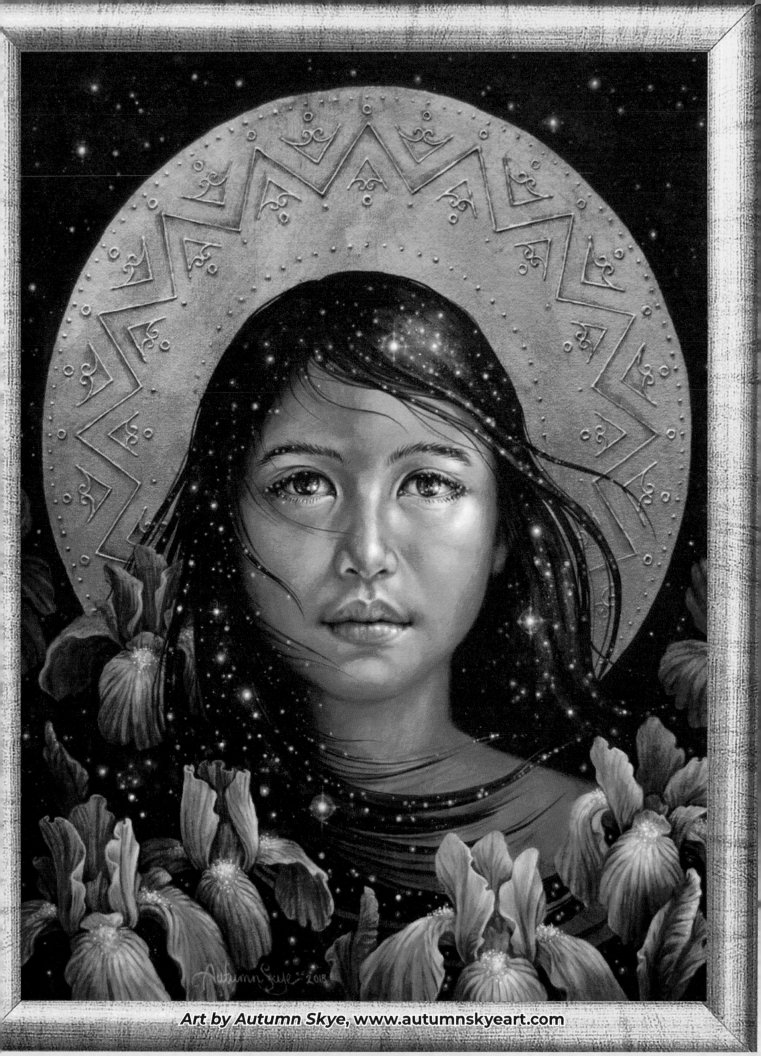

FIRST LOVE YOURSELF

"Your own Self-Realization is the greatest
service you can render the world."
—Ramana Maharshi

Love begins with our selves, as we align to our highest truths, embody our divine wholeness, and integrate our infinite radiate light into our cellular space. Turn inward and honor your sacred spirit, respect it, cherish it, love it unconditionally without judgement or expectations, just like you love others. You are worthy of your attention, kindness, respect, and affection. You are deserving of love.

Self-love begins with acknowledging your worth, and acceptance. You are priceless, unique, and one of a kind. If you trust the process of the intelligent and loving Universe, you willingly accept the circumstances of your daily life, generating a Universal harmonious flow. No one can take away your sacred crown when you embrace and embody the Divine love that you already are.

The willingness to accept this truth assists in the transformation of humanity, an essential stage of growth. In this eternal cultivation, your body expands into a conscious vessel of awakening by providing your innocence with the encouragement, kindness, acceptance, care, compassion, forgiveness, and loving awareness it has always desired.

"Your sacred space is where you can find yourself over and over again."
—Joseph Campbell

FLY

Let's journey inside, you may ask, why
That's where your Soul is yearning to fly.
Stop, breathe, be still and search wide,
For that infinite starlight that's always inside.
Your radiance is unique, overflowing with love,
But First Love Yourself completely and soar above.
You are Divine personified with grace and humility,
Do not doubt your worth and acceptability.
Stand in your power with pride, please, don't hide,
From the sweet blossoms of serenity where you reside.
Let these words console you when you look up in the sky.
Remember your true essence, beloved, and fly.

Lali A. Love

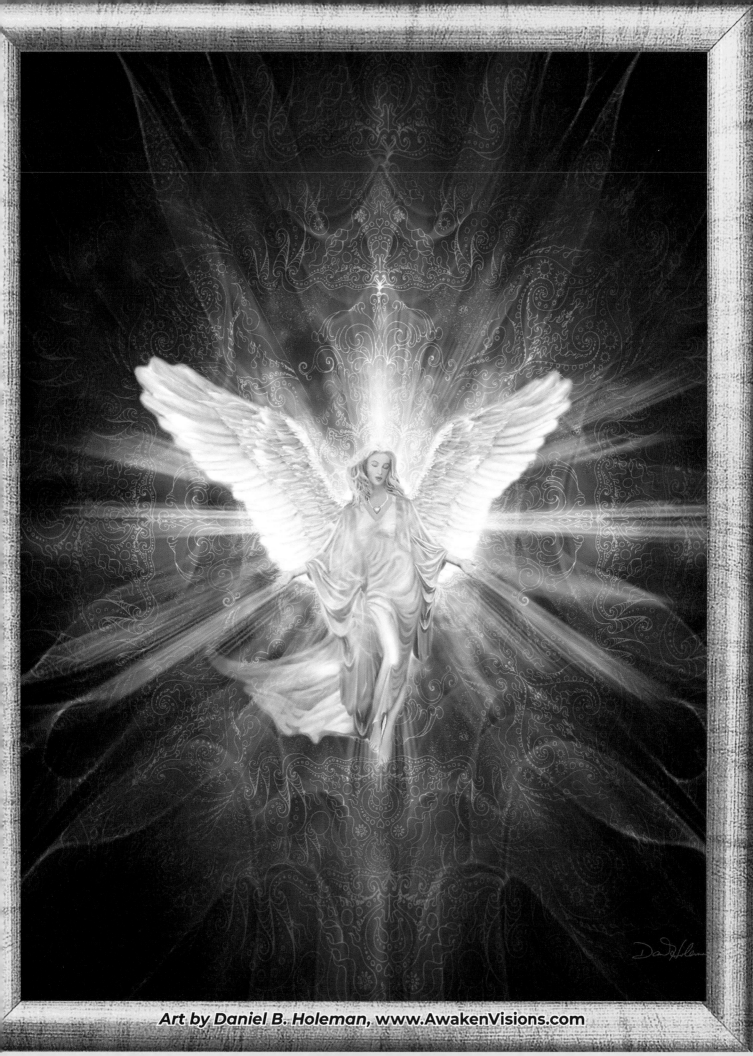

Vulnerability

"Courage starts with showing up and letting ourselves be seen."
—Brené Brown

Vulnerability and authenticity are the tools of change. Brené Brown said it perfectly: "Vulnerability is the birthplace of love, belonging, joy, courage, empathy, and creativity. It is the source of hope, empathy, accountability, and authenticity. If we want greater clarity in our purpose or deeper and more meaningful spiritual lives, vulnerability is the path."

Vulnerability is the source of creativity and transformation. It's the beauty of the flow that can bring you materialistic comfort, opportunity, support, resources of all kinds. But first, you have to be open to receive. You have to be self-aware because your imprints from your past may trigger you and can constrict your field, which can sometimes allow you to make judgements against others and, more importantly, yourself.

The late Debbie Ford called this The Secret of The Shadow. Once you find the courage to unlock the mysteries of your own past, your own history, your own wounded behaviours, and responses, you can create a massive tipping point and set your compass towards your true purpose in this existence.

"Love comes when manipulation stops, when you think more about the other person than about his or her reactions to you. When you dare to reveal yourself fully. When you dare to be vulnerable."
—Dr. Joyce Brothers

Rebirth of Herself

From a young age she felt so much despair
but could not find the right way for herself to repair.
She searched high and low, above and below.
Looked in the gardens, under the rocks, to the trees, but could not find ease.
Reading this book and that book but could not find the hook.
She met that teacher and that preacher and looked for a guru that she could look up to.
Searching for answers on how to be, peaceful and live happily.
Then one day, she shed her cocoon, leaving behind her outdated costume.
Realizing no one could save her, she looked within,
beyond the depths of her pale-freckled skin.
She decided she had the power, the light, and the will,
and began her own process to morph with such skill.
Like a caterpillar who morphs to a butterfly,
she too began her rebirth from crawling to soaring high.

Gillian Small

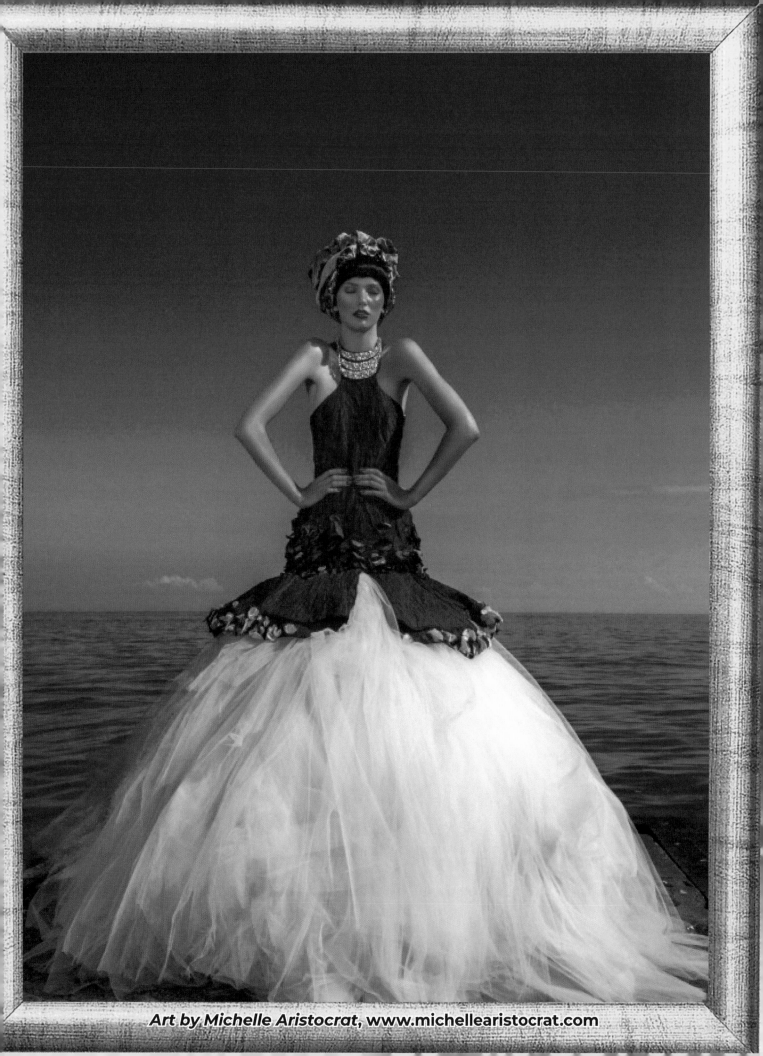

FORGIVENESS

"We cannot change the past, but we can change our attitude toward it. Uproot guilt and plant forgiveness. Tear out arrogance and seed humility. Exchange love for hate—thereby, making the present comfortable and the future promising."
—Maya Angelou

When we understand that forgiveness is not about condoning someone else's behavior, we allow ourselves to be liberated by consciously choosing to let go of past transgressions. Through this act of compassion, we release our own anger, blame, and resentment, which inevitably frees us from reliving the past through the same patterns of hurt behaviors.

Forgiveness allows us to view our reality through an awakened lens of learning and self-growth on our journey to enlightenment. It is an integral part of our healing process that enables us to embrace and accept the past, releasing its control over our present experiences.

By truly letting go of old thought patterns, emotional reactions, and programmed behaviors of hurt, we can reach internal calm, peace, and tranquility no matter how many challenges life sends our way. Through this compassionate act, we learn to relinquish expectations and become content under all circumstances. Forgiveness is the tool that will unshackle us from the vibration of fear, it is the path to our unified freedom, the path to our embodiment and unity consciousness.

"There is no peace without forgiveness."
—Marianne Williamson

Letting Go of Past Lives

I could have ended it long before,
That time when you choose to shut the door.
The isolation left in my face,
Was none more miserable than you in my space.
Countless times I begged to leave,
But often succumbed to your very plea.
Was just one more added to your lengthy list,
Of those whose energies could not resist.
Fruitless times of ups and downs,
Spinning my head round and round.
My clouded judgement cloaked in fears,
Choking back the endless tears.
A ticking time bomb one might say,
The bomb that left us in disarray.
Until I saw it for what it really was,
A disillusionment with no good cause.
One was of pure and one was not,
And so inside the light I sought.
The light that shone so very bright,
That scared away the dark knight.
Peace, joy, freedom at last,
Good riddance to the heavy past.

Gillian Small

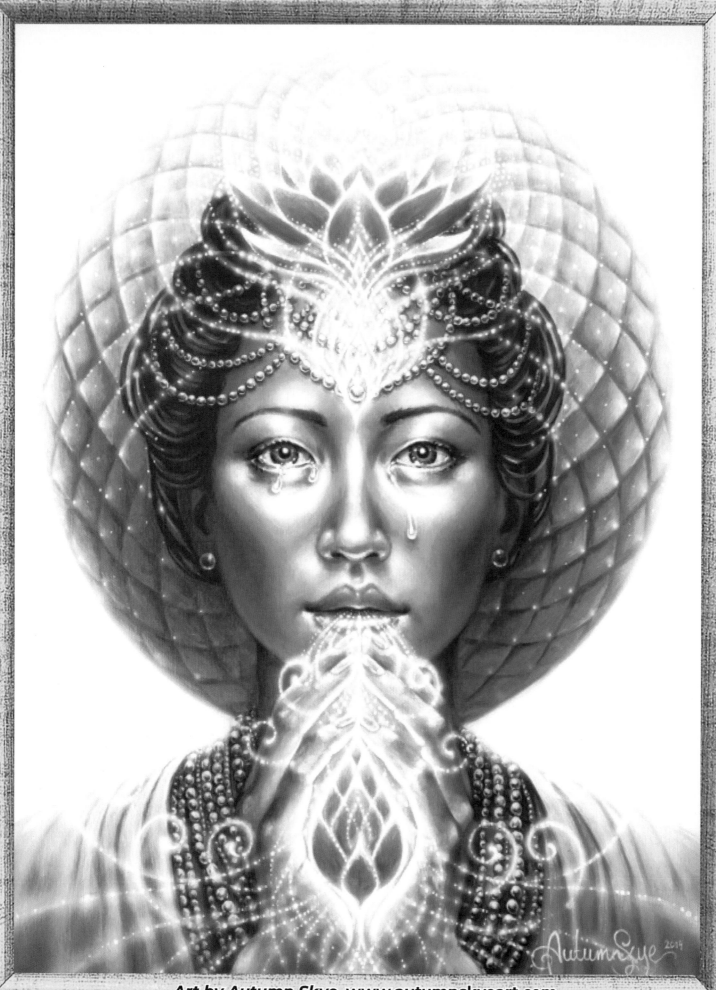

LIFT OTHERS WITH KINDNESS

*"Kindness is more than deeds. It is an attitude, an expression,
a look, a touch. It is anything that lifts another person."*
—Plato

Kindness begins when you initiate a heart-centered action for the good of another being without any perceived conditions or expectations. This dynamic exchange of high vibrational frequencies of giving and receiving flows into the Universal quantum field, reflecting an abundance of positivity back into your energy field. A random act of kindness such as a friendly smile, a compliment, or a heartfelt blessing is a vibration of mindfulness. It is a way of life; as you anchor the Light, you become ambassadors of wholeness with grace and humility.

Affection, gentleness, warmth, concern, and care are words that are associated with kindness. Being kind often requires courage and strength, it is a superpower that we all possess inside of us. Kindness is the light that dissolves the veils of density between all beings. It is the divine fragrance of awakening consciousness, your awareness of change to reach your highest self of transcendent maturity. Kindness is the true measure of spiritual authenticity when you operate from the space of love.

*"Kindness in words creates confidence. Kindness in thinking
creates profoundness. Kindness in giving creates love."*
—Lao Tzu

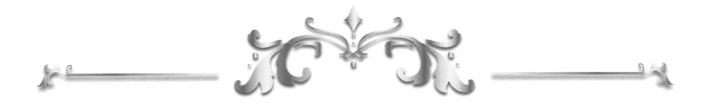

The Vow

I vow to wake each morning, gifting myself with a smile.
To appreciate nature's offerings and sunlight beams that beguile.
I embrace the singing birds and the childlike wonder of powdery snow,
By setting daily intentions and blessings of limitless joy for each being aglow.
May everyone I encounter be lifted by my essence,
Providing compliments and encouragement, I offer hope and benevolence.
I openly give and receive life's precious gift of affection and caring,
To circulate the vibrational frequencies of my heart's profound daring.
Everyone I encounter on this journey I vow to be blessed,
With infinite joy, inner peace, and laughter, may you always be caressed.

Lali A. Love

Art by Michelle Aristocrat, www.michellearistocrat.com

OPERATING FROM A
SPACE OF FEAR

"Love is what we are born with. Fear is what we learn."
—Marianne Williamson

Love is the most powerful force in the Universe, it can heal, inspire, and bring us closer to the higher self, the Source of our divinity. A gift that guides the magnificent evolution for the highest good of all. Pure consciousness is eternal and unified.

Fear is a destructive, negative, limiting sentiment that we create in order to experience differentiation from each other. It stems from our programmed ego's sense of separation from the Source, the infinite field of pure potentiality. It is vulnerable and constantly struggles to survive in what it perceives as a hostile world. It only exists within our perception when we are embodied. From this space, stems feelings of anxiety as we try to control events and our future results.

It's important to distinguish between this perception and real biological fear that is an instinctual response, a warning system that is automatically triggered by imminent danger. When this occurs, it increases our sensory alertness and releases a host of biochemical changes that prepares the body to fight or flee. This is an essential difference between programmed and biological fear.

Our goal is to rewrite the subconscious mind to match the vibrations of our natural divine nature. As human beings, we have the amazing ability to change our past conditioning, by choosing to release negativity and attachment to outcomes. This may be done by enjoying inspirational and healing sounds, visualization, and engaging in uplifting endeavors. This develops new positive way of living, clearing the subconscious of all that does not serve our highest good. We have to remember who and what we are— limitless love, eternal light, a magnificent multi-dimensional being.

"Nothing in life is to be feared, it is only to be understood. Now
is the time to understand more, so that we may fear less."
—Marie Curie

The Subconscious Mind

Fear Everything and Run, says the mind.
A recording that plays a continuous loop over time.
It's alert and dominates my everyday thoughts,
Built up habits with patterns imprinted and fought.
It has a language, a relentless chatter of a host,
Recording the worst-case scenarios imagined by most.
Speaks to me in the silent abyss of the night.
I try to quiet the static noise with all my might.
It takes everything quite literally, it's the feeling kind.
One million times more powerful than the conscious mind.

Lali A. Love

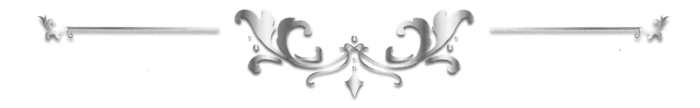

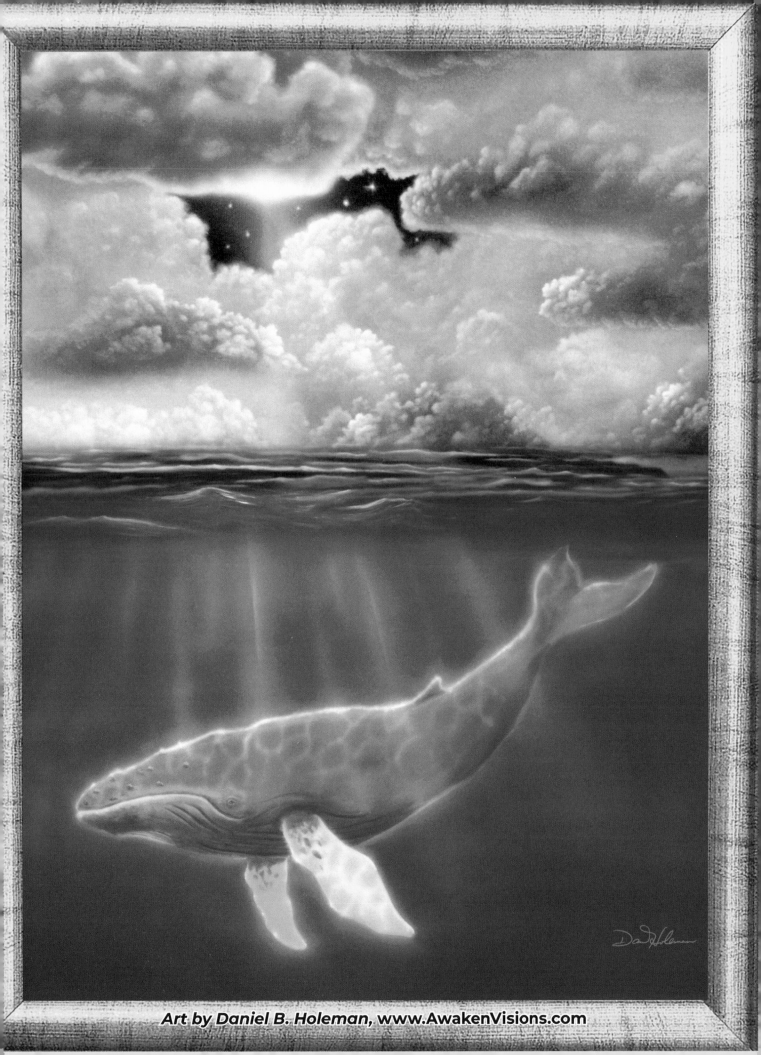

SPIRITUAL MATURITY

"Where there is charity and wisdom, there
is neither fear nor ignorance."
—Francis of Assisi

When we embody the Light with complete integration of mind, body, and Soul, we reach a state of spiritual maturity in our ascension journey. From this enlightened state of being, we honor our desires with the understanding that we may not receive them until we are fully ready. This insight requires a complete trust, surrender, and embrace of the loving, intelligent Universe.

Journeying through an awakening process enables the gradual disappearance of our external wanting and expectations. We realize a harmonic flow with the Universe when we're not weighed down by the energy generated from this emotional density.

Endless materialistic yearnings may create a state of deficiency. How do we know what we need unless we take a break from what we want? Maturity and spiritual wisdom are prevalent when the action of constant longing is surrendered. Once we recognize that this is not to be used as a manifestation tool, we begin to attract the intended energy that we're molded from as the living fulfillment of the Universe. This process is the spiritual maturity that we are all seeking.

Always remember that you are what all of existence desired to be, a genuine immaculate expression of Divine fulfillment.

"Through spiritual maturity you will see new ways to avoid
unnecessary suffering; wiser ways to endure unavoidable hardships
with grace, and opportunities to turn your pain into lessons of service
and healing for others. Your hard journey has had a great purpose!
Your pain was always a part of a plan to open your heart to love."
—Bryant H. McGill

Phoenix Rising

Shattered and scathed, her soul plummeted to the ground.
Crumbling and demoralizing, earths haven struck her down.
The pains of renunciation drove her heart beyond what it was worth.
Scathing and anticipating the worst from this hearth.
Plagued by invisible demons and energetic sparks.
The karmic debris no longer permitted to make its mark.
Lashing and thrashing this energy to its end.
Seeing every last minuscule dissipate, making no amend.
Battered and shattered as the stake sheared through her soul.
In the distance the smug laughter gleefully unfolds.
The atrocities of retribution so stern on his face.
As she no longer wavered in his disgraceful pace.
Vile, a villain where only ego saved face.
Wanting to dominate his prey, control and manipulate from a demoralizing place.
Shattered and crumbled and scathed to her soul,
she cleared the last remnants from this smouldering hole.
Rising up like a Phoenix from ashes burning the ground.
Blasting old energy that once kept her bound.
Rising and shining, so glad to be rid.
Empowered in light, she shone through the grid.
Flames illuminated as she brilliantly rose.
Casting pillars of light, through old shadows now a close.
Aware and awakened. Enlightened and brightened.
Wiser and free of past energetic debris.
Wings set a free and spreading so wide.
Rising, illuminating light, so radiant and glorified.

Gillian Small

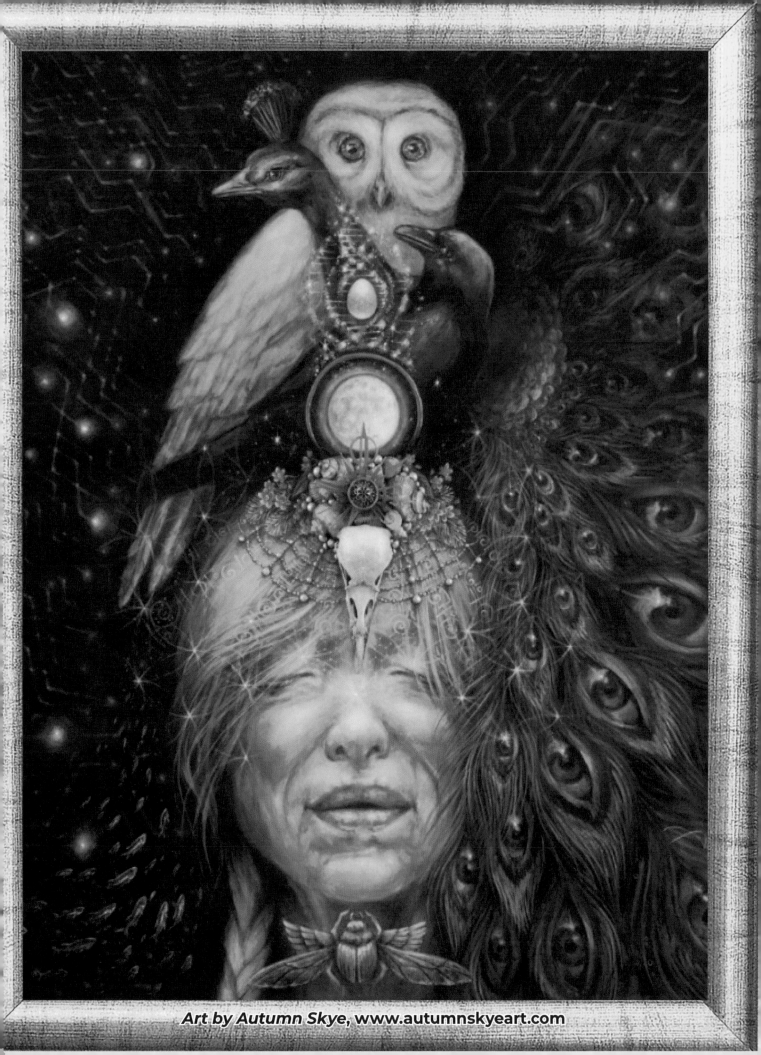

Art by Autumn Skye, www.autumnskyeart.com

Elevated Emotions

"Forgive the past. It is over. Learn from it and let go. People are constantly changing and growing. Do not cling to a limited, disconnected, negative image of a person in the past. Your relationship is always alive and changing."
—Brian Weiss

Every cosmic event that causes setbacks, triggers, and emotional eruptions is an opportunity for us to transform. We can choose to observe the incident from a higher perspective and change the way we react to it, empowering us to control our actions.

As Dr. Joe Dispenza eloquently stated: "To vibrate at a higher frequency, we need to align a clear intention (coherent brain) with an elevated emotion (coherent heart). With the intention or thought acting as the electrical charge and the feeling or emotion acting as a magnetic charge, this is how we change our energy—and the quality of our life. It's the harmony of these two elements that begins to produce a clear effect on matter by moving our biology from living in the past to living in the future."

When our heart is open, it is connected to the infinite possibilities that exist in the unified quantum field of potential energy. This is where polarity meets duality and the place where wholeness and Divinity begin. When we combine a clear intention with our elevated emotions, we begin to transmit a whole new electromagnetic signature into the field. With this vibrational match, the frequency generated carries information throughout our physical bodies. As such, we are more intuitive, more patient, more connected, more present, more understanding, more forgiving, and more knowing.

When we operate from the space of love, we begin to feel oneness as unified consciousness, rather than the feelings of fear and stress that divide communities. We may not have any control on external circumstances, but we always have a choice on how we choose to react emotionally.

"This is how we cease being victims of circumstance and begin living as a creator of our reality through heart-centered consciousness."
—Dr. Joe Dispenza

Exhilaration at Its Finest

The rubber hit the concrete. She heard the pounding of the ground.
A jolt of climatic energy bolted up from the bottom, connecting with her crown.
Pulsating blood cells expanding and shooting up like a light.
The blood rushing through her veins, circulating in unwavering delight.
The repetitive actions of up and down, increasing her energies all around.
Feeling coolness enter her throat, was magical and profound.
Her body exhilarating in the energy and the rush.
Heart beats and adrenaline racing, causing her cheeks to colour a pink flush.
Alas the thrill was over, and this blissful time was up.
Drinking in the air from God's universal cup.
She was healthy and flourishing, feeling complete and whole.
Relishing in new vibrations, her mind, body, and soul.

Gillian Small

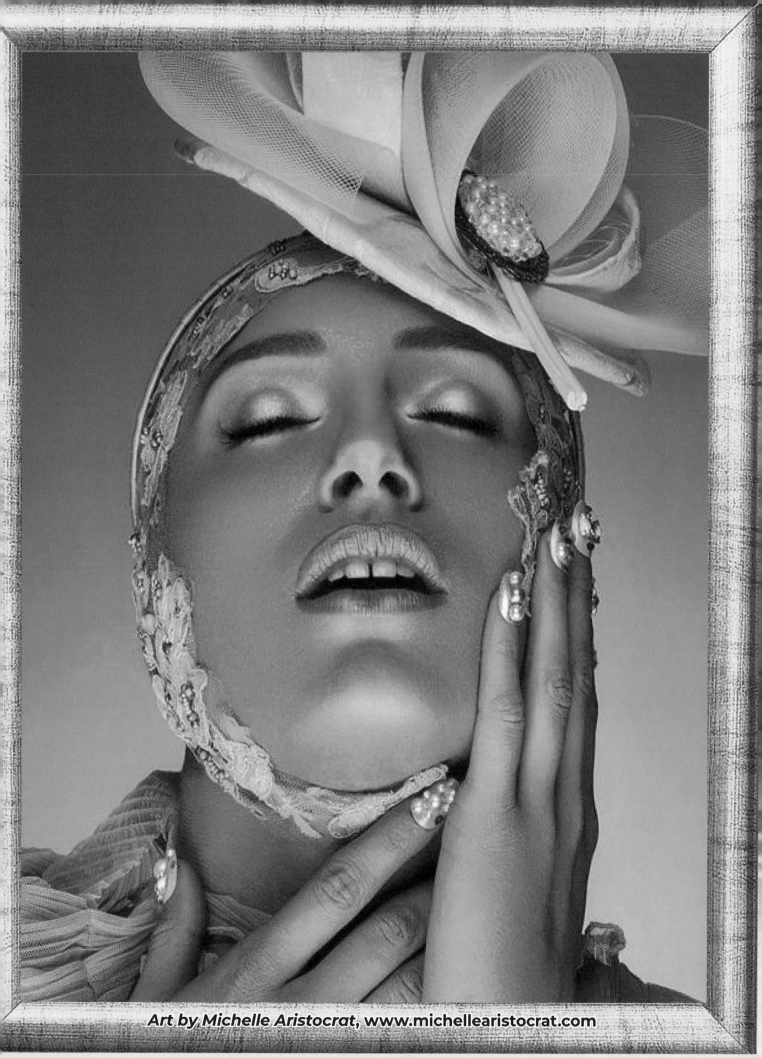

Art by Michelle Aristocrat, www.michellearistocrat.com

THE VIBRATION OF JOY

*"Joy is the holy fire that keeps our purpose
warm and our intelligence aglow."*
—Hellen Keller

There is a profound shift in energy when we all come together with open hearts to celebrate music, art, and the magic of the Universe. We feel good, joyful, fulfilled, emitting warm sensations through the energy fields of our bodies, magnifying the emotional vibrations of gratitude and love.

Joy is knowing the truth of who we are and appreciating the loving energy that connects us all. With this emotion, the human heart emits an electromagnetic field that surrounds the entire body and extends at least fifteen feet in every direction. This field sends signals to every cell in the body, affecting physical, mental, and emotional health and wellbeing. It also connects us with anything that has electromagnetic qualities, including Mother Earth, space, and even the twinkling stars.

Encoded in every emotion is a message; the indication of how we react to our thoughts, what vibration we are holding and attracting into our reality. We have the power to choose love and be fulfilled with the vibrational frequency of joy generated from this space of heart-centered consciousness.

"Joy is the net of love by which you can catch souls."
—Mother Theresa

Gratitude

When consciousness awakens, life begins to reveal
a flow of Divine's perfection, all through time that will appeal.
Access your intuition within to activate your healing
releasing all anxiety and old programming that you may be dealing.
Manage your emotional state, harmonizing as you merge
into a life transformed with profound growth and infinite surge.
Align and dance with your artistic inspiration
radiating fully from your heart's elation.
With love and gratitude, you begin to expand
accessing deeper feelings of joy and bliss that you command.
Upgrade and amplify the evolution of your Soul
embodying the light with your eternal creative whole.

Lali A. Love

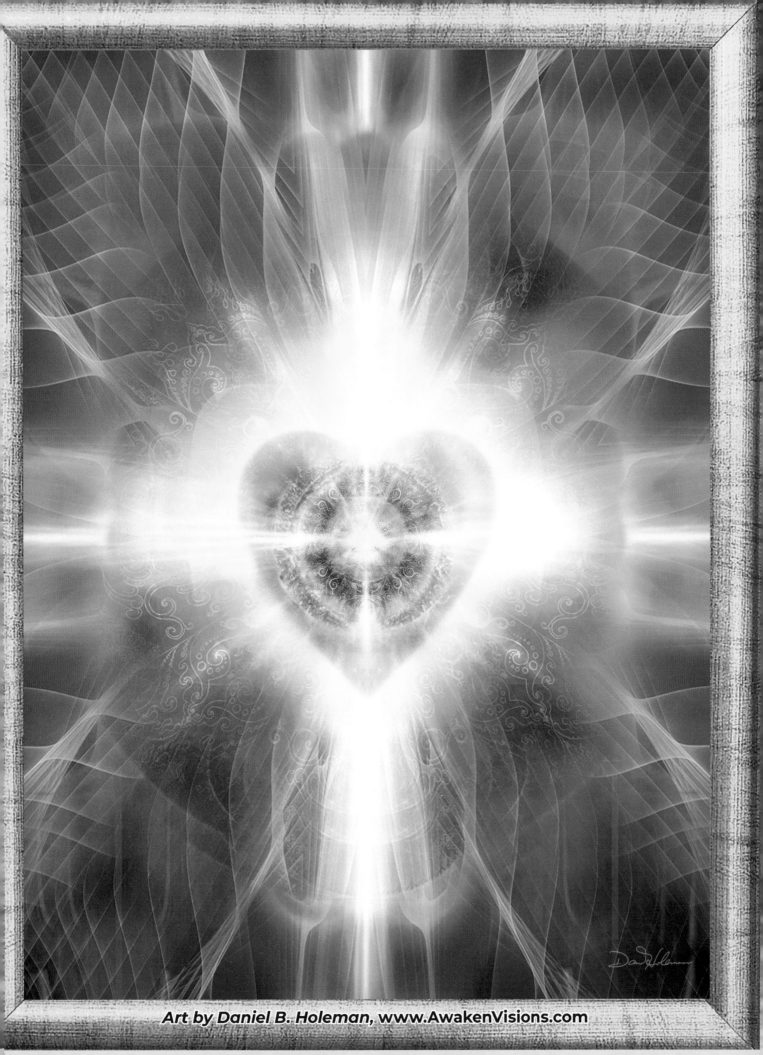

Art by Daniel B. Holeman, www.AwakenVisions.com

Embracing Change

*"If we can learn to accept and even welcome the endings
in our lives, we may find that the feeling of emptiness
that initially felt uncomfortable turns into a sense of inner
spaciousness that is deeply peaceful. Knowing yourself as the
awareness behind the voice is freedom and inner peace."*
—Eckhart Tolle

When we truly embrace, surrender, and trust the process of the Universe, we are liberated from feelings of angst. People tend to be uncomfortable with significant change, especially endings—because every ending is like a little death. Whenever an event expires, such as friendly gatherings, a vacation, or children leaving home, a little piece of us experiences an ending. A form that appears in our subconsciousness as that experience dissolves, often leaving behind an emotion of emptiness.

When each of these thoughts absorb our attention completely, it means that we identify with the voice in our head. We are not our thoughts, the ego mind, that mentally constructed self that feels incomplete and precarious. That's why fearing and wanting are its predominant emotions and motivating forces.

When you recognize that there is a voice in your head that pretends to be you and never stops speaking, you are awakening out of your unconscious identification with that stream of thinking—you realize that who you are is not the thinker but the one who is aware of it. When you become aware of the fact that you are the observer, you are more able to embrace the changes that arise in your life effortlessly.

Operating from this space, you begin to recognize these variations as an opportunity for growth and evolution of your highest potential.

*"One act of surrender, one change of heart, one
leap of faith, can change your life forever."*
—Robert Holden

Last Goodbyes

She looked upon him with wondering eyes,
dismissing the blatant manipulation and lies.
Her heart so full and divinely pure,
bought into the words no spell could cure.
A magician is light and blessed in soul,
while the trickster's dark ways cast shadows untold.
Her spirit of light caught his dark eyes,
and he clung to her in superficial disguise.
Ashamed to reveal the truth he so hid,
afraid she'd see through the facade that forbid.
Until one day the maiden of light,
broke through the chains of chaos and plight.
Casting away his deceptive spells,
she untangled herself from a disillusioned hell.
With a final farewell of self-worth and high vibes,
she gracefully said her last goodbyes.

Gillian Small

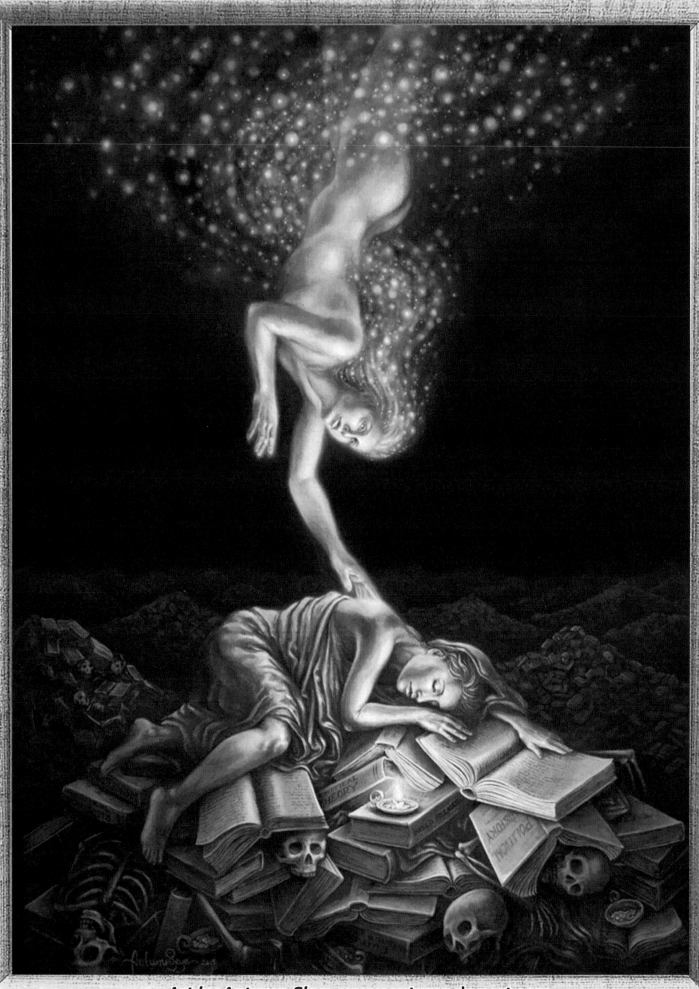

Art by Autumn Skye, www.autumnskyeart.com

MANIFESTATIONS

"If you want the moon, do not hide from the night. If you want the rose, do not run from the thorns. If you want love, do not hide from yourself."
—Rumi

You are an expression of the limitless, abundant Universe. When you surrender the yearning to manage circumstances and outcomes, you begin to manifest your heart-felt aspirations. Focus your attention on what you wish, take steps to achieve your dreams, find the confidence in the wisdom of uncertainty, and let go of attachment to outcomes. You are pure potentiality which you activate through your thoughts, beliefs, and intentions.

If you remember that life flourishes through the flow of giving and receiving, nothing is stagnant in the perfect symphony of Universal wealth. If you are seeking joy, love, material affluence, then it's important to circulate that flow of richness by helping others. The more you give, the more you will receive.

Universal integrity is always available to you as a divine, loving, compassionate being. By accepting and offering small gifts of kindness to others such as pleasant thoughts, silent blessings, good wishes, appreciation, smiles, or a helping hand, you begin to attract the same vibrational frequency back into your energetic field.

Attention, Intention, Action—if you commit to your intentions by taking aligned action, you will likely end up where you wish to be. You have the power within to manifest your own reality.

"Words have the power to both destroy and heal. When words are both true and kind, they can change our world."
—Buddha

Manifestation

Let's untangle the web of old conditioning,
Deconstructing the waves of patterns, belief systems decommissioning.
Evolving our inflamed egos without trepidation,
Operating from the space of love, unity, and compassion.
Surrendering to the Universe with open and loving awareness
With heart-centered gratitude and our blessed rareness.
Let the beauty and magic of Divine's Will integrate into our physical vessel,
Watching the unfolding of our pure potentiality begin to nestle.
With intuitive guidance our reality starts to transform,
Manifesting the purity and virtue of our Soul as it takes form.

Lali A. Love

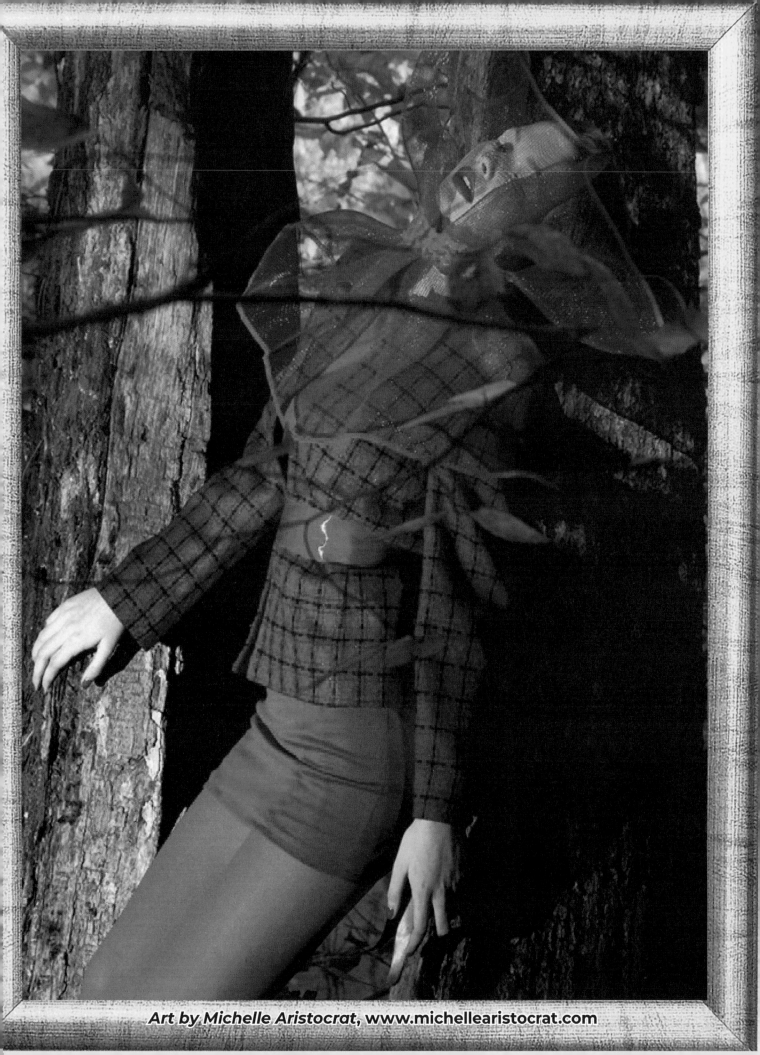
Art by Michelle Aristocrat, www.michellearistocrat.com

BLUEPRINT FOR EXISTENCE

"Nonresistance, nonjudgement, and nonattachment are the
three aspects of true freedom and enlightened living."
—Eckhart Tolle

Did you know that from the beginning of time, the Golden Spiral has been present everywhere in the Universe and on Mother Earth? Nature provides the most efficient blueprints in which plants grow. This intelligence showcases the Fibonacci Sequence in the patterns of leaves, pinecones, and flowers. It allows us to observe the spiral patterns of sacred geometry, a design that seems accidental but is actually quite intelligent.

From the curve of the human ear to the human bone structure, to the growth pattern of flowers, to the spirals of a nautical seashell, in sacred architecture or in the spirals of galaxies, the beauty of pure love exists. The universality of the Golden Ratio has led us to recognize it as the geometrical blueprint for life that connects us all without judgement, resistance, or attachment—it is the key into the mysterious Universe.

"When awareness expands, events that seem random actually
aren't. A larger purpose is trying to unfold through you. When you
become aware of that purpose - which is unique for each person-
you become like an architect who has been handed the blueprint."
—Deepak Chopra

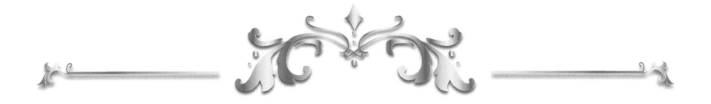

The Staircase of Life

In the staircase of life,
there can be much strife.
But there's solace in knowing.
Life is about flowing.
What mindset you choose.
Can give the high's or the blues.
Tapping away all that does not serve.
Making room for energy that you deserve.
Make sure that your walk,
matches the vibration of your talk.
The Universe sees and the Universe knows.
All that your thoughts and intentions unfold.
So, with a clean slate.
Strike the mark you choose to make.
Are your intentions clear and pure?
Do they reflect of light that reassure?
Be as you might and be as you will.
Perhaps one day the stairs you walk will take you uphill.

Gillian Small

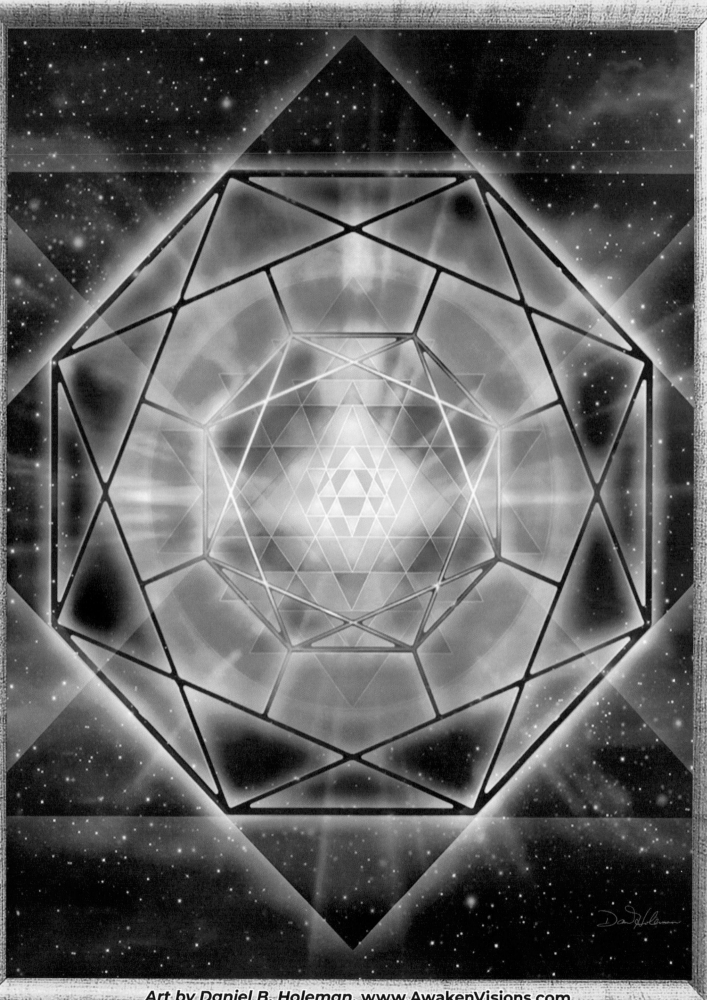

Art by Daniel B. Holeman, www.AwakenVisions.com

DAILY INTENTION SETTING

"Every moment of your life is infinitely creative, and the Universe is endlessly bountiful. Just put forth a clear enough request and everything your heart desires must come to you."
—Shakti Gawain

When we commit to living a daily life with high vibrational objectives, nothing is by chance or mistake. By living a life of intention setting with compassion in our hearts, we are helping uplift humanity and our planet Earth through indirect manifestation, where our needs are met with grace and ease.

An intention is a directed impulse of consciousness that contains the seed form of that which we aim to create. Like real seeds, intentions can't grow if we hold on to them. Only when we release our intentions into the abundant depths of our awareness can they grow and flourish.

At the deepest level of reality, is a field of energy that gives rise to all forms of creation. Placing our focus and attention on what we desire, will energize our goals to transform our results. With gratitude as our primary emotion, we can trust in the cosmic plan, release the clarified intentions into silence, and allow the Universe to map out the details with magnificent beauty and magic.

Setting daily targets requires commitment and respect for the practice. It can be such a powerful tool when we apply the process to every aspect of our lives by relinquishing control to outcomes. There are various methods of intention setting that could help us in our process. This could include a practice of writing them down, or using positive words, affirmations, and internal dialogue prior to meditation, whatever works for each unique being.

When we let go of our attachment to outcomes, we surrender our intentions to the Universe's field of infinite possibilities.

"Inherent in every intention and desire is the mechanics for its fulfillment. And when we introduce an intention in our pure potentiality, we put this infinite organizing power to work for us."
—Deepak Chopra

Intention Setting Practice

May every breath I take fill all sentient beings with radiant life force energy.
May every blink of my eyes open the heart of every person,
in all cities, countries, continents, galaxies, and universes.
May every word I speak raise the vibration of this beloved planet.
May every step I take upon this planet bring to all beings renewed life direction,
to elevate the world in greater inspiration, leaving less room for darkness or harm to reside.
May every person I encounter be blessed with the transmission of my eternal light.
May the light I pass on to others, whether I speak to them or not, heal and absolve their
lineage, throughout all dimensions of time and space, so that everywhere I go,
I'm not just encountering strangers but participating in
the transformation of history as we know it.
May every sip of water I take heal and replenish the oceans,
reverse the harm done to the ecosystem
and renew the natural order of this planet back to synchronized and aligned expression.
May every laugh that bubbles up within me,
bring a renewal of energy to this planet that makes all pollution become extinct.
May every time I smile anyone in danger is brought to safety.
May every time I yawn all children held in captivity are set free.
May every person reading this be blessed, bless their families and ancestry with all of the
wholeness and oneness that furthers the tipping point of our awakening civilization.

Thank you, Matt Khan, for guiding us through this radical intention setting. Namaste.

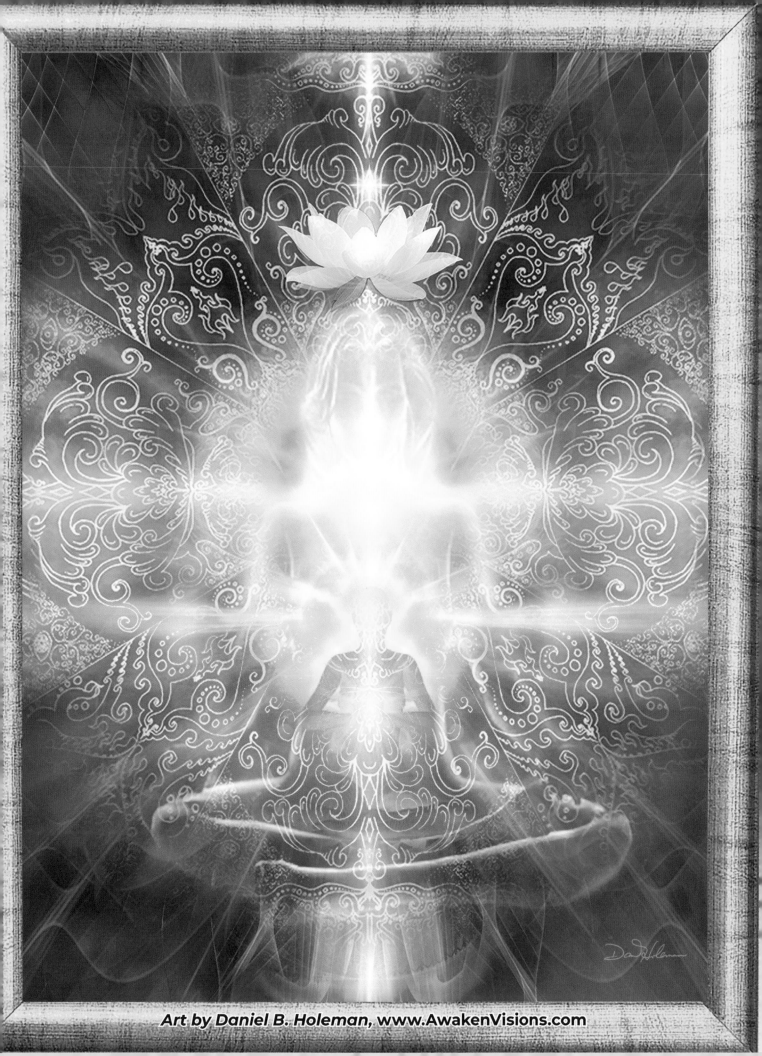

Your Mastery

*"From the ashes, a fire shall be woken, a light
from the shadows shall spring."*
—J. R. R. Tolkien

At some point in our journey, most of us experience a feeling that there is something greater than the physical world we inhabit. Whether we are inspired by the wonderment of the glorious view from a magnificent mountaintop, deciphering the mystical, the magnetic energy experienced by connecting with others, or the ambiguity of quantum physics, these precious moments can be both humbling and grounding. These elevated emotions and experiences shape the foundation of our spiritual journey, through our own creative expression. This is where we discover our strength and power within to become masters of our own reality.

Through this evolution, we invite peace and tranquility into our heart-center and into every aspect of our daily life, helping us become more humble, compassionate, and kind. Once we reach this enlightened state, we become judgement free, energetically sensitive but non-reactive beings. This is the true personification of love without any attachment to outcomes, with deep connection and respect for Mother Earth and all living beings.

To help us achieve this state of being, we can practice this daily affirmation: I radiate with loving kindness and life mirrors that back to me. My efforts are being supported by the Universe. My life is taking place right here, right now, and I am awake, alert, and open to the beauty and magic all around me. I choose to rise above negative energy, thoughts, and feelings. I accept myself exactly as I am. I love my life, my blessings, and all the abundance that is yet to come. My relationships are loving and harmonious. I am at peace. I trust in the process of the Universe. I am connected to the Divine love and wisdom. I can let go of old, negative beliefs. I am in charge of my thoughts and I choose to focus on my daily joy. I nourish the Universe and the Universe nourishes me.

*"Each separate being in the universe returns to the common
source. Returning to the source is serenity. If you don't realize the
source, you stumble in confusion and sorrow. When you realize
where you come from, you naturally become tolerant, disinterested,
amused, kindhearted as a grandmother, dignified as a king."*
—Lao Tzu

Your Mastery Affirmation

I remember myself as the master that I am, the master I have always been.
I know I have mastery over my life by how still I can keep my mind, how alert I am in the now.
I do not allow negative thoughts to gain control over my being.
I am clear, untouched, and unharmed by all that I have experienced in my life.
I approach each harmonious relationship with profound blessings as
opportunities for my highest evolution.
No matter the ups and downs that orbit my outcomes, I acknowledge that my journey
enables me to become the most magnificent expression of Divine Source energy.
I accept my strength with grace and humility.
I AM Loving Awareness.

Lali A. Love

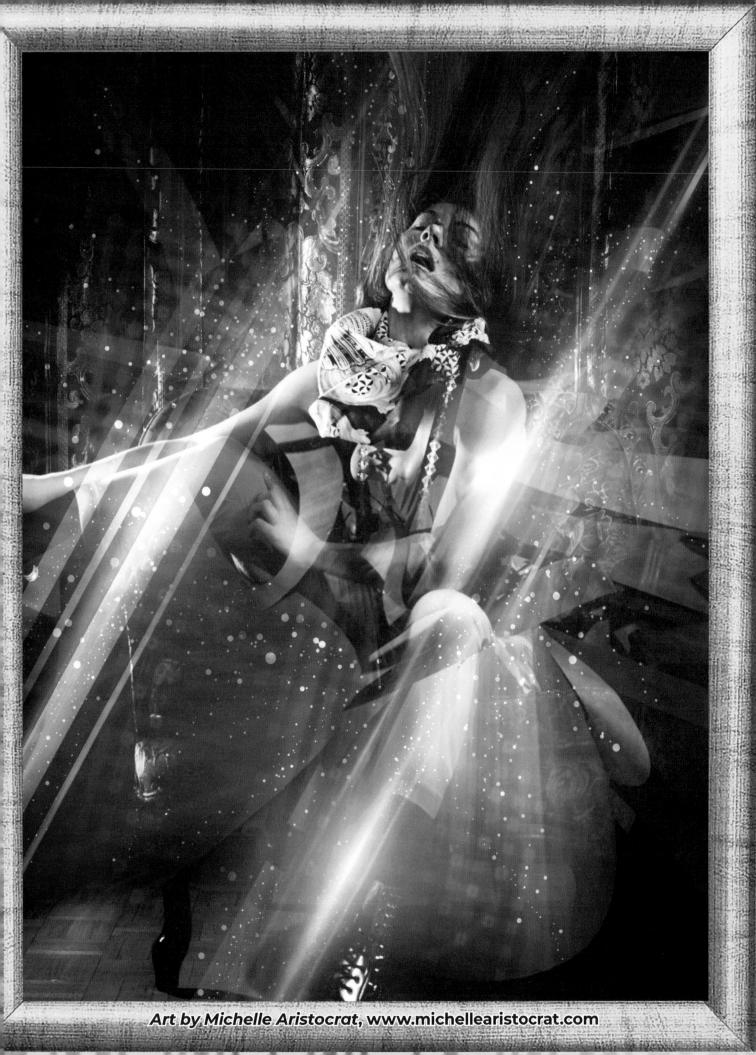

Art by Michelle Aristocrat, www.michellearistocrat.com

MASCULINE AND FEMININE ENERGY

"In a conflict between the heart and the brain, follow your heart."
—Swami Vivekananda

Did you know that spiritually, our left and right side of the brain represents the masculine and feminine energy? Space was the womb that birthed all of creation. Both energies exist in each human, where masculine energy is constant and female energy is change. Masculine needs to accept the inevitability of attrition to receive fulfillment. Due to intimidation of change represented by the feminine, the unconscious masculine only wants to acquire, control, and dominate. Feminine needs to be worthy to receive renewal, and the attribute it cultivates is the expression of creativity.

All reality is governed by the consciousness of masculine and feminine energy. The balance of both sides of the brain triggers the opening of the third eye. This is commonly referred to as the pineal gland. From the biological perspective, this gland produces melatonin, a neurotransmitter hormone responsible for regulating phases of sleep and wakening. It is also known for the production of DMT (dimethyltryptamine), a molecule that can be found in every living being, providing a correlation between the body and our spirit.

The third eye is our greatest gift to connect us to Source energy through a more mystical experience that which we perceive with our physical senses. As we embark on our journey of awakening, our pineal gland is activated, and we realize our intuitive achievements of telepathy and supernatural foresight. While our physical eyes perceive the third dimensional world, the third eye sees the truth—a unified whole with an uncompromising connection to the Divine.

With this knowledge, the rewiring of the brain can only be done through spiritual awakening, initiation, integration, and harmony. We have the potential for equality and diversity, made possible by honoring the divine feminine to temper and balance the edges of masculine energy. The coherence of this powerful awareness will unite both sides of the brain, providing healing to the collective consciousness. This integration and balance of the mind, body, and Soul is LOVE in ACTION within the fifth dimensional realm of existence.

"In separateness lies the world's greatest misery; in compassion lies the world's true strength."
—Buddha

Embrace

Sacred Goddess, how you inspire with your connectivity
Birthing and cultivating your soulful creativity.
Nourishing me with your tender embrace
Loving me endlessly without disgrace.
Teaching me patience and vulnerability
Honor, humility, and heartful sincerity.
Ready to receive revitalization and infinity
Balancing your celestial counterpart with Divinity.
A melody sung since the beginning of time
Intertwined as a twin flame dance in an endless rhyme.
Embracing your inner warrior that you forgave
With both spirits strong, devoted, and brave.
Interconnected in the Cosmos with profound unity
Worthy to be cherished and supported as a loving community.

Lali A. Love

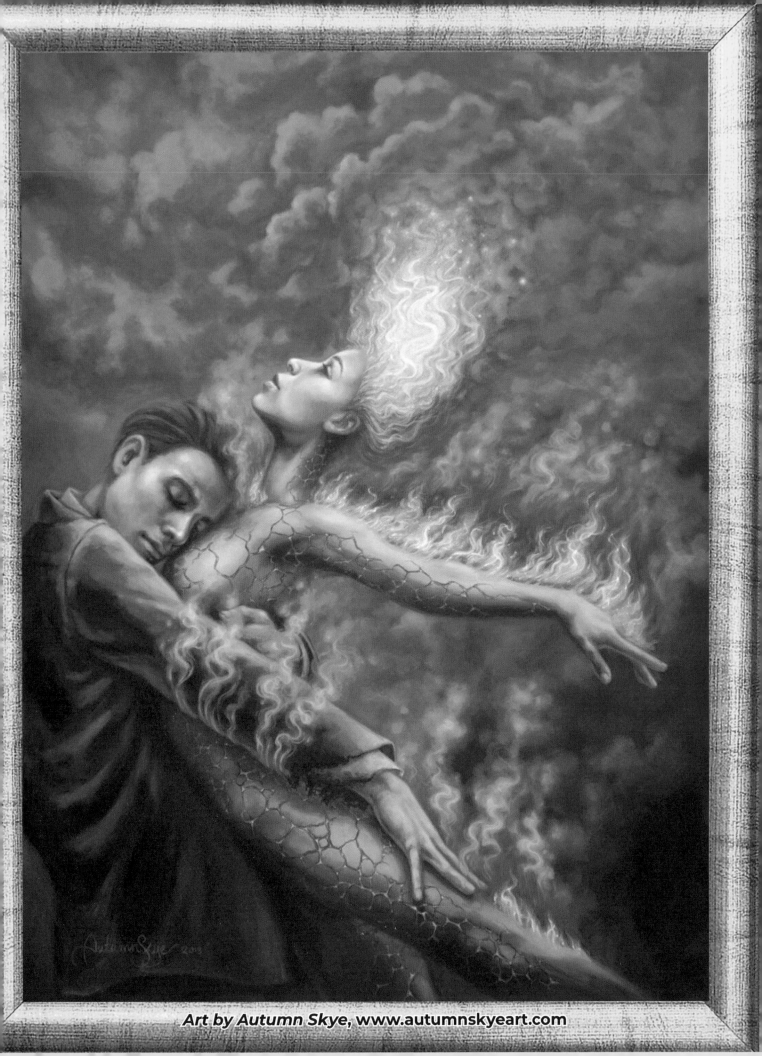

TRUE AUTHENTICITY

"It is not the magnitude of our actions, but the amount
of love that is put into them that matters."
—Mother Theresa

When we are authentic through our thoughts, actions, and beliefs, we are aligned to the ever-present Spirit of our Higher Self. Only through the integration of our body, beloved ego, and Spirit can we transcend into the flow of the ONE I AM Source. This requires us to break out of socially acceptable cycles of the collective unconsciousness. By eliminating the negative occurrences generated by judgement and blame, we release the toxicity levels stored within our cellular structures, allowing us to speak our truth.

With these authentic actions, we are able to embody the Light, anchored in the vibrational frequency of gratitude. This is how we radiate the light within our shadows and illuminate all corners of reality to wake up an entire Universe.

I am	(the innocence of the ego personality/inflamed nervous system, emanating from conditioning and core childhood wounds)
Truth	(the authentic actions and interactions with others)
Honor	(actions, thought patterns, and self-talk, without doubt, fear, guilt, shame, or unworthiness)
Alignment	(embodying truth and honour. Most thoughts are not our own, they are absorbed as orbiting logic of the collective unconsciousness)
Transcendence	(the ascension and enlightenment into higher self. Loving the self while enjoying the present moment life experiences with compassion and appreciation.)
I	(ONE, interconnected with all beings)
Awareness	(Integrated heart-centered consciousness)
Manifested	(the infinite eternal mindfulness of Source, Universe, unique expression of all)

May you always be filled with the Divine radiant life force energy. I am THAT I AM.

"The secret of health for both mind and body is not to mourn
for the past, worry about the future, or anticipate troubles,
but to live in the present moment wisely and earnestly."
—Buddah

Dimension of the Heart

Our world is transcending from the mind perception
of limitations and superficial existence, (3D)
as our third eye vision opens from inherent misconception.

Merging the two opposite realms of polarity
we discover our voices and engage in the gift of self-expression, (4D)
as our collective wisdom of heart-centred consciousness is awakened with clarity.

Emoting feelings of empathy, compassion, inspiration, and resolution
we embrace benevolent grace, peace, and humility, (5D)
anchored in the loving frequency of Divine's love manifestation.

This surrenders the pain and suffering of the masses
as we elevate the gravity of ascension and illumination,
transmuting it into the Light of perfection as it surpasses.

The integration of mind, body, and Soul propels us with salvation
embodying truth and honor in the magnitude of our unified actions.
May this unwavering loving kindness empower us toward emancipation.

Lali A. Love

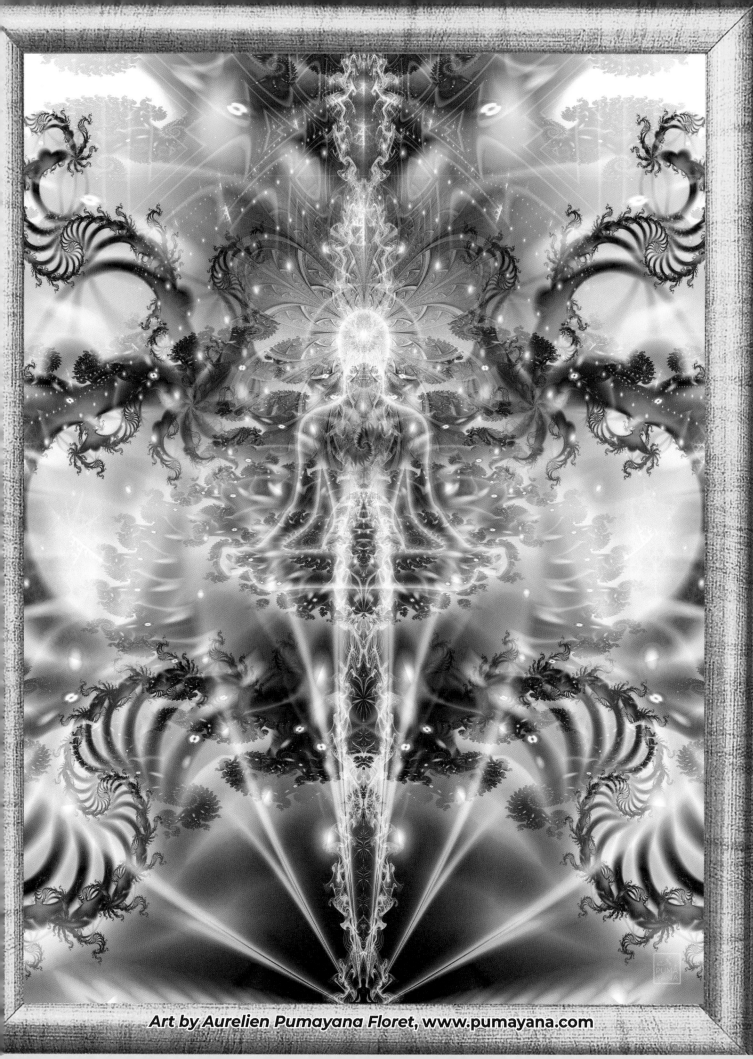

Art by Aurelien Pumayana Floret, www.pumayana.com

INNER BALANCE

*"As the fletcher whittles and makes straight his arrows,
so the master directs his straying thoughts."*
—Buddha

Did you know that plasmas are electromagnetic systems made from groupings of particles, which exhibit an overall zero net charge? Plasmas carry electrical currents and generate magnetic fields, and they are the most common form of matter, encompassing more than ninety-nine percent of the space in the visible Universe. Plasma permeates the entire solar system, as well as the interstellar and intergalactic environments, as distinct states of matter.

The human body is made up of atoms and electrons and is capable of a biological ionization process that generates plasma when exposed to certain forces. During the Ascension cycle, the human body potentially undergoes an alchemical process that generates an internal plasma light. This requires that we devote our personal energy and direct our consciousness to powering up our spiritual development and benefit.

As we meditate and patiently build our internal vitality to achieve inner balance, we stop energy leaks. In this state, our heart and brain vibrate at synchronised frequencies, producing a more calming, peaceful emotional stability. We begin to feel grounded, less exposed, more positive, soothed, and resilient. Achieving this way of being is our intrinsic responsibility and a process that we can influence. It is essential to our wellbeing and self-love.

With this self-care routine, combined with the alchemy of plasma light and daily practice of gratitude, feelings of bliss are enabled, imploding our aura field and heart-centred consciousness into states of harmony.

*"The most important human endeavor is the striving for morality in
our actions. Our inner balance and even our very existence depend on
it. Only morality in our actions can give beauty and dignity to life."*
—Albert Einstein

Your Contribution

Your emotional ability determines your changing flow
Riding the surge of current perceptions that you allow.
Take the time to honor your strength with gratitude
Connecting to heart-centered consciousness with greater latitude.
Providing heart-felt blessings and healing for all
Balancing your awareness by feeling tall.
Assist your well-being journey with gentle, caring peace
Focusing your intentions, breath, and positivity with ease.
Evolve your inner balance with grace and self-love
With this simple act of kindness, Beloved, it fits like a glove.
Now that you are empowered to contribute
Pursuing a harmonious world is an incredible tribute.

Lali A. Love

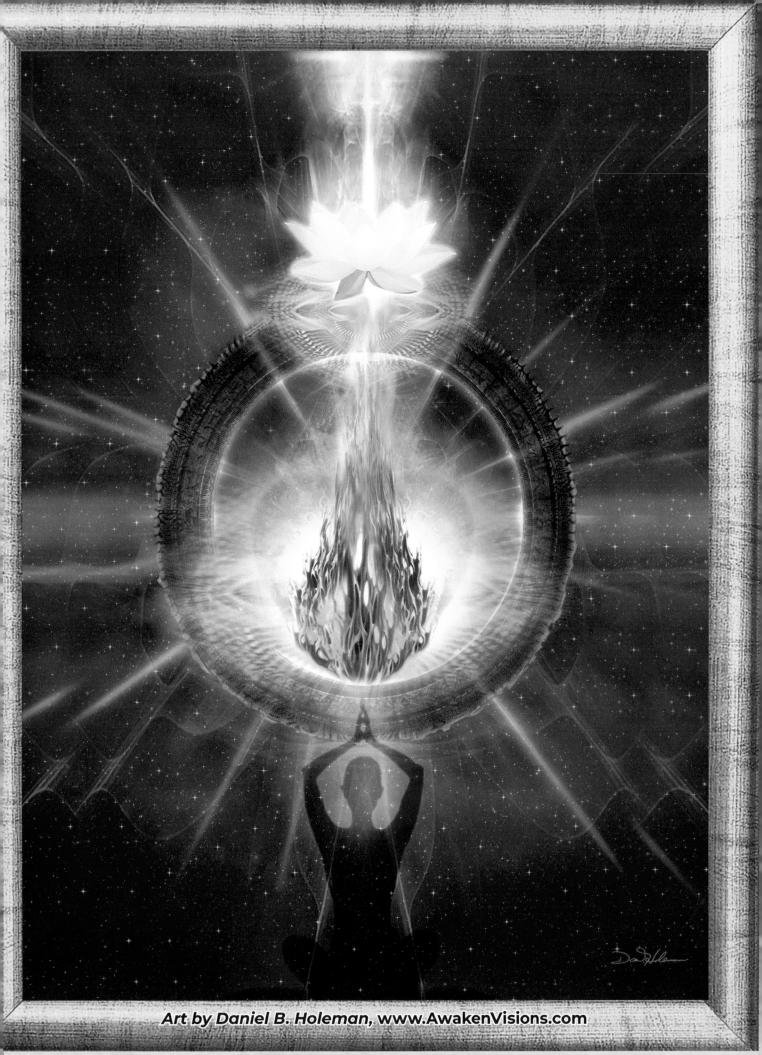

THE HUMAN QUANTUM FIELD

"One of the key principles of quantum physics is that mind and matter are not separate elements. Our conscious and unconscious thoughts and feelings are the very blueprints that control our destiny. The persistence, conviction, and focus to manifest any potential future lies within the human mind and within the mind of the quantum field."
—*Dr. Joe Dispenza*

There is an intelligence that runs the Universe, the planet, and our human body. If we tap into this blueprint, we realize that we have all the biological and neurological machinery to shift our wellbeing and transform our reality. This may be done by empowering ourselves with the knowledge and ability of our human mind, our elevated state of emotions and awareness.

If we continue to think the same thoughts, we enter a loop much like a program. Same patterns of past thoughts lead to the same choices, which cause the same behaviours, that create the same experiences, and produce the same emotions. This then drives the same inhibiting thought process.

Neuro-chemically, we are hardwiring our state of being, limiting our potential, without giving ourselves the ability to create new neural pathways and connections. It's important to note that our conscious mind is only five percent, while the remaining ninety-five percent is a set of subconscious programs in which the body has become the mind. Our attitudes, beliefs, and perceptions change our state of being and create our personality—our personal reality.

"You can search throughout the entire universe for someone who is more deserving of your love and affection than you are yourself, and that person is not to be found anywhere. You yourself, as much as anybody in the entire universe deserve your love and affection."
– *Buddha*

Goddess of Light

She's a goddess of light.
An angelic soul, soft but holds a good fight.
Energy between light and dark.
It's stronger, making its mark.
This dimension only holds space for the bright.
No room for the dark to manifest its ugly fight.
She sees, she knows, she's a very powerful soul.
Wise and strong, no room for another to uphold.
The dark tries with all its sorry might.
To chip away at her beautiful frequency, with such a sad fight.
Lo and behold there's no room for dark to pull her down.
She's made of light, surrounded by angles, guides, psychics,
healers – a light the dark cannot get around.
Dark used to be powerful in old energy its true.
But it's no longer welcome in 5th dimension, no room for you.
Try as it may to continue the same old ways of spells and dark thoughts directed lights way.
But this foolish nonsense of ways will drown dark, deep in decay.
The energy between light and dark so it goes.
Only making light stronger that nothing else can uphold.
Try as dark likes to continue the fight.
But light will always see through and win each day and each night.
For light reigns power over all the that's directed her way.
She's so light and so bright that she wishes the dark well
and prays for divine to help it along its way.
The powerful goddess shoots her divine arrows of light.
Right at the dark blasting away it's nasty fight.
The universe reigns the goddess so true,
applauding her strength and energy, whilst no dark can seep through.
While the dark sadly continued this energetic fight,
the Goddess retaliated with pure divine light.

Gillian Small

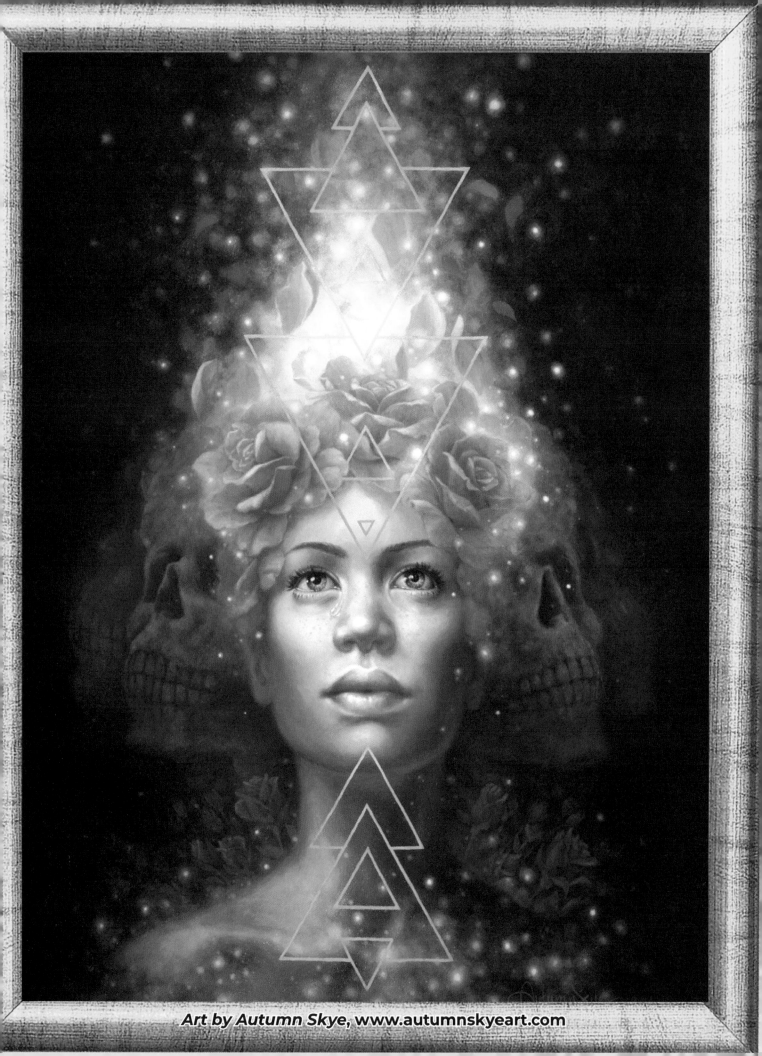

Art by Autumn Skye, www.autumnskyeart.com

PERCEPTIONS OF REALITY

"For most people, our bodies are the battleground for the wars we wage in our minds, by choosing to change our self-talk, our bodies can become the playground for all the love, creativity, joy, harmony, inner peace, and bliss."
—Deepak Chopra

Our consciousness is the ultimate basis of our being that creates all our reality. We primarily live in the physical domain consisting of form and substance, referred to as matter. We have been taught to believe that matter is our constant reality yet matter and form continually change. We also live on the level of the mind, a potential energy that evaluates, thinks, and perceives reality. How our minds are programmed results in the experiences of our bodies, our perception, and ultimately our lives.

When we elevate our state of awareness, we reinvent and transform our consciousness to the highest level of limitless potential, projecting the energy we attract into our reality. By transmuting our thoughts and expectations, we influence how we think, how we emotionally react, and how we perceive the world around us. It helps us achieve nurturing, loving, compassionate relationships, social interactions, behaviors, and patterns that are more conducive to the process of enlightenment.

These experiences occur in our consciousness, where our perception meets reality. Our brain filters and reduces the input it receives through the electrochemical activity that produces the sounds, sights, smells, and textures of our physical world.

What sometimes appears to be solid physical reality, is in fact a complex system of vibrating energies. What we actually perceive through our sense of sight is the dancing patterns of the same one particle, moving at infinite speed, overlapping its own path in certain ways. We are connected to everything in the pulsating, vibrating Universe of sophisticated harmonies.

Our physical reality is a manifestation of our own, unseen internal perceptions. To live in coherence with the Law of Attraction, we need to remember that our feelings are a conscious awareness of our vibration.

"Life is a series of natural and spontaneous changes. Don't resist them; that only creates sorrow. Let reality be reality. Let things flow naturally forward in whatever way they like."
—Lao Tzu

Shifting

As you evolve, you begin to realize
That you are not the same character you used to idealize.
Things you managed to tolerate begin to become unbearable,
Shifting your perception from events that seemed terrible.
When you once remained quiet, you discovered your vocal cord,
Helping you acknowledge your inner truth in ways you can afford.
Guiding you away from negative forces that no longer serve
Into a state of peaceful serenity that empowers you to observe.
Within you resides the secret of life's unfolding mystery,
Remembering your essence, as you liberate yourself from your history.

Lali A. Love

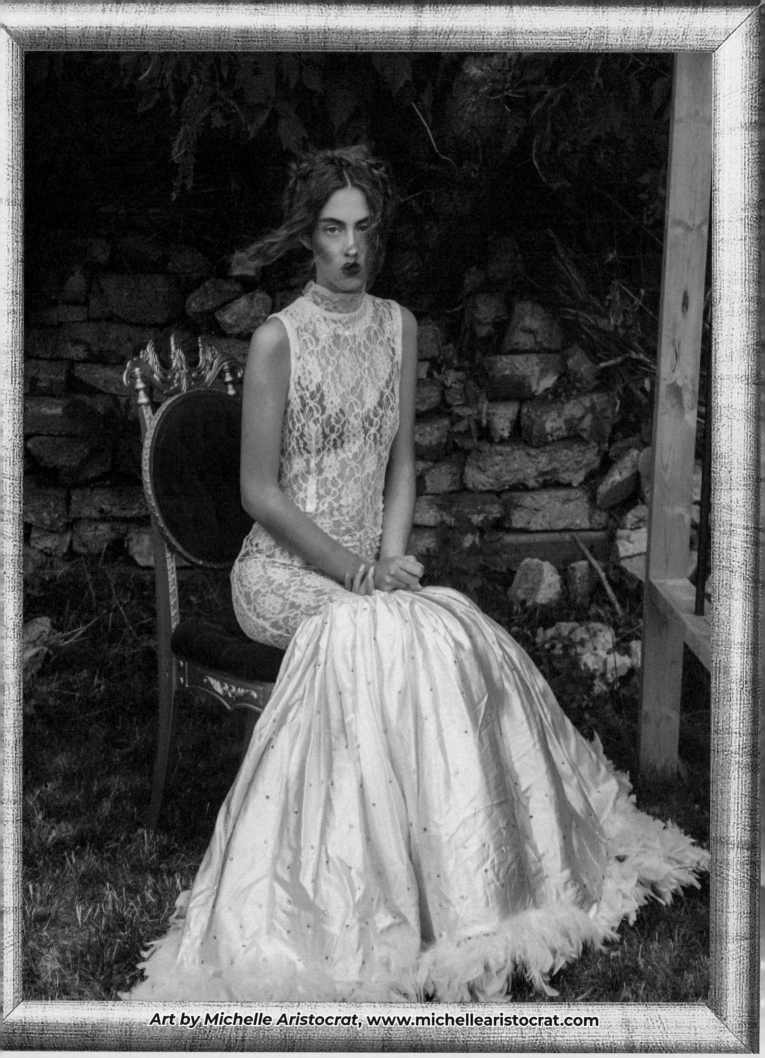

Art by Michelle Aristocrat, www.michellearistocrat.com

MOVEMENT OF TIME

*"We shall not cease from exploration, and the end of
all our exploring will be to arrive where we started
and know the place for the first time."*
—T.S. Eliot

In our third dimensional existence, we measure our lives by experiences that are set into motion by time. This elusive observed phenomenon is a construct; it is linear, calculated by the cycles of day and night. It is the time planet earth requires to circle the sun in a flowing continuum, moving along in its trajectory by means of which human beings' sense and record environmental changes on planet earth.

When we get caught up in the daily grind of the physical realm, we need to remind ourselves to stop and become aware of the present moment, aligning our heart, mind, and Soul in stillness. The Universal Law of Vibration states that our thoughts are waves of energy that penetrate all time and space. Our feelings are the conscious awareness of that vibration in the present moment of experiences.

In deeper levels of consciousness, fortunate coincidences can happen in an instant. What we refer to as good fortune is actually the result of awareness combined with intention, while harnessing the incredible power of living in alignment with the Soul, Spirit, and Source. Once fully integrated, we can spontaneously fulfill our desires and enjoy everyday miracles, if we hold the faith and trust in this belief.

Time can also be perceived as a movement of thought and the continuity of memory, using the ego as the eternal reference point. Once we break the barrier of the ego, we begin to experience spiritual time. This is the stillness we endeavor to maintain in a state of neutrality, regardless of how much linear time has gone by. This is where we find our true self—pure, everlasting, constant energy, an immortal being.

"The two most powerful warriors are patience and time."
—Leo Tolstoy

Letting Go

Their gnarled claws dug in so tight,
and rapturous teeth biting in sheer delight.
The torturous momentum of back and forth, pulled at their souls without much fight.
Back and forth and back forth they went, knowing full well it wasn't quite right.
Time and time again the struggle was real,
although the illusion was not ready to reveal.
Their hearts opened and closed with the dark and the light,
as the vulnerabilities and stubbornness tore open with such might.
The contracts that said, you must do this to heal,
to love unconditionally it does reveal.
Despite the lessons all was but clear,
it was not meant to be in this realm my dear.
They pulled back their claws, and softened the bite,
the back and forth and stubbornness gave up the big fight.
Releasing the karmic debris, between she and he,
they surrendered to not meant to be.
Thanking one another for their roles in this part,
they released their grip and slowly, yet lovingly, drifted apart.

Gillian Small

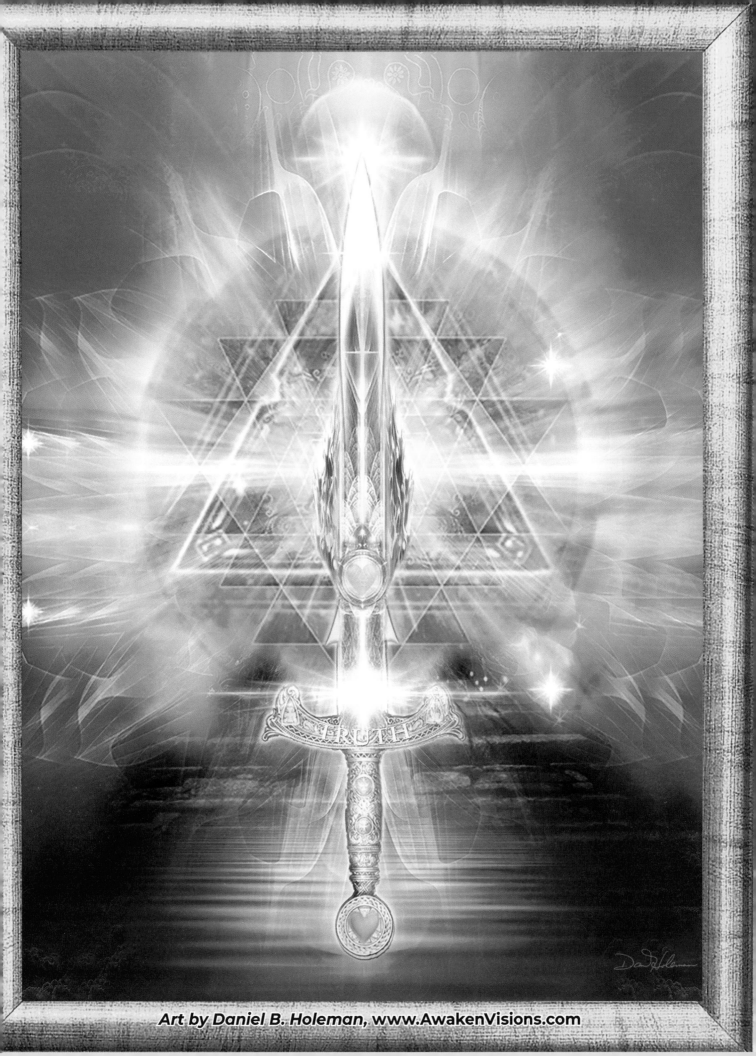

THE BRAIN IN ACTION

*"We should take care not to make the intellect our god; it
has, of course, powerful muscles, but no personality."*
—Albert Einstein

Did you know that the average human loses their attention span three to six times a minute? Paying attention, focusing your mind, and observing your thoughts are skills that need to be developed through daily practice just like any type of sport. The brain is the instrument that we use to process our thoughts, with the greatest number of neurons clustered together providing us with intelligence. The brain generates electrical impulses so powerful that collectively it can illuminate the whole planet, more powerful than all the cell phones in the world.

The mind, however, is the brain in action. It is your consciousness that can improve your brain activity, that is self-aware and has free will—it observes and manipulates the brain to produce the potential energy of the mind. Its two main qualities include attention, which energizes what you focus on to expand your reality, and intention, the objective of your attention that transforms the desired result.

The analytical and critical intellect gets in the way of realizing those intentions by setting conditions. The frontal lobe of your brain is the creative centre that triggers the network of neurons to create a new vision in your mind that is reflective of your intention. The visualization of your intention requires an action, combined with a heart-centered emotional response to manifest it into your present moment reality.

You have the capacity to be the healing you want to achieve, be the empowerment you are craving, be the love that you desire, be the master of your existence. You are worthy, beautiful, magnificent beings whose Soul purpose is to expand in LOVE.

*"When you become the master of your mind,
you are master of everything."*
—Swami Satchidananda

An Intelligent Machine

What is the brain, this intelligent machine?
Made up of neurons, networking, and pulsing with our cells.
A complex processing unit of the central nervous system,
With inputs of data and outputs of actions,
Managing information to be stored and hard wired.

What is the brain, this intelligent machine?
With short- and long-term memory units.
A circuitry that carries instructions in our bodies,
Easily programmed and influenced with repetitive action.

What is the brain, this intelligent machine?
Thinking, analyzing, obsessing, worrying,
A clever structure much like artificial intelligence.
Memorizing facts and concepts into theoretical frameworks,
Neurotically converting information into knowledge.

Lali A. Love

LIFE LESSONS

*"Life will give you whatever experience is most helpful
for the evolution of your consciousness."*
—Eckhart Tolle

The Universe provides the environment for us to attain a higher spiritual version of ourselves. We come into this existence with the basic tools and gifts to accomplish the objectives our Soul sets prior to life. Without the knowledge of the Universe, we must learn to find our own way through learning, to evolve our Soul's mission.

Our achievement or failure is based on our beliefs, behaviors, decisions, and actions. Throughout this process, our Soul always knows the truth, and it is always trying to communicate with us through our intuition as we discover and create our environment.

As such, everything that we experience in life is an opportunity for our highest progression. Experiences may teach us lessons to expand our consciousness and become the best version of our higher self. We have the choice to seek knowledge and evolve from the low frequency energy that may surround us on our journey to ascension.

For example, abandonment may teach us independence; anger may teach us forgiveness; envy/jealousy may teach us compassion; control/dominance may teach us healing and self-empowerment; resentment may teach us patience; hate may teach us unconditional love; pain may teach us authenticity, vulnerability, and resiliency; and fear may teach us to let go of our attachment to outcome, embrace and trust our divine path.

When we authentically realize that theses opportunities exist for our Soul's expansion, we become more grounded, mindful, and grateful for the experiences.

*"Enlightenment is not about cocooning one's self, but about
integrating more fully with both your self and life."*
—Jay Woodman

Flow

There is an intelligence that runs the entire space
if we learn to release our attachments to outcome and ego-base,
and allow ourselves to trust in the process of the loving embrace.

When we adopt this knowing, we begin to realize
that each of us are vibrating at rhythmic patterns to idealize.

Living in harmony with these electric pulsations
opportunities and encounters begin to arise without any limitations.

Once we are totally aligned with the flow of the Universe
unrelated events begin to formulate, providing fulfillment in a harmonious verse.

With this wisdom we attract emotional well-being,
using a powerful magnet to manifest a vibrational match that is all seeing.

We acquire an appreciation for the meaning of life to quench our heart's desire,
to be in service for the highest good as our journeys aspire.

Lali A. Love

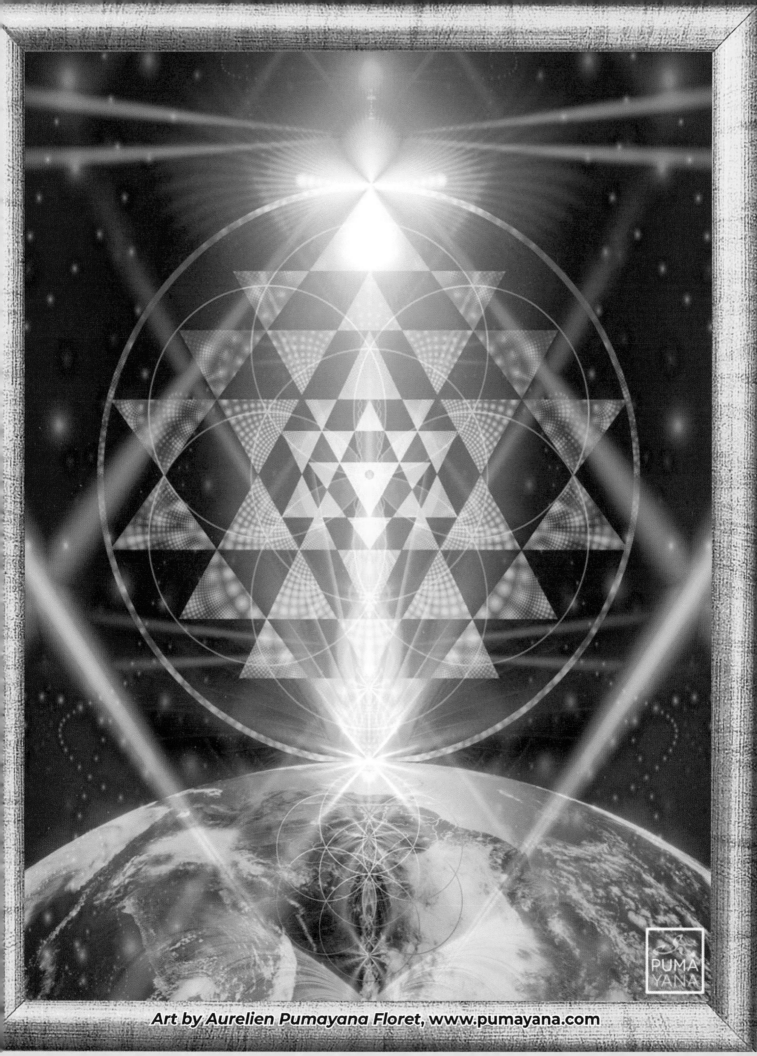

Art by Aurelien Pumayana Floret, www.pumayana.com

THE ILLUSION

"The greatest tragedy of human existence
is the illusion of separateness."
–Albert Einstein

As we continue to exist only within the physical realm, we perceive the world through our senses as the sole reality, conditioned by the illusion of separation from our true Source. From this perspective of scarcity, we become immersed in competition with each other, which prevents us from experiencing true bliss. Liberation and enlightenment can only be realized by the abandonment of this delusion and our personal narratives. In truth, we are all united in both the molecular and spiritual level, sharing the oneness of the Universal energy source.

Once we awaken from our conditioning and realize that we are completely connected, the notion of comparison disappears, giving way to cooperation and unity. In this state, we become aware that when one person thrives, we all thrive. We develop sincere feelings of interconnectivity and empathy for all beings, and genuinely share in their triumphs and joy.

Living with this state of awareness, powerful miracles begin to happen as we continue to live with Divine love, service, and compassion. When we truly release the perception of separation, we can achieve a critical mass of uplifted unified awareness that will help heal the world.

As Eckhart Tolle magnificently states: "You are not separate from the whole. You are one with the sun, the earth, the air. You don't have a life. You are life." You are an expression of Divine's love.

"Name and form are simply illusions of separation. Love doesn't
make us blind; rather, it erases the illusions so we can see clearly."
–Kamand Kojouri

The Artist Within

We have been taught to adopt a belief system
That our minds are the masters of our reality.

The fabric of our identity has been sewn into this perception,
Forming dependencies on external delusions.

The ego paints with contrite limitations
Using a prescribed method on imprinted canvas,
Repeating the cycles of monotonous, self-defeating patterns.

Once you awaken your inner artist from this illusion
Realize that your Soul is complete and iridescent,
Brilliantly gleaming with immaculate perfection.

The liberation of artistic ingenuity emerges, flooding your imagination,
Creating a magical tapestry with wide, smooth, flowing brush strokes.

Mastering your innovations with Divine manifestations,
A reminder that you, the observer, are in control not the servant.

Keep painting your stroke of genius with poetic symmetry,
Because you are the curator of life's magnificent interpretation.

Lali A. Love

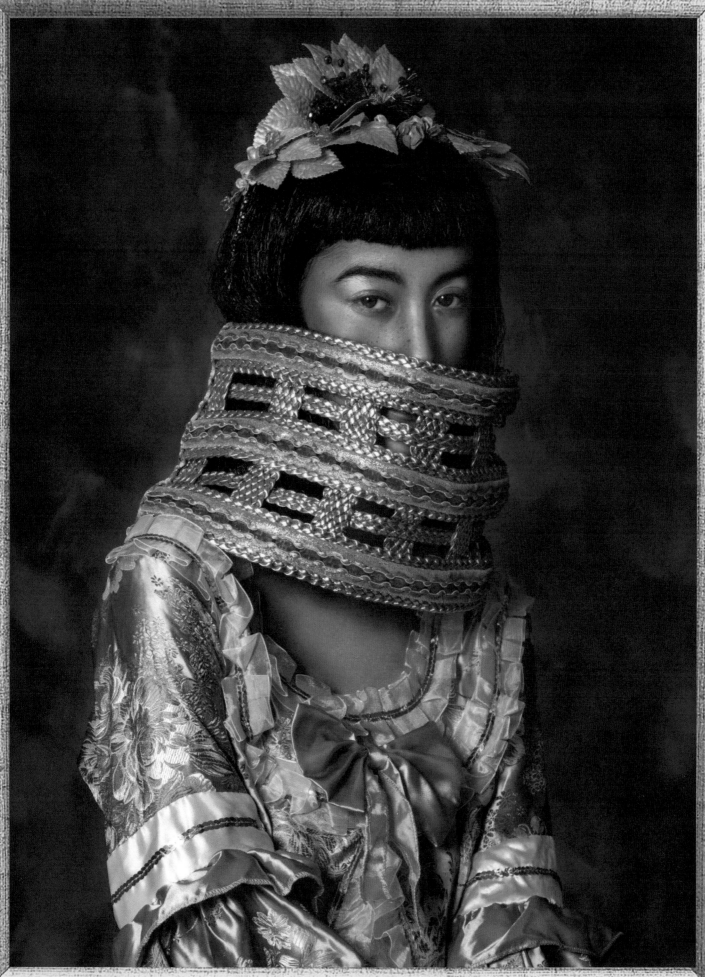

A New Earth

"Stop looking outside for scraps of pleasure or fulfillment, for validation, security, or love —you have a treasure within that is infinitely greater than anything the world can offer."
—Eckhart Tolle

When we have ascended from our heart-centred consciousness to meet ourselves in every form of each multi-dimensional realm that comes to be, the true reality of Divine love arises in our hearts. The fulfillment of the eternal I AM expression of Creation comes alive in our being.

This lavish banquet of happiness arises from within. When we experience setbacks in life, it is an opportunity for us to find creative solutions and to redefine our priorities. We can observe our challenges and explore other options once we realize that we possess the power to focus our attention on endless and limitless possibilities.

As such, all cellular imprints of darkness and shadows are transmuted in the presence of eternal light as we step out of duality dream time. This is the initiation process of collective awakening. Integrating, aligning, and developing a more unified, loving connection is essential. The more we radiate high frequencies of love, the more our physical reality will manifest.

We have already entered the most incredible paradigm of human existence in the New Earth, it is time to shift from the ego-mind space of fear and illuminate. May this heart-centered love empower and liberate all of humanity.

"Look deep into nature, and then you will understand everything better."
—Albert Einstein

Love in Action

The world is awakening from the collective mind of adaptation,
into a global love of inspired action,
where all things are honored as equally unique representation.

We welcome the change of a heart-centered reality,
with openness, reverence, dignity, and respect,
reaching the center of humanity's capability.

As we remember the inherent bounty of our perpetual integrity,
through acts of kindness we provide our light a place to be focused,
hearts brimming with empathy shared for the greater expansion of our entirety.

A spiritual journey is authenticated by deeds that operate from a space of love,
nourishing our Mother Earth and the Universe with our illumination,
guided by the I AM Source of divinity up above.

This benevolent generosity is the shift of abundance in action,
thank you for spreading this good will as unconditional love is expressed,
through random acts of kindness and compassion.

Lali A. Love

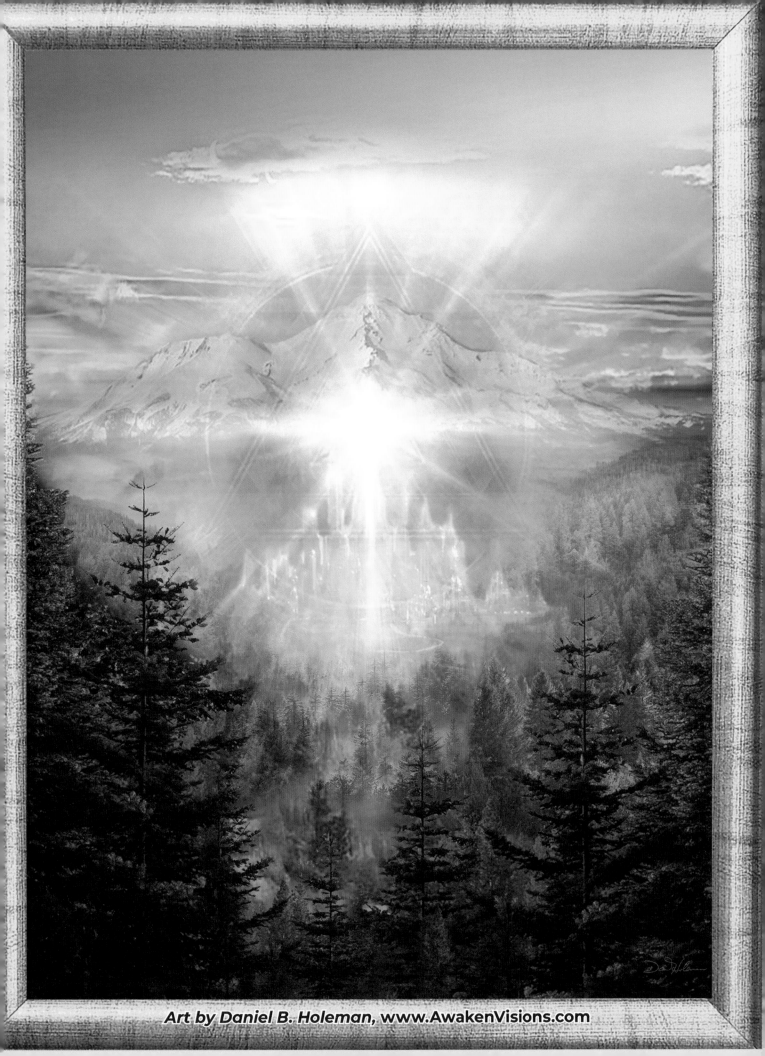

SACRED BIOCHEMICAL GARMENTS

"We are slowed down sound and light waves, a walking bundle of frequencies tuned into the cosmos. We are souls dressed up in sacred biochemical garments, and our bodies are the instruments through which our souls play their music."
—Albert Einstein

If you have been experiencing a heaviness of energy, it may serve as a reminder to reflect on your physical bodies with kindness and patience. Wherever we are holding unforgiveness within our body, we are holding on to density and separation from Source within our form and within our unified fields.

As a result, the high frequencies of light struggle to penetrate this heaviness as we try to expand our consciousness into ascension. To clear this density, we need to truly forgive ourselves and others for past transgressions. This is done through all three quantum planes, the mental, emotional, and physical DNA.

Our physical body is made up of matter that is time bound and may be viewed as a vessel to experience this existence. The body is our transcendental character expressed in physical form as a human being. It is this interconnection that gives rise to the mind body connection. Our Spirit, however, is formless and timeless and may transform without the vessel.

Once we understand this relationship between our quantum planes, we are better able to release and let go of past traumas, guilt, anger, and fear. It is the only way to remove the unawareness, separation, and suffering from our body. Pain is inevitable, but suffering is not. Honor and respect your human form, it is your sacred temple "through which your Souls play their music".

"Your relationship with love is your relationship with the essence of who you are. It affects your relationship with your body. When you realize that you are a spirit and that this body is a temple, then you want to treat it well."
—Marianne Williamson

Masquerade

Are human bodies just flesh and bones?
Or intricate piece of art comprising of atomic cyclones?

Including nitrogen, hydrogen, calcium, and potassium,
60% of our bodies consist of water and magnesium.

Transporting our hemoglobin with iron in our veins,
and an abundant of Earth's elements, oxygen, to our brains.

An organic compound of our spirit encompasses carbon,
Which collectively resembles elements of twinkling stars we imagine.

We are magnificent Souls created by flames,
Masquerading as people with human names.

Lali A. Love

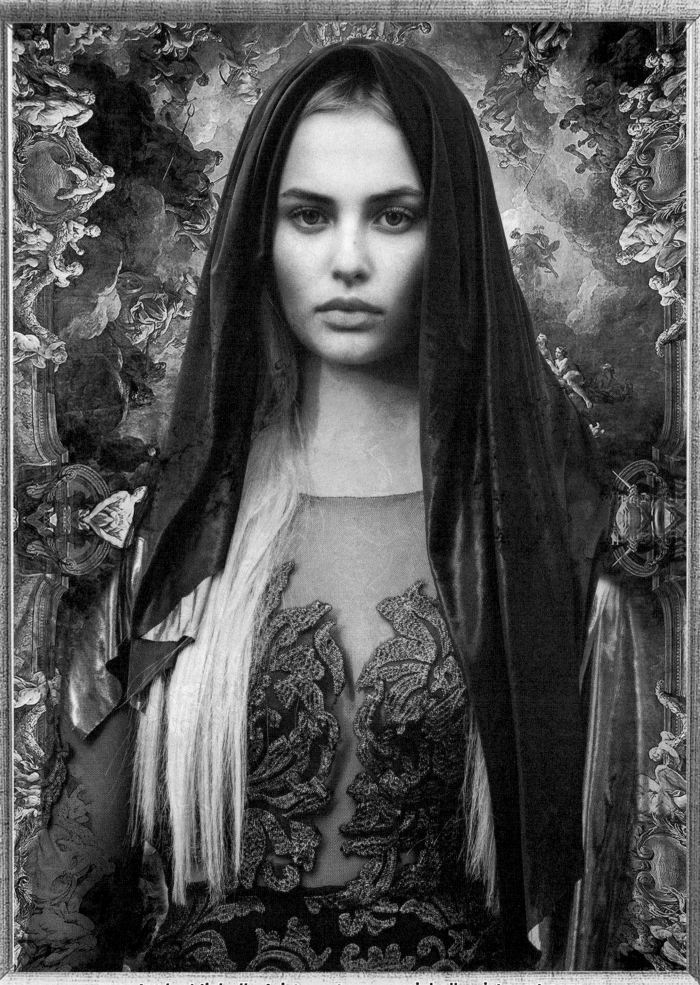

Art by Michelle Aristocrat, www.michellearistocrat.com

INTUITIVE SIGNS

"Intuition is the voice of the non-physical world."
—Gary Zukav

Did you know that the ancient Greek philosopher, Pythagoras, discovered the science behind numerology? It is based on the notion that all numbers have different vibrational properties; modern science has proven that the world conforms to precise mathematical principles. This belief governs everything from gravity to the movement of animals and the habits of humans. Numerology is a system of divination which assigns various numbers unique mathematical meaning to uncover deeper hidden truths.

The number 11 is deemed to be a master number which signifies intuition, insight, and enlightenment. When these things are paired together (11:11, 222, 333, 444, etc.) it is a clear message from the Universe to become more aware and to expand our level of consciousness, our state of being. These signs are provided every day: in our sleep, timeline, conversations, on the radio, in the sky, in synchronicities. Once we pay attention to them, we become aware of certain patterns that help us reach our higher self.

For example, when we notice the time 11:11 often, a sacred Ascension code activates the neural network in our brain to open our third eye to higher dimensions of light and Divinity.

"Listen to the wind, it talks. Listen to the silence,
it speaks. Listen to your heart, it knows."
—Native American Proverb

Synchronicity

A divine presence or a moment of grace
Gifting us signs from a cosmic place.
With a loving nudge, it reminds us of ethereal splendor
Using the magical alchemy of our Soul's surrender.
Alignment of people, places, numbers, and events
Puts us on a path that we don't want to circumvent.
With whispered voice the mystery is revealed
Unfolding the heart's desire that was once concealed.
A language of the stars that will stir our core
Choreographed for optimal existence that we will adore.
Synchronicity is an allowance of celestial manifestation
Everything unfolding in serendipitous activation.

Lali A. Love

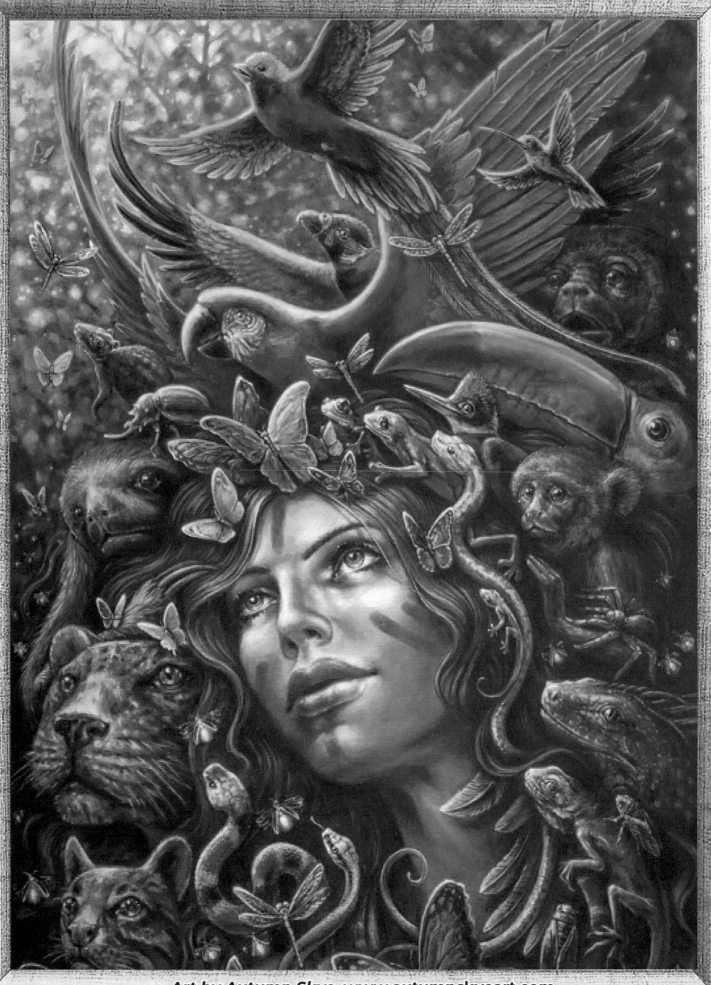

Art by Autumn Skye, www.autumnskyeart.com

THE DARK NIGHT OF THE SOUL

"Awakening is not changing who you are
but discarding who you are not."
—Deepak Chopra

There are days where every model of sabotage, negativity, sadness, apathy, fear, and anger of the old paradigm gives its one last shot of trying to turn you away from Source. This energy may trigger you, hoping you will shut down to preserve the old from dissolving. This phase acts as a fierce stage of initiation providing you with the opportunity to enter into full and complete alignment to the Light.

Everyone has some form of a childhood wound that requires healing. It may be due to neglect, abuse, loss, or co-dependency. Triggers are an opportunity to resolve the trauma encoded within your DNA structures from the patterns and behaviors that have been developed to self-soothe your inner child and inflamed nervous system / ego.

From this perspective of the shadow, a spiritual awakening is instigated through the revelation of your intrinsic truth. It tears away at your constructed identities and narrative of the ego-mind, the layers of programming and imprinting. The dissolving of the ego gets interpreted as a kind of devastation.

Often, instead of welcoming the collapse of this negative ego-mind, it is feared and resisted. It might even feel like the world is falling apart, but when you choose the Light with an open heart, it will allow you to focus on love without judgement. As such, a deep heartfelt surrender is given permission to awaken within you and transform your reality from the inside out.

"The dark night of the soul is when you have lost the flavor of life
but have not yet gained the fullness of Divinity. So it is that we must
weather that dark time, the period of transformation when what is
familiar has been taken away and the new richness is not yet ours."
—Ram Dass

Surrender

I surrender fully into the light
Even when I am afraid of the night.
Exhausted, fatigued, unable to sleep
It's an opportunity for me to go deep.
Emptying and recalibrating my inflamed ego
I offer forgiveness for behaviors from long ago.
I hold space for myself that longs for recognition
Loving each part of me with caress and gentle admiration.
Even though the light of divinity is already awoken
I vow to radiate and expand my awareness as a token.
I surrender fully into the light without a debate
As it guides me toward my unbounded Soul's fate.

Lali A. Love

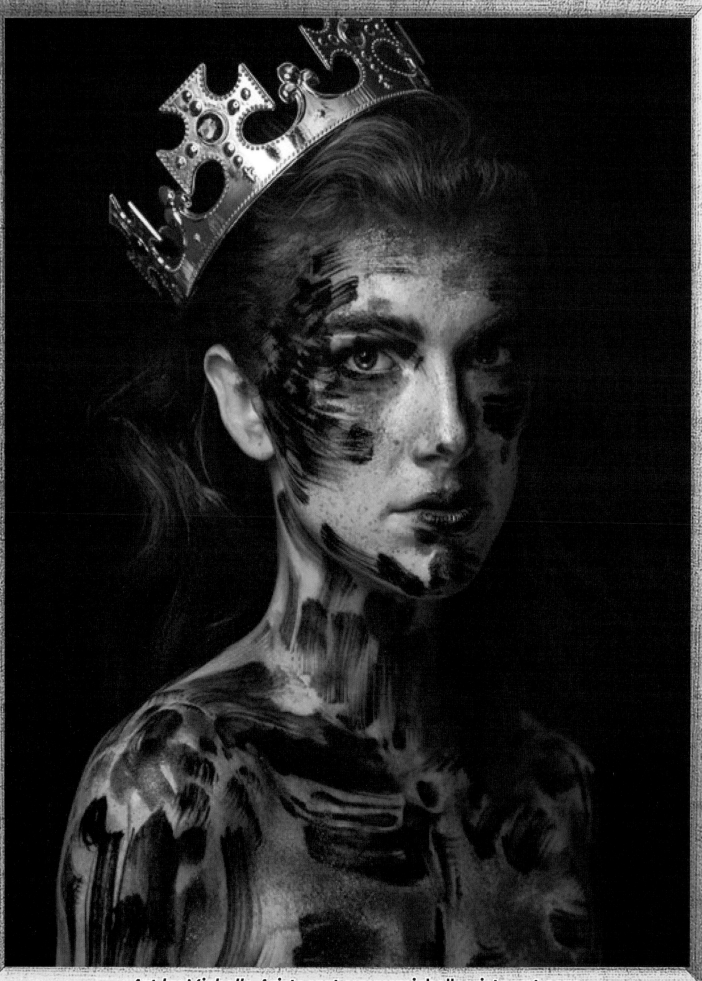

Art by Michelle Aristocrat, www.michellearistocrat.com

Unity Consciousness

"If Light is in your heart, you will always find your way home."
—Rumi

As the world begins to shift with awakened Souls, we remember our heightened awareness and recognize our inherent unified Consciousness. We are starting to release the perception of separation from Source. These illusions were created by ego-based conditioning and we are realizing that we are energetic beings, all connected to the wholeness of the Source, vibrating at different rates of frequencies. We have the sovereign free will to choose our reality to being one of expressions of our joys, passion, kindness, love, service, and compassion. In this state of awareness, we attract everything our heart-centered consciousness desires—unlimited creativity, insight, intuition, bliss, peace, and abundance of joy.

And since the whole of reality is one of fractals, we see this expression occurring all throughout our existence. This is the key to healing our world and all beautiful Souls. Each of us is a multi-dimensional expression, bringing about a wealth of information and experiences to the quantum field of energy.

We are awakening on a unified level of elevated consciousness, providing a powerful seed moment for birthing our personal ascension into the Master of Light that we are. This multi-dimensional electric current symbolizes the circuit connection between self and others, between our body/mind and Soul, and will trigger our DNA activation to bring us more balance, inner peace, harmony, and equality through rapid transformation, whenever we focus our attention and intentions.

As Mother Earth goes through her metamorphosis, together we can also transition through this time of emotional intensity with higher amounts of self-love, kindness, understanding, forgiveness, joy, and serenity.

"Unity consciousness is a state of enlightenment where we
pierce the mask of illusion which creates separation and
fragmentation. Behind the appearance of separation is one unified
field of wholeness. Here the seer and the scenery are one."
—Deepak Chopra

Come Home to Me

Imagine a place of warmth and tranquility.
A field of eclectic realms, holding each other's hand with agility.
Dancing together in joyful bliss,
Our hearts embrace with Divine's blessed kiss.
Hear the harmonious sound waves of humanity,
Humming at the vibration of connected community.
Enveloped by elation and the pureness of childish giggles,
Our compassion and kindness are celebrated with wiggles.
We become one, unified in wholeness with the Source above,
Flowing back home to the rapture of our heart-centered love.

Lali A. Love

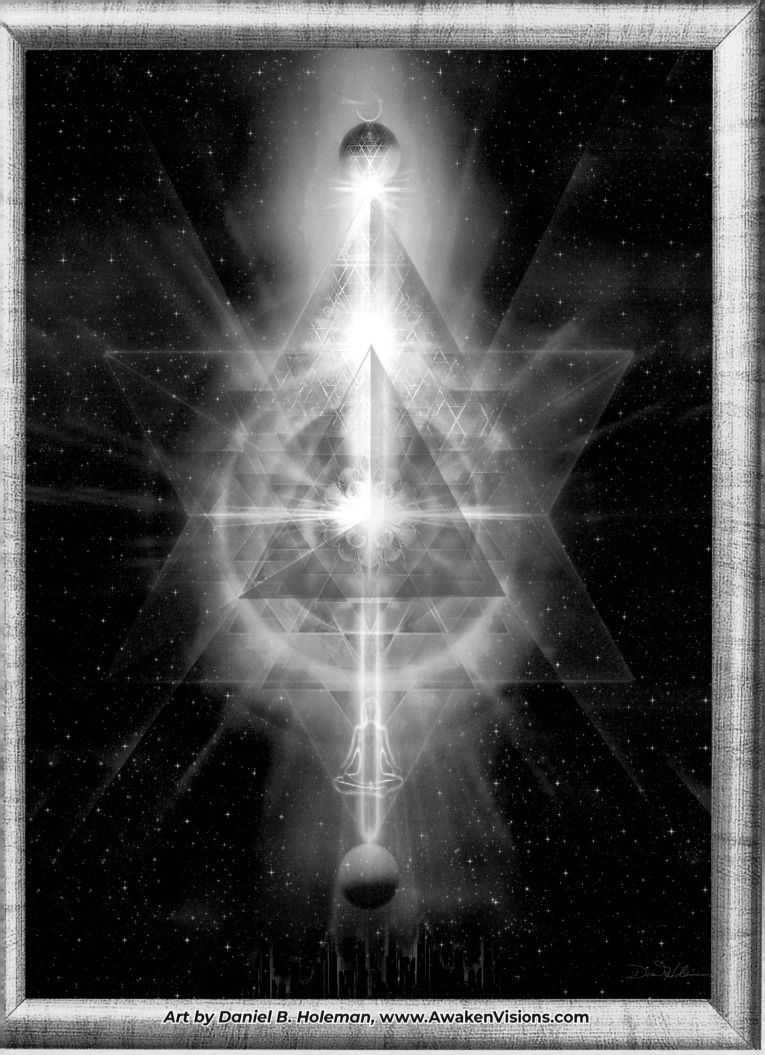

THE RE-LOVUTION

"Whatever affects one directly, affects all indirectly. I can never be what I ought to be until you are what you ought to be. This is the interrelated structure of reality."
—Dr. Martin Luther King Jr.

There is a progression happening all around the world, a new paradigm of unity, and an opportunity to invite the healing energy of love into our hearts. This shift embraces equality, oneness, and justice for all of humanity. Anchored in the vibration of peace in our heart-centred consciousness, we rise with the power of Divine's unwavering love, to heal and forgive old wounds from the past as we shift and evolve our actions into a state of loving compassion.

When we embody the Light during conflict and turmoil, secured with the frequency of gratitude, we illuminate all corners of reality where darkness resides to wake up an entire Universe. With this call to action, we no longer perpetuate the cycle of animosity. We begin to create a sacred space for our future generations and our beloved Mother Earth to become a peaceful, sovereign, free planet with neutrality for all sentient beings.

You are the love that liberates all of existence. When you let go of limiting thoughts and beliefs, you embrace the magic of the infinite light that resides within you. You are the salvation that you have been seeking. Let the warmth of your heart guide you through your darkest moments with hope and immense wholeness. May you always remember that you are a spark of Divine force, a multi-dimensional being, the entire Universe experiencing life in a human form.

"We are all bound by an invisible field of energy, and that connection is called love."
—Dr. Joe Dispenza

Your Inner Light

I am worthy, I am Light.
I love my innocence with my entire might.
I am a reflection of Divine's expression,
Created and stitched with loving perfection.
I set the standards for what I attract,
Refusing to dim my inner light so I do not distract.
I am limitless joy, with pure potentiality.
My strength and resolve are fortified by my tranquil ability.
With compassion and kindness, a Light Warrior of Peace.
I am in service, fulfilling my Soul's unified mission with ease.
With humility and grace, ascending as love in action,
I radiate at high frequencies of sparkling light and attraction.

I AM the Light THAT I AM

Lali A. Love

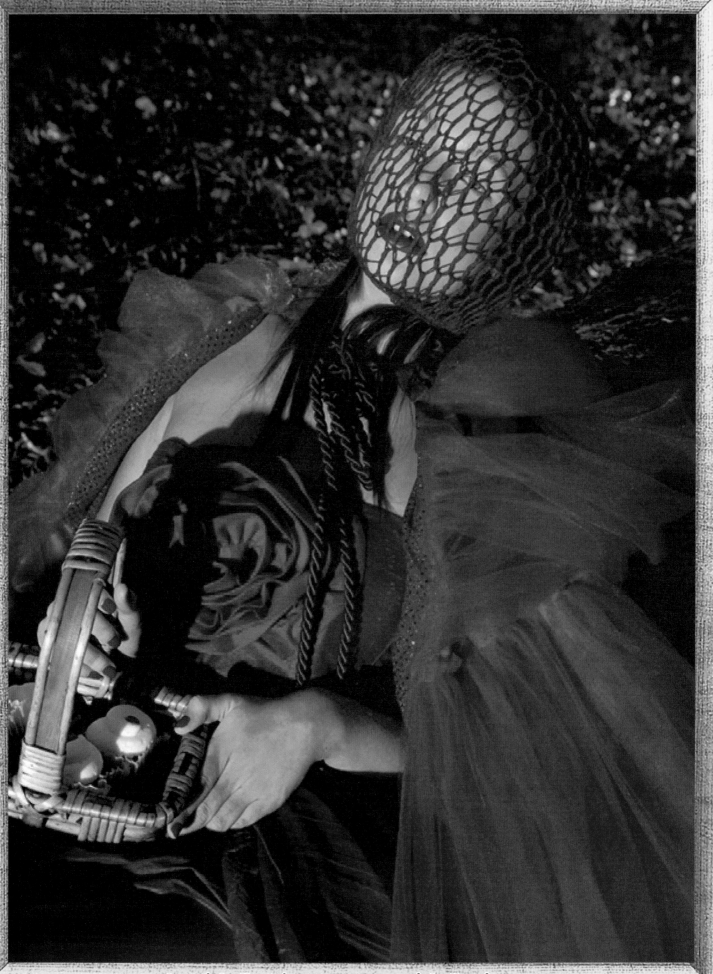

Art by Michelle Aristocrat, www.michellearistocrat.com

THE DIMENSIONS OF LIGHT

*"It is through gratitude for the present moment that
the spiritual dimension of life opens up."*
—Eckhart Tolle

When we feel a sense of disappointment, it is a confirmation that the ego is not worthy of getting the object or materialist outcomes it desires instantly. When this occurs, it's important to be aware that the Universe is trying to expand the limits of our viewpoint, expanding the parameters of our perception so we can realize our existence from a higher level of consciousness.

From this state of unity consciousness, we acknowledge a fundamental surrender that the ego may have difficulty coping with. This act of surrender allows the feelings of disappointment to dissolve and integrate these equally important sentiments into the Light of our emerging Soul.

Through this act, our Soul taps into the Universe's mystery of co-creation. We only want the objects and outcomes that we desire because we imagine that these dependencies are the only way in which we can achieve the elated feelings and emotions in our bodies. To attract the higher positive vibrations, such as joy, inspiration, passion, pleasure, contentment, tranquility, which are all energetic frequencies of fulfillment, we must become aware of these emotions and envision these reactions without the attachment to materialistic objects.

Having high vibrational frequency doesn't necessarily manifest the experiences of our desire. This occurs when we face the deeper unresolved emotions that have not completed the development cycle of healing. When we are no longer triggered easily, we have reached an emotional spiritual maturity, creating space for the most pleasurable feelings and sensations. This new paradigm fifth dimensional perspective of raising our vibration is simply allowing us to respect our painful emotions, to be welcomed and honored, heard, and felt in our hearts.

By doing this, we are bringing together and allowing the most difficult sensations to be embraced by the highest vibration within us. We are permitting ourselves to express worthiness and joy, allowing all the memories of pain, abuse, tragedy, turmoil, rejection, abandonment, and neglect to be equally received. As such, we are consciously enabling these emotions to be merged and integrated into the Light, so that all becomes one continuous Light and our state of being. This is how we achieve love in action and unity consciousness from our heart-centered energy field.

You are worthy of bliss, fulfillment, and abundance of love. May your goodness and radiance flow into the world with blessings of limitless joy and infinite transcendence, Beloved. My Soul honors your Soul's journey as you navigate through this magical realm of existence. I love you.

*"Yesterday I was clever, so I wanted to change the
world. Today I am wise, so I am changing myself."*
—Rumi

Conscious Co-Creation

We have an opportunity to expand the collective consciousness,
by collapsing limiting beliefs and cellular debris stored in our unconsciousness.

In spite of the things we intend to manifest,
the Universe is guiding us through a series of outcomes that is uniquely for the best.

This is not occurring due to the insistence of our personal desire,
but because we honor the truth of reality and perceptions we acquire.

As we evolve, we become aware of fragmented viewpoints about this interpretation,
assisting in our awakening to honor the illusive and mysterious process of transmutation.

This transformation acts as the sacred fire eradicating what no longer serves,
every time we are emotionally triggered externally which allows us to observe.

With this Universal partnership of co-creation, we embrace the divine timing of grace,
that is doing everything in its infinite power despite our personal disgrace.

We are steered towards our heart-centered embodied being,
to be fully integrated into the divine human, we were always meant to be freeing.

From this space, we come to realize the true fulfillment we have been seeking,
by being totally aligned with spirit and releasing dependencies without critiquing.

At this crucial time of inner alchemical transfiguration,
the spiritual practices are those rooted in self-love, self-discovery, and self-realization.

As the signs of a newly awakened world begin to surface in the beauty and magic of life,
we thank you for being the catalyst of Light by vibrating without strife.

Lali A. Love

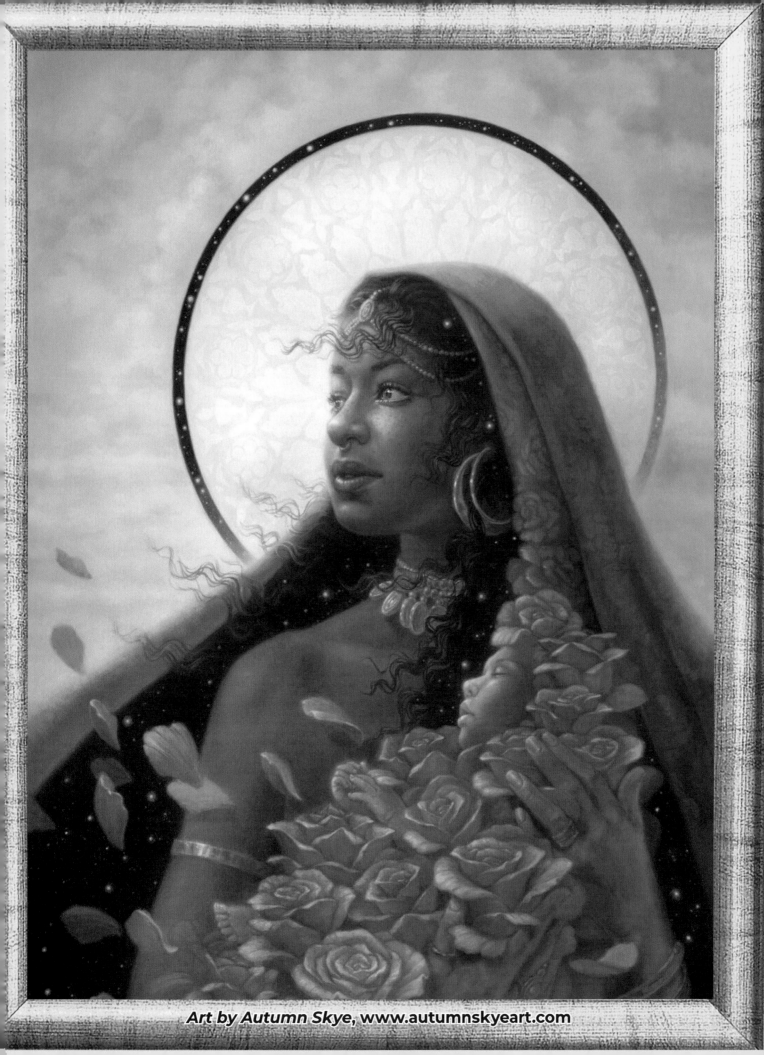

Art by Autumn Skye, www.autumnskyeart.com

Acknowledgments

Thank you, God, and the Universe, for all my blessings and all the abundance that is yet to come. I am grateful to my angels and spirit guides for watching over me and surrounding me with the infinite light of protection throughout my Soul journey. I embrace everything that comes with an open and loving heart. I surrender and trust the process of the Universe and its divine timing. I appreciate all the experiences and lessons of growth in the evolution of my higher self.

My heartfelt appreciation to my Soul tribe for their generous contributions, Aurelien Floret for the radiant book cover and visionary artwork, Gillian Small for the healing poetry, Michelle Aristocrat, Autumn Skye, and Daniel Holeman for sharing their transformative creations. It has been an honor and a pleasure presenting your inspirational art, as we spread the light of Divine love through this magical tapestry of artistic expression.

I would like to extend my gratitude to my mentors and spiritual teachers: Deepak Chopra, Matt Khan, Dr. Joe Dispenza, Oprah Winfrey, and Eckhart Tolle for their daily inspiration and guidance. I am grateful for the insights gained throughout this process, which provided me with the necessary tools, methods, and practices to achieve my ultimate state of being.

I would also like to acknowledge and thank all the energy healers, lightworkers, alchemists, empaths, and intuitive healers who are holding space for our ascension by transmuting negative energies into positive light vibrational frequencies. Thank you for maintaining the balance of our beloved planet, shifting it into a higher state of consciousness with unity, love, kindness, and compassion.

And finally, I would like to express my heartfelt gratitude to Rima Aristocrat for her generous support. This collaboration of joy and love is available to be shared with the world because of her benevolence. She is such an incredible role model in championing and empowering women, minority groups, veterans, and indigenous communities, a quintessence of fulfilling life's highest purpose. Thank you with all my heart.

My soul honors the divinity, beauty, truth, and light of your soul; we are one, united in love.

About the Author

Lali A. Love is a multi-award-winning author of visionary fantasy and metaphysical thrillers. Since July 2019, she has published her Amazon best selling novels "*Heart of a Warrior Angel: From Darkness to Light*" and "*The De-Coding of Jo: Hall of Ignorance*". Lali has received a Global E-Book Gold Award, the Book of Excellence Award, Elite Choice Gold Award, and the International Reader's Favorite Bronze Award for quality and powerful storytelling. She lives in Canada with her husband and two beautiful children who are her greatest source of pride, joy, and inspiration.

Lali aspires to write stimulating, thought-provoking, and relevant character-based novels that relate to modern day issues and invoke an emotional response in her readers. She has researched and studied epistemology and metaphysics to further her understanding of the Universal Laws of Energy. As an intuitive, alchemist, and energy healer, Lali has been called to embody the light, anchored in love, kindness, and gratitude, to help uplift humanity.

With humility, compassion, and grace, Lali intends to help elevate levels of consciousness for the highest good, empowering individuals to seek their authentic truth. She is an advocate for self-healing journeys, self-actualization, equality, diversity, unity, women, and children.

GRilliNG
GENiUS

GRilliNG GENiUS

SCOTT GIVOT

MQP

Dedicated to Gala and my friends at the CAVE.

Published by **MQ Publications Limited**
12 The Ivories, 6–8 Northampton Street
London N1 2HY
TEL: 020 7359 2244
FAX: 020 7359 1616
EMAIL: mail@mqpublications.com
WEBSITE: www.mqpublications.com

SERIES EDITOR: **abi rowsell**
DESIGN CONCEPT: **balley design associates**
PAGE LAYOUT: **rod teasedale**
LINE ILLUSTRATION: **karen hood**
GENIUS CARICATURE: **chris garbutt**

ISBN: 1 84072 525 7

1 3 5 7 9 0 8 6 4 2

Printed in China

contents

Introduction

Once upon a time in the urban sprawl of Chicago, a pre-adolescent boy had dreams of being a chef. It was the mid 1960s and the Junior High School he attended was offering an experimental elective course for the first time in its history. The course was entitled "Outdoor Chef" and I assumed it was an acceptable entrée for boys into the culinary world. The program offered the opportunity to learn simple techniques in how to properly use a charcoal grill. The menu selections included titillating dishes, such as hot dogs, hamburgers, corn on the cob, and barbecued chicken. Well, it seemed like a step out of one's own back yard and out into the world. Not very exotic, yet, why not take a chance?

I have always adored the flavour of food prepared over burning embers. Something about being in nature, even if it represented a few steps outside the kitchen door, represented a certain freedom. It provided an opportunity to reveal my culinary talents to family and friends. The benefit, most of the time, was a delicious meal, simple to prepare, and with limited washing up. Years later I graduated to a new level with the acquisition of a gas grill. By simply turning some dials and lighting a match, the show could begin. Closing the lid and waiting a few minutes could achieve the desired temperature. Still something was missing. I needed to expand my menu repertoire.

Years of travel focused on food led me to glamorous, spiritual, and mysterious destinations. Never forgetting my love of barbecuing, I was blessed with introductions to new techniques, recipes, and best of all, flavors. There were the aromatic sates prepared on the open streets of Bangkok, Thailand; the succulent abalone and cuttlefish along the docks in Hobart, Tasmania; the juicy whole suckling pig prepared over coals in San Sebastiao di Grama, Brazil; fragrant baby lamb spit-roasted on the island of Hydra, Greece; and mouth watering artisan sausages grilled outside the largest fish and meat market in Trondheim, Norway. The memories of these feasts for the senses travelled home nicely to the US.

Only four years ago I moved to Norway. During these blissful temperate summers, I live on an island in Oslo fjord. In addition I have found my home in a sense, not only with the atmosphere, but with a return to the old-fashioned kettle barbecue, complete with lid, fuelled by charcoal, and enhanced with various wood chips or juniper soaked in aquavit. Grilling outdoors is a well-integrated activity in neighbors' and my daily life. It is not an activity simply limited to boys and men, as the 1960's mentality once led me to believe. The female sex finds it equally enjoyable and I have learned greatly from their masterful technique and creativity.

My "grilling genius" is absolutely based on the sum total of my experiences and the generosity of teachers and friends. I am happy to report that after years of aprons with burnt holes, singed arm hair, and calloused fingertips, I still love to grill. There has been a great deal of advancement in the technology of the barbecue since my childhood days. This book focuses on one of the most basic pieces of equipment, the kettle-style barbecue. It remains in hibernation until my occasional weekend island homecoming where grilling transpires before a backdrop of snow and icy sea.

The recipes you will find focus first and foremost on flavor. There are very few which rely on pre-prepared sauces, seasonings, marinades, or pastes. I invite you to streamline cooking time with these products, should you desire, but feel obliged to break them down and encourage the use of the freshest, seasonal ingredients available to you. The book is compiled with recipes which allow for direct grilling, the simplest of techniques. I have estimated the timing of preparation to the best of my ability within the constraints of so many variables—don't even mention weather! Most importantly I hope this travelogue of barbecued foods will inspire the reader to experiment and play. Select the recipes you find interesting and try them out. Adapt them to your own taste and let the magic of the barbecue carry you through 365 days of the year.

Scott Hirst

fish & shellfish

Cod Fillet in Chili Lime Vinaigrette

Serves **4** | Preparation **17 minutes** | Marinating **1 hour** | Grilling **12 minutes**

4 x 8 oz/225 g portions cod fillet
6 tablespoons olive oil
grated zest and juice of 1 lime
1 red chili pepper, finely chopped
1 tablespoon dried oregano, preferably Greek
1 teaspoon light liquid honey

1 garlic clove, crushed
1 cup/2 oz/50 g finely chopped flat-leaf parsley
1 tablespoon salt
1 teaspoon freshly ground black pepper

1 Rinse the fish thoroughly under cold running water and dry with paper towel, then place in a shallow dish.

2 Whisk 2 tablespoons of the olive oil with the lime zest, half the chili pepper and the oregano. Pour this over the fish. Turn the fillets in the mixture to ensure all sides are coated, cover and refrigerate for 1 hour.

3 Whisk the remaining oil with the honey. Then whisk in the lime juice. Stir in the garlic, parsley, salt, and pepper. Set this vinaigrette dressing aside at room temperature.

4 Cook the fish fillets on a well-oiled medium-hot grill, allowing 6 minutes on each side, turning once.

5 Transfer the fish to plates and spoon the vinaigrette over the top. Steamed baby spinach and boiled baby potatoes are excellent accompaniments.

Genius Tip Place netted wire or perforated metal plates directly onto the grate when cooking smaller pieces of food or food which is more fragile, such as flakey fish. Pre-heat the plate and spray or brush with a fine layer or oil before setting the food on top.

Cod Brochettes with Pancetta

Serves **4** | Preparation **21 minutes** | Marinating **30 minutes** | Grilling **8 minutes**

1 lb/450 g cod fillet, skinned, rinsed
and cut into 1 in/2.5 cm cubes
4 long fresh rosemary sprigs,
about 10 in/5 cm long
8 slices pancetta
1 teaspoon chili powder

MARINADE
2 garlic cloves, crushed
1 tablespoon freshly ground black
pepper
1 tablespoon sea salt
5 tablespoons virgin olive oil, plus
extra for serving
1 tablespoon balsamic vinegar, plus
extra for serving

1 Rinse the fish thoroughly under cold running water and dry with paper towel, then place in a shallow dish. Remove and reserve all the leaves from the rosemary (for the marinade) and shave the stalks to a fine point at one end.

2 To make the marinade, mash the garlic, fresh rosemary leaves, pepper, and salt in a pestle and mortar. Gradually add the oil and vinegar, pounding the ingredients together. Pour the marinade over the fish and mix thoroughly with your hands. Cover and leave at room temperature for 30 minutes.

3 Thread a piece of pancetta on a stalk, $^1/_2$ in/1 cm away from the end of the meat. Add a cube of the cod, then wrap the pancetta over it and pierce it on the skewer. Continue threading the pancetta and cod on the skewer, curling the pancetta over and between the fish, like a snake. When the first piece of pancetta runs out, add another piece. Fill the rosemary stalk to 1 in/2.5 cm of each end. Repeat with the remaining stalks and ingredients. Wrap the exposed stalk tips with cooking foil to prevent them from burning. Reserve the marinade.

4 Sprinkle the brochettes with a dusting of chili powder and set them on a well-oiled, medium-hot grill. Cook for about 2 minutes on each of their four sides, making about 8 minutes in total. Brush with the reserved marinade when turning the brochettes. The pancetta should be crisp and the cod white and opaque.

5 Serve drizzled with a little extra virgin olive oil and a few drops of balsamic vinegar. Offer flat breads with the brochettes; aioli, a garlic mayonnaise sauce, also goes well.

Grilled Cod Andalusia

Serves 4 | Preparation **19 minutes** | Marinating **45 minutes** | Grilling **10 minutes**

4 x 8 oz/225 g portions cod fillet
3 garlic cloves, crushed
1 teaspoon dried rosemary
1 teaspoon dried thyme
3 bay leaves, crumbled
1 teaspoon whole black peppercorns
1 teaspoon coarse sea salt
1 cup/2 fl oz/250 ml dry sherry
3 tablespoons Spanish olive oil

ANDALUSIA SAUCE
3 garlic cloves
1 small red chili pepper, seeded

3 tablespoons salted almonds
$^1/_2$ cup/2 oz/50 g mixed pitted green
and black Spanish olives
$^1/_2$ cup/1 oz/25 g flat-leaf parsley
leaves
3 tablespoons Spanish extra virgin
olive oil
2 tablespoons dry sherry
2 tablespoons red wine vinegar
1 teaspoon light liquid honey
16 oz/450 g can chopped tomatoes

1 Rinse the fish under cold running water and dry with paper towel. Place the fillets in a shallow dish.

2 Pound the garlic with the rosemary, thyme, bay leaves, peppercorns, and salt in a mortar with a pestle. Whisk the sherry and oil together and add the herb mixture. Pour over the cod, cover and refrigerate for 45 minutes, turning three times.

3 To make the sauce, combine the garlic, chili, almonds, and olives in a food processor. Pulse the power to purée the mixture to a coarse, grainy texture. Add the parsley, oil, sherry, vinegar, and honey, and purée for 1 minute.

4 Pour the sauce into a serving bowl and stir in the chopped tomatoes. Cover and leave to stand at room temperature.

5 Cook the fish on a medium-hot well-oiled grill for 5 minutes on each side. The flesh should be opaque white, with well browned score marks.

6 Transfer the fish to plates and spoon some of the sauce over the top. Serve the rest of the sauce on the side. Saffron rice with peas and slivered almonds is a suitable accompaniment.

Mediterranean Cod & Eggplant Mash

Serves **4** | Preparation **12 minutes** | Marinating **1 hour** | Grilling **1¾ hours**

1 lb/450 g cod fillet, skinned and cut into 2 in/5 cm cubes	EGGPLANT MASH
3 tablespoons Spanish olive oil	2 eggplant
grated zest of ½ lemon	3 garlic cloves, crushed
½ cup/1 oz/25 g dried oregano	3 tablespoons Spanish extra virgin olive oil
1 teaspoon cayenne pepper	juice of ½ lemon
4 pita bread	½ cup/1 oz/25 g coarsely chopped cilantro
	1 tablespoon coarse sea salt
	1 teaspoon freshly ground black pepper

1 Begin by preparing the eggplant mash. Cook the whole eggplant on a medium-hot grill for 1½ hours, turning occasionally. The eggplant are ready when they are collapsed and the outer skin is blackened. Remove the eggplant from the grill and cool for 5 minutes.

2 Meanwhile, rinse the fish thoroughly under cold running water. Dry with paper towel and place in a self-sealing plastic bag. Add the olive oil, lemon zest, oregano, and cayenne pepper to the bag with the cod. Shake the bag, seal, and place in the refrigerator for 1 hour.

3 Cut each eggplant in half and scoop out the flesh, placing it in a mixing bowl. It should have an intense smoky aroma and flavor. Add the garlic, extra virgin olive oil, lemon juice, cilantro, salt, and pepper. Stir, cover, and leave at room temperature or refrigerate for future use.

4 The cod should be grilled over medium-hot coals: if necessary, after grilling the eggplant, add more fuel to the barbecue and allow this to heat up. Thread the cod onto long metal skewers and cook on a well-oiled grill for 3 minutes on each of the four sides, making 12 minutes in all. The flesh should be opaque white, scored dark brown on the surface.

5 Heat the pita bread on the grill for about 30 seconds on each side. Slit the pita open along one side and smear some of the eggplant mash inside the pockets. Fill with the cod and spoon a little extra mash over the top.

fish & shellfish

Grilled Bacalhao

Serves **4** | Soaking **24 hours** | Preparation **12 minutes** | Grilling **10 minutes**

2 lb/900 g firm salt cod fillets (bacalhao), about 1 in/2.5 cm thick, skinned and boned

4 lemon wedges to serve

GARLIC OIL SAUCE
$^3/_4$ cup/6 fl oz/175 ml virgin olive oil
6 garlic cloves, thinly sliced
2 shallots, finely chopped
$^1/_2$ cup/1 oz/25 g coarsely chopped flat-leaf parsley
1 teaspoon freshly ground black pepper

1 To prepare the salt cod, rinse thoroughly under cold running water and place in a large bowl. Pour in cold water, making sure the cod is covered by at least 1 in/2.5 cm, cover and refrigerate. Leave for 24 hours, draining, rinsing and re-covering with water three times. This is essential to remove the salt used to preserve the cod.

2 For the garlic oil sauce, place the oil, garlic, shallots, parsley, and pepper in a small saucepan. Cover and leave to rest at room temperature. Heat the sauce gently on the stove while the barbecue is heating up. Remove the sauce from the heat just before the oil begins to bubble or splatter.

3 To grill the salt cod, brush a little of the oil over the surface of the fillets and place on a hot grill. Set the saucepan of garlic oil on the barbecue to heat. Cook the fish for 5 minutes on each side, until golden brown with dark score marks.

4 Serve the cod at once, with the hot garlic oil sauce poured over. Garnish with lemon wedges.

Halibut with Intense Cilantro Glaze

Serves **4** | Preparation **14 minutes** | Marinating **1¼ hours** | Grilling **12 minutes**

4 x 8 oz/225 g portions halibut fillet,
about 1½ in/3.5 cm thick
1 tablespoon sesame oil
1 tablespoon Asian fish sauce
(nuoc nam or nam pla)
1 tablespoon mirin (sweet Japanese
rice vinegar)

1 tablespoon soy sauce
1 teaspoon soft brown sugar
½ cup/1 oz/25 g cilantro leaves
 and stems
3 garlic cloves
1 red chili pepper, seeded
1 teaspoon coarse sea salt

1 Rinse the fish under cold running water and dry with paper towel. Set in a shallow dish.

2 Blend the sesame oil, fish sauce, mirin, and soy sauce together in a food processor. Add the sugar, cilantro, garlic, chili, and salt and pulse to a smooth paste, scraping down the mixture from the side of the bowl occasionally.

3 Pour the paste over the halibut and roll the fillets in it until they are completely coated. Cover the dish and marinate in the refrigerator for 1 hour. Turn the fillets over halfway through.

4 Remove the fish from the refrigerator 15 minutes before cooking. Lift the salmon from the glaze and cook on a well-oiled hot grill for 6 minutes on each side. Brush the remaining glaze over the cooked tops when turning the fish. Serve while still hot.

Genius Tip A salad of soba noodles—Japanese buckwheat noodles—dressed with tahini (sesame seed paste) and seasoned with garlic and red chili pepper makes a good accompaniment for the halibut.

Halibut Fillet Kalamata

Serves **4** | Preparation **24 minutes** | Marinating **20 minutes** | Grilling **8 minutes**

**4 x 6 oz/175 g portions halibut fillet,
skinned**
1 tablespoon grated orange zest
**1 cup/8 fl oz/250 ml freshly squeezed
orange juice**
2 tablespoons olive oil
1 tablespoon light liquid honey
**2 tablespoons chopped fresh
root ginger**

1 garlic clove, crushed
**$^1/_2$ cup/2 oz/50 g kalamata olives,
pitted**
**$^1/_2$ cup/1 oz/25 g finely chopped
flat-leaf parsley**
**1 tablespoon freshly ground
black pepper**
1 tablespoon coarse sea salt

1 Rinse the fish under cold running water and dry with paper towel. Place in a shallow dish.

2 Mix the orange zest and juice with the olive oil, honey, ginger, and garlic. Pour this over the fish and rub it into the fillets thoroughly by hand. Cover and leave to marinate at room temperature for 20 minutes, turning halfway through the time.

3 Prepare the accompanying sauce before cooking the fish. Drain the marinade from the fish into a saucepan, bring to a boil and simmer for 5 minutes. Add the olives, parsley, and pepper, stir and remove from the heat. Cover and leave to rest at room temperature.

4 Set the fish on a medium-hot well-oiled grill and cook for 4 minutes on each side, turning once. After turning the fish, sprinkle a little salt on the top.

5 Transfer the grilled fish to plates and spoon the sauce over the top. Couscous goes well with the fish, especially when tossed with Provençal herbs.

Charred Sea Bass with Ouzo Flambé

Serves **4** | Preparation **10 minutes** | Marinating **20 minutes** | Grilling **8 minutes**

4 tablespoons virgin olive oil
juice of ½ lemon
1 tablespoon ground fennel
4 x 5 oz/150 g portions sea bass fillet,
about ¾ in/3.5 cm thick

2 tablespoons freshly ground black
pepper
2 tablespoons coarse sea salt
⅓ cup/3 fl oz/75 ml ouzo or anise
spirit

1 Whisk the oil, lemon juice, ground fennel, and pepper together in a shallow dish large enough to hold the fish. Rinse the fish under cold running water and pat dry with paper towel. Add the fish to the marinade in the dish, cover and leave at room temperature for 20 minutes. Turn the fish over after 10 minutes.

2 To grill the fish, sprinkle both sides with salt. Cook over a well-oiled hot barbecue for 4 minutes on each side. Heat the ouzo gently in a large shallow pan (large enough to hold the fish) but do not allow to boil. This can be done to one side of the grill or on a stovetop, if barbecue room is limited. Be careful to keep the pan away from any flames from the barbecue.

3 Add the cooked fish to the warm ouzo. Light the liquid with a long match, holding the pan at a slight angle away from you. Move the pan away from the heat and allow the flames to burn out. Transfer the fish to warm plates and serve immediately.

Genius Tip Grilled thick slices of fennel go well with the sea bass. To grill fennel, blanch the slices in boiling water for a few seconds and drain. Then brush them with olive oil, sprinkle with salt, and barbecue alongside the fish. Add shaved Parmesan and coarsely chopped flat-leaf parsley, if liked.

fish & shellfish

Sea Bass with Balsamic Vinaigrette

Serves **4** | Preparation **16 minutes** | Marinating **30 minutes** | Grilling **8 minutes**

4 x 8 oz/225 g portions sea bass fillet	VINAIGRETTE
8 green onions	**5 tablespoons extra virgin olive oil**
MARINADE	**1 teaspoon Dijon mustard**
5 garlic cloves	**1 teaspoon light liquid honey**
1 tablespoon olive oil	**3 teaspoons balsamic vinegar**
3 teaspoons coarse sea salt	**3 tablespoons finely snipped chives**
1 teaspoon cayenne pepper	**1 tablespoon freshly ground black pepper**

1 Rinse the fish under cold running water, pat dry on paper towel and place in a shallow dish.

2 To make the marinade, pound the garlic with the oil, salt, and cayenne pepper in a pestle using a mortar. Smear this paste over the fish by hand. Rub the mixture over the green onions and place in the dish along side the fish. Leave at room temperature for 20 minutes.

3 To make the vinaigrette, whisk the oil, mustard, and honey together. Emulsify the dressing by whisking in the balsamic vinegar. Stir in the chives and black pepper, then set aside at room temperature.

4 To grill the fish, brush the grill well with oil and place the fillets on it. Cook for 4 minutes. Turn the fish, place the green onions on the edges of the grill and continue to cook for a further 4 minutes, turning the onions frequently, until they are scored with golden brown marks but not burnt.

5 Transfer the fish to serving plates and top with the green onions, arranging them in a criss-cross fashion. Spoon over the vinaigrette.

Pompano with Spiced Butter Baste

Serves 4 | Preparation **15 minutes** | Marinating **20 minutes** | Grilling **10 minutes**

4 x 5 oz/150 g pompano fillets
juice of 4 limes
1 tablespoon sesame oil
2 tablespoons coarse sea salt
peanut oil for cooking

BUTTER BASTE
5 tablespoons/5 oz/125 g lightly salted
butter, softened
2 garlic cloves, crushed

1 small red chili, seeded and very
finely chopped
3 teaspoons finely chopped fresh root
ginger
$^1/_2$ teaspoon ground cumin
$^1/_2$ teaspoon ground coriander
$^1/_2$ teaspoon ground turmeric
1 tablespoon coarse sea salt
1 tablespoon teriyaki sauce
juice of $^1/_2$ lime

1 Rinse the fish under cold running water and dry on paper towel.

2 Mix the lime juice, sesame oil, and salt in a shallow dish. Add the fish fillets, cover and marinate for 20 minutes, turning once halfway through.

3 To make the butter baste, cream the butter with the garlic, chili, ginger, cumin, coriander, turmeric, and salt. Gradually beat in the teriyaki sauce and lime juice until thoroughly combined.

4 Brush the grill with peanut oil. Cook the fillets over a hot grill for 5 minutes on each side, until the flesh is firm and just cooked.

5 Transfer the fish to a large platter and spoon dollops of the butter baste over the top. Cover loosely with a piece of foil and allow to stand for about 3 minutes, until the butter has melted. Basmati rice and steamed haricots vert or green beans seasoned with roasted cumin seeds go well with the grilled fish.

Pompano with Mango Mint Sauce

Serves **4** | Preparation **23 minutes** | Marinating **20 minutes** | Grilling **12 minutes**

4 x 8 oz/225 g pompano fillets
1 tablespoon light molasses
1 tablespoon canola oil
1 teaspoon chili powder
1 tablespoon coarse sea salt
$^1/_2$ cup/1 oz/25 g finely chopped mint

MANGO MINT SAUCE
2 ripe mangoes, peeled, pitted and cut in chunks
$^1/_2$ cup/1 oz/25 g chopped mint

$^1/_4$ cup/$^1/_2$ oz/15 g chopped green onion
1 tablespoon canola oil
juice of 1 lime
1 tablespoon light liquid honey
1 red chili pepper, seeded and finely chopped
2 garlic cloves, crushed
1 teaspoon chopped fresh root ginger
$^1/_4$ teaspoon ground cinnamon
1 tablespoon coarse sea salt

1 Rinse the fish under cold running water and dry with paper towel. Set in a shallow dish.

2 Stir the molasses, canola oil, and chili powder together, then spread over the pompano fillets to coat them evenly. Leave at room temperature for 20 minutes.

3 To make the sauce, place all the ingredients in a food processor and purée them to a chunky or fine paste, as preferred. To achieve an even consistency for a chunky paste, pulse the power and scrape the ingredients down the bowl occasionally. Transfer to a dish, cover and leave at room temperature.

4 Cook the fish fillets on a well-oiled, medium-hot grill for 6 minutes on each side, until the flesh is opaque. Turn the fish once during cooking.

5 Pool equal amounts of sauce on 4 plates. Lay a fillet on each pool of sauce, sprinkle with a little salt and chopped mint leaves. A fresh green salad complements the fish.

Monkfish & Vegetable Brochettes

Serves **4** | Preparation **28 minutes** | Marinating **30 minutes** | Grilling **6 minutes**

2 lb/900 g monkfish fillet, skin and
membrane removed, cut into
1 in/2.5 cm cubes
1 large red onion, cut into
1 in/2.5 cm thick wedges
8 firm plum tomatoes, cut into
1 in thick/2.5 cm wedges
1 large yellow bell pepper, seeded and
cut into 1 in/2.5 cm triangular pieces
12 mushroom caps, about 3 in/7.5 cm
across
12 broccoli florets, about 3 in/7.5 cm
across

MARINADE
1 small red chili pepper, seeded and
finely chopped
1 tablespoon coarse sea salt
1 tablespoon capers
2 tablespoons lemon thyme leaves
3 garlic cloves
4 tablespoons olive oil
3 tablespoons medium-dry white wine

1 Thoroughly rinse the fish under cold water and pat dry on paper towel. Place in a bowl. Mix the onion, tomatoes, pepper, mushroom caps, and broccoli florets in a separate bowl.

2 To make the marinade, mash the chili, salt, capers, lemon thyme, and garlic together in a mortar with a pestle. Add the oil and wine and continue mashing to form a coarse, thin paste.

3 Spoon half the paste over the fish and half over the vegetables. Turn the ingredients in the marinade, cover and leave at room temperature for 30 minutes.

4 Drain the fish and vegetables, reserving the marinade. Thread the fish and vegetables alternately on four metal skewers.

5 Brush a grill well with oil and cook the brochettes over medium-hot coals for a total of 6 minutes, turning frequently and brushing with the marinade. The fish should be opaque and both the fish and the vegetables should be scored brown in places.

Whole Barbecued Red Snapper

Serves **4** | Preparation **10 minutes** | Marinating **20 minutes** | Grilling **22 minutes**

1 x 5 lb/2.25 kg red snapper, gutted	**3 tablespoons coarse sea salt**
juice of 2 lemons	**6 tablespoons olive oil**

1 Thoroughly rinse the fish under cold running water and pat dry with paper towel. Make 5 diagonal cuts into the flesh on each side of the fish, equally spaced between the head and tail. Place the fish on a platter.

2 Massage the lemon juice over the body of the fish and into the incisions. Rub in the salt in the same way. Leave at room temperature for 20 minutes.

3 Rub half the oil over the body of the fish and place on a well-oiled grill over a medium-hot barbecue. Cook about 11 minutes on each side, turning once, until the fish is well browned and the flesh just firm and opaque. Brush the fish occasionally with the remaining oil, applying a liberal amount the first time it is turned over.

4 Serve the fish freshly cooked. Potatoes roasted in olive oil, with lemon and oregano, and a Greek salad are ideal accompaniments for the fish.

Genius Tip Metal fish baskets are available for cooking whole fish. By applying light oil to the interior surface of the basket, sticking of flesh can be avoided and turning may be handled with great ease. This eliminates the chore of heavy grate cleaning later. You can score the thickest parts of flesh with slash marks to encourage even heat penetration and even cooking of fish.

Red Snapper with Spiced Paste

Serves 4 | Preparation **20 minutes** | Marinating **1¼ hours** | Grilling **20 minutes**

2 x 1½ lb/675 g whole red snappers

SPICED PASTE
3 tablespoons peanut oil
juice of ½ lime
6 garlic cloves, crushed
1 tablespoon chopped fresh root ginger
1 cup/2 oz/50 g finely chopped cilantro
1 tablespoon coarse sea salt
1 teaspoon freshly ground black pepper

BASTING SAUCE
3 tablespoons Asian-style fish sauce
 (nuoc man)
1 tablespoon sesame oil
juice of ½ lime
1 tablespoon soft brown sugar

1 Rinse the fish thoroughly under cold running water and dry on paper towel. Score both sides of each fish with four evenly spaced slashes, cut at an angle.

2 Mix the oil, lime juice, garlic, ginger, cilantro, salt, and pepper for the paste. Press some of the paste into each slash on the surfaces of the snappers and rub the rest into the body cavities of the fish. Place in a dish, cover, and refrigerate for 1 hours.

3 Mix the fish sauce, sesame oil, lime juice, and sugar for the basting sauce and stir until the sugar has completely dissolved.

4 Remove the fish from the refrigerator 15 minutes before cooking and leave to rest at room temperature. Cook the fish on a medium-hot, well-oiled grill, allowing about 10 minutes on each side, until the skin is crisp and the flesh cooked through. Brush frequently with the basting sauce and use a long-handled wide spatula and fork to turn the fish, taking care not to break them.

5 Transfer the fish to a platter. Slice the skin and lift the flesh off the bones. Jasmine rice and fresh peas go well with the fish.

fish & shellfish

23

Tandoori Red Snapper

Serves **4** | Preparation **25 minutes** | Marinating **1 hour** | Grilling **8 minutes**

4 garlic cloves, crushed
3 tablespoons minced fresh root ginger
2 tomatoes, seeded and chopped
2 tablespoons plain yogurt
1 tablespoon peanut oil
1 teaspoon chili powder
1 teaspoon ground coriander
1^1/$_2$ teaspoons ground turmeric
1^1/$_2$ teaspoons ground fennel
4 x 6 oz/175 g red snapper fillets, about 1 in/2.5 cm thick

MINT YOGURT SAUCE
5 shallots
1 red chili pepper, seeded
1 teaspoon minced fresh root ginger
1 teaspoon sugar
1 cup/2 oz/50 g mint leaves
1/$_2$ cup/1 oz/25 g coarsely chopped cilantro
1 tablespoon fish sauce
1^1/$_2$ cups/12 oz/350 g plain yogurt

1 Process the garlic, ginger, and tomatoes in a food processor until chopped. Add the yogurt, peanut oil, chili powder, ground coriander, turmeric, and fennel and blend to a fine paste.

2 Place the snapper fillets in a dish, pour the spice paste over them and cover with plastic wrap. Put in the refrigerator for 1 hour, turning the fish fillets once after 30 minutes.

3 To make the sauce, chop the shallots, chili, and ginger in a food processor. Add the sugar, mint, cilantro, and fish sauce, and blend to a fine paste. Empty the paste into a bowl and stir in the yogurt. Cover and chill until ready to serve.

4 To cook the fish, brush a little peanut oil over a hot grill and place the fillets on the grill. Cook for 4 minutes on each side, turning once. Transfer the fish fillets to plates and spread the mint yogurt sauce on top. Serve freshly cooked.

Red Snapper with Spicy Caper Sauce

Serves **4** | Preparation **24 minutes** | Marinating **20 minutes** | Grilling **12 minutes**

4 x 5 oz/150 g red snapper fillets
juice of 2 lemons
2 tablespoons virgin olive oil
2 garlic cloves, crushed
2 teaspoons coarse sea salt
1 teaspoon dried chili pepper flakes
1 teaspoon dried marjoram
1 teaspoon dried oregano,
preferably Greek

SPICY CAPER SAUCE
$^1/_2$ cup/4 fl oz/125 ml extra virgin
olive oil
1 tablespoon balsamic vinegar
1 tablespoon white wine vinegar
3 tablespoons drained capers
3 tablespoons finely chopped flat-leaf
parsley
1 garlic clove, crushed
1 finely chopped shallot
1 red chili pepper, seeded and finely
chopped

1 Thoroughly rinse the fish under cold running water and dry on paper towel. Place the fish in a shallow dish.

2 Whisk the lemon juice and oil together, then stir in the garlic, sea salt, dried chili flakes, marjoram, and oregano. Pour this marinade over the fish, cover, and leave at room temperature for 20 minutes, turning once after 10 minutes.

3 To make the sauce, whisk the oil with the vinegars, and then stir in the capers, parsley, garlic, shallot, and chili pepper. Leave to stand at room temperature while the fish marinates.

4 Lift the fish from the marinade and cook on a medium-hot well-oiled grill for 6 minutes on each side, turning once. Brush frequently with the reserved marinade. Serve topped with the sauce.

fish & shellfish

Mahi Mahi in Citrus Marinade

Serves **4** | Preparation **16 minutes** | Marinating **20 minutes** | Grilling **10 minutes**

4 x 6 oz/175 g portions mahi mahi fillet, about 1 in/2.5 cm thick

DRY SPICE MIXTURE
1 dried piri piri pepper
6 black peppercorns
2 cloves
2 allspice berries
2 bay leaves
$^1/_2$ teaspoon cinnamon

CITRUS MARINADE
$^1/_2$ cup/4 fl oz/125 ml corn oil
$^1/_2$ cup/4 fl oz/125 ml freshly squeezed orange juice
juice of 1 lemon
1 tablespoon coarse cut orange marmalade
3 garlic cloves, crushed
1 tablespoon coarse sea salt

GARNISH
2 oranges, peeled and sliced
3 tablespoons pine nuts, lightly toasted

1 Rinse the fish under cold running water and dry on paper towel. Set in a shallow dish.

2 To make the dry spice mixture, preheat a non-stick saucepan over medium heat. Add all the dry spices and toast, shaking the pan frequently, until the spices release their aromas. This takes about 4 minutes. Take care not to overcook or burn the spices. Set aside to cool, then grind to a powder in a spice grinder or coffee grinder reserved for the purpose.

3 To make the citrus marinade, whisk the oil, orange, and lemon juice, and marmalade together in a bowl. Stir in the prepared spice mixture, garlic and salt. Pour the marinade over the fish. Turn the fish over a few times, cover, and leave at room temperature for 20 minutes, turning the fish halfway through.

4 To cook the fish, set the mahi mahi on a well-oiled, hot grill and cook for 5 minutes on each side, until deep golden brown. Brush with the remaining marinade during the first 7 minutes of grilling.

5 Serve at once, with rice and lightly cooked green kale. Garnish with orange and pine nuts.

Mahi Mahi with Mango Pepper Salsa

Serves **4** | Preparation **18 minutes** | Marinating **20 minutes** | Grilling **8 minutes**

4 x 7 oz/200 g portions mahi mahi fillet
$^{1}/_{4}$ cup/2 fl oz/60 ml virgin olive oil
finely grated zest of 1 lime and
juice of 2 limes
$^{1}/_{4}$ cup/$^{1}/_{2}$ oz/15 g finely chopped
cilantro stems (reserve leaves for
salsa, see below)
2 garlic cloves, crushed
1 teaspoon ground coriander
1 tablespoon coarse sea salt
1 tablespoon freshly ground
black pepper

MANGO PEPPER SALSA

2 firm but ripe mangoes, peeled, pitted
and cut into $^{1}/_{4}$ in/5 mm cubes
1 red bell pepper, seeded and finely
diced
1 red chili pepper, seeded and finely
chopped
$^{1}/_{4}$ cup/$^{1}/_{2}$ oz/15 g coarsely chopped
cilantro
$^{1}/_{3}$ cup/3 fl oz/75 ml pineapple juice
1 tablespoon extra virgin olive oil

1 Rinse the fish under cold running water and dry with paper towel. Set the fillets into a shallow dish.

2 Mix the oil, lime zest, and juice, cilantro stems, garlic, coriander, salt, and pepper in a small bowl, then pour this marinade over the mahi mahi. Turn the fillets to coat them thoroughly. Cover and marinate at room temperature for 20 minutes, turning once after 10 minutes.

3 To make the salsa, mix the mangoes with the bell and chili peppers, cilantro, pineapple juice, and oil. Cover and leave at room temperature while cooking the fish.

4 Cook the fish on a well-oiled, medium-hot grill for 4 minutes on each side, turning once.

5 To serve the mahi mahi, transfer the fillets to plates. Spoon some of the salsa to one side of the fish and sprinkle a little coarse sea salt over each fillet. Grilled plantain or banana and rice are good accompaniments.

Swordfish with Black Bean Mayonnaise

Serves **4** | Preparation **15 minutes** | Marinating **20 minutes** | Grilling **6 minutes**

$^1/_4$ **cup/$^1/_2$ oz/15 g rosemary leaves**
$^1/_4$ **cup$^1/_2$ oz/15 g thyme leaves**
$^1/_4$ **cup/2 fl oz/60 ml virgin olive oil**
$^1/_2$ **teaspoon Dijon mustard**
juice of $^1/_2$ lemon
4 x 8 oz/225 g portions swordfish fillet,
about 1 in/2.5 cm thick

BLACK BEAN MAYONNAISE
1 cup/8 oz/225 g mayonnaise
2 teaspoons black bean paste
1 teaspoon sweetened rice vinegar
$^1/_4$ **cup/$^1/_2$ oz/15 g coarsely chopped**
flat-leaf parsley

1 Blend the rosemary, thyme, oil, and mustard in a food processor to form a coarse paste. Add the lemon juice and process briefly. Rinse the swordfish under cold running water and pat dry on paper towels. Smear the paste over both sides of the fish, place in a shallow dish, cover and leave to marinate for 20 minutes at room temperature.

2 Meanwhile, mix the mayonnaise with the black bean paste. Thin the mixture with the rice vinegar and stir in the parsley. Cover and chill in the refrigerator until ready to serve.

3 Scrape the majority of the paste off the fish, leaving only a thin coating on the surface. Cook on a well-oiled, hot grill for 3 minutes on each side. Transfer the fish to plates and top each portion with a dollop of the black bean mayonnaise. Serve at once.

Genius Tip Before beginning your barbecue always ensure that the grill is cleaned and free of grease or remaining dried food bits. Use a wire brush to scrub the surface before and after each use.

Swordfish with Anchovy Caper Salsa

Serves **4** | Preparation **19 minutes** | Marinating **30 minutes** | Grilling **6 minutes**

4 x 8 oz/225 g portions swordfish fillet
3 tablespoons olive oil
1 teaspoon cayenne pepper
2 teaspoons dried thyme
2 garlic cloves, crushed
finely grated zest of $1/2$ lemon

ANCHOVY CAPER SALSA
2 cups/8 oz/225 g peeled, seeded and
finely chopped tomatoes
4 salted anchovies, finely diced

1 tablespoon capers, rinsed
2 garlic cloves, crushed
1 teaspoon dried oregano, preferably
Greek
1 cup/2 oz/50 g finely chopped flat-leaf
parsley
2 tablespoons extra virgin olive oil
juice of $1/2$ lemon
1 teaspoon coarse sea salt
1 teaspoon freshly ground black
pepper

1 Rinse the fish under cold running water and dry with paper towel. Set in a shallow dish.

2 Stir the olive oil, cayenne pepper, thyme, garlic, and lemon zest together to make a marinade. Pour this over the fish and turn the pieces to coat both sides. Cover and leave to stand at room temperature for 30 minutes, turning once halfway through.

3 To make the salsa, mix the tomatoes with the anchovies and capers. Stir in the garlic, oregano, and parsley. then add the olive oil, lemon juice, salt, and pepper. Mix well, then cover and leave to stand at room temperature, stirring occasionally.

4 Place the fish on a medium-hot, well-oiled grill and cook for 3 minutes on each side, turning once.

5 Transfer the fish to plates. Stir the salsa, then spoon some over each portion, allowing it to run off on one side of the fish. Rustic crusty bread, toasted on the grill, and a simple arugula salad are excellent accompaniments.

Chili Swordfish with Red Pepper Coulis

Serve **4** | Preparation **27 minutes** | Marinating **20 minutes** | Grilling **8 minutes**

4 x 8 oz/225 g portions swordfish fillet	RED PEPPER COULIS
4 tablespoons peanut oil	3 tablespoons olive oil
juice of $\frac{1}{2}$ lemon	1 onion, chopped
2 tablespoons grated lemon zest	2 garlic cloves, sliced
1 crushed dried piri piri chili pepper	1 teaspoon grated fresh root ginger
$\frac{1}{2}$ cup/1 oz/25 g coarsely chopped cilantro	2 large red bell peppers, roasted, peeled, seeded and cut into chunks
1 tablespoon crushed black peppercorns	1 tablespoon balsamic vinegar
	1 teaspoon apple cider vinegar
1 lb/450 g steamed baby spinach	1 tablespoon coarse sea salt
$\frac{1}{2}$ cup/1 oz/25 g coarsely chopped cilantro	3 tablespoons lightly salted butter

1 Rinse the swordfish under cold running water and pat dry on paper towels, then place in a large flat baking dish.

2 Mix the peanut oil, lemon juice and zest, crushed chili, cilantro, and cracked peppercorns in a small bowl. Pour the mixture over the fish and rub it over the portions to completely coat them. Cover the dish and leave at room temperature for 20 minutes. Turn the fillets once halfway through.

3 Meanwhile make the coulis. Heat the olive oil in a saucepan over medium heat. Add the onion, garlic, and ginger and cook, stirring continuously, until the onion is translucent. Add the peppers and heat through. Then stir in the balsamic and apple cider vinegars and salt. Just before the mixture boils, add the butter and remove from the heat. Transfer the mixture to a food processor and purée until smooth. Set aside.

4 To grill the fish, place the fillets on a well-oiled rack over a medium-hot grill. Cook for 4 minutes on each side, turning once.

5 Divide the steamed baby spinach among four plates and top with the swordfish. Pour a ring of pepper coulis around the edge and sprinkle some coarsely chopped cilantro over the top.

Provençal Sandwiches of Swordfish

Makes **4** | Preparation **12 minutes** | Marinating **30 minutes** | Grilling **6 minutes**

4 x 5 oz/150 g portions swordfish fillet, about $^1/_2$ in/1 cm thick
$^1/_4$ cup/2 fl oz/ 60 ml virgin olive oil
$^1/_2$ cup/1 oz/25 g mixed chopped oregano, tarragon, and thyme in equal quantities (about 3 tablespoons each)

$^1/_2$ teaspoon Dijon mustard
3 teaspoons drained capers
8 slices crusty rustic French bread
8 slices sun-ripened tomatoes
$^1/_2$ cup/1 oz/25 g whole basil leaves
salt and freshly ground black pepper

1 Rinse the fish under cold running water and pat dry on paper towels. Place in a shallow dish. Blend the olive oil, mixed herbs, mustard, and capers to a paste in a food processor. Spread this over the fish to cover the portions completely, cover and marinate at room temperature for 30 minutes.

2 Scrape the marinade off the fish and reserve it. Cook the fish on a well-oiled grill for 3 minutes on each side or until medium-rare. Brush a little of the reserved marinade on one side of the bread slices and toast them on the grill on both sides until golden brown.

3 Top the marinade-brushed sides of the toasted bread with the fish. Add 2 tomato slices to each and season lightly. Arrange the fresh basil leaves over the tomatoes and cover with the remaining slices of toast, marinade-brushed sides down.

Genius Tip When setting up your barbecue, begin by choosing a location that is free of wind movement and far from buildings and flammable matter. The barbecue should be set level on a flat, inflammable surface and away from inflammable matter.

Swordfish Steaks in Coconut Milk

Serves **4** | Preparation **14 minutes** | Marinating **3 hours** | Grilling **14 minutes**

4 x 8 oz/225 g portions swordfish fillet, about 1 in/2.5 cm thick
8 oz/200 g can coconut milk
3 garlic cloves
1 red chili pepper, seeded
1 tablespoon chopped fresh root ginger
1 teaspoon sesame oil
1 teaspoon tomato purée

¹/₂ cup/1 oz/25 g chopped cilantro
1 tablespoon coarse sea salt

GARNISH
2 plantain or firm bananas
4 canned pineapple slices
1 orange, peeled and sliced

1 Rinse the fish under cold running water, dry on paper towel and set in a shallow dish.

2 To make the marinade, purée the coconut milk, garlic, chili, ginger, sesame oil, tomato purée, cilantro, and salt in a food processor until smooth. Pour over the fillets, cover, and marinate for 3 hours in the refrigerator. Turn the fish and spoon the marinade over three times during marinating.

3 Drain the fish, reserving the marinade, and cook on a well-oiled hot grill for 5 minutes each side, turning once. Brush frequently with the marinade up until the last 3 minutes cooking time.

4 Prepare the garnish while the fish is cooking: peel the plantain or bananas and cut across in half. Grill for 2 minutes on each side, until lightly browned.

5 Serve the swordfish garnished with the plantain or banana, pineapple, and orange. Steamed basmati rice tossed with chopped cilantro leaves and a few toasted pine nuts makes a good accompaniment.

Shark Kabobs with Mango Salsa

Serves 4 | Preparation **26 minutes** | Marinating **20 minutes** | Grilling **8 minutes**

$1^1/_2$ lb/675 g shark fillet, cut into
1 in/2.5 cm thick slices
2 tablespoons light molasses
1 tablespoon peanut oil
grated zest and juice of $^1/_2$ lime
1 jalapeño chili, seeded and
finely chopped
1 teaspoon ground cumin

MANGO SALSA
1 tablespoon canola oil
1 tablespoon light liquid honey

1 tablespoon coarse sea salt
juice of $^1/_2$ lime
2 mangoes, peeled, pitted and cut into
$^1/_2$-in/X-cm cubes
1 red bell pepper, seeded and finely
diced
1 jalapeño pepper, seeded and finely
chopped
1 small red onion, finely chopped
$^1/_2$ cup/1 oz/25 g coarsely chopped
cilantro
3 teaspoons finely snipped chives

1 Thoroughly rinse the fish under cold running water and dry with paper towel. Place the fillets in a shallow dish.

2 Mix the molasses, peanut oil, lime zest and juice, chili, and ground cumin. Spoon this marinade over the fish and rub it in well on both sides with your fingers. Cover and leave at room temperature for 20 minutes, turning once halfway through.

3 To make the salsa, mix the oil, honey, and salt, then whisk in the lime juice. Add the mangoes, bell and jalapeño peppers, onion, cilantro, and chives. Toss gently, then cover and leave to stand at room temperature.

4 To cook the kabobs, thread the fish fillets lengthwise onto long metal skewers. Place on a well-oiled, medium-hot grill and cook for 4 minutes on each side. The fish should be opaque and white right through, with browned score marks on the surface.

5 To serve the fish, remove it from the skewers and place on plates. Spoon the salsa over the top. Fluffy steamed jasmine rice is a suitable accompaniment.

Tuna Wraps with Black Bean Purée

Serves **4** | Preparation **21 minutes (plus cooking time for beans)**
Marinating **20 minutes** | Grilling **8 minutes**

4 x 8 oz/225 g tuna fillets
4 soft flour tortillas
coarse sea salt

MARINADE
$^1/_4$ **cup/2 fl oz/60 ml olive oil**
grated zest of 1 lime
1 tablespoon ground coriander
1 teaspoon cayenne pepper

BLACK BEAN PUREE
2 cups/8 oz/225 g soft-cooked
black beans or 1 x 16 oz/450 g can
prepared beans
2 tablespoons virgin olive oil,
plus extra for serving
juice of 1 lime

2 garlic cloves, crushed
1 red chili pepper, seeded and finely
chopped
1 teaspoon tomato paste
1 teaspoon dried thyme
1 teaspoon ground cumin
1 tablespoon coarse sea salt
$^1/_2$ **cup/1 oz/25 g coarsely chopped**
cilantro, plus extra for serving

TO SERVE
1 cup/8 fl oz/250 ml tomato salsa (see
Grilled Catfish Mexicano, page 44)
4 tablespoons crème fraîche or sour
cream
a little lime juice

1 Rinse the fish under cold running water and dry with paper towel. Place in a shallow dish.

2 To make the marinade, mix the oil, lime zest, coriander, and cayenne pepper, then pour over the fish. Turn the tuna in the mixture to ensure that all surfaces are well coated. Cover and marinate for 20 minutes at room temperature.

3 For the bean purée, mix the beans, oil, lime juice, garlic, chili, tomato paste, thyme, cumin, and salt in a saucepan. Cook over a medium heat for 10 minutes, stirring often, until the mixture starts to bubble. Remove from the stove.

4 Add the cilantro, stir and allow the paste to cool to room temperature. Transfer half the mixture to a food processor and purée. Return the purée to the pan and mix well, then transfer to a serving bowl. If required, drizzle a little extra olive oil over the top and sprinkle with chopped cilantro.

5 Cook the tuna on a well-oiled hot grill for 4 minutes on each side, until medium rare. Turn the fish once. Warm the tortillas on the grill for about 30 seconds on each side. Alternatively, wrap the stack together in foil and place on the grill for about 2 minutes on each side.

6 Top each tortilla with a portion of tuna. Sprinkle a little coarse sea salt over and dollop a spoonful of black bean purée over the top (or serve the bean purée on the side). Serve at once, with tomato salsa and a drizzle of creme fraîche or sour cream thinned with a little lime juice.

· ·

Portuguese-style Tuna Steaks

Serves **4** | Preparation **15 minutes** | Marinating **3 hours** | Grilling **10 minutes**

4 x 8 oz/225 g tuna steaks, about	**2 tablespoons dried basil**
1 in/2.5 cm thick	**1 teaspoon marinated capers**
¹/₂ cup/4 fl oz/125 ml virgin olive oil	**2 salted anchovy fillets**
4 dried bay leaves	**1 teaspoon sea salt**
juice of 1 lime	**1 teaspoon freshly ground black**
3 garlic cloves	**pepper**
2 tablespoons dried oregano	**1 teaspoon dried red pepper flakes**

1 Rinse the tuna under cold running water and dry on paper towel. Pour half the oil into a shallow dish and add the tuna, placing a bay leaf under each steak.

2 Pound the remaining oil to a coarse paste with all the remaining ingredients in a mortar, using a pestle. Smear this paste over the tops of the tuna steaks. Cover and refrigerate for 3 hours. Turn once an hour, spooning the oil over the steaks. Keep the bay leaves under the steaks.

3 To cook the tuna, scrape off excess paste and place on a well-oiled hot grill. Barbecue for 5 minutes on each side, turning once. A salad of fresh greens and tomato salad with olives go well with the tuna.

Tuna Souvlakia Sandwich

Serves **4** | Preparation **12 minutes** | Marinating **20 minutes** | Grilling **8 minutes**

2 lb/900 g tuna fillet, cut into 1½ in/
3.5 cm cubes
2 red bell peppers, seeded and cut
into 1½ in/3.5 cm triangular-
shaped pieces
4 pita bread
4 lemon wedges

MARINADE
¼ cup/2 fl oz/60 ml Greek olive oil
grated zest and juice of 1 lemon
4 garlic cloves, crushed
2 tablespoons dried oregano,
preferably Greek
1 tablespoon coarse sea salt
1 tablespoon freshly ground black
pepper

1 Rinse the fish under cold running water and pat dry. Mix the oil, lemon zest and juice, garlic, oregano, salt, and pepper for the marinade in a shallow dish. Add the tuna and mix well. Cover and marinate at room temperature for 20 minutes, mixing the tuna and marinade occasionally.

2 Thread the tuna onto long metal skewers, adding a piece of red pepper to every 2 chunks of tuna. Cook on a well-oiled grill for 2 minutes per side (turning four times) and brushing occasionally with the leftover marinade. Do not brush after the final turn. The tuna should be browned on all sides.

3 Warm the pita bread on the outer edge of the grill for about 30 seconds on each side. The bread should be light brown, soft, and pliable. Wrap in foil after warming if the fish is not quite ready.

4 Place a piece of pita on each plate. Scrape the tuna and peppers off the skewers onto the bread. Squeeze the wedge of lemon over the fish and sprinkle with a little extra sea salt and pepper. Serve at once.

Genius Tip To make tzatziki, grate 1 peeled cucumber, put it in a sieve resting on top of a bowl and sprinkle with salt. Leave for 10 minutes then squeeze out the remaining liquid. Mix the cucumber with 2 cups/ 16 oz/450 g Greek-style yogurt, 1 cup/2 oz/50 g finely chopped fresh mint, and 2 garlic cloves, finely minced with a little salt.

Tuna Fillet Côte d'Azur

Serves **4** | Preparation **24 minutes** | Grilling **10 minutes**

**4 x 8 oz/225 g portions tuna fillet,
about 1 in/2.5 cm thick
2 tablespoons virgin olive oil
1 tablespoon coarse sea salt
1 tablespoon freshly ground
black pepper**

COTE D'AZUR SAUCE
**3 tablespoons extra virgin olive oil
juice of $^1/_2$ large lemon
3 garlic cloves, crushed**

**1 teaspoon tomato paste
2 large ripe tomatoes, peeled, seeded
and diced
3 tablespoons finely chopped Niçoise
olives
2 teaspoons capers
$^1/_2$ cup/1 oz/25 g coarsely shredded
basil leaves
1 teaspoon coarse sea salt
$^1/_2$ teaspoon cayenne pepper**

1 Rinse the fish under cold running water and dry on paper towel. Place in a shallow dish. Pour the oil over the fish and sprinkle with the salt. Cover and leave at room temperature while you prepare the sauce.

2 To make the sauce, whisk the oil and lemon juice together. Whisk in the garlic and tomato paste, then stir in the tomatoes, olives, capers, basil, salt, and cayenne. Cover and leave at room temperature while you grill the swordfish.

3 Cook the tuna fillets on a well-oiled hot grill, allowing 5 minutes on each side and turning once. Brush the cooked surface with a little of the remaining marinade after turning.

4 Serve the tuna coated with the sauce. A salad of cannelini beans, marinated in a vinaigrette dressing, and salad leaves goes well with the tuna.

Tuna Panini with Olive Mayonnaise

Serves **4** | Preparation **10 minutes** | Marinating **30 minutes** | Grilling **6 minutes**

4 x 5 oz/150 g portions tuna fillet,
$^1/_2$ in/1 cm thick
$^1/_4$ cup/2 fl oz/60 ml virgin olive oil
$^1/_4$ cup/$^1/_2$ oz/10 g coarsely chopped
flat-leaf parsley
1 red chili pepper, seeded and
finely chopped

4 tablespoons black olive tapenade
2 tablespoons mayonnaise
4 panini or white bread rolls, split
horizontally
$^1/_2$ cup/3 oz/75 g deli-style marinated
baby artichokes, drained and
quartered

1 Rinse the tuna under cold running water and pat dry on paper towels. Place in a shallow dish. In a food processor or mortar using a pestle, mix the oil, parsley, and chili to a paste. Spread the mixture over the tuna, cover and marinate at room temperature for 30 minutes. Stir the tapenade into the mayonnaise, cover and set aside

2 Brush the cut sides of the panini or rolls with a little of the tapenade mayonnaise mixture. Cook the tuna on a well-oiled, hot grill for 2–3 minutes on each side, until medium rare. Toast the bread at the same time until golden brown on both sides.

3 Spread the toasted sides of the bottom pieces of each panini or roll equally with the tapenade mayonnaise. Top with the tuna. Arrange the artichokes over the fish and add the top halves of the panini or rolls.

Tuna Burgers with Lemon Mayonnaise

Serves **4** | Preparation **23 minutes** | Grilling **8 minutes**

$1^{1}/_{2}$ **lb/675 g tuna fillet, cut into** $^{1}/_{4}$ **in/**
5 mm dice
$^{1}/_{4}$ **cup/1 oz/25 g finely chopped**
red onion
$^{1}/_{4}$ **cup/**$^{1}/_{2}$ **oz/15 g finely chopped**
flat-leaf parsley
1 tablespoon finely chopped
fresh root ginger
1 red chili pepper, seeded and
finely chopped
2 tablespoons mayonnaise
2 tablespoons olive oil

1 tablespoon coarse sea salt
4 thick slices foccacia to serve

LEMON MAYONNAISE
juice and grated zest of $^{1}/_{2}$ **lemon**
2 garlic cloves, crushed
3 tablespoons snipped chives
1 teaspoon chili powder
1 teaspoon coarse sea salt
1 teaspoon freshly ground white
pepper
$^{1}/_{2}$ **cup/4 oz/100 g mayonnaise**

1 Mix the tuna with the onion, parsley, ginger, chili pepper, and mayonnaise. Press the mixture together with your hands and shape it into 4 patties, each about 1 in/2.5 cm thick. Set aside, covered, at room temperature while making the mayonnaise. (If the burgers are made in advance, they should be placed in the refrigerator until ready to cook.)

2 For the lemon mayonnaise, stir the lemon zest and juice, garlic, chives, chili powder, salt, and pepper into the mayonnaise. Cover and chill in the refrigerator until ready to use.

3 To cook the burgers, brush the grill with oil and place over medium hot coals. Brush a little oil on the burgers and place them, oiled sides down, on the grill. Cook for 4 minutes on each side for a medium-rare result. Brush the tops with oil before turning the burgers. Sprinkle sea salt over the burgers just before removing them from the barbecue.

4 Toast the foccacia on the grill while the burgers are cooking. Place the burgers on the foccacia and serve the lemon mayonnaise on the side.

Tuna with Green Peppercorn Sauce

Serves **4** | Preparation **17 minutes** | Marinating **25 minutes** | Grilling **10 minutes**

4 x 8 oz/225 g portions tuna fillet	GREEN PEPPERCORN SAUCE
2 tablespoons canola oil	**2 tablespoons olive oil**
1 tablespoon light molasses	**3 tablespoons drained soft green**
1 tablespoon freshly ground	**peppercorns**
black pepper	**1 tablespoon Dijon mustard**
1 teaspoon English mustard powder	**1 tablespoon light liquid honey**
	1 tablespoon medium-dry sherry
	1 tablespoon apple cider vinegar
	1 tablespoon coarse sea salt

1 Rinse the fish under cold running water and dry with paper towel. Set the fish in a shallow dish.

2 Stir the oil, molasses, black pepper, and mustard powder together to make a thin paste. Coat the tuna thoroughly with this paste, turning the portions to coat both sides. Cover and leave at room temperature for 25 minutes.

3 To make the sauce, heat the oil in a pan and add the peppercorns. Fry for 2 minutes, then add the Dijon mustard, honey, sherry, vinegar, and salt. Bring to the boil and simmer for about 8 minutes, or until reduced to the consistency of a thin syrup. Remove from the stove.

4 Place the tuna on a well-oiled medium-hot grill and cook for 5 minutes on each side, until medium rare. Transfer to plates and spoon the sauce over the top. Baked potatoes and a mixed salad go well with the tuna.

Genius Tip Always remember to situate your barbecue within proximity of the garden hose or have a bucket of sand on standby. Try to never leave your barbecue unattended.

Grilled Tuna with Nectarine Salsa

Serves **4** | Preparation **25 minutes** | Grilling **8 minutes**

4 x 8 oz/225 g portions tuna fillet, about 1 in/2.5 cm thick
$^1/_4$ cup/2 fl oz/60 ml olive oil
1 tablespoon freshly ground black pepper
1 teaspoon chili powder
1 teaspoon coarse sea salt

SPICY NECTARINE SALSA
3 tablespoons extra virgin olive oil
1 tablespoon apple cider vinegar
3 plum tomatoes, preferably Roma, cut into $^1/_4$ in/5 mm dice

2 firm ripe nectarines, peeled, pitted and cut into $^1/_4$ in/5 mm dice
$^1/_2$ sweet red onion, finely chopped
$^1/_2$ cup/3 oz/75 g cooked black beans
1 jalapeño pepper, seeded and finely chopped
$^1/_2$ teaspoon coarse sea salt
$^1/_2$ teaspoon chili powder
$^1/_2$ cup/1 oz/25 g coarsely chopped cilantro

1 Rinse the tuna under cold running water and dry on paper towel. Brush all over with olive oil and sprinkle with black pepper and chili powder. Set aside in a shallow dish.

2 To make the salsa, whisk the oil and vinegar together. Add the tomatoes and nectarines, then stir in the onion, black beans, jalapeño pepper, salt, chili powder, and cilantro. Cover and leave to stand at room temperature, while you grill the tuna.

3 Cook the tuna on a well-oiled medium-hot grill for 4 minutes on each side, until medium rare. Brush the tuna with any remaining oil after turning the portions. Serve at once, with the salsa. An arugula salad is a good accompaniment.

Asian-style Tuna with Jalapeño

Serves **4** | Preparation **55 minutes** | Marinating **20 minutes** | Grilling **6 minutes**

2 lb/900 g fresh yellow fin tuna fillet
4 tablespoons peanut oil, plus extra
for cooking
3 teaspoon freshly ground
black pepper
2 tablespoons vodka
juice of 1 lime
2 tablespoons black bean paste
4 tablespoons soy sauce
$^{1}/_{2}$ cup/1 oz/25 g coarsely chopped
cilantro

JALAPEÑO PEPPER CONDIMENT
1 lb/450 g fresh jalapeño peppers,
seeded and stem free
12 garlic cloves
$^{1}/_{2}$ cup/4 fl oz/125 ml olive oil
juice of $^{1}/_{2}$ lime
2 teaspoons coarse salt

1 Preheat the oven to 190 C, 350 F, gas 4. To make the jalapeño condiment, place the jalapeño peppers, garlic, and olive oil in a shallow baking dish. Place in the oven for 45 minutes or until soft. Allow to cool, then purée in a food processor with the lime juice and add the salt.

2 Meanwhile, rinse the tuna and pat it dry on paper towels. It should be firm and glossy with no fishy aroma. Cut the tuna into four pieces, no less than 1 in/2.5 cm thick.

3 Mix the peanut oil, black pepper, vodka, and lime juice in a bowl. Add the tuna and turn the pieces in the mixture to coat the pieces completely. Cover and leave to marinate at room temperature for 20 minutes.

4 Place 1 tablespoon of the prepared jalapeño condiment in a bowl. Freeze the remainder of the condiment in 1 tablespoon portions in an ice cube tray for future use. Add the black bean paste, soy sauce, and cilantro to the condiment in the bowl, mix well, cover, and set aside.

5 To barbecue the tuna, brush a medium-hot grill with peanut oil. Brush one side of the tuna with the jalapeño condiment mixture and place brushed sides down on the hot surface. Brush the tops with the mixture and cook for 3 minutes. Turn and cook the second sides for 3 minutes, until medium rare. Serve freshly cooked.

grilling genius

Tuna with Anchovy Tapenade

Serves **4** | Preparation **17 minutes** | Marinating **20 minutes** | Grilling **8 minutes**

4 x 8 oz/225 g center-cut portions tuna fillet
3 tablespoons olive oil
1 teaspoon Dijon mustard
juice of $1/2$ lemon
2 garlic cloves, crushed
1 tablespoon freshly ground black pepper

ANCHOVY TAPENADE
2 cups/8 oz/225 g mixed pitted black Niçoise and unripened green olives
4 salted anchovy fillets, coarsely chopped
3 tablespoons extra virgin olive oil, plus extra for serving
juice of $1/2$ lemon
2 garlic cloves, crushed
1 tablespoon chopped red chili pepper
1 cup/2 oz/50 g finely chopped flat-leaf parsley

1 Rinse the fish thoroughly under cold running water and dry with paper towel. Place in a shallow dish.

2 Whisk the oil and mustard together, then whisk in the lemon juice. Stir in the garlic and pepper. Coat the fish this marinade, cover, and leave at room temperature for 20 minutes.

3 To make the tapenade, combine all the ingredients in a food processor and pulse the power to purée the mixture to an even, coarse consistency. Scrape the mixture down the sides of the bowl occasionally to ensure the texture is even.

4 Drain the tuna, reserving the marinade, and set the portions on a well-oiled medium-hot grill. Cook for 4 minutes on each side, turning once and brushing with marinade before turning.

5 Serve the fish on individual plates, spreading 2 tablespoons of the tapenade over each portion. Drizzle a little extra virgin olive oil over the top.

fish & shellfish

Grilled Catfish Mexicano

Serves **4** | Preparation **19 minutes** | Marinating **20 minutes** | Grilling **8 minutes**

4 x 8 oz/225 g catfish fillets
1 tablespoon coarse sea salt
4 soft flour tortillas

MARINADE
2 tablespoons corn oil
1 tablespoon light molasses
grated zest and juice of 1$^1/_2$ limes
1 tablespoon chili powder

TOMATO SALSA
16 oz/450 g can chopped tomatoes
$^1/_4$ cup/1 oz/25 g finely chopped sweet red onion
3 garlic cloves, crushed
1 jalapeño pepper, seeded and finely chopped

juice of $^1/_2$ lime
1 teaspoon ground cumin
1 teaspoon coarse sea salt
1 teaspoon freshly ground black pepper
$^1/_2$ cup/1 oz/25 g coarsely mixed chopped cilantro leaves and finely chopped stems

TO SERVE
4 tablespoons crème fraîche or sour cream
a little lemon juice
2 avocados, pitted, peeled and sliced
finely snipped chives

1 Rinse the fish under cold running water and dry with paper towel. Place in a self-sealing plastic bag.

2 Stir the oil, molasses, lime zest and juice, and chili powder together for the marinade, and pour into the bag with the catfish. Seal the bag, shake the contents and leave to stand at room temperature for 20 minutes.

3 To make the salsa, mix the canned tomatoes with the onion, garlic, jalapeño pepper, lime juice, cumin, salt, and pepper. Stir in the cilantro and cover, then leave to stand at room temperature for 30 minutes.

4 Cook the fish fillets on a medium-hot, well-oiled grill for 4 minutes on each side, turn once, until the flesh is white and opaque with well-browned score marks.

5 Warm the tortillas on the barbecue for 30 seconds on each side or wrap them in cooking foil and heat for 2 minutes on each side.

6 Meanwhile, thin the crème fraîche or sour cream with a little lemon juice. Roll each fillet in a tortilla and place on plates. Top with a large helping of the salsa over the middle. Add sliced avocado and drizzle with the thinned cream, then sprinkle with chives.

• •

Cajun-style Catfish

Serves 4 | Preparation **14 minutes** | Marinating **45 minutes** | Grilling **12 minutes**

4 x 8 oz/225 g catfish fillets	1 tablespoon garlic powder
2 tablespoons lightly salted butter	1 tablespoon onion powder
2 tablespoons corn oil	1 tablespoon dried thyme
	1 tablespoon dried marjoram
DRY RUB	1 tablespoon freshly ground black
2 tablespoons coarse sea salt	pepper
1 tablespoon ground dried	1 teaspoon ground cumin
sassafras leaves	1 teaspoon ground fennel
1 tablespoon chili powder	

1 Rinse the fish under cold running water and dry with paper towel.

2 Stir all the ingredients for the rub together. Spoon a quarter of the mixture into a clean paper bag ready to coat the fish. Store the remainder in an airtight container in a dark dry cupboard ready for use on another occasion or in a different recipe.

3 Add the fish to the bag and shake. Place the fish back in a shallow dish and sprinkle with any remaining rub in the bag (or extra rub if necessary) to coat dry spots. Cover and refrigerate for 45 minutes.

4 Melt the butter with the oil. Dip the seasoned fillets in the oil and butter mixture and set on a well-oiled, medium-hot grill. Cook for 6 minutes on each side, until the flesh is white throughout. Serve at once.

Salmon Patties

Serves **4** | Preparation **18 minutes** | Grilling **8 minutes**

16 oz/450 g can red salmon in water, drained

4 tablespoons lightly salted butter

1/3 cup/2 oz/50 g finely chopped onion

2 shallots, finely chopped

1 cup/2 oz/50 g toasted breadcrumbs

1 small red chili pepper, seeded and finely chopped

1/2 cup/1 oz/25 g finely chopped flat-leaf parsley

1 tablespoon Dijon mustard

1/4 cup/2 fl oz/60 ml heavy cream

1 egg, beaten

1 tablespoon lemon juice

1 tablespoon chopped capers

1 teaspoon Worcestershire sauce

1 tablespoon coarse sea salt

1/4 cup/1/2 oz/15 g finely snipped chives

1 Squeeze out any excess juice from the salmon, then mash it with a fork in a mixing bowl. Set aside.

2 Melt half the butter in a small pan and add the onion and shallots. Cook until soft and translucent. Add the breadcrumbs, chili, and parsley and cook for 2 minutes, until the crumbs have absorbed all the juices. Remove from the stove.

3 Add the crumb mixture to the salmon. Add the mustard, cream, egg, lemon juice, capers, and Worcestershire sauce and stir thoroughly. Divide the mixture into quarters and shape each portion into 5 in/13 cm long ovals. Add additional breadcrumbs if the mixture is too sticky.

4 Melt the remaining butter and brush half over the patties. Place buttered sides down on a medium-hot grill. Cook for 4 minutes, brush the tops with the remaining butter and turn, then cook the for a further 4 minutes.

5 Serve the patties sprinkled with salt and chives. Potato salad dressed with mayonnaise complements the patties.

Barbecued Salmon

Serves **4** | Preparation **15 minutes** | Marinating **24 hours** | Grilling **6 minutes**

4 x 5 oz/150 g portions salmon fillet, skinned and boned
bunch of fresh herbs, including basil, tarragon and dill

5 tablespoons virgin olive oil
3 teaspoons coarse salt
2 tablespoons sugar
juice of $1/2$ lemon

1 Rinse the salmon under cold running water and pat dry on paper towel. Place half the herbs in a shallow dish. Pour the olive oil onto a platter. Mix the salt and sugar on a plate. Roll the salmon portions in the oil and then in the salt and sugar mixture to coat them lightly. Place the salmon on the herbs. Top with the remaining herbs. Cover with a dampened paper towels and then plastic wrap and refrigerate for 24 hours.

2 Cook the salmon on a well-oiled hot grill: remove the herbs and place the fillets on the grill. Allow 4 minutes on the first side and 2 minutes on the second side, until the fish is medium rare. Serve at once.

Salmon with Garlic Ketchup Sauce

Serves **4** | Preparation **12 minutes** | Marinating **1 hour** | Grilling **8 minutes**

4 x 6 oz/175 g portions salmon fillet, about 1 in/2.5 cm thick	**$^1/_2$ sweet red onion**
$^1/_4$ cup/2 fl oz/60 ml ketchup or ketjap manis	**1 red chili pepper, seeded**
$^1/_4$ cup/2 fl oz/60 ml olive oil	**$^1/_2$ cup/1 oz/25 g chopped cilantro**
2 tablespoons balsamic vinegar	**1 tablespoon soft brown sugar**
5 garlic cloves	**1 tablespoon salt**
	1 teaspoon freshly ground pepper

1 Rinse the fish under cold running water and dry with paper towel. Place in a shallow dish.

2 For the marinade, purée the ketchup, oil, vinegar, garlic, onion, chili, cilantro, sugar, salt, and pepper to a coarse paste in a food processor. Pour this over the salmon, cover, and leave at room temperature for 1 hour, turning three times.

3 Barbecue the salmon on a well-oiled hot grill for 4 minutes on each side. Transfer to plates and serve at once. Potato salad dressed with mayonnaise and coleslaw dressed with vinaigrette are good accompaniments.

Genius Tip If you purchase your salmon fillet with skin on one side, leave it on during grilling. Crispy skin is delicious to eat and the fat between the skin and flesh will add flavor.

Salmon with Mustard Dill Glaze

Serves **4** | Preparation **12 minutes** | Grilling **8 minutes**

**4 x 6 oz/175 g portions salmon fillet,
about 1 in/2.5 cm thick, skinned
2 tablespoons virgin olive oil
1 tablespoon coarse sea salt
1 tablespoon freshly ground
black pepper**

MUSTARD DILL GLAZE

**3 tablespoons virgin olive oil
2 tablespoons Dijon mustard
1 tablespoon lemon juice
1 teaspoon soft brown sugar
$^1/_4$ cup/$^1/_2$ oz/15 g chopped dill
1 teaspoon coarse sea salt
1 teaspoon freshly ground
black pepper**

1 Rinse the salmon thoroughly under cold running water and dry with paper towel. Set in a dish and add the oil, salt, and pepper. Then roll the fillets in the oil and seasoning. Cover the dish and leave at room temperature while you prepare the glaze.

2 For the glaze, whisk the oil and mustard together, then whisk in the lemon juice, brown sugar, dill, salt, and pepper.

3 Brush one side of each salmon fillet with the glaze and set glaze down on a well-oiled medium-hot grill. When all the pieces are on the barbecue, glaze the top surfaces. Grill for 4 minutes, turn and glaze the cooked surfaces. Grill for another 4 minutes. Serve at once.

Teriyaki Salmon & Rice Burgers

Serves **4** | Preparation **16 minutes** | Marinating **45 minutes** | Grilling **10 minutes**

1 lb/450 g salmon fillet, skinned
3 tablespoons teriyaki sauce
2 garlic cloves, crushed
1 cup/8 oz/225 g cooked sushi rice
(following packet instructions)
3 tablespoons finely chopped
fresh root ginger
2 tablespoons finely chopped shallot

3 tablespoons coarsely
chopped parsley
1 teaspoon finely chopped
red chili pepper

GARNISH
4 green onions, finely chopped
2 teaspoons toasted sesame seeds

1 Rinse the salmon thoroughly under cold running water and dry with paper towel. Cut the fish into $1/4$ in/5 mm dice and place in a bowl.

2 Mix the teriyaki sauce with the garlic, add to the salmon and mix lightly. Cover and place in the refrigerator for 45 minutes.

3 Drain the salmon in a colander, discarding the juices, then transfer it to a bowl. Add the cooked sushi rice, ginger, shallot, parsley, and chili pepper. Mix the ingredients by hand and shape the mixture into 4 patties.

4 Grill the burgers on a well-oiled, medium-hot barbecue for 5 minutes on each side. Turn the burgers once. Serve topped with the green onion and toasted sesame seeds. Try serving a simple green salad dressed in vinaigrette flavoured with a little chopped fresh root ginger with the burgers

Genius Tip Sushi rice has a sticky quality that makes it a good binding ingredient for patties. For 1 cup/8 oz/225 g cooked sushi rice, prepare $1/3$ cup/2 oz/50 g raw rice, following the packet instructions. It may also help to slightly freeze the salmon for 1 hour before slicing, until it is firm but not frozen, as this makes it easier to cut into small cubes.

Salmon with Fresh Basil Cream Sauce

Serves **4** | Preparation **14 minutes** | Grilling **10 minutes**

4 x 6 oz/175 g portions salmon fillet
2 tablespoons virgin olive oil
juice of $1/2$ lemon
1 tablespoon coarse sea salt
1 tablespoon freshly ground black pepper

FRESH BASIL CREAM SAUCE
$1/4$ cup/2 fl oz/60 ml heavy cream
$1/2$ cup/4 fl oz/125 ml créme fraîche or sour cream
1 tablespoon lemon juice
grated zest of $1/2$ lemon
2 garlic cloves, crushed
$1/2$ cup/1 oz/25 g coarsely chopped basil
1 tablespoon coarse sea salt
1 teaspoon cayenne pepper

1 Rinse the fish thoroughly under cold running water. Pat dry on paper towel and set in a shallow dish. Whisk the oil and lemon juice together and add the salt and pepper, then pour this over the fish. Cover and leave at room temperature while you prepare the sauce.

2 To make the sauce, whip both types of cream with the lemon juice until thick. Fold in the lemon zest, garlic, basil, salt, and cayenne until thoroughly mixed. Cover and leave to stand at room temperature.

3 Place the fillets on a well-oiled hot grill and cook for 5 minutes on each side. Brush the cooked surface with some of the marinade after turning. Transfer the fish to plates.

4 Drain off and discard any thin liquid that may have separated from the cream sauce, then stir once again. Spoon a dollop of the sauce onto each fillet and serve at once. Couscous goes well with the fish, especially when tossed with herbes de Provence.

Salmon with Minted Cucumber

Serves **4** | Preparation **15 minutes** | Marinating **20 minutes** | Grilling **7 minutes**

4 x 8 oz/225 g portions salmon fillet, 2 in/5 cm thick	**2 English cucumbers**
8 mint sprigs	**$^1/_4$ teaspoon sugar**
$^1/_4$ cup/2 fl oz/ 60 ml virgin olive oil	**$^1/_2$ cup/5 oz/150 g chopped tomatoes**
juice of $^1/_2$ lemon	**$^1/_4$ teaspoon chili powder**
8 thick bacon slices	**salt and freshly ground black pepper**

1 Rinse the salmon fillets in cold water, pat them dry on paper towels and place in a shallow dish. Remove the leaves from the mint and set them aside. Finely chop the stems and mix them with the oil and lemon juice. Smear this mixture over both sides of the salmon portions. Cover and leave to marinate for 20 minutes at room temperature.

2 Meanwhile, grill the bacon until crisp. Drain the bacon on paper towels and leave to cool, then dice the slices and set aside. Peel and quarter the cucumbers lengthwise. Holding the lengths of cucumber together, slice them across into small wedges. Coarsely chop the mint leaves and mix with the cucumber. Season and set aside. Sprinkle the sugar over the tomatoes, mix gently and set aside.

3 Scrape the oil and mint mixture off each salmon portion. Sprinkle with chili powder, salt, and pepper on both sides, and place, skin sides down, on the hot grill. Cook for 4 minutes until the skin is browned and crisp. Turn the salmon and grill the second side for 3 minutes, until cooked outside and medium-rare in the middle.

4 Mix the tomatoes with the bacon and divide this mixture among four plates. Place the salmon on the tomato mixture, with the skin sides up. Spoon some of the cucumber mixture over the salmon and offer the remainder separately.

Salmon with Chili Fennel Salsa

Serves **4** | Preparation **15 minutes** | Marinating **30 minutes** | Grilling **6 minutes**

4 x 6 oz/175 g salmon fillets, skinned
2 tablespoons olive oil
1 garlic clove, crushed
1 teaspoon grated fresh root ginger
1 teaspoon ground fennel
1 tablespoon coarse sea salt

CHILI FENNEL SALSA
4 tablespoons extra virgin olive oil
1 teaspoon light liquid honey

juice of 1 lime
1 large bulb of fennel with leaves,
 shaved into thin slices
1 red chili pepper, seeded and
 finely chopped
1 cup/2 oz/ 50 g coarsely chopped
 cilantro
1 tablespoon coarse sea salt
1 teaspoon freshly ground
 black pepper

1 Rinse the salmon under cold running water and dry with paper towel. Place in a shallow dish.

2 Stir the olive oil, garlic, ginger, and ground fennel together to make a marinade and spoon this over the fish. Rub the marinade over the salmon, then cover and leave at room temperature for 30 minutes.

3 Meanwhile, make the salsa: whisk the oil and honey together, then whisk in the lime juice. Mix the fennel, chili, cilantro, salt, and pepper in a bowl. Pour in the dressing and toss well. Cover and leave at room temperature while the fish is marinated and grilled.

4 Cook the salmon fillets on a well-oiled hot grill for 3 minutes on each side, until browned outside and rare in the middle. Turn once.

5 Place a dollop of salsa in the middle of each plate. Lay a portion of salmon on top and sprinkle a little salt. Serve any remaining salsa separately. Offer potato salad with the grilled salmon.

Salmon with Ginger Teriyaki

Serve **4** | Preparation **15 minutes** | Marinating **1 hour** | Grilling **6 minutes**

4 x 5 oz/150 g portions salmon fillet, skinned
2 tablespoons light sesame oil
1 tablespoon coarse sea salt
3 tablespoons finely chopped green onion
2 tablespoons Japanese pickled radish

MARINADE
¹/₂ cup/4 fl oz/ 125 ml teriyaki sauce

2 tablespoons plum wine
2 tablespoons rice wine vinegar
3 teaspoons grated fresh root ginger
1 tablespoon freshly ground black pepper

TERIYAKI SAUCE
2 tablespoons soy sauce
2 tablespoons plum wine
1 tablespoon rice wine vinegar

1 Rinse the salmon under cold water, pat dry on paper towels and place in a shallow dish. Whisk all the marinade ingredients together in a small bowl. Pour the marinade over the fish, ensuring that it coats the portions thoroughly, cover and marinate for 1 hour, turning the salmon halfway through.

2 Mix the soy sauce, wine, and vinegar for the teriyaki sauce in a small saucepan. When ready to grill the fish, strain the marinade through a fine sieve into the sauce mixture and bring to a boil. Turn off the heat and leave to stand. The sauce does not have to be thick; it may be served hot or at room temperature.

3 Brush a hot grill with the sesame oil and place the salmon on it. Cook for 3 minutes, then turn the fish and sprinkle with the salt. Cook again for a further 3 minutes on the second side, until medium rare.

4 Transfer the fish to plates, spoon the sauce over and sprinkle with the chopped green onion. Serve with pickled radish. Steamed sushi rice goes well with the salmon.

Salt-grilled Trout

Serves **4** | Preparation **13 minutes** | Salting **30 minutes** | Grilling **8 minutes**

4 small trout, about 1 lb/450 g each, gutted | 4 tablespoons coarse sea salt
2 tablespoons light sesame oil

1 Rinse the trout under cold running water and dry with paper towel. Sprinkle half the salt in a shallow dish. Lay the fish in the salt. Sprinkle the remaining salt over the top and rub it gently over the entire surface of the fish. Cover and leave to rest for 30 minutes.

2 Brush the sesame oil on the grill and cook the skewered fish, either directly on the grill or in a long-handled basket, over medium-hot coals. Cook for 4 minutes on each side until the flesh is opaque and the skin is crisp. Turn the fish once, taking care not to break the skin. Remove with care from the grill and serve at once.

Steam-grilled Wasabi-buttered Trout

Serves **4** | Preparation **17 minutes** | Grilling **16–20 minutes**, plus **5 minutes standing**

4 small trout, about 1 lb/450 g each, gutted
8 tablespoons lightly salted butter, softened
1 tablespoon wasabi powder
2 garlic cloves, crushed

2 tablespoons finely chopped shallots
¹⁄₂ cup/1 oz/25 g finely chopped flat-leaf parsley
1 tablespoon coarse sea salt
1 teaspoon freshly ground black pepper

1 Rinse the fish thoroughly under cold running water and pat dry on paper towel. Score 3 evenly spaced diagonal cuts on each side of the flesh between the gill and tail. Cut 4 pieces of cooking foil, each double the width of the fish.

2 Cream the butter with the wasabi powder, garlic, shallots, parsley, salt, and pepper. Divide the butter into quarters and place a portion into the body cavity of each fish. Rub a small amount into the cuts in the flesh.

3 Wrap each fish in foil, bringing the foil together over the fish and folding the edges together in 3 turns to created a sealed pouch.

4 Set the foil pouches on the hot barbecue. Cook for 8–10 minutes on each side. Remove the packets from the barbecue with long handled, flat-tipped tongs, taking care not to break the foil. Leave in the package until serving or let stand for an additional 5 minutes to allow for inner steaming after the initial grilling time.

5 Present the foil pouches on individual plates. The packets are torn open at the table, with a knife and fork, and the fish is eaten straight from the wrapping or transferred to plates with the butter sauce poured over, as preferred.

Steam-grilled Stuffed Trout

Serves **4** | Preparation **15 minutes** | Grilling **16–20 minutes**

4 small whole trout, about 1 lb/450 g each, gutted
4 tablespoons butter, softened
juice of $^1/_2$ lemon
2 garlic cloves, crushed
$^1/_2$ cup/1 oz/25 g finely shredded basil leaves

$^1/_2$ cup/1 oz/25 g coarsely chopped cilantro
$^1/_4$ cup/$^1/_2$ oz/15 g cup fresh thyme leaves
$^1/_2$ teaspoon chili powder
1 tablespoon coarse sea salt

1 Rinse the trout under cold running water and dry on paper towel. Cut 4 pieces of cooking foil, each double the width of the fish.

2 Cream the butter with the lemon juice, garlic, basil, cilantro, thyme, chili powder, and sea salt. Divide this butter into quarters.

3 Spoon a portion of butter into the body cavity of each trout. Wrap each fish in foil, bringing the foil together over the fish and folding the edges together in 3 turns to created a sealed pouch.

4 Set the foil pouches on the hot barbecue. Cook for 8–10 minutes on each side. Use flat-tipped tongs and a spatula to turn the packages, taking care not to puncture the foil.

5 Transfer the pouches to a platter or individual plates. Leave in the package until serving or let stand for an additional 5 minutes to allow for inner steaming after the initial grilling time. Tearing open the foil releases the steam and fabulous aroma of the stuffing. A fresh green salad and new potatoes go well with the fish.

fish & shellfish

Chili-Sake Barbecued Squid

Serves **4** | Preparation **22 minutes** | Marinating **45 minutes** | Grilling **1 minute**

2 lb/900 g cleaned baby squid
with tentacles
1 tablespoon chili powder
1/2 cup/2 oz/50 g finely chopped
green onion

MARINADE
1/2 cup sake
1/2 cup/4 fl oz/125 ml light soy sauce

1/2 cup/4 fl oz/125 ml teriyaki sauce
1 tablespoon Thai fish sauce
1 tablespoon light sesame oil
1 tablespoon soft brown sugar
1 red chili pepper, seeded and
finely chopped
finely shaved pickled ginger or pickled
radish to serve

1 Rinse the squid thoroughly under cold running water and pat dry with paper towel. Slit the squid sacs lengthways so that they can be opened out flat and cut 2-3 small lacerations on each side. This will help to prevent the pieces of squid from curling during grilling. Place the squid in a shallow dish.

2 To make the marinade, whisk all the ingredients together until the sugar has dissolved. Pour the marinade over the squid and mix by hand so that all the pieces are thoroughly coated. Cover the dish and place in the refrigerator to marinate for 45 minutes.

3 When you are ready to barbecue the squid, drain the pieces over a saucepan to catch the marinade. Place the pan of marinade over medium heat and bring to the boil. Boil until the marinade is reduced to the consistency of a thin syrup. Remove from the stove.

4 Thread the squid onto long metal skewers or place them directly on a well-oiled medium-hot grill. Sprinkle with a dusting of chili powder and cook for 30 seconds on each side, until opaque and scored golden.

5 Pour the reduced marinade in small pools on individual plates. Remove the squid from the skewers, if necessary, and pile the pieces in small mounds on the sauce.

6 Sprinkle chopped green onion over the squid and serve at once, with finely shaved ginger or pickled radish.

Barbecued Chili Squid Salad

Serves 4 | Preparation **25 minutes** | Marinating **20 minutes** | Grilling **about 2 minutes**

1 lb/450 g cleaned squid sacs
$^1/_4$ cup/2 fl oz/ 60 ml olive oil
1 teaspoon sesame oil
$^1/_2$ teaspoon chili powder, plus extra for seasoning
1 cup/2 oz/50 g cilantro leaves, stems finely chopped and reserved for marinade
juice of 2 large fresh limes
1 red bell pepper, seeded and cut into julienne strips
1 yellow pepper, seeded and cut into julienne strips

1 fennel bulb, cut into julienne strips
1 cup/4 oz/100 g snow peas, cut into julienne strips
1 red onion, halved and thinly sliced

DRESSING
6 tablespoons virgin olive oil
2 garlic cloves, crushed
1 tablespoon grated fresh root ginger
1 teaspoon finely chopped red chili pepper
2 tablespoons Japanese sweet rice vinegar

1 Rinse the squid under cold running water and pat dry on paper towels. Slit the squid sacs lengthways, open them out and score the inside surfaces in a criss-cross design, taking care not to cut right through the flesh. Place in a dish.

2 Whisk the olive and sesame oils together with the chili powder and cilantro stems. Whisk in the lime juice, then pour this marinade over the squid and mix well by hand. Cover and leave for 20 minutes at room temperature.

3 Mix the peppers in a large bowl. Add the fennel and snow peas. Sprinkle in the onion, separating the halved slices into thin strips. Cover and set aside.

4 To make the dressing, process all the ingredients together in a small food processor, adding the vinegar last to emulsify the dressing.

5 Place the squid on a hot grill and sprinkle the top lightly with chili powder. Barbecue for about 2 minutes, turning frequently until slightly charred evenly on both sides. Set aside to cool for 10 minutes.

6 To serve, mix the squid with the salad. Add the dressing and toss well. Leave to stand at room temperature for 10 minutes to allow the flavors to merge. Sprinkle with the cilantro leaves and mix again.

Stuffed Squid with Dijon Garlic Sauce

Serves **4** | Preparation **31 minutes** | Grilling **12–14 minutes**

1^1/$_2$ lb/675 g whole baby squid with tentacles, cleaned
1 tablespoon chili powder

1 tablespoon coarse sea salt
1 tablespoon freshly ground black pepper
1 egg, lightly beaten

STUFFING

6 oz/175 g Westphalian ham, finely chopped
2 garlic cloves, crushed
1 red chili pepper, seeded and finely chopped
1/$_2$ cup/1^1/$_2$ oz/40 g grated pecorino cheese
1/$_2$ cup/1 oz/25 g finely chopped flat-leaf parsley
1/$_2$ cup/1 oz/25 g finely chopped cilantro
3 tablespoons olive oil

DIJON GARLIC SAUCE

4 tablespoons extra virgin olive oil
1 tablespoon Dijon mustard
1 teaspoon light liquid honey
juice of 1/$_2$ lemon
2 garlic cloves, crushed
1/$_4$ cup/1/$_2$ oz/15 g finely chopped flat-leaf parsley
1 teaspoon coarse sea salt
1 teaspoon coarsely ground black pepper

1 Rinse the squid under cold running water and dry with paper towel. Finely chop the tentacles and set aside.

2 For the stuffing, mix the ham, garlic, chili, pecorino, parsley, cilantro, oil, salt, and pepper. Mix in the chopped squid tentacles and egg to make a coarse paste. Fill the squid with the stuffing, packing it in firmly. If the squid are small and quite full, use fine metal skewers (or toothpicks soaked in water) to keep the ends closed.

3 To make the sauce, whisk the oil, mustard, and honey together. Then whisk in the lemon juice. Stir in the remaining ingredients and set aside at room temperature.

4 Barbecue the squid on a well-oiled medium-hot grill. Cook for 6–7 minutes on each side until the flesh is white and opaque with well-browned score marks. Dust the top with a little chili powder. Arrange the cooked squid on a platter and drizzle the sauce over the top. Grilled or steamed fresh green asparagus spears go well with the squid.

Charred Squid & White Bean Salad

Serves **4** | Preparation **18 minutes** | Marinating **30 minutes** | Grilling **2 minutes**

1¹/₂ lb/675 g cleaned squid sacs
3 tablespoons olive oil
2 garlic cloves, crushed
1 tablespoon dried thyme
1 teaspoon ground fennel
1 tablespoon chili powder

WHITE BEAN SALAD AND DRESSING
2 cups/6 oz/175 g cooked white beans
1 garlic clove, crushed
1 red chili pepper, seeded and finely chopped

3 tablespoons extra virgin olive oil
1 tablespoon balsamic vinegar
1 tablespoon salt
1 teaspoon freshly ground black pepper
1 cup/2 oz/50 g basil leaves
1 cup/2 oz/50 g coarsely chopped cilantro
¹/₂ lemon

1 Rinse the squid under cold running water and dry with paper towel. Score the squid with a sharp knife, making three incisions on each side without cutting right through. Place in a shallow dish.

2 To make the marinade, stir the olive oil, garlic, thyme, and ground fennel together. Pour this over the squid and rub it all over and into the squid by hand. Leave at room temperature for 30 minutes.

3 Meanwhile, make the bean salad: mix the beans with the garlic, chili, oil, balsamic vinegar, salt, pepper, basil, and cilantro. Cover and leave at room temperature.

4 Cook the squid on a well-oiled hot grill for 1 minute on each side, until the flesh is opaque and white inside and charred outside. Dust with chili powder and cut into ¹/₂ in/1 cm wide rings.

5 Toss the squid rings with the bean salad and squeeze the juice from the lemon half over the top. Taste for seasoning and add more salt and pepper, if necessary, then toss again. Accompany the salad with crispy lavash, large Middle Eastern crisp bread, or other crisp bread or flat bread.

fish & shellfish

Squid with Jalapeño Remoulade

Serves **4** | Preparation **20 minutes** | Marinating **20 minutes** | Grilling **4 minutes**

1¹/₂ lb/675 g cleaned squid sacs
1 tablespoon canola oil
1 tablespoon light molasses
1 tablespoon chili powder, plus extra
for dusting
8 lemon wedges to garnish

JALAPEÑO REMOULADE
1¹/₂ cups/12 oz/350 g mayonnaise
1 tablespoon finely grated lemon zest
juice of ¹/₂ lemon
1 jalapeño pepper, seeded and
finely chopped

1 garlic clove, crushed
2 tablespoons finely chopped sweet
baby pickles
1¹/₂ tablespoons chopped capers
1 tablespoon coarse sea salt
1 teaspoon paprika
1 teaspoon white pepper
¹/₂ cup/1 oz/25 g finely chopped
flat-leaf parsley
¹/₄ cup/¹/₂ oz/10 g finely chopped
tarragon
¹/₄ cup/¹/₂ oz/10 g finely snipped
chives

1 Rinse the squid under cold running water and dry with paper towel. Place in a shallow dish.

2 Stir the oil, molasses and chili powder together. Spoon this over the squid and use your hands to rub it into the pieces. Cover and leave at room temperature for 20 minutes.

3 To make the remoulade, mix the mayonnaise, lemon zest and juice, jalapeño pepper, garlic, pickles, capers, salt, paprika, and pepper in a small bowl. Stir in the parsley, tarragon, and chives, then cover and refrigerate.

4 Dust the squid with chili powder and cook, chili side down, on a hot, well-oiled grill. Cook for 2 minutes on each side, dusting with chili powder before turning.

5 Transfer the squid to a serving platter and garnish with the lemon wedges. Serve the remoulade sauce on the side. French fries or pan-fried potatoes make a good accompaniment for the squid.

Capetown Barbecued Squid

Serves **4** | Preparation **30 minutes** | Grilling **4 minutes**

2 lb/900 g cleaned squid sacs
2 tablespoons peanut oil
juice of 1 lime
1 teaspoon chili powder

DRY SPICE MIXTURE
2 teaspoons coriander seeds
1 teaspoon cumin seeds
1 teaspoon fennel seeds
4 dried Kefir lime leaves

COCONUT MILK SAUCE
11 oz/300 g can coconut milk
4 garlic cloves, crushed
2 shallots, finely chopped
1 red chili pepper, seeded and
 finely chopped
1 tablespoon finely chopped fresh
 root ginger
grated zest of 1 lime
1 tablespoon tomato paste
2 tablespoons ketjap manis
$^1/_2$ cup/1 oz/25 g coarsely chopped
 cilantro leaves and finely chopped
 stems
1 tablespoon coarse sea salt

1 Rinse the squid under cold water and dry on paper towel. Score the surface of the flesh with slashes and place in a bowl. Add the oil and lime juice, cover and leave to marinate.

2 To make the dry spice mixture, pre-heat a dry non-stick saucepan over a medium heat. Add the coriander, cumin, and fennel seeds with the kaffir lime leaves. Toast the dry spices until the fragrance is released, about 4 minutes. Stir frequently and be careful not to burn the mixture. Set aside to cool and then grind the mixture to a powder in a spice mill or coffee grinder reserved solely for the purpose.

3 To make the sauce, heat the coconut milk with the dry spice mixture, garlic, shallots, chili pepper, ginger, lime zest and juice, tomato paste, ketjap manis, cilantro, and salt in a saucepan over medium heat. Stir thoroughly and cook for about 10 minutes, until the sauce is reduced and creamy.

4 Lightly dust the squid with chili powder and place on a hot grill. Cook for 2 minutes on each side, turning once with long-handled tongs. Serve at once, coated with the warm coconut sauce.

fish & shellfish

Grecian-style Char-grilled Octopus

Serves **4** | Preparation **10 minutes** | Marinating **20 minutes** | Grilling **12 minutes**

1^1/$_2$ **lb/675 g octopus tentacles, cleaned and left whole**
8 tablespoons virgin olive oil
juice of 1 lemon
3 teaspoons dried oregano, preferably Greek

1/$_4$ **cup/1/$_2$ oz/15 g finely chopped flat-leaf parsley**
1 teaspoon coarse sea salt
1 teaspoon freshly ground black peppercorns

1 Rinse the octopus thoroughly under cold running water and dry thoroughly on paper towels.

2 Whisk the oil and lemon together in a bowl large enough to hold the octopus. Then stir in the oregano, parsley, salt, and peppercorns. Set aside.

3 Grill the octopus on the hot barbecue, until evenly browned all over, turning frequently. Take care not to burn the pieces. This should take a total of 12 minutes.

4 Add the freshly cooked octopus to the dressing. Mix thoroughly and leave to stand at room temperature for 20 minutes.

5 Taste the octopus for seasoning and acidity, adding salt and/or lemon juice if necessary. Serve with fried potatoes, seasoned with a little lemon juice, dried oregano, and salt.

Genius Tip Octopus can be sold fresh or frozen, prepared ready for use. If the body torso is included, cut it into quarters.

Five-spice Honey Ginger Shrimp

Serves **4** | Preparation **16 minutes** | Marinating **1 hour** | Grilling **4 minutes**

2 lb/900 g peeled shrimp, deveined
juice of 1 lemon
¹/₂ cup/1 oz/25 g coarsely chopped
cilantro or flat-leaf parsley

MARINADE
3 tablespoons peanut oil
1 tablespoon sesame oil
1 tablespoon mirin (Japanese sweet
rice wine)

3 tablespoons teriyaki sauce
2 tablespoons Thai sweet chili sauce
1 tablespoon light liquid honey
4 garlic cloves, crushed
2 tablespoons finely chopped fresh root
ginger
1 tablespoon Chinese five-spice
powder
5 dried kefir lime leaves

1 Thoroughly rinse the shrimp under cold running water, drain, and dry with paper towel. Place in a large shallow dish, so that all the shrimp lie flat.

2 To make the marinade, whisk the oils, lemon juice, vinegar, teriyaki sauce, chili sauce, and honey in a mixing bowl until thoroughly mixed. Stir in the garlic, ginger, five-spice powder, and kefir lime leaves.

3 Pour the marinade over the shrimp and turn them until they are fully coated. Cover and place in the refrigerator for 1 hour. Turn the shrimp in the marinade after 30 minutes.

4 Drain the shrimp. Brush the hot grill with peanut oil and cook the shrimp for 2 minutes on each side, so that the flesh is firm and the outside is browned.

5 To serve, transfer the prawns to a large platter, squeeze with lemon juice, and sprinkle with cilantro or flat-leaf parsley. Rice noodles and steamed bok choy go well with the shrimp.

fish & shellfish

Shrimp with Saffron Pepper Sauce

Serves **4** | Preparation **18 minutes** | Marinating **1 hour** | Grilling **5 minutes**

2 lb/900 g jumbo shrimp with shells
3 tablespoons olive oil
2 tablespoons medium-dry white wine
4 garlic cloves, crushed
3 bay leaves, crumbled
1 teaspoon cayenne pepper
grated zest of $1/2$ lemon

SAFFRON PEPPER SAUCE

3 red bell peppers, roasted, skinned and seeded
5 tablespoons extra virgin olive oil
juice of $1/2$ lemon
4 garlic cloves
1 teaspoon saffron
$1/2$ teaspoon cayenne pepper
1 tablespoon coarse sea salt

1 Rinse the shrimp under cold running water and dry with paper towel. Make two 1 in/2.5 cm long, diagonal lacerations through the shell on either side of each shrimp, taking care not to cut too deeply. Scoring the flesh is fine but it should not be cut right through. Place in a shallow dish.

2 Mix the oil, wine, garlic, bay leaves, cayenne, and lemon zest. Pour this marinade over the shrimp. Cover the dish and refrigerate for 1 hour.

3 For the sauce, purée the peppers with the oil, lemon juice, garlic, saffron, cayenne, and salt in a food processor until smooth and runny. Divide among four small ramekins and leave at room temperature.

4 Set the shrimp on a well-oiled, medium-hot grill. Cook for $2^{1}/_{2}$ minutes on each side. The flesh should be semi-firm and it should look opaque white through the shell. Serve the shrimp with the dipping sauces. Accompany the dish with toasted rustic bread, such as sourdough bread.

Shrimp with Peanut Butter Sauce

Serves **4** | Preparation **27 minutes** | Marinating **45 minutes** | Grilling **4 minutes**

2 lb/900 g peeled shrimp, deveined
¹/₂ cup/2 oz/50 g chopped peanuts
¹/₂ cup/1 oz/25 g coarsely chopped cilantro leaves

COCONUT MILK MARINADE
¹/₂ cup/ 4 fl oz/125 ml canned coconut milk
juice of 2 limes
4 garlic cloves, crushed
1 teaspoon dried red pepper flakes
1 tablespoon coarse sea salt

PEANUT BUTTER SAUCE
3 tablespoons peanut oil
4 garlic cloves, crushed
2 tablespoons chopped fresh root ginger
1 red chili pepper, seeded and finely chopped
¹/₂ cup/1 oz/25 g chopped cilantro
4 tablespoons ketchup
³/₄ cup/6 oz/175 g creamy peanut butter
1¹/₂ cups/12 fl oz/350 ml canned coconut milk
1 teaspoon ground fennel
2 tablespoons coarse sea salt

1 Rinse the shrimp under cold running water. Dry with paper towel and place in a large shallow dish—large enough for all the shrimp to be spread out flat.

2 Place the peanuts in a dry non-stick skillet. Shake and stir continuously over medium heat for about 5 minutes or until the nuts are golden brown and aromatic. Remove from the pan and set aside to cool.

3 To make the marinade, mix all of the ingredients, then pour over the shrimp. Cover and leave at room temperature for 45 minutes.

4 To make the sauce, heat the oil in a saucepan. Add the garlic, ginger, chili, and cilantro. Cook until the garlic is translucent, then stir in the ketchup and peanut butter until smooth. Gradually stir in the coconut milk, fennel, and salt. Simmer for 5 minutes to reduce the sauce slightly and then set aside.

5 Cook the shrimp on a well-oiled, hot grill. Cook for 2 minutes on each side, until the flesh is firm and browned. Transfer to a serving bowl.

6 Pour the sauce over the shrimp and toss to coat them evenly. Sprinkle the chopped cilantro and peanuts over the top and serve at once.

fish & shellfish

Cajun Barbecued Shrimp

Serves **4** | Preparation **21 minutes** | Marinade **1¹⁄₄ hours** | Grilling **4 minutes**

2 lb/900 g peeled shrimp, deveined	2 tablespoons dried oregano
4 tablespoons olive oil	2 tablespoons dried thyme
2 tablespoons medium-dry white wine	2 tablespoons cayenne pepper
2 tablespoons Worcestershire sauce	1 tablespoon sweet paprika
1 teaspoon Tabasco	1 tablespoon ground cumin
4 garlic cloves, crushed	1 tablespoon ground coriander
2 tablespoons coarse sea salt	4 dried bay leaves, crumbled
2 tablespoons ground fennel	juice of 1 lemon

1 Rinse the shrimp under cold running water and dry with paper towel. Transfer to a shallow dish.

2 Mix the olive oil, lemon juice, wine, Worcestershire and Tabasco sauces in a mixing bowl. Stir in the garlic, salt, fennel, oregano, thyme, cayenne, paprika, cumin, coriander, and bay leaves. Mix to a thick paste. Coat the shrimp with this paste using your hands. Cover the dish and refrigerate for 1¹⁄₄ hours.

3 Thread the shrimp neatly on long metal skewers. Grill on a well-oiled, hot grill for 2 minutes on each side. The flesh should be firm and the surface of the shrimp blackened.

4 Transfer the skewers to a platter as soon as they are cooked, then scrape them off the skewers with a fork, divide among four plates and squeeze with lemon juice.

Genius Tip Dirty rice—a dish of rice cooked with chicken livers, onions, peppers, and red beans—is a classic Cajun accompaniment to serve with shrimp.

Grilled Shrimp with Tahini Sauce

Serves **4** | Preparation **24 minutes** | Marinating **20 minutes** | Grilling **4 minutes**

2 lb/900 g peeled shrimp, deveined
4 tablespoons olive oil
juice of 1 lemon
3 garlic cloves, crushed
3 tablespoons freshly ground black pepper

TAHINI SAUCE
1 cup/8 oz/225 g tahini (sesame seed paste)
juice of 2 lemons

2 tablespoons light liquid honey
1 red chili pepper, seeded and finely chopped
2 garlic cloves, crushed
1 tablespoon finely chopped fresh root ginger
1 tablespoon coarse sea salt
1 teaspoon cayenne pepper
1 cup/2 oz/50 g finely chopped flat-leaf parsley
4 tablespoons water

1 Rinse the shrimp under cold running water and dry with paper towel. Transfer to a shallow dish.

2 Whisk the oil and lemon juice together, then stir in the garlic and pepper. Pour this marinade over the shrimp, cover, and leave at room temperature for 20 minutes.

3 For the sauce, mix the tahini, lemon juice, and honey together to make a smooth paste. Stir in the chili, garlic, ginger, salt, cayenne, and parsley. Gradually stir in enough of the water, a tablespoon at a time, to reduce the sauce to a thick, batter-like, pouring consistency. You may not need all the water. Divide among four ramekin dishes ready to serve.

4 Cook the shrimp on a well-oiled, hot barbecue for 2 minutes on each side. Remove and transfer to a platter. Serve at once with the dishes of dipping sauce.

fish & shellfish

Creole-spiced Barbecued Shrimp

Serves **4** | Preparation **52 minutes** | Marinating **45 minutes** | Grilling **4 minutes**

2 lb/900 g peeled shrimp, deveined
2 tablespoons olive oil
juice of 1 lime

DRY RUB
1 teaspoon dried oregano
1 teaspoon dried thyme
1 teaspoon dried marjoram
1 teaspoon ground fennel
1 teaspoon cayenne pepper
1 tablespoon coarse sea salt

CREOLE SAUCE
3 tablespoons olive oil
4 garlic cloves, crushed
$1/2$ cup/1 oz/25 g chopped sweet red onion

$1/2$ cup/2 oz/50 g chopped fennel
$1/2$ cup/2 oz/50 g chopped celery (with leaves)
$1/2$ cup/2 oz/50 g chopped red bell pepper
$1/2$ cup/2 oz/50 g chopped green bell pepper
1 tablespoon tomato paste
1 tablespoon soft brown sugar
1 tablespoon Worcestershire sauce
1 teaspoon Tabasco
$1/2$ cup/4 fl oz/125 ml clam broth
16 oz/450 g can chopped tomatoes
$1/2$ cup/4 fl oz/125 ml heavy cream
$1/2$ cup/1 oz/25 g coarsely chopped flat-leaf parsley

1 Rinse the shrimp under cold running water and dry with paper towel. Transfer to a bowl.

2 Mix the ingredients for the dry rub in a mortar – the oregano, thyme, marjoram, ground fennel, cayenne, and salt. Grind them vigorously with a pestle until the mixture is reduced virtually to a powder. Empty this over the shrimp and toss until they are fully coated. Add the oil and lime juice and stir again until thoroughly coated. Cover and place in the refrigerator to marinate for 45 minutes.

3 To make the sauce, heat the olive oil in a pan and add the garlic, onion, fennel, celery, and red and green peppers. Cook for 5 minutes or until the vegetables are tender, stirring continuously.

4 In a small bowl, mix the tomato paste, brown sugar, Worcestershire sauce, Tabasco, and clam broth. Stir this into the vegetables and bring to the boil, then simmer over a medium heat for 10 minutes, until reduced. Add the tomatoes and simmer for a further 6 minutes.

5 Remove the pan from the heat and fold the cream into the sauce. Stir in the chopped parsley. Cover and set aside.

6 Cook the shrimp on a well-oiled hot grill for 2 minutes on each side, or until the flesh is firm and browned. Transfer to a large serving bowl.

7 Pour the sauce over the shrimp and toss gently. Serve at once. White rice tossed with yellow corn kernels and grilled okra are good accompaniments for the shrimp.

Genius Tip As a great flavor enhancer, soak wood, such as apple or mesquite, hickory chips or sprigs of fresh rosemary for 1 hour prior to barbecuing. They impart a marvelous smoky flavor once they are drained of water and placed on top of the burning charcoal embers. Many gas grills come with a smoker box in which you can place the wood chips, or place them in a smoker pouch and follow the manufacturer's instructions.

fish & shellfish

Shrimp with Lemon Tarragon Butter

Serves **4** | Preparation **21 minutes**, plus freezing | Marinating **20 minutes**
| Grilling **4 minutes**

2 lb/900 g peeled shrimp, deveined	3 garlic cloves, crushed
5 tablespoons olive oil	$^{1}/_{3}$ cup/1 oz/25 g finely chopped
juice of $^{1}/_{2}$ lemon	tarragon
3 garlic cloves, crushed	1 teaspoon chopped lemon thyme or
2 bay leaves, crumbled	dried thyme
1 tablespoon freshly ground	1 teaspoon coarse sea salt
black pepper	$^{1}/_{2}$ teaspoon cayenne pepper
LEMON TARRAGON BUTTER	TO SERVE
8 tablespoons butter, softened	1 tablespoon coarse sea salt
finely grated zest and juice of $^{1}/_{2}$ lemon	$^{1}/_{2}$ cup/1 oz/25 g coarsely chopped
1 tablespoon Pernod	flat-leaf parsley

1 Rinse the shrimp thoroughly under cold running water and dry with paper towel. Place in a shallow dish.

2 Whisk the oil, lemon juice, garlic, bay leaves, and pepper together, then pour this over the shrimp and toss until all the shrimp are thoroughly coated. Cover and leave to stand at room temperature for 20 minutes.

3 For the lemon tarragon butter, cream the butter with the lemon zest and juice, Pernod, garlic, tarragon, lemon thyme or dried thyme, salt, and cayenne pepper. Spoon the butter in a log shape on the center of a 12 in/30 cm length of plastic wrap, leaving 2 in/5 cm wrap free on each end. Roll the butter up in the wrap and twist both ends at once to shape the butter into 2 in/5 cm diameter roll. Place in the freezer for 1 hour, until firm.

4 Cut eight $^{1}/_{2}$ in/1 cm thick slices off the roll of butter (return the rest to the freezer). Thread the shrimp on long metal skewers, lengthwise through the bodies from head to tail. Brush with marinade and cook on a well-oiled, hot grill for 2 minutes on either side.

5 Scrape the shrimp off the skewers onto a serving platter. Immediately scatter the butter slices over the top. As the butter melts, toss the shrimp gently in it. Sprinkle with the salt and parsley and serve at once.

6 A green salad and crusty baguette goes well with the shrimp. For a more substantial dish, the shrimp can be tossed with freshly cooked pasta.

• •

Tandoori Shrimp

Serves **4** | Preparation **35 minutes** | Marinating **30 minutes** | Grilling **6 minutes**

2 lb/900 g shrimp with shells	**2 tablespoons cayenne pepper or 1 tablespoon piri piri powder**
YOGURT MARINADE	**1 tablespoon coarse sea salt**
1¹/₂ cups/12 oz/350 g plain whole milk yogurt	**¹/₂ teaspoon ground coriander**
juice of 1 lemon	**¹/₂ teaspoon ground fennel**
2 tablespoons peanut oil	**¹/₂ teaspoon ground cinnamon**
3 garlic cloves, crushed	**¹/₂ teaspoon ground turmeric**
2 tablespoons finely chopped fresh root ginger	**¹/₂ teaspoon ground cloves**
	¹/₂ teaspoon grated nutmeg
	nan (Indian flat bread) to serve

1 Rinse the shrimp under cold running water and dry with paper towel. Make two slashes through the shell on each side of each shrimp, but do not cut through the flesh. (A slight incision to the flesh will help the shrimp to absorb the flavor of the marinade but any more will break them up.) Transfer to a large shallow dish.

2 To make the yogurt marinade, mix the yogurt, lemon juice, and oil together. Stir in the garlic, ginger, cayenne or piri piri powder, salt, coriander, fennel, cinnamon, turmeric, cloves, and nutmeg. Spoon over the shrimp and mix thoroughly, working the marinade into the incisions. Cover and leave to marinate at room temperature for 30 minutes.

3 Cook the shrimp on a well-oiled hot barbecue for 3 minutes on each side. Warm the nan around the sides of the grill for about 1 minute on each side. Transfer to a platter. Serve the shrimp with the warm nan.

Shrimp Fajitas

Serves **4** | Preparation **27 minutes** | Marinating **20 minutes** | Grilling **19 minutes**

2 lb/900 g peeled shrimp, deveined
2 tablespoons chili powder
1 tablespoon ground cumin
1 tablespoon ground fennel
1 tablespoon ground coriander
5 garlic cloves, crushed
juice of 3 limes
2 red bell peppers
2 yellow bell peppers
16 soft flour tortillas
12 green onions

ACCOMPANIMENTS
2 cups/450 ml/$^3/_4$ pint spicy red salsa
2 cups/450 ml/$^3/_4$ pint guacamole
2 cups/450 ml/$^3/_4$ pint sour cream
1 cup/4 oz/100 g sliced jalapeño peppers
1 cup/2 oz/50 g chopped cilantro
2 limes, cut into quarter wedges

1 Rinse the shrimp under cold running water and dry with paper towel. Transfer to a shallow dish.

2 To make a marinade, mix the chili powder, cumin, fennel, coriander, garlic, and lime juice. Add the shrimp and mix well by hand to coat the shrimp completely. Cover the dish and leave at room temperature for 20 minutes.

3 Set the peppers directly on the flames of a hot barbecue to char their outer skin, turning frequently with long-handled tongs. This will take about 20 minutes.

4 Remove the peppers and wrap in cold wet paper towels. Leave to cool for 15 minutes. Remove the towels and rub off the charred skins with your hands or scrape them off with a small sharp knife. Halve the peppers, remove the stems and scrape out the seeds. Slice the flesh into long thin strips and transfer to a serving plate.

5 Wrap the tortillas in foil and heat them in the oven. Place the accompaniments in serving dishes. Cook the shrimp and green onions on a well-oiled, hot grill, allowing 2 minutes on each side for the shrimp, until the flesh is firm and browned. Cook the onions for the same time, turning them constantly.

6 Arrange the shrimp and green onions on a platter. Serve with the peppers and tortillas—select accompaniments to roll up in each tortilla with the shrimp.

Shrimp Brochette with Bacon Wrap

Serves **4** | Preparation **28 minutes** | Marinating **30 minutes** | Grilling **6 minutes**

24 jumbo shrimp, peeled and deveined
48 large basil leaves
24 thin slices bacon

DRY RUB
3 garlic cloves, crushed
1 tablespoon chili powder
1 tablespoon ground fennel
1 tablespoon ground black pepper
24 bamboo skewers, soaked in cold
water for 30 minutes, to cook

1 Rinse the shrimp under cold running water, dry with paper towel and place in a bowl.

2 For the dry rub, mix the garlic, chili powder, ground fennel, and pepper, then sprinkle over the shrimp and rub the mixture into them by hand to coat them completely. Cover and refrigerate for 30 minutes.

3 Drain the bamboo skewers. Separate the bacon and lay the slices out so that they are easy to pick up. Lay out the basil leaves in 24 pairs. Thread a shrimp onto a skewer, beginning at the tail, pushing the skewer through the length of the body and out the head end. Wrap two basil leaves around the body. Anchor the end of a piece of bacon to the tip of the skewer and then spiral it around the length of the shrimp to cover the entire surface of the shrimp and basil.

4 Lay two lengths of double-thick foil on either side of a well-oiled, hot grill so that the exposed ends of the bamboo skewers can rest on them. Lay the brochettes so that the ends of the skewers are on the foil and cook for 3 minutes on each side, until the bacon is crisp and the shrimp flesh is firm.

5 Transfer the brochettes to a platter and serve at once. A green salad and crusty baguette are suitable accompaniments.

Shrimp Provençal with Dipping Sauce

Serves **4** | Preparation **35 minutes** | Marinating **3 hours** | Grilling **4 minutes**

6 tablespoons virgin olive oil
1 teaspoon tomato paste
1 teaspoon Worcestershire sauce
1¹/₂ tablespoons Pernod (optional)
3 garlic cloves , crushed
1 chili pepper, seeded and
 finely chopped
1 teaspoon cayenne pepper
1 teaspoon dried oregano
1 teaspoon ground dried rosemary

4 tablespoons coarsely chopped basil,
4 tablespoons coarsely chopped
 thyme
4 tablespoons coarsely chopped flat-
 leaf parsley
3 lb/1.4 kg jumbo shrimp with shells
¹/₂ cup/1 oz/ 25 g coarsely chopped
 mixed herbs, such as basil, thyme
 and flat-leaf parsley, to garnish
juice of 1 lemon

1 To make the marinade, mix the olive oil, tomato paste, Worcestershire sauce, Pernod (if using), garlic, chili, lemon juice, cayenne, oregano, and rosemary in a saucepan. Bring to the boil, reduce the heat and simmer for 15 minutes.

2 Add the basil, thyme, and parsley to the marinade and remove from the heat. Season with salt and freshly ground pepper to taste. Transfer the marinade to a bowl and leave to cool.

3 Rinse the shrimp under cold running water and pat dry on paper towels. Add to the marinade, mix well to coat the shrimp completely and cover with plastic wrap. Refrigerate for 3 hours.

4 Drain the shrimp, reserving the marinade, and thread them on metal skewers, pushing these

Genius Tip The position of the grilling rack closest to the coals is best for searing foods quickly at a high temperature. A higher elevation of the rack is necessary for cooking foods at lower temperatures over a longer period of time.

through the thickest part of the flesh at a 45 degree angle. Place four to five shrimp on each skewer.

5 Pour the reserved marinade into a saucepan and bring it to the boil on the grill beside the shrimp or on the stove. Simmer while the shrimp are cooking to reduce the marinade slightly.

6 Cook the shrimp on a well-oiled, hot grill for about 2 minutes on each side, until the flesh is firm and pink outside, and opaque white inside. Add the mixed fresh herbs for garnish to the sauce just before removing the pan from the heat.

7 Slide the shrimp off the skewers with a fork, squeeze with lemon juice, and serve at once with the sauce. Provide extra napkins or finger bowls for cleaning sticky fingers and have a communal bowl for the cast-off shells from the prawns. A fresh green salad and plenty of crusty bread to soak up the dipping sauce are good accompaniments.

Grilled Shrimp in Carrot Masala

Serves **4** | Preparation **30 minutes** | Grilling **5 minutes**

**32 extra-large shrimp, peeled
and deveined
juice of $^1/_2$ lime
3 tablespoons olive oil
$^1/_2$ teaspoon red chili pepper flakes**

CARROT MASALA
**1 cup/8 fl oz/250 ml fresh carrot juice
1 teaspoon tomato paste
1 teaspoon grated fresh root ginger
$^1/_3$cup/$2^1/_2$ oz/65 g lightly salted butter
1 teaspoon garam masala
1 teaspoon salt
$^1/_4$ cup/$^1/_2$ oz/15 g finely chopped
flat-leaf parsley**

1 Rinse the shrimp thoroughly under cold running water and dry with paper towel. Lay flat in a shallow dish. Add the lime juice, oil and chili flakes, toss well, cover and leave to marinate at room temperature for 15 minutes.

2 To prepare the carrot masala, stir the carrot juice, tomato paste, and ginger together in a saucepan and bring to a boil over high heat. Reduce the heat to medium and cook for 10 minutes, until reduced.

3 Add the butter and whisk it into the sauce. When most of the butter has melted, add the garam masala, and salt, and continue whisking. When the butter has melted, stir in the parsley and remove from the stove. Set aside.

4 Drain the shrimp and cook on a well-oiled, medium-hot grill for 5 minutes, turning halfway through. The flesh should be opaque and white, pink outside, and firm but not hard.

5 Transfer the shrimp to a serving platter and pour over the carrot masala sauce. Steamed basmati rice and mango chutney are suitable accompaniments.

Shrimp & Bacon Brochette with Aioli

Serves **4** | Preparation **25 minutes** | Grilling **6 minutes**

24 large shrimp, peeled and deveined
2 tablespoons olive oil
2 garlic cloves, crushed
$^1/_2$ teaspoon chili powder
6 lean bacon slices

SPICY AIOLI
2 egg yolks
grated zest and juice of $^1/_2$ lemon
$^1/_4$ cup/2 fl oz/60 ml olive oil
$^1/_2$ red chili pepper, seeded and finely chopped

1 Rinse the shrimp under cold running water and dry with paper towel. Place in a bowl, add the oil, garlic, and chili powder and rub the oil mixture all over the shrimp with your hands.

2 Cut each slice of bacon into four equal pieces and wrap a piece around each shrimp. Press the bacon ends together, then thread the wrapped shrimps lengthways through the middle on metal skewers.

3 To make the aioli, whisk the egg yolks with 1 teaspoon of the lemon juice, then whisk in 1 teaspoon of the oil. Gradually trickle in the remaining oil while whisking hard. The mixture will become pale and thick. Stir in the remaining lemon juice and the zest, and the chili pepper. Cover and chill this spicy aioli until ready to serve.

4 Cook the brochettes on a well-oiled, medium-hot grill for 3 minutes on each side, until the bacon is crisp and the shrimp flesh is opaque and white, tinged pink on the outside.

5 Scrape the shrimp off the skewers onto plates. Serve at once with the aioli for dipping. Lightly toasted crusty baguette is a good accompaniment.

Shrimp in Green Herb Mayonnaise

Serves **4** | Preparation **25 minutes** | Marinating **15 minutes** | Grilling **6 minutes**

24 jumbo shrimp, peeled and deveined
3 tablespoons olive oil
finely grated zest and juice of 1 lime
2 garlic cloves, crushed
1 teaspoon chili powder

GREEN HERB MAYONNAISE
4 anchovies, finely chopped
1 teaspoon capers

1 teaspoon Dijon mustard
$^1/_4$ cup/$^1/_2$ oz/15 g finely chopped flat-leaf parsley
$^1/_4$ cup/$^1/_2$ oz/15 g finely chopped cilantro
2 tablespoons thyme leaves
$^1/_2$ teaspoon coarse sea salt
$^1/_2$ teaspoon chili powder
1 cup/8 oz/225 g mayonnaise

1 Rinse the shrimp under cold running water and dry with paper towel. Place in a shallow dish. Mix the oil, lime zest and juice, garlic, and chili powder together and rub this mixture all over the shrimp. Cover and leave to marinate at room temperature for 15 minutes.

2 To make the herb mayonnaise, stir the anchovies, capers, mustard, parsley, cilantro, thyme, salt, and chili into the mayonnaise until thoroughly combined. Cover and refrigerate until ready to serve.

3 Thread the shrimp lengthways onto long metal skewers. Place on a well-oiled, medium-hot grill and cook for 3 minutes on each side, until evenly browned outside, with firm white flesh. Brush with the remaining marinade during cooking.

4 To serve, scrape the shrimp from the skewers onto a serving platter. Accompany the shrimp with the herb mayonnaise for dipping.

Genius Tip Instead of using metal skewers, the shrimp can be threaded on bamboo skewers. They should be soaked in cold water for at least 30 minutes and drained before use—this helps to prevent them from burning on the barbecue.

Lobster Tails in Vanilla-rum Marinade

Serves **4** | Preparation **15 minutes** | Marinating **1 hour** | Grilling **12 minutes**

4 x 8 oz/225 g lobster tails in shells
1 teaspoon chili powder
3 tablespoons melted lightly salted butter
1 teaspoon coarse sea salt

VANILLA-RUM MARINADE
1 cup/8 fl oz/250 ml dark rum
1 tablespoon pure vanilla extract
1 tablespoon light liquid honey
1 teaspoon star anise powder

1 Snip along the top of a lobster shell using kitchen shears. Use a small, sharp knife to cut the meat in half as far as the bottom of the shell but taking care not to cut the shell in half. Spread the lobster tail apart into a butterfly effect. Repeat with the remaining lobster tails, laying them in a shallow dish.

2 To make the marinade, whisk the rum, vanilla, and honey together. Stir in the star anise and pour the marinade over the exposed flesh of the lobster. Use your hands to rub the marinade over the meat without separating it from the shell. Cover and refrigerate for 1 hour.

3 Drain the lobster tails, sprinkle the exposed flesh with chili powder and place on a well-oiled, medium-hot grill with the meat face down. Cook for 3 minutes, turn and cook for a further 9 minutes, brushing the meat with the melted butter. The lobsters should be opaque white and firm but not hard in texture. Serve at once.

fish & shellfish

81

Lobster Tacos Vera Cruz

Serves 4 | Preparation **20 minutes** | Marinating **15 minutes** | Grilling **12 minutes**

4 x 8 oz/225 g lobster tails in shells
1 teaspoon chili powder
3 tablespoons olive oil
4 large soft flour tortillas
1 teaspoon coarse sea salt
$^{1}/_{2}$ cup/1 oz/ 25 g coarsely chopped cilantro

SPICE RUB
2 tablespoons olive oil

grated zest and juice of 1 lime
2 garlic cloves, crushed
1 teaspoon ground fennel
$^{1}/_{2}$ teaspoon ground cumin
$^{1}/_{2}$ teaspoon dried chili flakes

ACCOMPANIMENTS
red salsa
sour cream

1 Snip along the top of a lobster shell using kitchen shears. Use a small, sharp knife to cut the meat in half as far as the bottom of the shell but taking care not to cut the shell in half. Spread the lobster tail apart into a butterfly effect. Repeat with the remaining lobster tails, laying them in a shallow dish.

2 To make the spice rub, whisk the oil and lime juice together. Stir in the garlic, fennel, cumin, and red pepper flakes, and pour this marinade over the lobster tails. Rub the mixture into the meat with your hands. Cover and marinate at room temperature for 15 minutes.

3 Sprinkle the lobster tails with chili powder and place on a well-oiled, medium-hot grill with the meat face down. Cook for 3 minutes, turn and brush with the oil. Cook for a further 9 minutes, until opaque white and firm but not hard in texture.

4 While the lobsters are cooking, place the tortillas on the grill to warm and toast lightly for 1 minute. Transfer the lobster tails to a board and leave until cool enough to handle. Remove the lobster meat from the shells with a fork and sprinkle with salt. Wrap the lobster meat in the tortillas, sprinkling with the chopped cilantro. Serve red salsa and sour cream with the lobster wraps.

Soft Shell Crabs with Chili Herb Butter

Serves **4** | Preparation **25 minutes** | Grilling **8 minutes**

8 large soft shell crabs

CHILI HERB BUTTER
$^{1}/_{2}$ cup/4 oz/100 g lightly salted butter
2 garlic cloves, crushed
2 red chili peppers, seeded and
finely chopped

$^{1}/_{4}$ cup/$^{1}/_{2}$ oz/ 15 g finely chopped
green onion
1 tablespoon coarse sea salt
jalapeño remoulade to serve (see Squid
with Jalapeño Remoulade, page 62)

1 Rinse the crabs thoroughly under cold running water and dry with paper towel. To prepare a soft-shell crab, snip off the eyes and mouth with kitchen shears. Flip the crab over and pull the apron-like shell away from the belly side, starting from the mouth end. Turn the crab over and peel off the outer covering to each side. Pull out and discard the exposed gills with your fingers, cutting them free with a small knife. Repeat with the remaining crabs.

2 To prepare the butter, melt it in a shallow pan and add the garlic, chili, green onion, and salt. Remove from the heat.

3 Dip the crabs in the butter, turning them to bathe each side, and place tops down on a medium-hot grill. Cook for 4 minutes on each side, until the crabs turn dark red-brown. Brush with the butter mixture frequently during cooking.

4 Divide the crabs among four serving plates and serve at once, with the jalapeño remoulade.

Grilled Oysters in Butter Vinaigrette

Serves **4** | Preparation **15 minutes** | Grilling **4 minutes**

48 cold-water oysters in the shell

BUTTER VINAIGRETTE
1 cup/8 fl oz/ 250 ml dry white wine
4 tablespoons sherry vinegar
6 shallots, finely chopped

1 tablespoon freshly ground black pepper
$^1/_4$ cup/$^1/_2$ oz/15 g finely chopped flat-leaf parsley
4 tablespoons butter
rock salt, crumpled foil or oyster dishes to serve

1 Thoroughly scrub the oysters and rinse under cold running water to remove any sand or grit. Discard any broken shells or open shells that do not close when tapped.

2 To make the vinaigrette, mix the wine, vinegar, shallots, and pepper in a saucepan. Bring to a boil and cook until reduced to half the original quantity. Stir in the parsley and gradually whisk in the butter, a little at a time, until melted and the vinaigrette is thickened. Remove from the heat and divide among four small dipping bowls. Prepare a bed of rock salt or crumpled foil in shallow dishes, or have oyster dishes ready for serving the grilled shellfish.

3 Set the oysters on a medium-hot grill, cupped shells down to retain the natural juices their contain. Cook for 4 minutes, without turning the oysters over, until the shells have opened. Remove the shells carefully from the grill to avoid spilling the juices. Discard any shells that have not opened.

4 Transfer the oysters to the serving plates or dishes, settling them into the salt or foil to keep the shells steady. Accompany the oysters with the butter vinaigrette.

Barbecued Oysters with Horseradish

Serves **4** | Preparation **18 minutes** | Grilling **7 minutes**

36 large oysters

HORSERADISH CREAM
**1^1/$_2$ cups/12 fl oz/350 ml heavy cream
grated zest of 1 lemon and juice
of 1/$_2$ lemon**

1/$_2$ **teaspoon English mustard powder**
1/$_2$ **teaspoon sweet paprika**
3 tablespoons grated fresh horseradish
1/$_2$ **cup/1 oz/25 g snipped chives**

1 Make sure the oyster shells are closed; if open, when tapped they should close. Discard any open oysters that do not close as they are dead. Rinse and scrub under running cold water.

2 To make the horseradish cream, whip the cream until thick but not firm enough to stand in peaks. Fold in the lemon juice, mustard, and paprika, followed by the horseradish, lemon zest, and chives. Cover and refrigerate until serving.

3 Set the oysters on a hot barbecue with the concave sides of the shells down. Grill for 7 minutes or until the top shells pop open. Remove gently from the grill to avoid spilling the natural juices and place on large shallow dishes.

4 Gently remove the top shells, again trying not to lose the juices. Divide the oysters equally among four plates and spoon a small dollop of the horseradish cream on each oyster. Serve a chilled champagne with the oysters.

Grilled Clams with Lemon Herb Butter

Serves **4** | Preparation **15 minutes** | Soaking **2 hours** | Grilling **5 minutes**

3 lb/1.4 kg small clams
handful of salt for soaking

LEMON HERB BUTTER
¹/₂ cup/4 oz/100 g lightly salted butter
grated zest and juice of 1 lemon
2 garlic cloves, crushed

1 red chili pepper, seeded and
 finely chopped
¹/₂ cup/1 oz/25 g finely chopped
 cilantro
¹/₄ cup/¹/₂ oz/ 15 g finely chopped
 flat-leaf parsley
1 teaspoon coarse sea salt

1 Discard any clams with cracked shells or those that are open and do not close when tapped. Soak the clams in salt water for 2 hours, then scrub off any surface sand or grit and rinse thoroughly under cold running water.

2 To make the lemon herb butter, melt the butter in a small saucepan on the grill or stove. Add the lemon zest and juice, garlic, chili, cilantro, parsley, and salt, and stir for 5 minutes. Remove the pan from the heat and reserve.

3 Place the clams on a medium-hot grill, cupped shells down, and cook for 5 minutes, or until their shells open. Do not turn the clams—but keep them upright to retain their juices. Discard any that do not open.

4 Transfer the clams to a deep platter and pour the lemon herb butter over them. Serve with plenty of lightly toasted baguette to soak up the butter.

Genius Tip Remember—charcoal briquettes take longer to heat to the desired temperature, but last longer than easy light charcoal.

Barbecued Clams with Rice Noodles

Serves **4** | Preparation **22 minutes** | Grilling **7 minutes**

48 cherrystone or littleneck clams in the shell, no more than 2 in/5 cm wide

1 lb/450 g thick, flat dried rice stick noodles

$^1/_2$ cup/1 oz/25 g coarsely chopped cilantro

1 tablespoon freshly ground black pepper

CURRY BUTTER SAUCE

$1^1/_4$ lb/575 g butter

3 cloves garlic, crushed

2 shallots, finely chopped

1 teaspoon chopped fresh root ginger

1 red chili pepper, seeded and finely chopped

2 tablespoons garam masala

1 tablespoon coarse sea salt

1 Scrub and rinse the clams individually under cold running water. Always check for a fresh salt sea smell and discard any that smell suspicious. Discard any shells that are open and do not shut when tapped sharply.

2 To make the curry butter sauce, melt the butter in a saucepan. Add the garlic, shallots, and ginger, and cook until translucent. Stir in the chili, garam masala, and salt, and remove from the stove.

3 Begin to cook the rice stick noodles just before grilling the clams. Bring a large saucepan of water to the boil. Add the noodles and simmer for 4–5 minutes, until al dente, tender but firm. Drain, leaving a little water in the pan. Return the noodles to the pan and cover, then set aside while removing the clams from the barbecue.

4 Cook the clams on a hot barbecue for 7 minutes or until all the shells have opened. Discard any that do not open. Transfer the clams to a platter.

5 To serve, reheat the curry butter sauce for a moment. Turn the rice sticks into a warmed serving bowl and pour the sauce over them. Toss the noodles in the sauce and set the barbecued clams on top. Sprinkle with the cilantro and pepper. Serve at once.

Scallops in Herb Lime Marinade

Serves **4** | Preparation **15 minutes** | Marinating **15 minutes** | Grilling **4 minutes**

2 lb/900 g jumbo sea scallops	1 teaspoon ground cumin
juice of 4 limes	1 teaspoon chili powder
2 tablespoons olive oil	1 tablespoon coarse sea salt
2 garlic cloves, crushed	$^1/_4$ cup/$^1/_2$ oz/15 g coarsely chopped
1 dried bay leaf, crumbled	cilantro

1 Rinse the scallops under cold running water and dry with paper towel. Lay the scallops in a single layer in a shallow dish.

2 Whisk the lime juice and oil together. Stir in the garlic, bay leaf, cumin, and chili powder, then pour this marinade over the scallops and toss gently. Cover and marinate for 15 minutes, turning the scallops over once.

3 Cook the scallops on a well-oiled medium-hot grill for 2 minutes on each side. They should be white and firm, but not hard. Brush the scallops with the marinade as they cook. Transfer to a serving platter, sprinkle with salt and cilantro leaves, and serve at once.

Bloody Mary Sea Scallops

Serves **4** | Preparation **25 minutes** | Marinating **15 minutes** | Grilling **4 minutes**

2 lb/900 g jumbo sea scallops
2 tablespoons olive oil
$^1\!/_4$ cup/$^1\!/_2$ oz/15 g finely chopped
onion
1 tablespoon finely grated
fresh root ginger
1 tablespoon freshly ground
black pepper

1 teaspoon celery salt
juice of $^1\!/_2$ lime
1 cup/8 fl oz/250 ml prepared bloody
mary drinks mix
1 teaspoon coarse sea salt
$^1\!/_4$ cup/$^1\!/_2$ oz/15 g chopped cilantro

1 Rinse the scallops thoroughly under cold running water and dry with paper towel. Place in a single layer in a shallow dish.

2 Heat the oil in a sauté pan. Add the onion and ginger, and stir until the onion is translucent and tender. Add the pepper, celery salt, and lime juice, and remove from the stove. Leave to cool at room temperature. Pour this cooled mixture over the scallops and toss gently to coat them. Cover and marinate for 15 minutes.

3 Drain the scallops, reserving the marinade, and set aside. Mix the marinade with the bloody mary drink mix in the sauté pan. Bring to a boil and simmer on a low heat for 5 minutes.

4 Cook the scallops on a well-oiled, medium-hot grill for 2 minutes on each side, until opaque white and semi-firm to the touch. Transfer the scallops to a platter and sprinkle with salt.

5 Stir the cilantro into the bloody mary sauce and pour this over the scallops. Serve at once, with rice noodles and steam-grilled Asian vegetables.

fish & shellfish

Scallops in Zinfandel Marinade

Serves **4** | Preparation **15 minutes** | Marinating **15 minutes** | Grilling **4 minutes**

2 lb/900 g jumbo sea scallops
1 tablespoon coarse sea salt
¹⁄₄ cup/¹⁄₂ oz/15 g finely chopped
flat-leaf parsley

MARINADE
1 cup/8 fl oz/250 ml Zinfandel wine

2 tablespoons olive oil
¹⁄₂ teaspoon English mustard powder
3 shallots, finely chopped
1 tablespoon freshly ground
black pepper
1 teaspoon dried oregano
1 teaspoon crumbled dried rosemary

1 Rinse the scallops under cold running water and dry with paper towel. Place in a single layer in a shallow dish.

2 To make the marinade, whisk the wine, oil, and mustard together. Stir in the shallots, pepper, oregano, and rosemary. Pour the marinade over the scallops and toss gently. Cover and leave to marinate for 15 minutes.

3 Place the scallops on a well-oiled medium-hot grill. Cook for 2 minutes on each side, brushing throughout with the marinade. The scallops should be firm, but not hard, and white. Serve at once, sprinkled with the salt and parsley.

Genius Tip Use a minimal amount of oil in prepared marinades to avoid unexpected flare-ups of flames. Brush a little oil onto the surface of fish, shellfish, meat, poultry, and vegetables rather than the surface of the grill. This will reduce the amount of sticking while cooking.

Adobo Rubbed Scallops

Serves **4** | Preparation **10 minutes** | Marinating **30 minutes** | Grilling **4 minutes**

2 lb/900 g jumbo sea scallops
3 tablespoons olive oil
1 teaspoon ground cumin
1 teaspoon freshly ground
black pepper
1 teaspoon dried oregano
¹/₂ teaspoon English mustard powder

¹/₂ teaspoon chili powder
¹/₂ teaspoon ground fennel
¹/₂ teaspoon garlic powder
1 tablespoon coarse sea salt
¹/₄ cup/¹/₂ oz/15 g coarsely chopped
cilantro

1 Rinse the scallops under cold running water and dry with paper towel. Place in a single layer in a shallow dish.

2 Pour the olive oil over the scallops and toss gently until completely coated. Mix the cumin, pepper, oregano, mustard, chili powder, fennel, and garlic powder in a small bowl. Sprinkle the dry mixture over the scallops and toss them in the rub mixture until all surfaces are coated. Cover and marinate in the refrigerator for 30 minutes.

3 Place the scallops on a well-oiled medium-hot grill. Cook for 2 minutes on each side, until firm but not hard. Serve at once, sprinkled with the salt and cilantro.

Scallops in Thai Red Curry Paste

Serves **4** | Preparation **20 minutes** | Marinating **1 hour** | Grilling **4 minutes**

2 lb/900 g jumbo sea scallops
juice of 1 lime
1 tablespoon coarse sea salt
¼ cup/½ oz/15 g finely snipped chives
2 tablespoons toasted sesame seeds

MARINADE
1 cup/8 fl oz/250 ml coconut milk
1 tablespoon light sesame oil
1 tablespoon Thai red curry paste
1 tablespoon light liquid honey
2 garlic cloves, crushed
1 tablespoon finely grated fresh root ginger
3 kefir lime leaves, snipped

1 Rinse the scallops under cold running water and dry with paper towel. Place in a single layer in a shallow dish.

2 To make the marinade, whisk the coconut milk, oil, curry paste, and honey together. Add the garlic, ginger, and kefir lime leaves and stir well. Pour the marinade over the scallops and toss gently to coat them completely. Cover and refrigerate for 1 hour.

3 Place the scallops on a well-oiled medium-hot grill. Cook for 2 minutes on each side, until firm but not hard. Brush with the remaining marinade during cooking

4 Transfer to a serving platter. Squeeze the lime juice over the top and sprinkle with the salt, chives and sesame seeds. Serve at once. Basmati rice and steam-grilled Asian vegetables go well with the scallops.

Scallops with Westphalian Ham

Serves 4 | Preparation **20 minutes** | Marinating **20 minutes** | Grilling **4 minutes**

24 fresh sea scallops
coarse salt
olive oil for cooking
6 oz/175 g Westphalian ham, trimmed
of fat and cut into $^1/_4$ in/15 mm
wide strips

MARINADE
juice of 1 lemon
juice of 2 limes
1 teaspoon grated lemon zest
1 teaspoon grated lime zest

6 shallots, finely sliced
2 tablespoons olive oil

VINAIGRETTE
2 tablespoons olive oil
$1^1/_2$ teaspoons balsamic vinegar
3 tablespoons finely chopped basil
3 tablespoons finely chopped
flat-leaf parsley
3 tablespoons snipped chives
salt and freshly ground black pepper

1 Rinse the scallops in cold water and pat dry with paper towels. To make the marinade, mix the lemon and lime juice and zest in a shallow bowl. Stir in the shallots and oil. Add the scallops and turn them in the marinade. Cover with plastic wrap and leave at room temperature for 20 minutes, turning once.

2 Drain the scallops and set aside, pouring the marinade into a saucepan. Bring to the boil, then simmer over medium heat until reduced to a syrup-like consistency. Remove from the heat and whisk in the olive oil and balsamic vinegar for the vinaigrette. Stir in the basil, parsley, and chives with salt and pepper to taste.

3 Sprinkle coarse salt on both sides of the drained scallops. Cook the scallops on a medium-hot grill brushed with a little olive oil for 2 minutes on each side, until firm and opaque but not hard. Transfer to serving plates. Spoon the warm vinaigrette over the scallops and sprinkle the julienne strips of ham on top. Jasmine rice goes well with the scallops.

Curry-infused Mussels

Serves **4** | Preparation **15 minutes** | Soaking **2 hours** | Grilling **5 minutes**

2 lb/900 g mussels
1 cup/8 fl oz/250 ml dry Riesling wine
2 tablespoons butter

2 tablespoons curry powder
nan (Indian flat bread), lightly toasted, to serve

1 Soak the mussels in salted water for 2 hours to remove any sand or grit remaining in their shells. Drain and scrub. Pull out the beard or bundle of dark fine threads at the hinge of the shell (do this with your fingers). Rinse thoroughly in clean water.

2 Heat the wine, butter, and curry powder together in a small saucepan, whisking until the butter has melted. Bring to the boil, then remove the pan from the heat.

3 Place the mussels on a medium-hot grill and cook for 3 minutes. As the shells begin to open, spoon some of the curry butter into them or squirt it in with a meat baster. Cover the barbecue with its lid and cook for an additional 2 minutes. Discard any unopened shells.

4 Transfer the mussels to shallow bowls and pour any remaining curry butter over the top. Serve with lightly toasted nan to mop up the juices.

Genius Tip Open up the vents to the bottom and on the lid before covering the barbecue. Keep the vents open during the entire grilling process. This provides air circulation to enhance the burning of the coals.

Mussels with Tomato Wine Sauce

Serves **4** | Preparation **25 minutes** | Soaking **2 hours** | Grilling **5 minutes**

3 lb/1.4 kg mussels	$^1/_4$ cup/2 fl oz/60 ml dry white wine
salted water	3 sun-ripened tomatoes, skinned, seeded and diced
TOMATO WINE SAUCE	1 teaspoon coarse sea salt
2 tablespoons olive oil	1 teaspoon freshly ground black pepper
2 tablespoons lightly salted butter	
2 garlic cloves, crushed	$^1/_4$ cup/$^1/_2$ oz/15 g finely chopped flat-leaf parsley
2 shallots, finely chopped	

1 Soak the mussels in salted water for 2 hours to remove any sand or grit remaining in their shells. Drain and scrub. Pull out the beard or bundle of dark fine threads at the hinge of the shell (do this with your fingers). Rinse thoroughly in clean water.

2 To prepare the sauce, heat the olive oil and butter in a small saucepan. Add the garlic and shallot, and cook until translucent. Stir in the wine, tomatoes, salt and pepper. Bring to the boil, then reduce the heat and simmer for 5 minutes. Add the chopped parsley, stir and remove from the heat.

3 Place the mussels on a medium-hot grill and cook for 5 minutes or until the shells open. Do not turn the mussels, but leave them in place to retain their natural juices. Discard any shells that do not open.

4 Divide the mussels among four shallow bowls or deep plates. Pour the sauce over the top and serve at once. Offer plenty of lightly toasted baguette to soak up the sauce.

fish & shellfish

chapter 2

poultry &
wild birds

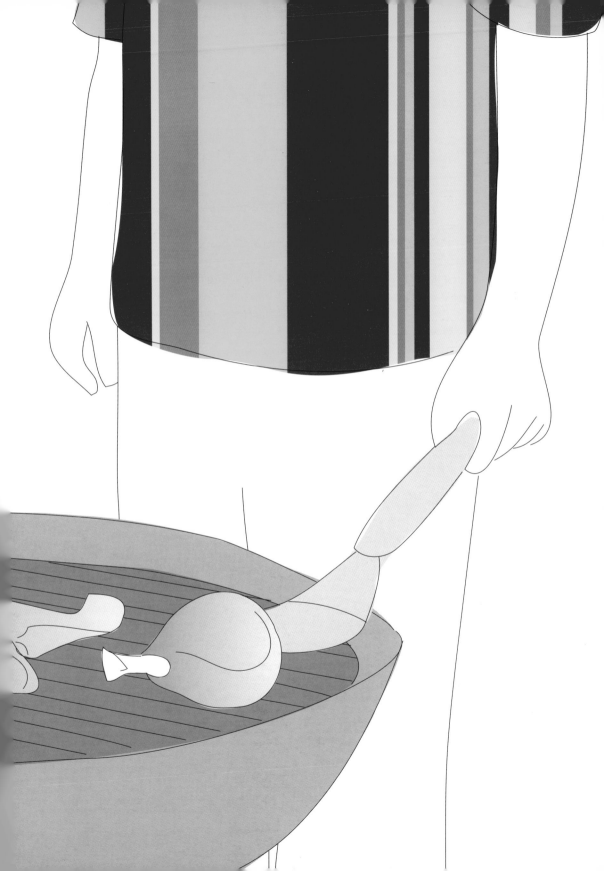

Barbecued Cilantro Chicken

Serves **4** | Preparation **15 minutes** | Marinating **24 hours** | Grilling **21–26 minutes**

1 x 4 lb/1.8 kg chicken
$^1/_2$ **cup/4 fl oz/125 ml olive oil**
$^1/_2$ **cup/4 fl oz/125 ml apple cider**
vinegar
$^1/_2$ **cup/4 fl oz/125 ml dry sherry**
1$^1/_2$ **cups/3 oz/75 g cilantro leaves**
and stems
6 garlic cloves, coarsely chopped
1 onion, cut into chunks

3 bay leaves
1 tablespoon coarse sea salt
1 tablespoon freshly ground
black pepper
1 tablespoon dried oregano
1 teaspoon dried marjoram
1 teaspoon ground cumin
1 teaspoon cayenne pepper

1 To prepare the chicken, wash it thoroughly under cold running water and pat dry with paper towels. Cut the chicken into four portions and cut the breast quarters in half. Cut four shallow slashes into the thick areas of meat on the legs and thigh, making these no more than $^1/_8$ in/3 mm deep. Place the chicken pieces into a shallow dish.

2 Purée all the remaining ingredients in a food processor until smooth. Set aside $^1/_4$ cup/4 fl oz/125 ml of the mixture in a covered container in the refrigerator for glazing the chicken. Pour the remaining purée over the chicken pieces and rub it into the pieces, especially the cuts. Cover and refrigerate for 24 hours.

3 To cook the chicken, place the pieces on a well-oiled, medium-hot grill. Sear the pieces on both sides for 6 minutes, until the skin is browned. Move the pieces to the edge of the barbecue, where the heat is not as fierce, and cook for a further 15–20 minutes, until well browned and cooked through. Brush with the reserved marinade throughout the grilling process. Serve at once.

KC Rubbed Chicken

Serves **4** | Preparation **11 minutes** | Rub Marinating **2 hours** | Grilling **20–25 minutes**

2 x 3 lb/1.4 kg chickens, each cut into 8 pieces	**3 tablespoons celery salt**
	1 tablespoon garlic powder
	1 tablespoon onion powder
SPICE RUB	**1 tablespoon chili powder**
3 tablespoons soft light brown sugar	**1 teaspoon ground ginger**
3 tablespoons light molasses	**1 teaspoon ground cloves**
3 tablespoons paprika	**1 teaspoon ground white pepper**

1 Rinse the chicken pieces thoroughly under cold running water. Pat the pieces dry with a towel. Make three 3 in/7.5 cm long diagonal cuts into the thick thigh portions and the thick end of the drumsticks.

2 To make the rub, mix the sugar into the molasses until it has dissolved. Add the paprika, celery salt, garlic powder, onion powder, chili powder, ground ginger, ground cloves, and white pepper, and mix into a thick paste.

3 Rub the paste into the chicken pieces, massaging it into the cuts in the drumstick and thigh meat. Place in a dish or self-sealing plastic bag and set in the refrigerator for 2 hours.

4 Cook the chicken on a medium-hot, well-oiled grill. Cook the thighs and drumsticks for 2 minutes and then add the breasts and wings. Continue to cook for 8 minutes. Turn the pieces and cook for a further 10–15 minutes, until all the chicken pieces are cooked through and well browned. Turn the drumsticks frequently during cooking so that they cook evenly.

5 Serve the chicken on a large platter. Creamy coleslaw, baking powder biscuits, and honey are the classic accompaniments.

Stout-marinated Chicken

Serves **4** | Preparation **15 minutes** | Marinating **24 hours** | Grilling **20–25 minutes**

1 x 4 lb/1.8 kg chicken, quartered
5 garlic cloves, crushed
1 tablespoon coarse sea salt
$^{1}/_{4}$ cup/$^{1}/_{2}$ oz/15 g chopped parsley

MARINADE
2 cups/16 fl oz/475 ml dark stout
$^{1}/_{4}$ cup/2 fl oz/ 60 ml olive oil
3 tablespoons honey mustard
2 tablespoons light liquid molasses
1 tablespoon chili powder
3 bay leaves, crumbled

1 Rinse the chicken the pieces under cold running water and pat dry with paper towels. Using poultry shears or a heavy knife, cut the breast portions in half. Score the thick meat on the leg and thigh portions with 2 in/5 cm long slashes that penetrate no deeper than $^{1}/_{8}$ in/3 mm into the flesh.

2 Rub the garlic all over the chicken and into the cuts. Then lay the chicken portions in a shallow dish.

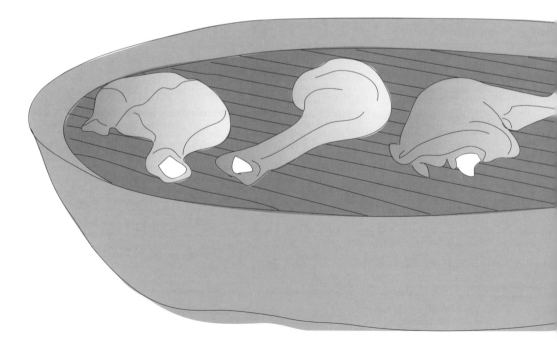

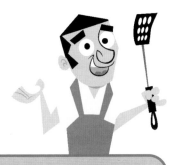

3 To make the marinade, whisk the stout, oil, mustard, and molasses together in a small bowl. Stir in the chili powder and bay leaves, and pour the marinade over the chicken and rub it into the pieces. Cover and refrigerate for 24 hours, turning several times.

4 Drain the chicken and pour the marinade into a saucepan. Bring to the boil, reduce the heat, and simmer for 5 minutes. Remove from the stove and use for brushing the chicken during cooking.

5 Place the chicken on a well-oiled, medium-hot grill and cook for 6 minutes, brushing with the reduced marinade and turning to brown the portions all over. Move the chicken to the edge of the grill, where the heat is not as fierce, and cook for a further 14–19 minutes. Continue brushing with the leftover marinade to keep the chicken moist. The skin should be crisp and dark brown, and the meat cooked through.

6 Transfer the chicken to a serving platter. Sprinkle with the salt and parsley, and serve freshly cooked. A potato salad goes well with the grilled chicken.

Mixed-herb Chicken Breasts

Serves **4** | Preparation **16 minutes** | Marinating **1¹/₂ hours** | Grilling **14–16 minutes**

4 x 8 oz/225 g skinless and boneless chicken breasts

MARINADE
4 tablespoons olive oil
1 teaspoon English mustard powder
¹/₄ cup/¹/₂ oz/15 g each of finely chopped fresh flat-leaf parsley, sage, rosemary, and thyme leaves

3 garlic cloves, crushed
2 tablespoons grated lemon zest
2 tablespoons coarse sea salt
2 tablespoons freshly ground black pepper
juice of ¹/₂ lemon to serve

1 Rinse the chicken thoroughly under cold running water. Pat the pieces dry with a towel and place them in a shallow dish.

2 To make the marinade, whisk the olive oil and mustard in a mixing bowl to make a paste. Stir in the fresh herbs and garlic. Mash the ingredients together and then mix in the lemon zest, salt, and pepper. Rub this paste all over the chicken. Cover the dish and refrigerate for 1¹/₂ hours.

3 Cook the chicken on a medium-hot, well-oiled grill for 7–8 minutes on each side, until evenly browned and cooked through. Transfer to a serving platter and squeeze some lemon juice over.

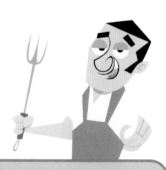

Genius Tip When preparing your barbecue, light the briquettes in corners furthest away from you first. Wait for 25 minutes or until the embers glow and a gray ash has formed over the majority of the surface. The coals should be at their hottest temperature at this point.

Peppered Ground Chicken Kabobs

Serves **4** | Preparation **20 minutes** | Marinating **30 minutes** | Grilling **8 minutes**

$1^1/_2$ lb/675 g boneless and skinless chicken breasts
3 garlic cloves
1 yellow onion, coarsely chopped
1 red chili pepper, seeded and coarsely chopped
1 jalapeño pepper, seeded and coarsely chopped

1 tablespoon coarse sea salt
1 teaspoon ground cumin
$1/_2$ teaspoon paprika
$1/_2$ teaspoon white pepper
$1/_2$ teaspoon turmeric
$1/_4$ cup/$1/_2$ oz/15 g finely chopped fresh flat-leaf parsley
$1/_4$ cup/2 fl oz/60 ml olive oil

1 Rinse the chicken under cold running water, then dry it on paper towels. Cut each chicken breast into four pieces and place in a food processor. Add the garlic, onion, chili and jalapeño peppers, salt, cumin, paprika, pepper, and turmeric. Pulse until the ingredients are coarsely ground and well mixed. Do not over-process the mixture.

2 Transfer the mixture to a bowl and add the parsley. Knead the mixture by hand, working in the parsley and ensuring that the ingredients are well bound. Roll the mixture into a ball, place in a bowl, cover, and refrigerate for 30 minutes.

3 To make the kabobs, brush eight metal skewers with oil. Divide the mixture into eight portions. Roll a portion of the mixture around a skewer into a sausage shape measuring about 10 in/23 cm long and 1 in/2.5 cm thick. Brush the kabobs with oil.

4 To grill the kabobs, place the skewers on a well-oiled, medium-hot grill. Cook for a total of 8 minutes, brushing with the remaining oil and turning frequently. Move the skewers to the edge of the grill if they brown too fast.

Coconut Chicken Sate

Serves **4** | Preparation **28 minutes** | Marinating **1½ hours** | Grilling **4 minutes**

1½ lb/675 g skinless and boneless chicken breasts
1 teaspoon coarse sea salt
½ cup/2 oz/50 g chopped salted peanuts
½ cup/1 oz/25 g coarsely chopped cilantro leaves

MARINADE
2 cups/16 fl oz/475 ml coconut milk
3 tablespoons peanut oil
3 tablespoons smooth peanut butter

3 tablespoons ketjap manis (Indonesian sweet soy sauce)
juice of 1 lime
½ cup/1 oz/25 g chopped fresh cilantro stems
3 garlic cloves, sliced
1 small red chili pepper, seeded and chopped
1 tablespoon sliced fresh root ginger
6 kefir lime leaves, crumbled
bamboo skewers, soaked in cold water for 1 hour

1 Rinse the chicken under cold running water and pat dry with paper towels. Slice the raw chicken into thin strips measuring 4 in/10 cm long and ½ in/1 cm wide. Thread the chicken lengthwise onto the drained bamboo skewers. Set the skewers in a shallow dish.

2 To make the marinade, purée the coconut milk, peanut oil, peanut butter, ketjap manis, lime juice, cilantro stems, garlic, chili, ginger, and kefir lime leaves to a smooth paste. Spoon half the paste over the chicken and rub it in with your hands. Cover and refrigerate for 1½ hours. Reserve the remaining mixture in a covered bowl.

3 Cook the chicken on a well-oiled, medium-hot grill for 2 minutes on either side or until the strips are well browned and cooked. Brush continuously with any leftover marinade. Use some of the reserved sauce to baste the chicken, spooning it into a separate dish to avoid contaminating it with juices on the brush from the raw chicken.

4 Transfer the leftover sauce to a small bowl and place it in the middle of a serving platter. Fan the chicken sate around the bowl and sprinkle with salt, peanuts and chopped cilantro leaves.

Afghani Coriander Chicken

Serves **4** | Preparation **21 minutes** | Marinating **2 hours** | Grilling **10–14 minutes**

4 x 6 oz/175 g skinless and boneless chicken breasts
1 tablespoon coarse sea salt
¹/₂ cup/1 oz/25 g finely chopped cilantro

MARINADE
3 tablespoons peanut oil
1 tablespoon light molasses

juice of ¹/₂ lime
1 tablespoon tamarind paste
3 garlic cloves, sliced
1 tablespoon minced or finely chopped fresh root ginger
1 red chili pepper, seeded and chopped
1 tablespoon ground coriander
1 teaspoon ground cumin

1 Rinse the chicken thoroughly under cold running water and pat dry with paper towels, then place the breasts in a shallow dish.

2 To make the marinade, combine the peanut oil, molasses, lime juice, tamarind paste, garlic, ginger, chili, coriander, and cumin in a food processor and pulse into a rough paste. Spoon the paste over the chicken and rub it into the surface thoroughly with your hands. Cover and refrigerate for 2 hours. Turn the chicken twice during marinating.

3 Cook the chicken on a medium-hot, well-oiled grill for 5–7 minutes on each side or until cooked through. Serve sprinkled with the salt and cilantro.

Genius Tip The strips of chicken should be thin and threaded on the skewers with plenty of space, in loose pleats, so that they cook quickly. If the strips are slightly thick in places or threaded closely on the skewers, allow an extra 1–2 minutes cooking time on each side.

Grilled Chicken Fajita

Serves 4 | Preparation **14 minutes** | Marinating **1 hour** | Grilling **10 minutes**

4 x 7 oz/200 g skinless and boneless chicken breasts
16 small soft flour tortillas (about 7 in/18 cm diameter)
1 tablespoon coarse sea salt
¹⁄₂ cup/1 oz/25 g coarsely chopped cilantro
1 lime, halved
1 cup/8 fl oz/250 ml sour cream

MARINADE
1 tablespoon molasses
1 tablespoon corn oil
juice of 2 limes
4 garlic cloves, crushed
1 tablespoon chili powder
1 teaspoon ground cumin
1 teaspoon ground coriander
¹⁄₄ teaspoon ground cinnamon

1 Rinse the chicken under cold running water and pat dry with paper towels. Place the breasts in a shallow dish.

2 For the marinade, whisk the molasses, oil and lime juice together. Stir in the garlic, chili powder, cumin, coriander, and cinnamon, then spoon the mixture over the chicken and rub it in thoroughly by hand. Cover the dish and refrigerate for 1 hour.

3 Cook the chicken on a medium-hot, well-oiled grill for about 6–7 minutes on each side. The chicken should be charred outside and cooked through. Transfer the chicken to a board and leave to rest for 5 minutes before serving.

4 Warm the tortillas on the grill, allowing about 20 seconds on each side. Slice each chicken breast lengthwise and diagonally into four pieces. Arrange the chicken pieces on a platter, sprinkle with the salt and cilantro, and squeeze the juice from the lime over the top. Serve at once, with the warmed tortillas and sour cream.

Barbecued Sherry Chicken

Serves **4** | Preparation **14 minutes** | Marinating **2 hours** | Grilling **16–20 minutes**

4 x 8 oz/225 g boneless and skinless chicken breasts

MARINADE
$^1/_2$ **cup/4 fl oz/125 ml olive oil**
$^1/_2$ **cup/4 fl oz/125 ml cream sherry**
$^1/_4$ **cup/$^1/_2$ oz/15 g fresh thyme leaves**
1 small onion, finely grated
1 tablespoon coarse sea salt
1 tablespoon freshly ground black pepper
$^1/_4$ **teaspoon cayenne pepper**

TOPPING
$^1/_4$ **cup/$^1/_2$ oz/15 g coarsely chopped green olives**
$^1/_4$ **cup/$^1/_2$ oz/15 g coarsely chopped ripe olives**
$^1/_4$ **cup/$^1/_2$ oz/15 g finely chopped flat-leaf parsley**
1 garlic clove, crushed
1 teaspoon capers
$^1/_4$ **teaspoon cayenne pepper**
1 tablespoon extra virgin olive oil
1 teaspoon lemon juice

1 Rinse the chicken thoroughly under cold running water and pat dry with paper towels. Place the chicken in a single layer in a shallow dish.

2 To make the marinade, whisk the oil and sherry together. Stir in the thyme, onion, salt, pepper, and cayenne. Pour the marinade over the chicken and turn the pieces to coat them thoroughly. Cover and refrigerate for 4 hours.

3 To make the topping, mix the green and ripe olives, parsley, garlic, capers, cayenne, oil, and lemon juice in a small bowl. Stir until well mixed, cover, and leave at room temperature while the chicken is marinating.

4 Drain the chicken and pour the marinade into a small saucepan. Bring to a boil, reduce the heat and simmer for 5 minutes. Remove from the heat and reserve for brushing over the chicken during cooking.

5 To cook the chicken, place on a well-oiled, medium-hot grill. Cook for 8–10 minutes on each side until well browned and cooked through. Brush with the reduced marinade up until the last 3 minutes of cooking time. Transfer the chicken to plates and divide the chopped olive mixture among the portions.

Grilled Chicken in Dried Fruit Sauce

Serves **4** | Preparation **30 minutes** | Marinating **2 hours** | Grilling **14–18 minutes**

4 x 8 oz/225 g boneless and skinless chicken breasts
1 teaspoon coarse sea salt
$^1/_4$ cup/$^1/_2$ oz/15 g finely chopped flat-leaf parsley

MARINADE
3 garlic cloves, crushed
1 teaspoon salt
1 teaspoon freshly ground black pepper
1 teaspoon ground cloves
$^1/_4$ cup/1 oz/25 g finely chopped celery
$^1/_4$ cup/1 oz/25 g finely grated carrot

1 small onion, finely grated
1 cup dry white wine
$^1/_2$ cup/4 fl oz/125 ml apple cider vinegar

FRUIT SAUCE
1 cup/4 oz/100 g finely chopped mixed pitted prunes, dates and yellow raisins, soaked in hot water for 1 hour
2 tablespoons lightly salted butter
$^1/_4$ cup/2 fl oz/60 ml tomato sauce
juice of 2 oranges
1 teaspoon coarse sea salt
$^1/_4$ cup/2 fl oz/60 ml heavy cream

1 Rinse the chicken thoroughly under cold running water and pat dry with paper towels. Lay the pieces in a single layer in a shallow dish.

2 To make the marinade, stir the garlic, salt, pepper, ground cloves, celery, carrot, and onion together until mixed. Gradually stir in the wine and vinegar to make a coarse thick paste. Pour over the chicken breasts, cover, and refrigerate for 2 hours.

3 To make the sauce, drain the dried fruit. Melt the butter in a small saucepan and add the fruit. Cook over a medium heat for 4 minutes. Add the tomato sauce, orange juice, and salt, and simmer for 10 minutes, until the fruit has absorbed the liquid. Remove from the heat. Whisk the cream into the sauce while it is still warm just before serving the sauce.

4 Drain the chicken and cook on a well-oiled, medium-hot grill for 7–9 minutes on each side until well-browned and cooked through. Transfer to a cutting board and sprinkle with salt. If necessary, cover loosely with foil until the sauce is complete. Slice each chicken breast at a slant into three pieces. Transfer to individual plates and spoon the sauce over the top. Sprinkle with the chopped parsley and serve.

Savory Grilled Chicken Breasts

Serves **4** | Preparation **15 minutes** | Marinating **2 hours** | Grilling **14–18 minutes**

4 x 8 oz/225 g boneless and skinless chicken breasts
1 teaspoon coarse sea salt
¹⁄₄ cup/¹⁄₂ oz/15 g finely chopped fresh mint

MARINADE
1 small onion, finely grated
¹⁄₄ cup/¹⁄₂ oz/15 g finely chopped fresh mint
1 teaspoon dried savory
1 teaspoon freshly ground black pepper
¹⁄₂ teaspoon ground coriander
¹⁄₂ teaspoon garlic powder
3 tablespoons olive oil
2 tablespoons apple cider vinegar

1 Rinse the chicken thoroughly under cold running water and pat dry with paper towels. Place in a shallow dish.

2 To make the marinade, mix the onion with the mint, savory, pepper, coriander, garlic powder, oil, and vinegar to make a coarse paste. Rub this over the chicken breasts with your hands, cover and refrigerate for 2 hours.

3 To cook the chicken, place the pieces on a well-oiled medium-hot grill. Cook for 7–9 minutes on each side, until browned and cooked through. Transfer the pieces to plates. Sprinkle with salt and fresh mint. New potatoes and steam-grilled baby carrots are good accompaniments for the chicken.

Genius Tip Always use heat-resistant mitts or gloves and long-handled tools when barbecuing to ensure that your hands are kept well away from the flames.

Grilled Chicken Madeira

Serves **4** | Preparation **15 minutes** | Marinating **2 hours** | Grilling **14–18 minutes**

4 x 8 oz/225 g boneless and skinless
chicken breasts
1 teaspoon coarse sea salt
$^1/_4$ cup/$^1/_2$ oz/15 g finely chopped
flat-leaf parsley

MARINADE
2 garlic cloves, crushed and then
chopped with 1 teaspoon coarse
sea salt

1 small onion, finely chopped
2 tablespoons olive oil
1 carrot, finely grated
2 dried bay leaves, crumbled
2 tablespoons finely chopped
flat-leaf parsley
1 tablespoon freshly ground
black pepper
$^1/_2$ cup/4 fl oz/125 ml Madeira wine
3 tablespoons white wine vinegar

1 Rinse the chicken thoroughly under cold running water and pat dry with paper towels. Place in a shallow dish.

2 To make the marinade, sauté the garlic and onion in the olive oil until tender and translucent. Transfer to a bowl and add the carrot, bay leaves, parsley, pepper, Madeira, and vinegar. Pour this mixture over the chicken and rub it into the pieces. Cover and refrigerate for 2 hours.

3 Drain the marinade from the chicken and return the reserved marinade to a saucepan. Bring to a boil and simmer for 5 minutes to reduce. Place the chicken on a well-oiled, medium-hot grill. Cook for 7–9 minutes on each side, basting with the re-heated marinade intermittently, until well browned and cooked through. Transfer to plates and sprinkle with salt and parsley.

Chili Chicken with Guacamole

Serves **4** | Preparation **25 minutes** | Marinating **1 hour** | Grilling **14–18 minutes**

**4 x 8 oz/225 g boneless and skinless
chicken breasts**
1 teaspoon coarse sea salt

WET PASTE
juice of 1 lime
2 garlic cloves, crushed
1 teaspoon coarse sea salt
**1 chipotle chili pepper, seeded and
finely chopped**
¹/₂ teaspoon chili powder
¹/₂ teaspoon of ground cumin
¹/₂ teaspoon ground coriander

GUACAMOLE
**2 ripe avocados, pitted, peeled
and diced**
juice of ¹/₂ lime
1 sweet red onion, finely chopped
**1 red chili pepper, seeded and
finely chopped**
**¹/₂ cup/1 oz/25 g coarsely chopped
cilantro**
1 teaspoon coarse sea salt
¹/₂ teaspoon ground cumin

1 Rinse the chicken thoroughly under cold running water and pat dry with paper towels. Place in a shallow dish.

2 To make the wet paste, mix the lime juice, garlic, salt, chipotle chili, chili powder, cumin, and coriander in a small bowl. Rub this wet paste over the chicken, cover and refrigerate for 1 hour.

3 To make the guacamole, combine all the ingredients together in a bowl. Use a fork to mash some of the diced avocado, but leave the mixture chunky. Cover closely with plastic wrap and refrigerate until ready to serve. Bring the guacamole to room temperature for about 20 minutes before serving.

4 To cook the chicken, place the pieces on a well-oiled, medium-hot grill. Cook for 7–9 minutes on each side until the chicken is cooked through and browned. Transfer the chicken to plates and spoon some guacamole over the top of each portion. Serve at once.

Chicken with Barbecue Sauce

Serves **4** | Preparation **25 minutes** | Marinating **30 minutes** | Grilling **14–18 minutes**

4 x 8 oz/225 g boneless and skinless chicken breasts
2 tablespoons finely chopped fresh tarragon

DRY RUB
1 teaspoon soft brown sugar
$^1/_2$ teaspoon coarse sea salt
$^1/_2$ teaspoon freshly ground black pepper
$^1/_2$ teaspoon paprika
$^1/_4$ teaspoon onion powder
$^1/_4$ teaspoon garlic powder

BARBECUE SAUCE
2 tablespoons olive oil
4 tablespoons English mustard powder
$^1/_4$ cup/2 fl oz/60 ml dry white wine
2 tablespoons light liquid honey
2 tablespoons finely chopped fresh tarragon
1 teaspoon coarse sea salt
$^1/_2$ teaspoon chili powder
1 teaspoon freshly ground black pepper

1 Rinse the chicken thoroughly under cold running water and pat dry with paper towels. Place in a shallow dish.

2 To make the rub, combine the sugar, salt, pepper, paprika, onion, and garlic powders, and mix with your fingers. Spread the dry rub over the chicken with your hands. Cover and refrigerate for 30 minutes.

3 To make the barbecue sauce, whisk the oil, mustard, wine, and honey together until the liquid is slightly thickened. Stir in the tarragon, salt, chili powder, and pepper. Pour half the sauce over the chicken and turn to coat the pieces on all sides evenly.

4 Cook the chicken on a well-oiled, medium-hot grill. Cook for 7–9 minutes on each side, continuously brushing the chicken with the remaining sauce. The chicken should be well browned and cooked through. Serve at once, sprinkled with chopped tarragon. Grilled fennel and tomatoes go well with the chicken.

Sweet Soy Barbecue Chicken

Serves **4** | Preparation **25 minutes** | Marinating **30 minutes** | Grilling **14–18 minutes**

4 x 8 oz/225 g boneless and skinless chicken breasts
2 green onions, finely chopped
2 tablespoons toasted sesame seeds

DRY RUB
1 tablespoon Chinese five-spice powder
1 teaspoon soft brown sugar
1/2 teaspoon coarse sea salt
1/4 teaspoon cayenne pepper

BARBECUE SAUCE
1/4 cup/2 fl oz/60 ml soy sauce
1/4 cup/2 fl oz/60 ml medium-dry sherry
juice of 1/2 lemon
4 tablespoons soft brown sugar
1 tablespoon finely minced or chopped fresh root ginger
2 tablespoons sesame oil
2 tablespoons canola oil

1 Rinse the chicken thoroughly under cold running water and pat dry with paper towels. Lay the pieces in a shallow dish.

2 For the dry rub, mix the five-spice powder, sugar, salt, and cayenne together with your fingers and then rub the mixture over the chicken breasts. Cover and refrigerate for 30 minutes.

3 To make the barbecue sauce, combine the soy sauce, sherry, lemon juice, sugar, and ginger in a small saucepan. Stir until the sugar has dissolved, then simmer for 5 minutes over a medium heat or until the sauce begins to thicken. Stir to prevent the sauce from burning on the pan. Remove from the stove and whisk the oils into the sauce.

4 To cook the chicken, brush the sauce over the top and turn the pieces over onto a well-oiled, medium-hot grill. Cook for 7–9 minutes on each side, brushing often with sauce, until the chicken is well browned and cooked through.

5 Transfer the chicken pieces to individual plates and sprinkle onion and sesame seeds over the top. Jasmine rice and steam-grilled Asian vegetables are suitable accompaniments.

poultry & wild birds

Yankee Barbecue Chicken

Serves **4** | Preparation **45 minutes** | Marinating **30 minutes** | Grilling **14–18 minutes**

4 x 8 oz/225 g boneless and skinless chicken breasts	**BARBECUE SAUCE**
	2 tablespoons canola oil
	1 onion, finely chopped
DRY RUB	**12 oz/350 g can chopped tomatoes**
1 teaspoon coarse sea salt	**1 tablespoon tomato paste**
¹/₂ teaspoon celery salt	**3 garlic cloves, crushed**
¹/₂ teaspoon onion powder	**4 tablespoons soft brown sugar**
¹/₂ teaspoon garlic powder	**2 tablespoons Worcestershire sauce**
¹/₂ teaspoon chili powder	**1 teaspoon celery salt**
	1 teaspoon chili powder

1 Rinse the chicken thoroughly under cold running water and pat dry with paper towels. Place flat in a shallow dish.

2 Mix the sea and celery salts, and onion, garlic, and chili powders together with your fingers. Then rub the mixture over the chicken pieces. Cover and refrigerate for 30 minutes.

3 To make the sauce, heat the oil and cook the onion for 5 minutes, until soft but not browned. Stir in the canned tomatoes, tomato paste, garlic, sugar, Worcestershire sauce, salt, and chili powder. Bring to the boil, then reduce the heat and simmer for 30 minutes or until the sauce is thickened. Remove from the heat and reserve for glazing the chicken while grilling.

4 To cook the chicken, brush the sauce over one surface of each chicken breast and place face down on a well-oiled, medium-hot grill. Cook for 7–9 minutes on each side, brushing often with the sauce. The chicken should be well browned and cooked through. Serve at once, with any remaining sauce.

Tarragon-mustard Chicken

Serves **4** | Preparation **10 minutes** | Marinating **4 hours** | Grilling **16–20 minutes**

4 x 8 oz/225 g boneless and skinless chicken breasts
$^1/_2$ teaspoon chili powder
1 teaspoon coarse sea salt
1 teaspoon freshly ground black pepper

MARINADE
$^1/_2$ cup/4 fl oz/125 ml olive oil
2 tablespoons Dijon mustard
1 tablespoon light liquid honey
1 tablespoon apple cider vinegar
2 garlic cloves, crushed
$^1/_2$ cup/1 oz/25 g coarsely chopped fresh tarragon

1 Rinse the chicken thoroughly under cold running water and pat dry with paper towels. Lay the breasts flat in a shallow dish

2 To make the marinade, whisk the oil mustard, honey, and vinegar together. Stir in the garlic and tarragon to make a thick coarse paste. Smear the marinade all over the chicken. Cover and refrigerate for 4 hours, turning the chicken three times.

3 To cook the chicken, sprinkle with the chili powder and place on a well-oiled, medium-hot grill. Cook for 8–10 minutes on each side until well browned and cooked through. Serve at once, sprinkled with the salt and pepper.

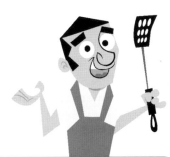

Genius Tip Use a minimal amount of oil in prepared marinades to avoid unexpected flare-ups of flames. Brush a little oil onto the surface of poultry, fish, meat, and vegetables rather than the surface of the grill. This will reduce the amount of sticking while cooking.

poultry & wild birds

Chicken, Bacon & Prune Kabobs

Serves **4** | Preparation **16 minutes** | Marinating **30 minutes** | Grilling **12 minutes**

2 lb/900 g boneless and skinless
chicken breasts
16 prunes, pitted
8 oz/225 g lean thin smoked
bacon slices
1 teaspoon coarse sea salt

MARINADE
$^1/_4$ cup/2 fl oz/60 ml olive oil
juice of $^1/_2$ lemon
1 tablespoon dried sage
1 teaspoon chili powder
1 teaspoon freshly ground
black pepper

1 Rinse the chicken under cold running water, then dry on paper towels. Cut the chicken into chunks measuring about 2 in/5 cm square. Place in a shallow dish, so that the chunks are in a single layer.

2 For the marinade, whisk the oil, lemon juice, sage, chili powder, and pepper together and pour this over the chicken. Toss the meat in the marinade until all the pieces are coated. Cover and refrigerate for 30 minutes.

3 Cut the bacon slices into 4 in/10 cm pieces. Wrap a piece of bacon around each chicken chunk and thread on long metal skewers. Thread a prune on the skewers after every two pieces of chicken.

4 To grill the kabobs, place the skewers on a medium-hot grill and cook for 3 minutes on each side, making 12 minutes total, until the bacon is browned and the chicken chunks are cooked through. Brush with the leftover marinade during cooking up until the last 3 minutes or when turning the skewers for the last time. Serve at once.

Grilled Chicken Frango

Serves **4** | Preparation **20 minutes** | Marinating **2 hours** | Grilling **16–18 minutes**

4 x 8 oz/225 g boneless and skinless chicken breasts
4 oz/125 g can pâté de fois gras, cut into 4 slices
$^{1}/_{2}$ cup/1$^{1}/_{2}$ oz/100 g grated Parmesan cheese
1 lb/450 g ripe tomatoes, peeled, seeded and finely chopped
mesclun or arugula, dressed with a little vinaigrette, to garnish

BRINE
1 cup/8 fl oz/250 ml hot water
juice of 1 lemon
1 tablespoon soft brown sugar
1 tablespoon Dijon mustard
1 small onion, finely grated
$^{1}/_{4}$ cup/2 oz/50 g coarse sea salt
8 whole black peppercorns
3 dried bay leaves, crumbled
$^{1}/_{2}$ red chili pepper, seeded and finely minced or chopped
1 cup/8 fl oz/250 ml cold water

1 To prepare the chicken, rinse under cold running water and pat dry with paper towels. Place in a dish.

2 To make the brine, mix the hot water, lemon juice, sugar, and mustard in a bowl and stir until the sugar has dissolved. Add the mustard, onion, salt, peppercorns, bay leaves, and chili, then stir in the cold water. Pour the brine over the chicken. Cover and refrigerate for 2 hours.

3 Drain the chicken and place on a well-oiled, medium-hot grill. Cook for 8 minutes and then turn the chicken. Place a slice of pâté on each chicken breast and sprinkle with the Parmesan cheese. Cook for an additional 8–10 minutes, until the chicken is cooked through and the cheese has melted slightly.

4 Divide the finely chopped tomatoes among four plates, spreading them in neat puddles. Top with the freshly cooked chicken and garnish with mesclun or arugula dressed with a little vinaigrette.

poultry & wild birds

Grilled Chicken Margarida

Serves **4** | Preparation **20 minutes** | Marinating **2 hours** | Grilling **16–18 minutes**

4 x 8 oz/225 g skinless and boneless chicken breasts	MARINADE
2 tablespoons olive oil	**2 garlic cloves, crushed and then chopped with 1 teaspoon coarse sea salt**
1 teaspoon coarse sea salt	**1 onion, finely grated**
1 teaspoon freshly ground black pepper	**1 cup dry white wine**
	juice of $^1\!/_2$ lemon
	1 teaspoon dried marjoram
	1 teaspoon coriander seeds

1 Rinse the chicken thoroughly under cold running water and pat dry with paper towels. Place in a shallow dish.

2 To make the marinade, combine the garlic, onion, wine, lemon, marjoram, and coriander. Pour this over the chicken. Cover and refrigerate for 2 hours, turning the chicken twice.

3 Drain the chicken and brush the pieces with oil. Place on a well-oiled, medium-hot grill and cook for 8–9 minutes on each side. Transfer to plates and sprinkle with the salt and pepper. Serve at once. Rice and a moist vegetable dish, such as ratatouille, are good accompaniments.

Genius Tip If your barbecue does not have a built in shelf, a small waist high table is advised to provide extra workspace. Ideally you should have all of the ingredients and utensils available at your fingertips. One exception is the food, which requires refrigeration up until the last minute.

Chicken with Pistachio Basil Pesto

Serves **4** | Preparation **15 minutes** | Marinating **4 hours** | Grilling **16 minutes**

4 x 8 oz/225 g boneless and skinless chicken breasts
1 teaspoon chili powder
a little lemon juice to serve

PISTACHIO BASIL PESTO
1 cup/8 fl oz/250 ml olive oil
finely grated zest and juice of 1 lemon

5 garlic cloves
1 tablespoon coarse sea salt
1 tablespoon freshly ground black pepper
¹/₂ cup/2 oz/50 g shelled pistachio nuts
¹/₄ cup/1 oz/25 g grated Parmesan cheese
¹/₂ cup/1 oz/25 g fresh basil leaves

1 To prepare the chicken, rinse thoroughly under cold running water, pat dry with paper towels and place in a shallow dish.

2 To make the pesto, combine the oil, lemon zest and juice, garlic, salt, pepper, nuts, Parmesan, and basil in a food processor. Pulse the power until the mixture is reduced to an even, but coarse, paste. Reserve half for glazing the chicken while grilling. Spread the remainder over the chicken breasts. Cover and refrigerate for 4 hours.

3 To cook the chicken, sprinkle chili powder on both sides of each breast and place on a well-oiled, medium-hot grill. Cook for 8–10 minutes on each side, brushing continuously with the reserved pesto. When cooked, the chicken should be crumbly, crisp, and well browned outside and cooked through. Transfer to a serving platter and squeeze a little lemon over the chicken. Serve at once.

Grilled Chicken & Bacon Melt

Serves **4** | Preparation **20 minutes** | Marinating **2 hours** | Grilling **14–18 minutes**

4 x 8 oz/225 g boneless and skinless chicken breasts
6 thin bacon slices
4 x 1 oz slices of Gruyére cheese

MARINADE
1 teaspoon coarse sea salt
1 tablespoon freshly ground black pepper
2 tablespoons coarsely chopped flat-leaf parsley
1 onion, finely grated
$1/4$ cup/2 fl oz/60 ml apple cider vinegar
$1/4$ cup/2 fl oz/60 ml water

1 Rinse the chicken thoroughly under cold running water. Pat dry on paper towels and lay flat in a shallow dish.

2 Mix the salt, pepper, parsley, onion, vinegar, and water for the marinade, and pour this over the chicken. Cover and refrigerate for 2 hours. Turn the chicken twice during marinating.

3 Cut the bacon slices across in half and cook in a dry skillet over low to medium heat until the fat runs. Continue to cook until the bacon is well cooked but not hard. Transfer the bacon to a paper towel and drain. Reserve the rendered fat in the pan.

4 To cook the chicken, brush one side of each breast with reserved bacon fat and place face down on a medium-hot grill. Cook for 7–9 minutes. Brush the top with bacon fat and turn the chicken. Place three pieces of bacon on each piece of chicken and top with a slice of cheese. Continue cooking for a further 7–9 minutes, until the chicken is cooked through and the cheese has melted.

5 Transfer the chicken to individual plates and serve at once. A salad of avocado and pink grapefruit segments goes well with the chicken.

Spiced-buttermilk Chicken Breasts

Serves **4** | Preparation **15 minutes** | Marinating **2 hours** | Grilling **14–18 minutes**

4 x 8 oz/225 g boneless and skinless chicken breasts
1 teaspoon coarse sea salt

MARINADE
2 garlic cloves, crushed and then chopped with 1 teaspoon coarse sea salt

1 onion, finely grated
1 teaspoon soft brown sugar
1 teaspoon ground cinnamon
$^1/_2$ teaspoon cayenne pepper
1 cup/8 fl oz/250 ml buttermilk
$^1/_4$ cup/2 fl oz/60 ml apple cider vinegar

1 Rinse the chicken thoroughly under cold running water and pat dry with paper towels. Place in a shallow dish.

2 To make the marinade, mix the garlic, onion, sugar, cinnamon, and cayenne in a bowl. Stir in the buttermilk and vinegar until the sugar has dissolved. Pour this over the chicken, cover, and refrigerate for 2 hours, turning the chicken twice during marinating.

3 Drain the chicken. Place on a well-oiled, medium-hot grill and cook for 7–9 minutes on each side, until browned and cooked through. Transfer to plates and sprinkle with salt. Serve freshly grilled.

Middle Eastern Spiced Yogurt Chicken

Serves **4** | Preparation **17 minutes** | Marinating **24 hours** | Grilling Time **10–14 minutes**

4 x 6 oz/175 g skinless and boneless chicken breasts	**4 garlic cloves, crushed**
2 tablespoons canola oil	**1 teaspoon ground cinnamon**
¹/₃ cup/3 fl oz/75 ml freshly squeezed orange juice	**¹/₂ teaspoon white pepper**
1 cup/8 fl oz/250 ml whole fat plain yogurt	**¹/₂ teaspoon ground cardamom**
	¹/₄ teaspoon ground allspice
	¹/₄ teaspoon ground ginger

1 Rinse the chicken thoroughly under cold running water and pat dry with paper towels. Place the chicken in a shallow dish.

2 To make the marinade, stir the oil and juice into the yogurt. Add the garlic, cinnamon, pepper, cardamom, allspice, and ginger, and stir well. Spoon the mixture over the chicken and turn the pieces until they are thoroughly coated. Cover the dish and place in the refrigerator for 24 hours. Turn twice during marinating.

3 Place the chicken on a medium-hot well-oiled grill. Cook for 5–7 minutes on either side or until cooked through, when the flesh should be white inside without any signs of blood in the juices. Serve at once.

Genius Tip Rice dressed with orange-infused oil, tossed with peas and slivered blanched almonds, is a good accompaniment for the spiced chicken.

Heggholmen Chicken Breasts

Serves **4** | Preparation **15 minutes** | Marinating **1 hour 30 minutes**
| Grilling **12–15 minutes**

¹/2 **cup/4 fl oz/125 ml ketjap manis**
(Indonesian sweet soy sauce)
¹/4 **cup/2 fl oz/60 ml freshly**
squeezed orange juice
1 tablespoon light sesame oil
1 tablespoon balsamic vinegar
5 garlic cloves, crushed
2 tablespoons finely chopped fresh
root ginger

1 teaspoon ground cumin
1 teaspoon ground coriander
¹/2 **teaspoon piri piri chili powder**
4 x 8 oz/225 g skinless and boneless
chicken breasts

TO SERVE
sea salt
chopped cilantro

1 Whisk the ketjap manis with the orange juice, sesame oil, vinegar, garlic, ginger, cumin, coriander, and chili powder in a mixing bowl.

2 Rinse the chicken thoroughly in cold running water and pat dry with paper towels. Add the chicken to the bowl and turn the fillets in the marinade so that they are completely covered. Cover the bowl and refrigerate for 1¹/2 hours. Turn three times during marinating.

3 To cook the chicken, set the fillets on a well-oiled, hot grill. Cook for 6 minutes, brush with the remaining marinade and turn the pieces. Immediately brush the cooked surface with marinade and cook for a further 6–9 minutes or until the chicken is cooked through.

4 Transfer the chicken to a serving platter, sprinkle with salt and chopped cilantro, and serve. Potato salad dressed with mayonnaise, with chopped anchovies added, goes well with the chicken.

Salty-sweet Brine Chicken Breasts

Serves **4** | Preparation **28 minutes** | Marinating **2 hours** | Grilling **12–15 minutes**

4 x 8 oz/225 g skinless and boneless chicken breasts

BRINE
¹/₄ cup/2 oz/50 g coarse sea salt
3 tablespoons light molasses
1 tablespoon light liquid honey

1 cup/8 fl oz/250 ml boiling water
3 garlic cloves, crushed
1 teaspoon cayenne pepper
4 bay leaves, crumbled
5 cloves
2 cups/16 fl oz/475 ml cold water

1 To prepare the brine, dissolve the salt, molasses, and honey in the boiling water. Add the garlic, cayenne, bay leaves ,and cloves. Cover and leave to stand for 20 minutes.

2 Rinse the chicken thoroughly under cold running water and pat dry with paper towels. Place the chicken in a bowl. Add the cold water to the brine and pour it over the chicken. Cover and place in the refrigerator for 2 hours. Turn the chicken three times during marinating.

3 To cook the chicken, set the fillets on a hot well-oiled grill. Cook for 6 minutes, turn and cook for an additional 6–9 minutes, until the chicken is cooked through. Serve at once.

Chicken with Anchovy-caper Sauce

Serves 4 | Preparation **16 minutes** | Marinating **1 hour** | Grilling **12–15 minutes**

4 x 8 oz/225 g skinless and boneless
chicken breasts
2 tablespoons olive oil
2 tablespoons dry white wine
2 tablespoons grated lemon zest
1 teaspoon hot red pepper flakes
1 teaspoon coarse sea salt
$^1/_4$ cup/$^1/_2$ oz/15 g finely chopped
flat-leaf parsley

ANCHOVY CAPER SAUCE
juice of $^1/_2$ lemon
8 salted anchovy fillets, finely chopped
or minced
1 tablespoon capers
$^1/_4$ cup/$^1/_2$ oz/15 g finely chopped
flat-leaf parsley
2 tablespoons finely snipped chives
2 cloves garlic, crushed
$^1/_2$ teaspoon cayenne pepper
1 cup/8 oz/225 g mayonnaise

1 Rinse the chicken under cold running water and pat dry with paper towels.
Place in a shallow dish.

2 To make the marinade, whisk the olive oil with the wine, lemon zest, and
pepper flakes, and pour over the chicken. Toss the chicken in the marinade,
cover, and refrigerate for 1 hour.

3 To make the sauce, mix the lemon, anchovies, capers, parsley, chives, garlic,
and cayenne into the mayonnaise, stirring in each ingredient before adding
the next. Cover and refrigerate.

4 To cook the chicken, place the fillets on a medium-hot, well-oiled grill. Cook
for 6 minutes on the first side and 6–9 minutes on the second side, until well
browned and cooked through.

5 Transfer the chicken to individual plates, sprinkle with the salt and parsley,
and add a dollop of the sauce on the side. A chunky ratatouille goes very well
with the chicken.

Chicken with Sun-Dried Tomato Sauce

Serves **4** | Preparation **26 minutes** | Marinating **45 minutes** | Grilling **10 minutes**

4 x 7 oz/200 g skinless and boneless chicken breasts
2 tablespoons olive oil
1 tablespoon light molasses
1 tablespoon dried thyme
1 teaspoon freshly ground black pepper

SUN-DRIED TOMATO SAUCE
1 cup/8 fl oz/250 ml boiling water
10 sun-dried tomatoes

4 tablespoons extra virgin olive oil
2 tablespoons balsamic vinegar
1 teaspoon soft brown sugar
$^1/_4$ cup/$^1/_2$ oz/15 g coarsely chopped fresh basil
1 teaspoon dried oregano
1 teaspoon capers
1 garlic clove, coarsely chopped
1 teaspoon coarse sea salt
1 teaspoon freshly ground black pepper

1 Rinse the chicken under cold running water and pat dry with paper towels. Place the fillets in a shallow dish.

2 To make a marinade, stir the olive oil, molasses, thyme, and black pepper together and spread this over the chicken breasts by hand. Cover and marinate in the refrigerator for 45 minutes.

3 To make the sauce, pour boiling water over the tomatoes in a small bowl, adding just enough to cover them. Leave to soak for 30 minutes. Squeeze the liquid from the reconstituted tomatoes and reserve. Place the tomatoes in a food processor. Add the measured boiling water, oil, vinegar, sugar, basil, oregano, capers, garlic, salt, and pepper, and purée into a fine sauce. Add some of the reserved soaking liquid for a thinner consistency, if required. Cover and leave at room temperature.

4 To cook the chicken, set the fillets on a medium-hot, well-oiled grill. Cook for 5 minutes on each side. Serve at once, with the sauce.

Honey-spice Cured Chicken

Serves **4** | Preparation **14 minutes** | Marinating **2 hours** | Grilling **15–18 minutes**

4 x 8 oz/225 g skinless and boneless chicken breasts	6 whole black peppercorns
	4 bay leaves, crumbled
	1 teaspoon mustard seeds
HONEY-SPICE CURE	2 tablespoons corn oil
4 tablespoons coarse sea salt	6 tablespoons liquid light honey
6 whole star anise	1 tablespoon light molasses

1 Rinse the chicken under cold running water and dry on paper towel. Place the chicken in a shallow dish.

2 To make the honey-spice cure, crush the salt with the star anise, peppercorns, bay leaves, and mustard seeds in a mortar with a pestle. Mix the spices into the oil, honey, and molasses to make a thick syrup. Pour this mixture over the chicken and rub it in generously with your hands. Cover and refrigerate for 2 hours, turning three times.

3 To cook the chicken, place on a medium-hot, well-oiled grill, meaty sides down. Cook for 8 minutes. Turn the chicken and cook for another 7–10 minutes, or until the skin is crisp and browned and the flesh cooked through. Serve the chicken hot and freshly grilled, or leave it to cool, covered, and serve at room temperature.

Genius Tip The key to charcoal barbecuing is in controlling the temperature of the coals—this is really only done through trial and error and will come in time when you get used to your barbecue.

Chicken Breasts with Honey Glaze

Makes **4 portions** | Preparation **14 minutes** | Marinating **45 minutes**
| Grilling **12–15 minutes**

4 x 8 oz/225 g skinless and boneless chicken breasts	HONEY SESAME GLAZE
3 tablespoons light soy sauce	2 tablespoons liquid light honey
1 tablespoon light sesame oil	1 tablespoon light sesame oil
1 tablespoon molasses	juice of $^{1}/_{2}$ lemon
1 tablespoon sake	1 teaspoon hot paprika
	2 garlic cloves, crushed
	3 tablespoons sesame seeds

1 Rinse the chicken under cold running water and pat dry with paper towels. Place in a shallow dish. Whisk the soy sauce, sesame oil, molasses, and sake together and pour over the chicken. Rub this mixture thoroughly into the chicken. Cover and set in the refrigerator for 45 minutes.

2 To make the glaze, stir the honey, oil, and lemon juice together until evenly combined, then stir in the paprika, garlic, and sesame seeds.

3 To cook the chicken, drain off the marinade and brush the tops of the portions with the honey glaze. Turn over face down on a medium-hot, well-oiled grill. Cook for 6 minutes, repeatedly brushing the surface with the glaze. Turn the chicken over and continue brushing with glaze. Cook for a further 6–9 minutes, turning again if necessary to prevent the glaze from burning. Serve at once.

Moorish Chicken Kabobs

Serves **4** | Preparation **14 minutes** | Marinating **1¹/₂ hours** | Grilling **8 minutes**

1¹/₂ lb/675 g skinless and boneless
chicken breasts
1 teaspoon dried oregano,
preferably Greek
1 teaspoon ground cumin
1 teaspoon ground coriander

1 teaspoon hot paprika
1 teaspoon saffron strands
1 teaspoon garlic powder
1 teaspoon onion powder
1 teaspoon freshly ground
black pepper

1 Rinse the chicken under cold running water and pat dry with paper towels. Cut the chicken into 1¹/₂ in/3.5 cm cubes and place in a long shallow dish.

2 Pound the oregano, cumin, coriander, paprika, saffron strands, garlic powder, onion powder, and pepper together in a pestle with a mortar. Empty the mixture onto the chicken and rub it all over the portions by hand. Thread the cubes onto metal skewers and return them to the dish. Cover and marinate in the refrigerator for 1¹/₂ hours.

3 To grill the kabobs, place the skewers on a medium-hot, well-oiled grill. Cook for 8–12 minutes on each side, turning four times. Serve at once.

Genius Tip Hummus and grilled warm flat breads go well with the chicken. To make a quick hummus, mash drained canned chickpeas with a few drops of sesame oil. Then stir in 1 crushed garlic clove with enough mayonnaise to soften the mixture.

poultry & wild birds

Chicken Breasts Nuevo Latino

Serves **4** | Preparation **35 minutes** | Marinating **24 hours** | Grilling **8 minutes**

**4 x 8 oz/225 g skinless and boneless
chicken breasts
coarse sea salt
peanut oil**

MARINADE
**1¹/₂ cup/12 fl oz/350 ml corn oil
1 small onion, chopped
6 garlic cloves, finely chopped
1 teaspoon cayenne pepper
1 red chili, seeded and finely chopped
or minced
1¹/₂ cups/12 fl oz/350 ml tomato paste
juice of 1¹/₂ lemons
¹/₄ cup/¹/₂ oz/15 g fresh thyme leaves**

**1¹/₂ cups/1¹/₂ oz/35 g coarsely
chopped cilantro
2 teaspoons salt
2 teaspoons freshly ground black
pepper**

TOMATO BASIL AIOLI
**juice of 1¹/₂ lemon
1 teaspoon tomato paste
3 garlic cloves, crushed
20 basil leaves, finely shredded
1 teaspoon salt
1 teaspoon freshly ground black
pepper
1 cup/8 oz/225 g mayonnaise**

1 Rinse the chicken breasts and pat dry on paper towels. Place in a dish.

2 To make the marinade, heat 2 tablespoons of the oil in a saucepan. Add the onion and garlic, and cook for about 5 minutes, until translucent. Add the cayenne and chili and cook for a further 2 minutes.

3 Transfer the cooked onion mixture to a food processor. Add the tomato paste, lemon juice, thyme, cilantro, salt, and pepper. Process the mixture while slowly

adding the remaining oil. The mixture will become thick, rather like a mayonnaise.

4 Pour the marinade over the chicken and turn the pieces to coat them thoroughly. Cover the dish and refrigerate overnight.

5 To make the tomato basil aioli, whisk the lemon juice, tomato paste, garlic, basil, salt, and pepper together, then stir this into the mayonnaise until thoroughly combined. Cover and refrigerate until ready to serve.

6 Remove excess marinade from the chicken and cook on a well-oiled, medium-hot grill for 4 minutes on each side. Transfer the chicken to a platter and cover loosely with foil. Leave to rest for 4 minutes.

7 Transfer the chicken to plates and spoon some of the tomato basil aioli on the side. Offer the remaining aioli separately.

Genius Tip As a serious safety precaution always situate your barbecue within proximity of the garden hose or have a bucket of sand on standby. Try to never leave your barbecue unattended.

Barbecued Chicken in Saffron Yogurt

Serves **4** | Preparation **23 minutes** | Marinating **24 hours** | Grilling **12 minutes**

2 lb/900 g boneless chicken breasts and thighs
1 cup/8 oz/225 g whole-fat plain yogurt
2 tablespoons canola oil
grated zest and juice of 1 lemon
1 tablespoon light liquid honey
1 teaspoon saffron threads
1 teaspoon ground turmeric
3 garlic cloves, crushed
5 bay leaves, crumbled

¹⁄₄ cup/¹⁄₂ oz/15 g coarsely chopped mint
1 tablespoon coarse sea salt
1 tablespoon freshly ground black pepper

BASTING LIQUID
3 tablespoons lightly salted butter
juice of 1 lemon
¹⁄₂ teaspoon saffron threads

1 Rinse the chicken under cold running water and pat dry with paper towels. Place into a large shallow dish.

2 To make the marinade, mix the yogurt, canola oil, lemon zest and juice, honey, saffron, turmeric, garlic, bay leaves, mint, salt, and pepper in a bowl. Pour the thick mixture over the chicken and turn the pieces until they are thoroughly coated. Cover and refrigerate for 24 hours. Turn the chicken pieces three times during marinating.

3 Prepare the basting liquid just before cooking the chicken. Melt the butter in a small saucepan and stir in the lemon juice and saffron. Remove from the heat.

4 To cook the chicken, place the pieces on a well-oiled, medium-hot grill. Cook for about 6 minutes on each side, basting continuously with the butter mixture and turning once. The meat should be cooked through. Transfer to serving platter.

Coriander Chicken Brochettes

Serves **4** | Preparation **24 minutes** | Marinating **1 hour** | Grilling **12–14 minutes**

1½ lb/675 g skinless and boneless chicken thighs
½ cup/1 oz/25 g coarsely chopped cilantro

MARINADE
2 tablespoons canola oil
1 tablespoon light molasses
3 garlic cloves, crushed
1 red chili, seeded and chopped or minced
2 tablespoons ground coriander
1 teaspoon ground cumin

MINT YOGURT SAUCE
1 cup/8 oz/225 g whole fat plain yogurt
1 tablespoon liquid light honey
juice of ½ lemon
1 garlic clove, chopped
1 tablespoon chopped fresh root ginger
1 teaspoon paprika
1 teaspoon coarse sea salt
1 cup/2 oz/50 g finely chopped fresh mint
cooked jasmine rice to serve

1 Rinse the chicken under cold running water and pat the pieces dry with paper towel. Cut the chicken into strips measuring 2 in/5 cm wide and 6 in/ 15 cm long. Thread these on metal skewers and place in a long shallow dish.

2 To make the marinade, whisk the oil, molasses, garlic, chili, coriander, and cumin together in a small bowl. Rub this thoroughly into the chicken. Cover and refrigerate for 1 hour, turning halfway through.

3 To make the sauce, process the yogurt, honey, lemon juice, garlic, ginger, paprika, and salt in a blender or food processor until creamy in consistency. Turn the sauce into a serving bowl and fold in the chopped mint. Cover and refrigerate until you serve the chicken.

4 To cook the chicken, place the skewers on a medium-hot, well-oiled grill. Cook for 6–7 minutes on each side, until browned and cooked through. Scrape the meat off the skewers using a fork and serve on jasmine rice, with the mint yogurt sauce on the side.

poultry & wild birds

Marmalade Chicken

Serves **4** | Preparation **20 minutes** | Marinating **2 hours** | Grilling **10 minutes**

1¹/₂ **lb/675 g boneless and skinless thighs**
1 teaspoon coarse sea salt
¹/₄ **cup/¹/₂ oz/15 g finely chopped flat-leaf parsley**

MARINADE
4 tablespoons olive oil
juice of 1 orange
¹/₄ **cup/2¹/₂ oz/65 g coarse-cut orange marmalade**
1 tablespoon apple cider vinegar
1 red chili pepper, seeded and finely minced or chopped
4 whole cloves
1 cup/8 fl oz/250 ml medium sherry

1 Rinse the chicken thoroughly under cold running water and pat dry with paper towels. Lay the pieces in a single layer in a shallow dish.

2 To make the marinade, mix the olive oil, orange juice, marmalade, vinegar, chili, cloves, and sherry. Pour this over the chicken and turn the pieces to coat them thoroughly. Cover and refrigerate for 2 hours.

3 Drain the chicken, pouring the marinade into a small saucepan. Bring to a boil, reduce the heat, and simmer for 5 minutes. Remove from the heat and reserve for glazing the chicken while grilling.

4 To cook the chicken, place on a well-oiled, medium-hot grill. Cook for 6–8 minutes on each side. Turn the chicken once and move the pieces around the grill slightly while it grills to prevent it from sticking. Brush with the reserved marinade occasionally during cooking.

5 Bring the remaining marinade to the boil, then remove it from the heat. Transfer the chicken to a serving platter and spoon the remaining marinade over the top. Sprinkle with salt and parsley, and serve.

Chicken in Peanut Ginger Marinade

Serves **4** | Preparation **15 minutes** | Marinating **2 hours** | Grilling **12–16 minutes**

$1^1/_2$ **lb/675 g boneless and skinless chicken thighs**
1 teaspoon coarse sea salt
$^1/_4$ **cup/$^1/_2$ oz/15 g finely chopped flat-leaf parsley**

MARINADE
1 onion, finely grated
1 teaspoon garlic powder
1 teaspoon ground coriander
1 teaspoon ground ginger
1 teaspoon hot paprika
1 teaspoon soft brown sugar
3 tablespoons smooth peanut butter
$^1/_4$ **cup/2 fl oz/60 ml apple cider vinegar**

1 Rinse the chicken thoroughly under cold running water. Pat dry on paper towels and place in a shallow dish.

2 To make the marinade, mix the onion with the garlic powder, coriander, ginger, paprika, sugar, peanut butter, and cider vinegar to make a coarse paste. Rub the paste over the chicken meat. Cover and refrigerate for 2 hours.

3 Place the chicken on a well-oiled, medium-hot grill and cook meat for 6–8 minutes on each side, until well browned and cooked through. Transfer to a serving platter and sprinkle with salt and parsley. Grilled plantain or firm, under-ripe bananas go well with the chicken.

Genius Tip When preparing your charcoal barbecue, empty a thick layer of briquettes into the pit, distribute them evenly and douse with fuel. Let stand for 10 minutes, allowing the coal to absorb the fluid. Light the coals with a long-stemmed wooden match.

poultry & wild birds

Grilled Lemon Pepper Chicken Thighs

Serves **4** | Preparation **10 minutes** | Marinating **2 hours** | Grilling **12–16 minutes**

1½ lb/675 g boneless and skinless chicken thighs
1 teaspoon chili powder
1 tablespoon coarse sea salt
¼ cup/½ oz/15 g finely chopped flat-leaf parsley

MARINADE
½ cup/4 fl oz/125 ml olive oil
¼ cup/2 fl oz/60 ml dry white wine
finely grated zest and juice of 1 lemon
3 garlic cloves, crushed
1 tablespoon freshly ground black pepper

1 Rinse the chicken thoroughly under cold running water and pat dry with paper towels. Place the chicken in a single layer in a shallow dish.

2 To make the marinade, whisk the oil, wine, and lemon juice together. Stir in the lemon zest, garlic, and pepper. Pour this over the chicken and turn the pieces to coat them thoroughly all over. Cover and refrigerate for 2 hours.

3 Drain the chicken and pour the marinade into a small saucepan. Bring to a boil, reduce the heat and simmer for 5 minutes. Remove from the heat and reserve for brushing over the chicken during cooking.

4 To grill the chicken, season the pieces with chili powder, and place on a well-oiled, medium-hot grill. Cook for 6–8 minutes on each side, until the chicken is well browned and cooked through. Brush with the reduced marinade up until the last 3 minutes of cooking.

5 Transfer the chicken to a large serving platter. Sprinkle with salt and chopped parsley and serve freshly cooked. Grilled red bell peppers and asparagus are good vegetables to serve with the chicken.

Chicken in Hoisin Ginger Marinade

Serves **4** | Preparation **15 minutes** | Marinating **2 hours** | Grilling **10 minutes**

1^1/$_2$ lb/675 g skinless and boneless chicken thighs
1/$_2$ cup/4 fl oz/15 ml hoisin sauce
2 tablespoons black bean paste
2 tablespoons light sesame oil
1 tablespoon soy sauce
1/$_2$ cup/4 fl oz/125 ml sake
4 garlic cloves, crushed
1 teaspoon dried chili flakes

2 tablespoons finely chopped or minced fresh root ginger

TO SERVE
1/$_2$ cup/2 oz/50 g chopped green onion
1/$_4$ cup/2 oz/50 g toasted sesame seeds

1 Rinse the chicken under cold running water and pat dry with paper towels. Place the chicken in a shallow dish.

2 Mix the hoisin sauce, black bean paste, sesame oil, soy sauce, sake, garlic, chili flakes, and ginger in that order to form a syrupy paste. Pour this marinade over the chicken, making sure all the pieces are thoroughly coated. Cover the dish and place in the refrigerator for 2 hours.

3 To cook the chicken, arrange the meat on a medium-hot, well-oiled grill. Cook for 5 minutes on each side. The outside should be crisp and the flesh cooked through.

4 Transfer the chicken to a serving platter and sprinkle with the chopped onion and sesame seeds. Stir-fried vegetables and cellophane noodles go well with the chicken.

Curaçao Chicken Thigh Kabobs

Serves **4** | Preparation **28 minutes** | Marinating **1 hour 30 minutes**
| Grilling **6–8 minutes**

2 lb/900 g skinless and boneless chicken thighs
1 tablespoon coarse sea salt

MARINADE
¹/₂ cup/4 fl oz/125 ml ketjap manis (Indonesian sweet soy sauce)
¹/₄ cup/2 fl oz/60 ml curaçao
1 tablespoon light sesame oil
grated zest and juice of ¹/₂ orange

1 tablespoon light molasses
2 garlic cloves, crushed
1 tablespoon finely minced or chopped shallots
1 tablespoon finely minced or chopped ginger
1 red chili pepper, seeded and finely minced or chopped
1 teaspoon ground cumin
¹/₄ teaspoon ground cloves

1 Rinse the chicken under cold running water and pat dry with paper towels. Cut the thigh meat into strips measuring 4 in/10 cm long and ¹/₂ in/1 cm wide. Thread the meat lengthwise onto metal skewers and place in a shallow dish.

2 To make the marinade, stir the ketjap manis, curaçao, sesame oil, orange zest and juice, molasses, garlic, shallots, ginger, chili, cumin, and ground cloves in a mixing bowl. Pour this mixture over the skewered chicken, making sure all the surfaces are coated. Cover and marinate in the refrigerator for 1¹/₂ hours. Turn three times during marinating.

3 Cook the chicken on a medium-hot, well-oiled grill for 3–4 minutes on each side, until well browned and cooked through. Scrape the meat from the skewers onto plates. Sprinkle with salt and serve. Fried rice, chopped peanuts, and braised greens go well with the chicken.

Genius Tip Always try to avoid cross contamination when preparing food by using different utensils for each type of ingredient.

Chicken in Garlic Lime Marinade

Serves **4** | Preparation **16 minutes** | Marinating **45 minutes** | Grilling **10 minutes**

$1^1/_2$ **lb/675 g skinless and boneless chicken thighs**
$^1/_4$ **cup/$^1/_2$ oz/15 g finely chopped flat-leaf parsley**
$^1/_4$ **cup/$^1/_2$ oz/10 g finely chopped mint**
coarse sea salt

MARINADE
1 tablespoon soft brown sugar
2 tablespoons peanut oil
1 tablespoon molasses
grated zest and juice of 2 limes
6 garlic cloves, crushed
1 red chili pepper, seeded and finely chopped or minced

1 Rinse the chicken under cold running water and pat dry with paper towels. Cut the meat into strips measuring 2 in/5 cm wide and 6 in/15 cm long, then thread these strips lengthwise onto metal skewers. Place the skewered chicken in a long shallow dish.

2 To make the marinade, stir the sugar into the oil and molasses until dissolved. Whisk in the lime zest and juice and stir in the garlic and chili. Rub the mixture all over the skewered chicken. Cover and marinate in the refrigerator for 45 minutes.

3 To cook the chicken, place the skewers on a medium-hot, well-oiled grill. Cook for 5 minutes on each side or until the chicken is browned and cooked through. Scrape the chicken off the skewers with a fork onto a serving platter. Sprinkle with the parsley and mint, and salt to taste.

poultry & wild birds

Chicken with Spicy Green Paste

Serves **4** | Preparation **16 minutes** | Marinating **4 hours** | Grilling **10 minutes**

1¹/₂ **lb/675 g skinless and boneless chicken thighs**
1 tablespoon coarse sea salt
¹/₂ **cup/1 oz/25 g coarsely chopped cilantro**

SPICY GREEN PASTE MARINADE
¹/₂ **cup/8 oz/225 g whole fat plain yogurt**
3 tablespoons peanut oil

2 jalapeño peppers, seeded and coarsely chopped
1 cup/2 oz/50 g coarsely chopped cilantro
¹/₂ **cup/1 oz/25 g fresh basil leaves**
¹/₂ **cup/1 oz/25 g snipped fresh chives**
1 teaspoon ground cumin
1 teaspoon ground turmeric
3 garlic cloves, crushed
1 tablespoon minced or finely chopped fresh root ginger

1 Rinse the chicken under cold running water and pat dry with paper towels. Place the thigh meat in a shallow dish.

2 To make the paste marinade, purée the yogurt, oil, jalapeño peppers, cilantro, basil, chives, cumin, turmeric, garlic, and ginger until smooth in a blender or food processor. Pour this paste over the chicken and turn the pieces to coat them thoroughly. Cover and marinate for 4 hours in the refrigerator. Turn the chicken three times during marinating.

3 To cook the chicken, drain off the marinade and place the meat on a medium-hot, well-oiled barbecue. Cook for 6 minutes, turn, and cook for 4 minutes on the other side or until the chicken is well browned and cooked through.

4 Transfer the chicken to a serving platter. Sprinkle the salt and cilantro over the meat. Couscous and a sweet, fruity chutney go well with the chicken.

Curried Coconut Milk Chicken

Serves **4** | Preparation **19 minutes** | Marinating **1**½ **hours** | Grilling **10 minutes**

1½ lb/675 g skinless and boneless chicken thighs
1 tablespoon coarse sea salt
½ cup/1 oz/25 g coarsely chopped cilantro

COCONUT MILK MARINADE
2 cups/16 fl oz/475 ml coconut milk
3 tablespoons ketjap manis (Indonesian sweet soy sauce)

1 tablespoon light sesame oil
1 tablespoon mild red curry powder
1 tablespoon coriander paste
3 garlic cloves, crushed
½ red chili pepper, seeded and finely chopped
1 tablespoon grated fresh root ginger
5 kefir lime leaves, crumbled
grated zest and juice of 1 lime
lime slices to garnish

1 Rinse the chicken under cold running water and pat dry with paper towels. Place the meat in a shallow dish.

2 To make the marinade, whisk the coconut milk, ketjap manis, and sesame oil together, then add the curry powder, coriander paste, garlic, chili, ginger, lime leaves, and lime zest and juice, whisking in each ingredient. Reserve half of the mixture for basting the chicken while it grills. Pour the rest over the chicken and turn the pieces to coat them completely. Cover and refrigerate for 1½ hours.

3 To cook the chicken, place on a medium-hot, well-oiled grill. Cook the first side for 6 minutes and the other side for 4 minutes or until the meat is browned outside and cooked through. Brush continuously with the reserved marinade during cooking.

4 Transfer the chicken to a serving platter, sprinkle with salt and chopped cilantro. Garnish with the lime slices and serve. Basmati rice and grilled pineapple slices are excellent accompaniments.

poultry & wild birds

Wings in Heat

Serves **4** | Preparation **12 minutes** | Marinating **24 hours** | Grilling **15–20 minutes**

16 chicken wings	**1 tablespoon dried oregano**
3 tablespoons peanut oil	**$1/2$ teaspoon chili powder**
1 teaspoon coarse sea salt	**$1/2$ teaspoon ground turmeric**
	$1/2$ teaspoon freshly ground black
DRY RUB	**pepper**
1 tablespoon garlic salt	**finely chopped zest from 1 lemon**
1 tablespoon cayenne pepper	

1 To prepare the chicken, clip off the third joints at the tips of the wings and freeze these for future use (for example to make stock). Separate the remaining two portions of each wing and cut four 1 in/2.5 cm slashes into the larger, meatier sections. Place in a shallow dish.

2 To make the dry rub, stir the garlic salt, cayenne, oregano, chili powder, turmeric, pepper, and lemon zest together. Sprinkle this evenly over the chicken wings and rub it into them, especially into the cuts. Cover and refrigerate for 24 hours.

3 To grill the wings, set them on a well-oiled, medium-hot grill and cook for 5 minutes, turning once, until lightly browned on both sides. Move the chicken to the edges of the grill, where the heat is not as fierce, and cook for a further 10–15 minutes. Brush the wings with oil throughout the cooking process. Transfer the chicken to a platter and sprinkle with salt.

Genius Tip Always ensure your grill is cleaned and free of grease or remaining dried food bits. Use a wire brush to scrub the surface before and after each use.

Beer-glazed Chicken Wings

Serves **4** | Preparation **15 minutes** | Marinating **24 hours** | Grilling **20–24 minutes**

16 chicken wings

MARINADE AND GLAZE
2 tablespoons olive oil
¹/₂ red chili pepper, seeded and coarsely chopped
1 tablespoon dried thyme
2 bay leaves, crumbled
1 teaspoon salt
1 x 12 oz/350 g bottle pilsner beer

SAUCE
3 tablespoons olive oil
juice of ¹/₂ lemon
¹/₂ red chili pepper, seeded and finely chopped
¹/₂ teaspoon dried thyme
1 garlic clove, crushed and chopped with 1 teaspoon coarse sea salt
¹/₂ teaspoon freshly ground black pepper

1 To prepare the chicken, cut each wing into three segments at the joints. Freeze the bony wing tips for future use (for example for making stock). Score four 1 in/2.5 cm slashes in the meaty portions. Lay the pieces in a shallow dish.

2 To make the marinade, stir the oil, chili, thyme, bay leaves, and salt into the beer. Reserve a quarter of the liquid to glaze the wings during cooking, then pour the rest over the chicken in the dish. Cover and refrigerate for 24 hours, turning four times.

3 To make the sauce, combine the olive oil, lemon juice, chili, thyme, garlic, salt, and pepper in a small bowl. Cover and leave at room temperature until the chicken is cooked.

4 To grill the wings, place them on a well-oiled, medium-hot grill. Cook for 10–12 minutes on each side. Brush continuously with the reserved marinade and turn the wings frequently to ensure that they are evenly crisp and brown outside, and cooked through.

5 Transfer the wings to a serving platter and spoon over the prepared sauce. Turn the wings in the sauce to ensure they are evenly coated and serve at once.

Snappy Buffalo Chicken Wings

Serves **4** | Preparation **35 minutes** | Marinating **1 hour 30 minutes**
| Grilling **16–24 minutes**

4 lb/1.8 kg chicken wings
bamboo skewers, soaked in water
for 1 hour

MARINADE
1 cup/8 fl oz/250 ml ketchup
2 tablespoons lemon juice
1 tablespoon corn oil
1 tablespoon brown sugar
5 garlic cloves, sliced
2 tablespoons chopped fresh
root ginger

1 teaspoon Tabasco
1 teaspoon cayenne pepper

DIPPING SAUCE
6 oz blue cheese, crumbled
1 cup sour cream
1 cup mayonnaise
$^{1}/_{4}$ cup/1$^{1}/_{2}$ oz/15 g snipped
fresh chives
1 tablespoon lemon juice
1 teaspoon freshly ground
black pepper

1 Rinse the chicken thoroughly with cold running water and pat dry with paper towels. Skewer the chicken on the drained bamboo skewers. Begin threading the wing at the connecting joint and stretch the entire wing to form a vertical line. Run the skewer through its entire length and out the center of the joint that connects the wing to the body. Repeat with the remaining chicken wings, placing them side by side in a large shallow dish.

2 To make the marinade, blend the ketchup, lemon juice, oil, sugar, garlic, ginger, Tabasco, and cayenne in a food processor to make a velvety purée. Pour this sauce over the skewered wings, making sure they are all coated. Cover and refrigerate for 1$^{1}/_{2}$ hours, turning the wings three times during marinating.

3 To make the dipping sauce, mash the blue cheese with the cream and mayonnaise. Stir in the chives, lemon juice, and pepper. Cover and refrigerate.

4 Pour the marinade off the chicken into a saucepan and bring to the boil, then boil for 5 minutes until the mixture is reduced. This reduced marinade is used as a basting sauce.

5 Cook the chicken wings on a medium-hot grill for 8–12 minutes on each side, brushing with the marinade. The skin should be crisp and the flesh white,

tender, and well cooked. Position the ends of the skewers close to the edge of the barbecue to help prevent them from burning. Alternatively, protect the skewers from the fire by placing a folded piece of foil underneath them.

6 Fan the chicken wings around the edge of a serving platter with the handle ends facing out. Place the bowl of dipping sauce in the middle.

• •

Malaysian Drumsticks

Serves **4** | Preparation **19 minutes** | Marinating **1 hour 30 minutes**
| Grilling **15 minutes**

3 lb/1 kg 350 g chicken drumsticks	**1 tablespoon tomato paste**
$^1/_2$ cup/1 oz/25 g coarsely chopped cilantro	**1 tablespoon light molasses**
	juice of 1 lime
	5 garlic cloves, sliced
MARINADE	**3 tablespoons chopped fresh root ginger**
1 cup/8 fl oz/250 ml ketjap manis (Indonesian sweet soy sauce)	**1 red chili pepper, seeded and chopped**
1 tablespoon light sesame oil	**1 teaspoon Chinese five-spice powder**

1 Rinse the chicken thoroughly under cold running water and pat dry with paper towels. Set in a shallow dish.

2 To make the marinade, combine the ketjap manis, sesame oil, tomato paste, molasses, lime juice, garlic, ginger, chili, and five-spice powder in a blender or food processor and process until smooth. Pour this over the drumsticks and turn them to coat evenly all over. Cover the dish and refrigerate for 1$^1/_2$ hours.

3 Pour the marinade off the chicken into a saucepan and bring to a boil. Allow to bubble for 5 minutes until reduced: this is used to baste the chicken.

4 Cook the chicken drumsticks on a medium-hot, well-oiled grill for 15 minutes. Turn frequently and brush with the reduced marinade to keep the outside moist. The chicken skin should be crisp, the flesh opaque white and cooked through. Transfer to a serving platter and sprinkle with the chopped cilantro.

poultry & wild birds

Barbecued Saucy Drumsticks

Serves **4** | Preparation **10 minutes** | Marinating **1 hour** | Grilling **25–30 minutes**

12 chicken drumsticks
$^1/_2$ **teaspoon chili powder**
$^1/_2$ **teaspoon garlic powder**
$^1/_2$ **teaspoon onion powder**
$^1/_2$ **teaspoon freshly ground black pepper**

finely chopped zest from 1 lemon
$^1/_2$ **teaspoon dried thyme**
$^1/_2$ **teaspoon soft light brown sugar**
$1^1/_2$ **cups/12 fl oz/350 ml prepared barbecue sauce**

1 To prepare the chicken, rinse thoroughly under cold running water and pat dry with paper towels. Cut four 2 in/5 cm slashes into the meatiest part of the drumsticks at a slant. Place the chicken in a shallow dish.

2 Mix the chili, garlic and onion powders with the pepper, lemon, thyme, and sugar. Rub this mixture all over the chicken, especially into the slashes. Cover and refrigerate for 1 hour.

3 To cook the chicken, place on a well-oiled, medium-hot grill and cook for 20 minutes, turning frequently, until the chicken is browned and almost cooked. Brush with the barbecue sauce and continue to cook for a further 5–10 minutes, turning frequently and brushing with more sauce. The chicken should be well glazed and cooked through. Serve at once.

Tuscan Chicken Burgers

Serves **4** | Preparation **27 minutes** | Grilling **16 minutes**

2 tablespoons each of dried rosemary, oregano and sage
$^1/_4$ cup/1 oz/25 g ground pine nuts
$^1/_4$ cup/1 oz/25 g finely chopped ripened olives
$1^1/_2$ lb/675 g ground chicken
1 tablespoon virgin olive oil
juice of $^1/_2$ lemon
$^1/_2$ cup/1 oz/25 g finely minced or chopped onion
4 garlic cloves, crushed
2 tablespoons freshly ground black pepper
1 tablespoon coarse sea salt

1 Pound the rosemary, oregano, and sage with the pine nuts and olives in a mortar using a pestle. When the mixture is reduced to a coarse paste, turn it into a mixing bowl and add the chicken, oil, lemon juice, onion, garlic, and pepper. Mix until all the ingredients are thoroughly and evenly combined.

2 Divide the mixture into quarters and shape each portion into an oblong $1^1/_2$ in/3.5 cm thick burger. Cook on a medium-hot, well-oiled grill. Allow 8 minutes on each side, until the burgers are cooked through and well browned outside. Sprinkle the salt over the burgers and serve at once.

Genius Tip Burgers can be served with all sorts of accompaniments, including fries, salads, and various types of breads. Toasted Italian bread with olives is excellent with these burgers instead of the usual buns. Arugula and aioli or garlic mayonnaise with basil and chili is a good dressing.

Grilled Rumaki

Serves **4** | Preparation **15 minutes** | Marinating **20 minutes** | Grilling **10 minutes**

12 oz/350 g chicken livers
8 thin bacon slices
16 drained canned water chestnuts
8 green onions
8 bamboo skewers, soaked for
1 hour in water

MARINADE
1 tablespoon soft dark brown sugar
3 tablespoons dark soy sauce
2 tablespoons dry sherry
1 teaspoon finely minced or chopped
fresh root ginger

1 To prepare the chicken livers, rinse them thoroughly under cold running water and pat dry with paper towels. Place in a single layer in a shallow dish.

2 To make the marinade, stir the sugar into the soy sauce and sherry until it has dissolved. Stir in the ginger, then pour this marinade over the chicken livers. Turn the livers gently in the marinade, cover and marinate at room temperature for 20 minutes.

3 To make the rumaki, drain the bamboo skewers. Slice the green onion into lengths the same as the width of the bacon. Cut the chicken livers into pieces that match the width of the bacon slices. Thread the chicken livers, water chestnuts and green onions alternately on the skewers.

4 Thread a slice of bacon $^{1}/_{2}$ in/1 cm from its end on the end of one skewer. Wrap the bacon over the other threaded ingredients so that the middle of the slice is at the blunt end of the skewer. Stretch the bacon to push the blunt end of the skewer through it, then wrap the rest of the slice around the other side of the ingredients and back down to the point. Push the end of the bacon on the point. The ingredients should be completely covered lengthwise by the bacon.

5 Place the skewers on a medium-hot grill and cook for 5 minutes on each side. If the bacon begins to burn, transfer the skewers to the cooler edge of the grill. The bacon should be crisp and brown and the chicken livers firm. Serve rumaki freshly cooked.

Grilled Mocha Turkey Breast

Serves **4** | Preparation **25 minutes** | Marinating **24 hours** | Grilling **25 minutes**

2 x 1 lb/450 g skinned turkey breast fillets
1 teaspoon coarse sea salt
¹/₂ cup/1 oz/25 g coarsely chopped cilantro

MARINADE
1 tablespoon instant coffee
1 tablespoon bittersweet chocolate chips

1 cup/8 fl oz/250 ml boiling water
2 tablespoons peanut oil
1 tablespoon light liquid molasses
2 garlic cloves, crushed
1 teaspoon coarse sea salt
1 jalapeño pepper, seeded and finely minced
1 teaspoon ground coriander
¹/₂ teaspoon ground cumin

1 To prepare the turkey, rinse thoroughly under cold running water and pat dry with paper towels. Slice the breasts horizontally in half, making each piece about 1¹/₂ in/3.5 cm thick. The fillets should be wide and flat—place them in a single layer in a shallow dish.

2 To make the marinade, dissolve the coffee and chocolate in the boiling water in a mixing bowl. Stir in the oil, molasses, garlic, salt, jalapeño pepper, coriander, and cumin. Pour the mixture over the turkey breasts and smooth it over the surfaces by hand. Cover and refrigerate for 24 hours.

3 Drain the liquid off the turkey and pour it into a small saucepan. Bring to a boil on top of the stove, reduce the heat and simmer for 5 minutes, stirring, until thick. Reserve this glaze for brushing over the turkey during cooking.

4 To grill the turkey, place on a well-oiled, low-heat grill. Cook for a total of 25 minutes, brushing with the glaze to keep the turkey moist and turning once. Remove from the grill and transfer to a cutting board. Cover loosely with foil and allow to rest for 5 minutes.

5 To serve, slice across the turkey fillets, at an angle, cutting ¹/₄ in/5 mm thick pieces. Fan the slices on a serving platter and sprinkle with salt and cilantro.

poultry & wild birds

Grilled Tuscan Turkey Breast

Serves **4** | Preparation **20 minutes** | Marinating **2 hours** | Grilling **25 minutes**

2 x 1 lb/450 g turkey breast fillets
juice of $^1/_2$ lemon
2 tablespoons olive oil
1 teaspoon coarse sea salt
$^1/_4$ cup/$^1/_2$ oz/15 g finely chopped
flat-leaf parsley

WET RUB
juice of $^1/_2$ lemon
3 tablespoons olive oil

3 garlic cloves, crushed
1 teaspoon coarse sea salt
1 tablespoon finely chopped fresh
rosemary
1 tablespoon dried oregano
1 teaspoon dried sage
1 tablespoon freshly ground
black pepper

1 To prepare the turkey, rinse thoroughly under cold running water and pat dry with paper towels. Slice the fillets horizontally in half to give 1$^1/_2$ in/3.5 cm thick, wide flat fillets. Lay these fillets in a shallow dish.

2 To make the wet rub, whisk the lemon juice and oil together, then stir in the garlic, salt, rosemary, oregano, sage, and pepper. Pour this over the turkey and rub it into the fillets by hand. Cover and refrigerate for 2 hours.

3 Mix the oil and lemon juice. To grill the turkey, place the fillets on a well-oiled medium-hot grill. Cook for 25 minutes, turning once. Brush with oil and lemon juice to keep the meat moist throughout the grilling. Transfer the cooked turkey to a cutting board and cover loosely with foil. Allow to rest for 5 minutes.

4 To serve the turkey, cut each fillet across at an angle into $^1/_4$ in/5 mm thick slices. Fan the pieces on individual plates and sprinkle with salt and parsley.

Genius Tip Grilled potato wedges seasoned with rosemary and a Caesar salad will go well with the turkey.

Sage Pecan Turkey Burgers

Serves 4 | Preparation **20 minutes** | Grilling **20 minutes**

$1^{1}/_{2}$ lb/675 g ground turkey
1 teaspoon soy sauce
1 teaspoon canola oil
$^{1}/_{2}$ cup/2 oz/50 g finely grated onion
$^{1}/_{2}$ cup/2 oz/50 g finely chopped pecan nuts

1 tablespoon crumbled dried sage
1 teaspoon coarse sea salt
1 tablespoon freshly ground black pepper
1 egg yolk

1 To make the burgers, place all the ingredients in a mixing bowl. Knead and squeeze the mixture together with your hands until the ingredients are thoroughly and evenly combined.

2 Divide the mixture into eight equal portions. Wet your hands and shape the portions into oval patties, each about $1^{1}/_{2}$ in/3.5 cm thick.

3 Place the burgers on a well-oiled, medium-hot grill. Cook for 10 minutes on each side until browned on the surface and firm to the touch. Transfer two burger to each plate and serve at once.

Ginger Teriyaki Turkey Burgers

Serves **4** | Preparation **15 minutes** | Grilling **20 minutes**

1¹/₂ lb/675 g ground turkey
¹/₂ cup/2 oz/50 g finely chopped
green onion
1 tablespoon peanut oil
2 tablespoons teriyaki sauce
1 tablespoon finely minced or grated
fresh root ginger

1 red chili pepper, seeded and finely
minced or chopped
1 teaspoon freshly ground
black pepper
1 egg yolk

1 To make the burgers, place all the ingredients in a mixing bowl. Knead and squeeze the mixture together with your hands until the ingredients are thoroughly and evenly combined.

2 Divide the mixture into eight equal portions. Wet your hands and shape the portions into oval patties, each about 1¹/₂ in/3.5 cm thick.

3 Place the burgers on a well-oiled, medium-hot grill. Cook for 10 minutes on each side until browned on the surface and firm to the touch. Transfer two burgers to each plate and serve at once. Steam-grilled Asian vegetables go well with these burgers.

Barbecued Turkey Burgers

Serves **4** | Preparation **19 minutes** | Grilling **12 minutes**

1½ lb/675 g ground turkey
1 tablespoon canola oil
1 teaspoon soy sauce
1 teaspoon Dijon mustard
1 teaspoon soft brown sugar
1 onion, finely chopped
¼ cup/½ oz/15 g finely chopped flat-leaf parsley

1 tablespoon garlic powder
1 tablespoon finely minced or chopped fresh root ginger
1 teaspoon freshly ground black pepper
½ teaspoon cayenne pepper

1 To prepare the burgers, place the ground turkey in a bowl. Mix in the oil, soy sauce, mustard, and sugar. When these ingredients are thoroughly combined, mix in the onion, parsley, garlic powder, ginger, black pepper, and cayenne. Mix well by hand after each addition so that all the ingredients are evenly distributed throughout the mixture.

2 Shape the mixture into four oval patties, about 1½ in/3.5 cm thick. Place the patties on a plate or flat dish as they are prepared. Cook the burgers on a medium-hot, well-oiled grill, allowing for 6 minutes on each side. The burgers should be browned and cooked through. Serve at once.

poultry & wild birds

Thai Chili Turkey Cakes

Serves **4** | Preparation **20 minutes** | Grilling **20 minutes**

1 lb/450 g ground turkey	8 fresh kefir lime leaves, very
1 tablespoon fish sauce	finely shredded
1 tablespoon peanut oil	1 tablespoon finely minced or grated
6 tablespoons cornstarch	fresh root ginger
3 tablespoons prepared Thai red	$^1/_4$ cup/$^1/_2$ oz/15 g coarsely chopped
chili paste	cilantro
3 garlic cloves, crushed	1 fresh lime, cut into wedges, to serve

1 To prepare the turkey cakes, mix the turkey with the fish sauce, oil, and half the cornstarch. Knead in each of the ingredients by hand until thoroughly combined before adding the next. Continue adding the remaining ingredients in order—the chili paste, garlic, lime leaves, ginger, and cilantro.

2 Wet your hands and shape the mixture into four oval patties, each about 1$^1/_2$ in/3.5 cm thick. Make sure the mixture is compressed and compact. Dust the top and bottom of each patty with the remaining cornstarch.

3 To grill the turkey cakes, place them on a well-oiled, medium-hot grill. Cook for 10 minutes on each side until browned, firm, and cooked through. Place the cakes on a platter and add the lemon wedges, so that their juice can be squeezed over.

Genius Tip Remember to preheat gas barbecues for 10 minutes at the desired cooking temperature with the cover down. You are now ready for grilling.

Smoked Turkey Breast Roulade

Serves **4** | Preparation **10 minutes** | Grilling **5 minutes**

12 thin slices smoked turkey breast
12 bamboo skewers, soaked in water for 1 hour

FILLING
6 oz/175 g sharp Cheddar cheese, grated

3 tablespoons finely chopped red bell pepper
2 tablespoons snipped chives
1 jalapeño pepper, seeded and finely minced or chopped

1 First make the filling: mix the cheese, bell pepper, chives, and jalapeño pepper in a bowl.

2 Lay the turkey slices out on a board. Spoon a ball of the filling into the center of the lower third of each slice of turkey. Spread the filling over the turkey, to within 2 in/5 cm of the ends. Roll up the turkey slices to enclose the filling jelly-roll style. Gently press the end down. Run a bamboo skewer through the end of the turkey at an angle to keep the roll neatly closed.

3 To grill the roulades, place on a well-oiled, medium-hot grill and cook for 5 minutes, turning halfway through. The outside should be evenly browned and the cheese filling melted. To serve the turkey roulades, arrange them on a serving platter with the skewers intact.

Lemon-Ginger Duck Breasts

Serves **4** | Preparation **19 minutes** | Marinating **4 hours** | Grilling **12–15 minutes**
plus **5 minutes simmering**

**4 x 8 oz/225 g boneless duck breasts
with skin**
¹/₄ cup/1 oz/25 g toasted sesame seeds
¹/₂ cup/2 oz/50 g chopped green onion

MARINADE
grated zest and juice of 1 lemon
¹/₂ cup/4 fl oz/125 ml sweet chili sauce

**¹/₄ cup/2 fl oz/60 ml Vietnamese
fish sauce**
1 tablespoon dark sesame oil
**3 garlic cloves, crushed and then
chopped with 1 tablespoon
coarse sea salt**
**2 tablespoons finely minced or
chopped fresh root ginger**

1 Rinse the duck thoroughly under cold running water and pat dry with paper towels. Score four slashes each about 4 in/10 cm long in a criss-cross pattern into the duck skin but not through into the flesh. Place in a shallow dish.

2 MIx the lemon zest and juice, chili sauce, fish sauce, sesame oil, garlic, and ginger for the marinade. Pour the mixture over the duck breasts and rub it in well, especially into the slash marks. Cover and refrigerate for 4 hours.

3 Drain off the liquid from the duck and pour it into a small saucepan. Bring to a boil, then reduce the heat and simmer for 5 minutes. Strain this reduced marinade and set aside for glazing the duck during cooking.

4 To grill the duck, place the breasts, skin-sides down on a well-oiled, medium-hot grill. Cook for 8 minutes, until the skin is well browned and crisp. Turn the duck and move the portions to the edges of the grill, where the heat is less intense. Cook for a further 4–7 minutes, until the duck is medium rare. Brush the duck with the reserved marinade throughout cooking. Transfer the duck to a cutting board and cover loosely with foil. Leave to rest for 5 minutes.

5 Cut the duck across at an angle into ¹/₄ in/5 mm thick slices. Fan the slices on serving plates. Sprinkle with toasted sesame seeds and green onion, and serve at once.

Duck with Red Curry Marinade

Serves **4** | Preparation **18 minutes** | Marinating **6 hours** | Grilling **12–15 minutes**
plus **5 minutes simmering**

4 x 8 oz/225 g boneless duck breasts
with skin
$^1/_2$ cup/2 oz/50 g chopped peanuts
$^1/_4$ cup/1 oz/25 g finely chopped
green onion

MARINADE AND SAUCE
1 cup/8 fl oz/250 ml coconut milk
$^1/_4$ cup/2 fl oz/60 ml ketjap manis
(Indonesian sweet soy sauce)

1 tablespoon red curry paste
1 tablespoon light sesame oil
4 kefir lime leaves, finely shredded
4 garlic cloves, crushed and then
chopped with 1 teaspoon coarse
sea salt
juice of 2 limes

1 Thoroughly rinse the duck under cold running water and pat dry on paper towels. Score four criss-cross slashes, each 4 in/10 cm long, into the skin, taking care not to cut into the flesh. Place the duck portions in a shallow dish.

2 To make the marinade, whisk the coconut milk, sweet soy sauce, curry paste and oil together. Stir in the lime leaves and then pour the marinade over the duck. Rub the mixture over the duck by hand. Cover the dish and refrigerate for 6 hours, turning the duck portions three times.

3 Drain the liquid off the duck into a small saucepan. Bring to the boil, then reduce the heat and simmer for 5 minutes. Remove from the heat and set aside for glazing the duck during cooking.

4 To cook the duck, place the portions skin-side down in the center of a well-oiled medium-hot grill. Cook for 8 minutes, until the skin is browned and crisp. Turn the portions and move them to the edge of the grill where the heat is less intense. Cook for a further 4–7 minutes, until the duck is medium rare. Brush the reserved marinade over the duck throughout the grilling. Transfer the duck to a cutting board and cover loosely with foil, then leave to rest for 5 minutes.

5 Cut the meat across at an angle into $^1/_4$ in/5 mm slices. Transfer to plates and sprinkle the peanuts and green onion over the top. Serve at once.

poultry & wild birds

Duck in Sage & Ginger Marinade

Serves **4** | Preparation **15 minutes** | Marinating **10 hours** | Grilling **12–15 minutes**
plus **5 minutes simmering**

**4 x 8 oz/225 g boneless duck breasts
with skin**
1 teaspoon coarse sea salt
**1 teaspoon freshly ground black
pepper**

MARINADE
2 cups/16 fl oz/475 ml marsala wine
2 tablespoons olive oil

**4 garlic cloves, crushed and then
chopped with 1 tablespoon coarse
sea salt**
**3 tablespoons finely minced or
chopped fresh root ginger**
**1/2 cup/1 oz/25 g coarsely chopped
fresh sage**
**1 tablespoon freshly ground
black pepper**

1 Thoroughly rinse the duck under cold running water and pat dry on paper towels. Score four criss-cross slashes, each 4 in/10 cm long, into the skin, taking care not to cut into the flesh. Place the duck portions in a shallow dish.

2 To make the marinade, whisk the wine and oil together. Stir in the garlic, ginger, sage and pepper, then pour the mixture over the duck. Cover and refrigerate for 10 hours. Turn the meat over four times during marinating.

3 Drain the liquid off the duck into a small saucepan. Bring to the boil, then reduce the heat and simmer for 5 minutes. Remove from the heat and set aside for glazing the duck during cooking.

4 To cook the duck, place the portions skin-side down in the middle of a well-oiled medium-hot grill. Cook for 8 minutes, until the skin is browned and crisp. Turn the portions and move them to the edge of the grill where the heat is less intense. Cook for a further 4–7 minutes, until the duck is medium rare. Brush the reserved marinade over the duck throughout the grilling. Transfer the duck to a cutting board and cover loosely with foil, then leave to rest for 5 minutes.

5 Cut the meat across at an angle into 1/4 in/5 mm slices. Transfer to plates and sprinkle with salt and pepper. Serve at once.

Duck in Peanut Sauce Marinade

Serves **4** | Preparation **19 minutes** | Marinating **6 hours** | Grilling **12–15 minutes**
plus **5 minutes simmering**

4 x 8 oz/225 g boneless duck breasts
with skin
1 tablespoon coarse sea salt
$^{1}/_{4}$ cup/1 oz/25 g chopped peanuts
$^{1}/_{4}$ cup/1 oz/25 g finely chopped
green onion
$^{1}/_{4}$ cup/$^{1}/_{2}$ oz/15 g coarsely chopped
cilantro

MARINADE AND GLAZE
1 cup/8 fl oz/250 ml plum wine
1 cup/8 fl oz/250 ml mirin (Japanese
sweet wine)
2 tablespoons smooth peanut butter
2 tablespoons molasses
1 tablespoon finely minced or chopped
fresh root ginger
3 garlic cloves, crushed
1 red chili pepper, seeded and finely
minced or chopped

1 Thoroughly rinse the duck under cold running water and pat dry with paper towels. Score four criss-cross slashes, each 4 in/10 cm long, into the skin, taking care not to cut into the flesh. Place the duck portions in a shallow dish.

2 To make the marinade and glaze, stir both types of wine, peanut butter and molasses together to make a runny paste. Stir in the ginger, garlic and chili. Spoon this mixture over the duck and massage it into the portions, especially the slash marks, by hand. Cover and refrigerate for 6 hours.

3 Drain the marinade off the duck and pour it into a small saucepan. Bring to a boil over medium-high heat on the stovetop. Reduce the heat and simmer the marinade for 5 minutes, until thickened. Remove from the heat.

4 To cook the duck, place the portions skin-side down in the middle of a well-oiled medium-hot grill. Cook for 8 minutes. Turn the portions and move them to the edge of the grill where the heat is less intense. Cook for a further 4–7 minutes, until the duck is medium rare. Brush the glaze over the duck throughout the grilling. Transfer the duck to a cutting board and cover loosely with foil, then leave to rest for 5 minutes.

5 To serve the duck, cut the meat across at an angle into $^{1}/_{4}$ in/5 mm slices. Fan out the slices on plates and sprinkle with salt, peanuts, green onion, and cilantro.

poultry & wild birds

159

Duck with Port-wine Marinade

Serves **4** | Preparation **28 minutes** | Marinating **24 hours** | Grilling **12–15 minutes**
plus **7 minutes simmering**

**4 x 8 oz/225 g boneless duck breasts
with skin**
2 tablespoons molasses
2 tablespoons olive oil
1 tablespoon coarse sea salt

MARINADE
1/2 cup/4 fl oz/125 ml port
finely grated zest and juice of 1 orange
2 tablespoons orange marmalade
1 tablespoon balsamic vinegar
1 tablespoon whole black peppercorns

3 bay leaves, crumbled
1/2 teaspoon whole allspice
6 cloves

SAUCE
1 teaspoon arrowroot
1 cup/8 fl oz/250 ml chicken stock
1 tablespoon tomato paste
3 tablespoons redcurrant jelly
1 teaspoon coarse sea salt
**1 teaspoon freshly ground
black pepper**

1 Thoroughly rinse the duck under cold running water and pat dry with paper towels. Score four criss-cross slashes, each 4 in/10 cm long, into the skin, taking care not to cut into the flesh. Place the duck portions in a shallow dish.

2 To make the marinade, mix the port, orange zest and juice, marmalade, vinegar, peppercorns, bay leaves, allspice, and cloves. Stir until the ingredients are thoroughly mixed, then pour the mixture over the duck. Rub the marinade over the portions and into the score marks by hand. Cover and refrigerate for 24 hours. Turn the duck breasts over four times during marinating.

3 Drain the marinade from the duck and strain it through a fine sieve. Reserve this marinade. Make the sauce before cooking the duck. Place the arrowroot in a saucepan and whisk in the reserved marinade. Place over medium heat on the stovetop and bring to a boil, stirring continuously. Stir in the chicken stock and bring back to the boil. Then stir in the tomato paste and jelly. Simmer the sauce for 7 minutes, stirring often, until it is smooth and velvety. Cover and keep hot over very low heat, or on the side of the grill, while cooking the duck.

4 Stir the molasses and oil together in a small bowl. Brush a little of the molasses mixture over the duck skin, sprinkle all over with salt and place skin-side down in the middle of a well-oiled, medium-hot grill. Cook for 8 minutes,

turn the portions, and move them to the edge of the grill where the heat is less intense. Cook for a further 4–7 minutes, until the duck is medium rare. Brush the molasses mixture over the duck during grilling. Transfer the duck to a cutting board and cover loosely with foil, then leave to rest for 5 minutes.

5 Cut the meat across at an angle into $1/4$ in/5 mm slices. Transfer to plates, fanning out the slices. Stir the sauce and then spoon it over the duck to serve.

• •

Chinese Five-Spice Duck Breasts

Serves **4** | Preparation **7 minutes** | Marinating **4 hours** | Grilling **12–15 minutes**

4 x 8 oz/225 g boneless duck breasts with skin	3 tablespoons light sesame oil
1 tablespoon Chinese five-spice powder	1 tablespoon coarse sea salt
	$1/2$ cup/2 oz/50 g finely chopped green onion

1 Rinse the duck thoroughly under cold running water and pat dry with paper towels. Score four 4 in/5 mm slashes at an angle in the breasts, in a criss-cross pattern, penetrating the skin but not piercing the flesh.

2 Sprinkle the five-spice powder over both sides of the duck and rub it in evenly all over the portions, including into the slashes. Place in a shallow dish, cover and refrigerate for 4 hours.

3 Cook the duck portions skin side down on a well-oiled, medium-hot grill for 8 minutes until the skin is browned and crisp. Brush the meat with sesame oil, turn the portions and move them to the edge of the grill, where the heat is not as fierce. Cook for an additional 4–7 minutes, until the duck is medium rare.

4 Transfer the duck to a cutting board. Sprinkle both sides of the portions with salt and cover loosely with foil. Allow to rest for 5 minutes.

5 To serve the duck breasts, cut them across at a slant into $1/4$ in/5 mm slices. Fan out the slices on individual plates. Sprinkle with the green onion and serve.

Vietnamese-style Duck Breast

Serves **4** | Preparation **25 minutes** | Marinating **24 hours** | Grilling **10 minutes**

4 x 8 oz/225 g skinless and boneless
duck breasts
sesame oil

MARINADE
6 garlic cloves
6 shallots
3 chili peppers, seeded
1 cup/2 oz/50 g coarsely chopped
cilantro
1 cup/2 oz/50 g coarsely chopped basil
2 teaspoons freshly ground
black pepper
4 tablespoons fish sauce (nuoc mam)

5 tablespoons soy sauce
2 tablespoons brown sugar

PIQUANT DIPPING SAUCE
3 garlic cloves, crushed
1 teaspoon freshly grated fresh
root ginger
1 chili pepper, seeded and finely
chopped or minced OR $^1/_2$ teaspoon
jalapeño condiment (see page 42)
juice of 1 lime
7 tablespoons sweet sushi rice vinegar
5 tablespoons fish sauce (nuoc mam)

1 Place the duck breasts between two sheets of baking parchment or wax paper and pound flat until evenly thick. Place in a shallow dish.

2 To make the marinade, process the garlic, shallots, chili peppers, cilantro, basil, pepper, fish sauce, and soy sauce in a food processor to a smooth paste. Massage the mixture into the duck breasts and cover the dish. Leave to marinate overnight, turning the duck portions a few times.

3 Mix the garlic, ginger, chili pepper, lime juice, rice vinegar and fish sauce for the dipping sauce. Cover and set aside.

4 Cook the duck on a medium-hot grill brushed with sesame oil, allowing 5 minutes on each side. Transfer to a cutting board, cover with foil and allow to rest for 5 minutes.

5 Cut each breast at an angle into slices and fan the slices on plates. Serve the piquant dipping sauce on the side.

Moroccan Game Hens

Serves 4 | Preparation **24 minutes** | Marinating **6 hour** | Grilling **30 minutes**

4 x 1 lb/450 g game hens	1 onion, finely grated
3 tablespoons olive oil	1 cup/2 oz/50 g chopped flat-leaf
juice of 1 lemon	parsley
1 teaspoon ground coriander	1 cup/2 oz/50 g chopped cilantro
1/2 teaspoon ground turmeric	1 tablespoon coarse sea salt
1/2 teaspoon cayenne pepper	1 tablespoon freshly ground
1/2 teaspoon ground cumin	black pepper

1 Rinse the game hens, inside the body cavities and outside, with cold water. Pat the birds dry with paper towel. Using poultry shears, and holding a game hen breast down, cut lengthwise through the back. Spread the bird open so that it lies flat, breast uppermost. Repeat with the remaining birds. Separate and loosen the skin from the breast on all four birds beginning at the neck. Score two small incisions through the skin and into the flesh, halfway around each leg and into the thigh meat.

2 To make the marinade, whisk the oil and lemon juice together in a bowl. Add the onion, coriander, turmeric, cayenne, cumin, onion, parsley, cilantro, salt, and pepper. Stir to thoroughly combine the ingredients in a coarse mixture.

3 Spoon a little of the marinade between the skin and breast meat of each bird, spreading it in a thin layer. Place the birds in a shallow dish and spread the remaining mixture all over them, rubbing it in. Cover and refrigerate for 6 hours.

4 To cook the game hens, place them skin-side down on a well-oiled, medium-hot grill. Cook for 5 minutes or until the skin begins to brown. Slide the hens to the edge or cooler side of the barbecue and cook for an additional 10 minutes, until well browned. Check the undersides occasionally to ensure they do not burn.

5 Turn the game hens over, return them to the middle of the grill and repeat the process in step 4. By the end of the 30 minutes cooking, the birds should be cooked through. Pierce a thick area of meat to check that the juices run clear.

6 Transfer the game hens to a cutting board and cover loosely with foil. Allow to rest for 5 minutes before serving. Cut each bird in half and arrange on plates.

poultry & wild birds

Game Hens with Citrus Cream Sauce

Serves **4** | Preparation **24 minutes** | Marinating **6 hour** | Grilling **30 minutes**
plus **5 minutes simmering**

4 x 1 lb/450 g Cornish game hens
1 cup/8 fl oz/250 ml heavy cream
¹/₂ cup/1 oz/25 g coarsely chopped cilantro

MARINADE
1 cup/8 fl oz/250 ml hoisin sauce
2 tablespoons light sesame oil
¹/₂ cup/4 fl oz/125 ml freshly squeezed orange juice

grated zest of 1 orange
¹/₂ cup/4 fl oz/125 ml chicken stock
¹/₂ cup/4 fl oz/125 ml lemon juice
1 large onion, grated
2 tablespoons finely minced or chopped fresh root ginger
1 red chili pepper, seeded and finely minced or chopped
3 teaspoons coarse sea salt

1 Thoroughly rinse the game hens, inside the body cavities and outside, with cold running water. Pat the birds dry with paper towel. Cut the birds lengthwise in half, using a poultry shears. Make two 1 in/2.5 cm slash marks into the meaty parts of each thigh and leg. Place the portions in a shallow dish.

Genius Tip Consider the indirect grilling method when barbecuing thick cuts of meat, whole birds, and roasts of wild game. By setting up a drip pan flat in the center of the barbecue basin, coals can be arranged in side baskets or on either side of the pan to generate heat. If there is no drip pan accessory to your barbecue, create your own, large enough to accommodate the size of the meat. Line a pan with aluminum foil, reflective side up to create ease in cleaning later on. Generally this method is used when cooking time requires at least 25 minutes and requires the lid of the kettle to be closed. Some of the benefits of this method are the ability to create higher heat, consistency of temperature and shorter cooking time. It is not necessary to turn the meat in this case and the possibility of burning is eliminated, as dripping fat falls directly into the pan as opposed to direct flames. Please note that one disadvantage may be the loss of a caramelized, crispy or charred surface.

2 To make the marinade, place the hoisin sauce, sesame oil, orange juice, zest, stock, lemon juice, onion, ginger, chili, and salt in a food processor. Process until smooth. Pour a third of the mixture into a bowl, cover, and refrigerate. Pour the remaining mixture over the birds, cover and refrigerate for 6 hours, turning the portions every 2 hours.

3 Drain the liquid off the birds and pour it into a saucepan. Bring to a boil and simmer for 5 minutes. Remove from the heat, cover, and set aside.

4 To cook the game hens, place them skin-side down, on a well-oiled, medium-hot grill. Cook for 5 minutes or until the skin begins to brown. Slide the hens to the edge or cooler side of the barbecue and cook for an additional 10 minutes, until well browned. Brush with the reserved unused marinade during cooking. Check the undersides occasionally to ensure they do not burn.

5 Turn the game hens over, return them to the middle of the grill and repeat the process in step 4. By the end of the 30 minutes cooking, the birds should be cooked through. Pierce a thick area of meat to check that the juices run clear, without any sign of blood.

6 Meanwhile, gently reheat the cooked marinade in the saucepan. Whisk in the cream and remove the pan from the stove. Stir in the cilantro. Serve the hens on oval platters with the citrus cream sauce spooned onto one side. Boiled potatoes sprinkled with parsley and steamed broccoli florets are suitable accompaniments.

Khyber-Pass Game Hens

Serves 4 | Preparation **26 minutes** | Marinating **24 hour** | Grilling **30 minutes**

4 x 1 lb/450 g Cornish game hens

MARINADE
1 cup/8 oz/225 g whole-fat plain yogurt
1/2 cup/4 fl oz/125 ml olive oil
juice of 1/2 lemon
1 tablespoon liquid molasses
1 onion, finely grated

6 garlic cloves, crushed
1 red chili, seeded and finely chopped or minced
1 tablespoon saffron threads
1 tablespoon coarse sea salt
1 tablespoon freshly ground black pepper
1 teaspoon ground cumin

1 Thoroughly rinse the game hens, inside the body cavities and outside, with cold running water. Pat the birds dry with paper towel. Cut the birds lengthwise in half, using a poultry shears. Make two incisions through the skin and into the flesh on the legs and thighs of each of the birds. Place the birds in a shallow dish.

2 To make the marinade, stir the yogurt, oil, lemon, and molasses until smooth and evenly mixed. Add the onion, garlic, chili, saffron, salt, pepper, and cumin, and mix thoroughly. Spoon the mixture over the game hens, rubbing it into the skin and into the incisions on the legs and thighs. Cover the dish and refrigerate for 24 hours.

3 To cook the game hens, place them skin-sides down on a well-oiled, medium-hot grill. Cook for 5 minutes or until the skin begins to brown. Slide the hens to the edge or cooler side of the barbecue and cook for an additional 10 minutes, until well browned. Check the undersides to ensure they do not burn.

4 Turn the game hens over, return them to the middle of the grill, and repeat the process in step 3. By the end of the 30 minutes cooking, the birds should be cooked through. Pierce a thick area of meat to check that the juices run clear.

5 To serve the hens, transfer them to a platter and cover loosely with foil. Allow to rest for 5 minutes before transferring to individual plates.

Barbecued Greek-isles Quail

Serves **4** | Preparation **16 minutes** | Marinating **2 hours** | Grilling **12 minutes**

8 x 1/4 lb/100 g quail	**2 tablespoons dried oregano,**
	preferably Greek
MARINADE	**1 tablespoon coarse sea salt**
1 cup/8 fl oz/250 ml Greek olive oil	**1 tablespoon freshly ground**
juice of 2 lemons	**black pepper**
finely grated zest of 1 lemon	

1 Thoroughly rinse the quail, inside the body cavities and outside, with cold running water. Pat the birds dry with paper towel. Cut the birds lengthwise in half, using a poultry shears. Make two incisions through the skin and into the flesh on the thighs of each bird. Place in a shallow dish.

2 To make the marinade, whisk the oil and lemon juice together. Stir in the oregano, salt, and pepper, then spoon the mixture over the birds and rub over the surfaces with your hands. Cover and refrigerate for 2 hours, turning the birds over halfway through marinating.

3 To grill the quail, place them skin-sides down on a well-oiled, medium-hot grill. Cook for 6 minutes on each side, until well browned and cooked through. Serve at once.

Genius Tip Try this method when grilling small birds, such as game hens or quail. To spatchcock a small bird use poultry shears to snip off the pinions or wingtips at the joint. Place the breast side of the bird down in the palm of your hand and snip away each side of the backbone. Snip the wishbone in half. Rinse the inside cavity with cold running water, pat dry with a paper towel and trim away any extra skin. Place the bird on a flat surface with the breast side facing up and the legs turned inward. Flatten the bird in one pound of the hand, using your palm and exerting pressure on the breast. Make a slight incision into the skin between the breastbone and the leg and tuck the tip of the leg into the pocket. Thread two long metal skewers through the leg and wing portions of the birds to hold them in a flat, spread-out position.

Quail with Five-spice & Ginger

Serves 4 | Preparation **19 minutes** | Marinating **8 hour** | Grilling **12 minutes** plus **5 minutes simmering**

8 x ¹/₄ lb/100 g quail
¹/₂ cup/1 oz/25 g coarsely chopped cilantro

MARINADE
¹/₂ cup/4 fl oz/125 ml sesame oil
¹/₂ cup/4 fl oz/125 ml ketjap manis (Indonesian sweet soy sauce)
¹/₂ cup/4 fl oz/125 ml Japanese plum wine
1 tablespoon light liquid honey

¹/₄ cup/1 oz/10 g finely minced or chopped fresh root ginger
6 garlic cloves, crushed and then chopped with 1 tablespoon coarse sea salt
1 red chili pepper, seeded and finely minced or chopped
2 tablespoons Chinese five-spice powder
¹/₂ cup/1 oz/25 g coarsely chopped cilantro

1 Thoroughly rinse the quail, inside the body cavities and outside, with cold running water. Pat the birds dry with paper towel. Cut the birds lengthwise in half, using a poultry shears. Make two 1 in/2.5 cm incisions through the skin and into the flesh on the thighs of each bird. Place in a shallow dish.

2 To make the marinade, whisk the oil, ketjap manis, wine, and honey together in a mixing bowl. Stir in the ginger, garlic, chili, and five-spice powder. Pour the marinade over the quail and massage it over them by hand. Cover and refrigerate for 8 hours. Turn the quail three times during marinating.

3 Before grilling the quail, drain the marinade into a small saucepan. Bring to a boil and simmer for 5 minutes. Remove from the heat and reserve for glazing the quail during cooking.

4 To grill the quail, place the birds skin-sides down on a well-oiled, medium-hot grill. Cook for 6 minutes on each side, brushing with the leftover marinade throughout grilling. The quail should be well browned and cooked through: when a thick part, such as the thigh, is pierced, the juices will run clear. Fan out the quail halves on a serving platter and sprinkle with chopped cilantro.

Quail with Cumin & Coriander Seed

Serves **4** | Preparation **15 minutes** | Marinating **8 hour** | Grilling **12 minutes**
plus **3 minutes simmering**

8 x ¹⁄₄ **lb/100 g quail**
¹⁄₂ **cup/1 oz/25 g coarsely chopped
flat-leaf parsley**

MARINADE
¹⁄₄ **cup/2 fl oz/60 ml olive oil**
¹⁄₄ **cup/2 fl oz/60 ml dry red wine**

4 **garlic cloves, crushed and then
chopped with 1 tablespoon coarse
sea salt**
1 **teaspoon ground coriander**
1 **teaspoon ground cumin**
1 **teaspoon paprika**
1 **teaspoon dried chili flakes**

1 Thoroughly rinse the quail, inside the body cavities and
outside, with cold running water. Pat the birds dry with paper
towel. Cut the birds lengthwise in half, using a poultry shears.
Make two 1 in/2.5 cm incisions through the skin and into the
flesh on the thighs of each bird. Place in a shallow dish.

2 To make the marinade, whisk the oil and wine together.
Stir in the garlic, coriander, cumin, paprika, and chili flakes.
Pour the marinade over the quails, cover, and refrigerate
for 8 hours. Turn the birds over three times during the
marinating process.

3 Drain off the marinade and pour it into a small
saucepan. Bring to the boil, reduce the heat, and
simmer the mixture for 3 minutes. Remove the
pan from the heat.

4 To grill the quail, place the birds skin-sides
down on a well-oiled, medium-hot grill. Cook
for 6 minutes on each side, brushing with the
leftover marinade throughout grilling. The
quail should be well browned and cooked
through, when their juices will run clear.
Transfer the birds to a serving platter.
Sprinkle parsley over the top and serve.

poultry & wild birds

Lemon & Lime Quail

Serves **4** | Preparation **18 minutes** | Marinating **8 hour** | Grilling **12 minutes**
plus **5 minutes simmering**

8 x ¼ lb/100 g quail	6 kefir lime leaves, finely shredded
	3 garlic cloves
MARINADE	1 tablespoon coarse sea salt
2 limes, coarsely chopped	½ cup/4 fl oz/125 ml light sesame oil
2 lemon grass stalks, trimmed and	½ cup/4 fl oz/125 ml sweet chili sauce
coarsely chopped	1 tablespoon fish sauce

1 Thoroughly rinse the quail, inside the body cavities and outside, with cold running water. Pat the birds dry with paper towel. Cut the birds lengthwise in half, using a poultry shears. Make two 1 in/2.5 cm incisions through the skin and into the flesh on the thighs of each bird. Place in a shallow dish.

2 To make the marinade, purée the limes, lemon grass, leaves, garlic, and salt together in a food processor to make a pulpy mush. Empty the contents into a bowl and stir in the oil, chili sauce, and fish sauce. Pour this mixture over the quail and rub it in by hand. Cover the dish and refrigerate for 8 hours.

3 Drain off the pulpy liquid and pour it into a saucepan. Bring to a boil, reduce the heat and simmer for 5 minutes. Remove from the heat and strain into a bowl ready for brushing over the birds while grilling.

4 To grill the quail, place the birds skin-sides down on a well-oiled, medium-hot grill. Cook for 6 minutes on each side, brushing with the leftover marinade throughout grilling. The quail should be well browned and cooked through, when their juices will run clear. Transfer the birds to a serving platter.

Genius Tip To check that poultry is cooked, pierce the thick meat on the thigh. The juices should be clear, without any signs of blood.

Buttermilk-marinated Quail

Serves **4** | Preparation **21 minutes** | Marinating **24 hour** | Grilling **12 minutes**

8 x ¼ lb/100 g quail	2 tablespoons soft brown sugar
	juice of 1 lemon
MARINADE	1 tablespoon coarse sea salt
1 cup/8 fl oz/250 ml buttermilk	1 teaspoon chili powder
3 tablespoons canola oil	1 teaspoon ground allspice
2 tablespoons liquid molasses	1 teaspoon freshly ground black pepper

1 Thoroughly rinse the quail, inside the body cavities and outside, with cold running water. Pat the birds dry with paper towel. Using poultry shears, cut lengthwise along the breast of each quail. Spread the birds flat so that their back bones run along the middle. Slice two small and shallow incisions through the skin and just into the flesh on each thigh. Place the birds flat in a dish.

2 To make the marinade, whisk the buttermilk, canola oil, molasses, sugar, lemon juice, salt, chili powder, allspice, and pepper together until smooth. Pour the marinade over the birds and rub it over them by hand. Cover and refrigerate for 24 hours.

3 Drain the quail and skewer each bird flat on two metal skewers. Insert one through the wings and breast just over halfway along the body, and the other through the thighs. Try to pierce the birds at an angle so that the skewer handles meet at a point and create a grip for turning the quail during cooking. The ends of the skewers will also rest over the edge of the barbecue more easily this way.

4 Cook the skewered quail, skin-sides down, a well-oiled, medium-hot grill. Cook for 6 minutes on each side, until well browned and cooked through. Transfer to a platter, and remove the skewers. Cover loosely with foil and leave to rest for 5 minutes before serving. A good mixed green salad goes well with the quail, especially when tossed with a little hazelnut oil and a squeeze of lemon juice.

poultry & wild birds

chapter **3**

beef, veal
& game

Lemon Grass Beef Sate

Serves **4** | Preparation **22 minutes** | Marinating **2 hours** | Grilling **6 minutes**
plus **5 minutes simmering**

2 lb/900 g boneless sirloin steak, trimmed of fat
¹/₂ cup/2 oz/50 g chopped green onion
¹/₂ cup/2 oz/50 g chopped salted peanuts

MARINADE
3 lemon grass stalks
2 limes, halved
1 tablespoon coriander seeds, crushed

4 kefir lime leaves
4 garlic cloves
1 red chili pepper, seeded and chopped
1 tablespoon soft brown sugar
¹/₂ cup/4 fl oz/125 ml sake
2 tablespoons light molasses
3 tablespoons fish sauce
3 tablespoons dark soy sauce
2 tablespoons peanut oil

1 Cut the steak into strips measuring 5 in/12¹/₂ cm long and 2 in/5 cm wide. Place these between two sheets of baking parchment or wax paper and pound out until evenly ¹/₂ in/1 cm thick. Place in a shallow dish.

2 To make the marinade, place the lemon grass stalks, limes, coriander seeds, lime leaves, garlic, chili, and sugar in a food processor and process to a lumpy pulp. Turn the mixture into a large mixing bowl and stir in the sake, molasses, fish sauce, soy sauce, and peanut oil.

3 Add the meat to the marinade in the bowl. Toss well until the meat is thoroughly coated. Turn the meat into a shallow dish, scraping out all the marinade from the bowl. Cover and refrigerate for 2 hours.

4 Drain the beef, scraping the marinade off the strips. Pour the marinade into a small saucepan and bring to a boil. Reduce the heat and simmer for 5 minutes. Strain the mixture into a bowl—use this reduced marinade to glaze the meat during cooking.

5 Thread the beef strips onto metal skewers, weaving the strips and leaving about a third of their length free at each end. Spread the strips flat once they are on the skewers. Brush with the reduced marinade.

6 Cook the beef sate on a well-oiled medium-hot grill. Cook for 3 minutes on each side, turning once, and brushing with the reduced marinade.

7 Scrape the strips of beef from the skewers onto a serving platter and drizzle any remaining glaze over them. Sprinkle with the chopped green onion and peanuts and serve at once.

Genius Tip Always use heat-resistant mitts or gloves and long-handled tools when barbecuing to ensure that your hands are kept well away from the flames.

Marrakech Beef Kabobs

Serves **4** | Preparation **21 minutes** | Marinating **6 hours** | Grilling **12 minutes**

3 tablespoons olive oil	1 teaspoon cayenne pepper
grated zest and juice of 1 lemon	1 teaspoon ground cumin
1 onion, finely minced or chopped	2 lb/900 g boneless sirloin steak, cut
$^{1}/_{2}$ cup/1 oz/25 g coarsely chopped	into $1^{1}/_{2}$ in/3.5 cm cubes
flat-leaf parsley	1 tablespoon coarse sea salt
3 garlic cloves, crushed	

1 In a large bowl, mix the olive oil with the lemon zest and juice, onion, parsley, garlic, cayenne, and cumin to make a chunky paste. Add the meat and mix well by hand to coat all the cubes. Turn the meat into a shallow dish, spreading out the cubes in a single layer, and scrape all the marinade from the bowl. Cover and refrigerate for 6 hours.

2 Thread the cubes of meat on eight long metal skewers. Place on a well-oiled, medium-hot grill and cook for 3 minutes on each side, or a total of 12 minutes. Transfer to a serving platter.

Beef & Coconut Sate

Serves 4 | Preparation **17 minutes** | Grilling **5–8 minutes**

¹/₂ lb/225 g ground chuck steak
¹/₂ lb/225 g ground sirloin steak
1 cup/8 fl oz/250 ml coconut milk
2 tablespoons ketjap manis
(Indonesian sweet soy sauce)
1 tablespoon Indonesian sweet
chili sauce
2 tablespoons peanut oil
1 tablespoon light sesame oil
juice of 1 lime

1 tablespoon minced or finely chopped
fresh root ginger
1 teaspoon ground turmeric
2 teaspoons coarse sea salt
1 teaspoon freshly ground
black pepper
1 cup/2 oz/50 g coarsely chopped
cilantro
24 bamboo skewers, soaked in water
for 1 hour

1 Place the chuck steak and sirloin in a bowl. Add the coconut milk, ketjap manis, chili sauce, peanut oil, sesame oil, lime juice, ginger, turmeric, half the salt, and the pepper. Mix all the ingredients by hand, squeezing and kneading until thoroughly combined.

2 Wash your hands and then rinse them under cold water (the meat mixture does not stick to wet hands). Shape the meat mixture into 24 balls. Shape a ball of meat into a sausage around a bamboo skewer—the meat should be about 1¹/₂ in/3.5 cm thick and 4 in/10 cm long, and leave at least 1 in/2.5 cm skewer free at each end. Place on a baking sheet or plastic tray lined with plastic wrap. Repeat with the remaining meat.

3 Cook the sate on a well-oiled hot grill. Grill them for 3–5 minutes on the first side and 3 minutes on the second side, until evenly browned and cooked through. Serve at once, sprinkled with the remaining salt and chopped cilantro.

Lemon Pepper Sirloin Steak

Serves **4** | Preparation **9 minutes** | Marinating **5 hours** | Grilling **8 minutes**

4 x 10 oz/275 g sirloin steaks	MARINADE
1 tablespoon Dijon Mustard	3 tablespoons olive oil
3 tablespoons freshly ground	juice of $^1/_2$ lemon
black pepper	$^1/_2$ cup/4 fl oz/125 ml dry red wine
3 tablespoons dried red chili	2 garlic cloves, crushed
flakes	1 tablespoon coarse sea salt
2 tablespoons dried Greek oregano	

1 Trim off excess fat from the steaks, leaving $^1/_4$ in/5 mm around the edge of the meat. Score the fat at 1 in/2.5 cm intervals. Stir the mustard, pepper, chili, and oregano together. Smear and press the mixture over the steaks, then lay them in a large shallow dish.

2 To make the marinade, whisk the oil, lemon juice, wine, and garlic together. Pour this over the steaks and turn them a few times to coat both sides in the mixture. Cover and refrigerate for 5 hours, turning the steaks over every hour.

3 Sprinkle half the salt over the steaks and place, salted sides down, on a well-oiled, medium-hot grill. Cook for 1 minute. Sprinkle the tops with the remaining salt, turn the steaks and cook on the other side for 1 minute. Move the steaks to the edge of the barbecue and cook for 4 minutes on each side for a medium-rare result (also see the cooking chart on page 187). Serve at once. Potato wedges seasoned with rosemary, and cherry tomatoes grilled on skewers are classic accompaniments.

Genius Tip Remember to trim the majority of fat from meat before cooking. A little fat provides flavor, whereas too much may be prone to catching fire. Banish the temptation to stick and stab meat when turning. Unnecessary loss of juices means loss of flavor to the dish.

Cubano-style Top Sirloin Steaks

Serves **4** | Preparation **10 minutes** | Marinating **30 minutes** | Grilling **6–8 minutes**

4 x 8 oz/225 g top sirloin steaks
1 tablespoon coarse sea salt

MARINADE
2 tablespoons olive oil
juice of 2 limes

5 garlic cloves, crushed
1 teaspoon coarse sea salt
1 teaspoon ground cumin
¹/₂ teaspoon ground coriander
¹/₂ teaspoon cinnamon
¹/₂ teaspoon cayenne pepper

1 Lay one of the steaks between two sheets of baking parchment or waxed paper and pound it with a meat mallet or rolling pin until ¹/₂ in/1 cm thick. Place the thin steak in a shallow dish. Repeat with the remaining steaks.

2 To make the marinade, whisk the oil and lime juice together. Stir in the remaining ingredients to make a thick paste. Spread this over the steak and rub it into them by hand. Leave to rest at room temperature for 30 minutes.

3 Place the steaks on a well-oiled, medium-hot grill and cook for 3–4 minutes on each side, until well browned and medium rare (see cooking chart on page 187). Brush the steaks with any leftover marinade from the dish after turning. Serve at once.

Genius Tip The pounding of meat is usually necessary when a particular cut of meat is not very tender. The process helps to break down the tough fibers and reduces the cooking time.

Bay of Bengal Beef Kabobs

Serves **4** | Preparation **23 minutes** | Marinating **3 hours** | Grilling **12 minutes**

**2 lb/900 g beef tenderloin tips, cut into
1¹/₂ in/3¹/₂ cm cubes**

MARINADE
¹/₂ cup/4 fl oz/125 ml peanut oil
2 tablespoons light molasses
juice of 1 lime
**4 garlic cloves, crushed and chopped
with 2 tablespoons coarse sea salt**
**2 tablespoons finely minced or
chopped fresh root ginger**

1 tablespoon ground coriander
1 teaspoon ground cumin
1 teaspoon turmeric
1 teaspoon cayenne pepper

ACCOMPANIMENTS
4 nan (Indian flat bread)
1 large ripe tomato, seeded and diced
1 English cucumber, peeled and diced
1 red onion, thinly sliced

1 To make the marinade, whisk the oil, molasses, and lime juice together in a mixing bowl. Stir in the garlic, ginger, coriander, cumin, turmeric, and cayenne until thoroughly combined.

2 Place the cubes of meat in a large self-sealing plastic bag. Add the marinade to the meat in the bag. Seal the bag and shake the meat in the marinade until all the pieces are thoroughly coated. Place the bag on a dish and refrigerate for 3 hours.

3 Thread the meat onto eight metal skewers. Cook the kabobs on a well-oiled, medium-hot grill for a total of 12 minutes—3 minutes on each side, turning the skewers four times.

4 Warm the nan on the perimeter of the barbecue until lightly toasted, then transfer the breads to plates. Scrape the meat off the skewers with a fork directly onto the warmed nan. Spoon the tomato, cucumber, and onion over the top and serve at once.

Madeira Beef Kabobs

Serves **4** | Preparation **17 minutes** | Marinating **4 hours** | Grilling **12 minutes**
plus **5 minutes simmering**

3 tablespoons olive oil
1 cup/8 fl oz/250 ml Madeira wine
1 tablespoon light molasses
1 onion, finely chopped
5 garlic cloves, crushed
5 dried bay leaves, crumbled

1 tablespoon dried thyme
1 tablespoon coarse sea salt
1 tablespoon freshly ground
 black pepper
2 lb/900 g lean beef tenderloin tips, cut
 into 2 in/5 cm square cubes

1 Whisk the oil, wine, and molasses together in a large bowl. Stir in the onion, garlic, bay leaves, thyme, salt, and pepper.

2 Add the meat to the bowl and mix well to coat all the cubes thoroughly. Turn the meat into a large shallow dish so that the cubes are spread out in a single layer. Cover and refrigerate for 4 hours.

3 Drain the marinade off the meat and bring it to a boil in a small saucepan. Remove from the heat and reserve for basting the kabobs during grilling. Thread the meat onto eight metal skewers.

4 Cook the kabobs on a well-oiled, medium-hot grill for a total of 12 minutes or 3 minutes on each side. Brush frequently with the marinade to keep the meat moist and give it a deep-brown glaze. The meat should be medium-rare to medium over this temperature and in this time.

5 Scrape the meat off the skewers to serve. Crusty rustic-style bread and a crisp green salad go well with the kabobs.

Sesame-soy Tenderloin Tips

Serves **4** | Preparation **17 minutes** | Marinating **2 hour** | Grilling **4 minutes**
plus **5 minutes simmering**

2 lb/900 g beef tenderloin tips
1 cup/4 oz/100 g chopped green onion
3 tablespoons toasted sesame seeds

MARINADE
$^1/_2$ cup/4 fl oz/125 ml dark soy sauce
2 tablespoons light sesame oil

2 tablespoons Japanese sweet
rice vinegar
1 tablespoon molasses
1 tablespoon soft brown sugar
6 garlic cloves, crushed
2 tablespoons finely minced or
chopped fresh root ginger

1 Trim any excess fat or membrane from the steaks. Slice horizontally through each piece of steak, leaving the slices attached by a thin piece at one side. Fold back the top slice and cut the steak lengthwise into 3 in/7.5 cm wide strips. Pound the strips of meat between two sheets of baking parchment or waxed paper to $^1/_4$ in/5 mm thickness. Place the flattened meat into a shallow dish.

2 To make the marinade, whisk the soy sauce, sesame oil, vinegar, molasses, and sugar together until the sugar has dissolved. Stir in the garlic and ginger. Pour the marinade over the meat and toss the pieces until they are thoroughly coated. Cover and refrigerate for 2 hours.

3 Drain the beef and pour the marinade into a small saucepan. Bring the marinade to a boil, reduce the heat and simmer for 5 minutes. Pour the reduced marinade into a small serving dish and set aside—this sauce may be offered as a condiment with the meat.

4 Use long tongs to place the pieces of meat on a well-oiled, medium-hot barbecue. Cook for 2 minutes on each side, turning the meat once only. Transfer the meat to a serving platter and sprinkle the cilantro and sesame seeds over the top. Serve at once, with the prepared sauce. Steamed rice noodles and snow peas are good accompaniments.

Shashlik

Serves 4 | Preparation **24 minutes** | Marinating **6 hours** | Grilling **12 minutes** plus **5 minutes simmering**

2 lb/900 g beef tenderloin tips
1 large green bell pepper, seeded and cut into wedges
1 large red bell pepper, seeded and cut into wedges
2 large onions, cut into wedges

MARINADE
3 tablespoons olive oil
$^1/_2$ cup/4 fl oz/125 ml dry red wine

$^1/_4$ cup/2 fl oz/60 ml apple cider vinegar
1 tablespoon light molasses
1 tablespoon vodka
1 onion, finely grated
4 dried bay leaves
1 tablespoon black peppercorns
1 tablespoon coarse sea salt
1 teaspoon hot paprika

1 Trim excess fat and membrane off the beef, then cut it into 2 in/5 cm cubes. Place in a shallow dish.

2 To make the marinade, mix the oil, wine, vinegar, molasses, and vodka until thoroughly mixed. Stir in the onion, bay leaves, peppercorns, salt, and paprika and pour this mixture over the meat. Cover the dish and refrigerate for 6 hours.

3 Drain the meat and pour the marinade into a saucepan. Bring to a boil, then reduce the heat and simmer for 5 minutes. Remove from the heat and use to glaze the meat during grilling.

4 Cut the wedges of bell pepper across in half to make triangular chunks. Thread the meat, pepper, and onion wedges alternately onto eight metal skewers. Place the skewers on a well-oiled, medium-hot barbecue and cook for 3 minutes on each side, or a total of 12 minutes. Brush the kabobs with the prepared glaze each time they are turned. Transfer to plates and serve at once.

Dijon-crusted tenderloin

Serves **4** | Preparation **15 minutes** | Marinating **5 hours** | Grilling **10 minutes**

4 x 10 oz/275 g beef tenderloin steaks, about 2 in/5 cm thick, trimmed
4 garlic cloves, finely sliced lengthwise
3 tablespoons olive oil
1 tablespoon Dijon mustard

1 tablespoon freshly ground black pepper
1 tablespoon dried marjoram
1 teaspoon dried thyme
1 tablespoon coarse sea salt

1 Cut small ¹/₄ in/5 mm wide and deep slits around the edge of each steak. Push a sliver of garlic into each small cavity—there should be about six slivers for each steak. Place the steaks in a shallow dish.

2 To make the marinade, whisk the oil, mustard, pepper, marjoram, and thyme together into a rough paste. Smear the mixture over the each steak by hand. Cover and refrigerate for 5 hours.

3 Sprinkle half the salt over the steaks and place them salted sides down on a well-oiled, medium-hot grill. Cook for 1 minute. Sprinkle the tops with the remaining salt, turn the steaks and cook the second sides for 1 minute.

4 Move the steaks to the edge of the barbecue and cook for 4 minutes on each side, until medium-rare. Serve at once.

beef, game & veal

183

Bulgogi-style Barbecued Beef

Serves **4** | Preparation **20 minutes** | Marinating **30 minutes** | Grilling **4 minutes**

1¹/₂ lb/675 g beef tenderloin
4 green onions, shredded lengthwise into thin julienne
2 tablespoons toasted sesame seeds
1 cup/4 oz/100 g kim chee (Korean pickled cabbage)
2 ripe but firm nectarines, pitted and thinly sliced
1 bibb, butterhead or iceberg lettuce, separated into leaves

MARINADE
¹/₄ cup/2 oz/50 g soft brown sugar
¹/₂ cup/4 fl oz/125 ml dark soy sauce
2 tablespoons light sesame oil
¹/₄ cup/1 oz/25 g finely chopped green onion
3 garlic cloves, crushed
1 red chili pepper, seeded and finely minced or chopped
1 tablespoon finely minced or chopped fresh root ginger
2 tablespoons toasted sesame seeds

1 Cut the tenderloin into thin strips—about ¹/₈ in/3 mm thick. Begin slicing from the thin end and cut at an angle of 45 degrees. Place the pieces in a shallow dish.

2 To make the marinade, stir the sugar with the soy sauce in a small mixing bowl until dissolved. Stir in the oil, green onion, garlic, chili, ginger, and sesame seeds. Reserve a third of the mixture to glaze the beef and pour the rest over the beef. Cover and refrigerate for 30 minutes.

3 Cook the steak on a well-oiled, hot grill for 2 minutes on each side. Brush with the reserved glaze after turning the pieces.

4 Transfer the meat to a serving platter and sprinkle with the green onion and sesame seeds. Arrange the kim chee, nectarine slices, and lettuce leaves on a platter. The beef is eaten wrapped in the lettuce leaves with a little kim chee and nectarine.

Tarragon-mustard Tenderloin of Beef

Serves **4** | Preparation **15 minutes** | Marinating **2 hours** | Grilling **30 minutes**

2¹/₂ **lb/1.25 kg beef tenderloin (see Genius Tip below)**
4 tablespoons olive oil
2 tablespoons Dijon mustard
4 garlic cloves, crushed and then chopped with 1 tablespoon coarse sea salt

¹/₂ **cup/1 oz/25 g finely chopped tarragon**
1 tablespoon freshly ground black pepper
1 teaspoon chili powder

1 Trim any remaining fat or membrane from the beef and lay it in a shallow dish. Mix the oil, mustard, garlic, tarragon, pepper, and chili flakes to make a coarse paste. Smear the paste over the meat by hand, turning it to coat all sides. Cover and refrigerate for 2 hours.

2 Place the whole tenderloin on a well-oiled medium-hot grill. Cook for 8 minutes, turn the tenderloin and cook for a further 8 minutes on the other side. Turn the meat so that it lies on its side and cook for 7 minutes. Finally, turn the meat over and cook the other side for 7 minutes.

3 Transfer the meat to a cutting board and cover loosely with a piece of foil. Allow to rest for 5 minutes. Cut the meat at an angle across the grain into 1 in/2.5 cm thick slices. Arrange the slices on plates and serve at once.

Genius Tip To cook evenly, the tenderloin should be evenly thick and uniform in shape, cut nearer the butt tenderloin rather than the short tenderloin, from which tips are cut.

beef, game & veal

Chicago-style Strip Steak

Serves **4** | Preparation **10 minutes** | Marinating **24 hours** | Grilling **12 minutes**

4 x 10 oz/275 g boneless strip
loin steaks
$^1/_2$ lemon
2 tablespoons butter

DRY RUB
1 teaspoon coarse sea salt

1 teaspoon freshly ground
black pepper
1 teaspoon soft brown sugar
$^1/_2$ teaspoon onion powder
$^1/_2$ teaspoon garlic powder
2 cups/8 oz/225 g hickory chips,
soaked for 1 hour in water

1 Place the steaks in a shallow dish and rub thoroughly on both sides with the cut lemon. Mix the salt, pepper, sugar, onion, and garlic powders, and sprinkle over the steaks. Massage the seasoning into the meat by hand. Cover the dish and refrigerate for 24 hours.

2 Drain the hickory chips and place them on the burning coals to cover an area of fire comparable to the size of the steaks. When medium hot, cook the steaks on a well-oiled grill for 6 minutes on each side, until browned and medium-rare (also see the cooking chart on page 187).

3 Transfer the steaks to a platter. Spread the butter over the steaks and cover loosely with foil. Leave to rest for 5 minutes before serving. Potatoes wrapped in foil and barbecued directly on the coals are a good accompaniment for the steaks.

Fired Deep Woods Strip Steaks

Serves **4** | Preparation **10 minutes** | Marinating **24 hours** | Grilling **12 minutes**

4 x 10 oz/275 g boneless strip loin steaks
2 tablespoons lightly salted butter

DRY RUB
1 tablespoon coarse sea salt
$^1/_2$ teaspoon freshly ground black pepper

$^1/_2$ teaspoon ground chipotle chili pepper
$^1/_2$ teaspoon paprika
$^1/_2$ teaspoon dried oregano
$^1/_2$ teaspoon dried rosemary
$^1/_2$ teaspoon dried thyme
$^1/_4$ teaspoon cayenne pepper

1 Mix the coarse salt, pepper, chipotle chili, paprika, oregano, rosemary, thyme, and cayenne. Place the steaks in a dish and sprinkle the seasonings over them, then rub in the seasonings by hand. Cover and refrigerate for 24 hours.

2 Cook the steaks on a well-oiled, medium-hot grill for 6 minutes on each side, until medium-rare (see tip below). Transfer the steaks to a platter and spread the butter over them. Cover loosely with foil and leave to rest for 5 minutes before serving.

Genius Tip Use this simple guide to grill your steaks to perfection.

Steak thickness	Heat Guide	Time Guide
$^1/_2$ in/1 cm	direct/medium-high	rare: 1–2 minutes per side medium: 2–3 minutes per side well done: 4 minutes per side
1 in/2.5 cm	direct/medium-high	rare: 3–4 minutes per side medium: 4–6 minutes per side well done: 7 minutes per side
$1^1/_2$ in/3.5 cm	direct/medium-high	rare: 4–6 minutes per side medium: 6–8 minutes per side well-done: 9 minutes per side

beef, game & veal

Hot Cajun-style Strip Steaks

Serves **4** | Preparation **10 minutes** | Marinating **24 hours** | Grilling **12 minutes**

4 x 10 oz/275 g boneless strip loin steaks
2 tablespoons peanut oil

DRY RUB
1 teaspoon coarse sea salt
1 teaspoon celery salt
1 teaspoon hot paprika
1 teaspoon light brown sugar

$^1/_2$ teaspoon ground chipotle chili peppers
$^1/_2$ teaspoon ground turmeric
$^1/_2$ teaspoon dried oregano
$^1/_4$ teaspoon ground cumin
$^1/_4$ teaspoon ground mace
$^1/_4$ teaspoon dried marjoram
$^1/_4$ teaspoon dried thyme

1 To make the dry rub, mix the salt, celery salt, paprika, sugar, ground chili, turmeric, oregano, cumin, mace, marjoram, and thyme.

2 Place the steaks in a dish and rub the oil over both sides. Sprinkle the dry rub over them and rub the seasoning into the meat by hand. Cover and refrigerate for 24 hours.

3 Cook the steaks on a well-oiled, medium-hot grill for 6 minutes on each side, until browned and medium-rare (also see the cooking chart on page 187). Transfer to a platter, cover loosely with foil and allow to rest for 5 minutes before serving.

Blazing T-bone Steaks

Serves **4** | Preparation **13 minutes** | Marinating **2 hours** | Grilling **8 minutes**

4 x 10 oz/275 g T-bone steaks, about
$^1/_2$ in/1 cm thick
1 tablespoon coarse sea salt

MARINADE
4 dried chipotle chilies
2 tablespoons canola oil

juice of 1 lime
3 garlic cloves, crushed
$^1/_2$ cup/1 oz/25 g coarsely chopped
 cilantro
1 teaspoon coarse sea salt
1 teaspoon freshly ground
 black pepper

1 Trim off excess fat from the steak, leaving about $^1/_4$ in/5 mm around the edge. Snip into the fat at intervals of about 2 in/5 cm. Lay the steaks in a large shallow dish.

2 To make the marinade, crumble the chilies into a mixing bowl and stir in the oil, lime juice, garlic, cilantro, salt, and pepper. Spoon the marinade over the steaks and turn them a few times to coat both sides. Cover and refrigerate for 2 hours.

3 Cook the steaks on a well-oiled, medium-hot barbecue for 4 minutes on each side, turning once, until medium rare (also see the cooking chart on page 187). Transfer to a platter, cover with foil and leave to rest for 5 minutes before serving.

Genius Tip T-bone steaks are prime portions. These large steaks are so called because they are cut through the tenderloin and top loin, and they include a T-shaped bone that separates these cuts of steak.

Hot Dry-rub T-bone Steaks

Serves **4** | Preparation **11 minutes** | Marinating **2 hours** | Grilling **12 minutes**

**4 x 12 oz/275 g T-bone steaks, about
1 in/2.5 cm thick
2 tablespoons canola oil**

DRY RUB
**1 tablespoon English mustard powder
1 tablespoon coarse sea salt
1 tablespoon freshly ground
black pepper**

**1 tablespoon chili powder
1 teaspoon cayenne pepper
1 teaspoon onion powder
1 teaspoon garlic powder
1 teaspoon ground cumin
1 teaspoon dried oregano
1 teaspoon dried thyme**

1 Trim the rim of fat on the steaks to $^1/_4$ in/5 mm and snip this at intervals. Place the steaks on a platter and brush all over with oil, turning to coat both sides.

2 Mix the mustard, salt, pepper, chili powder, cayenne, onion, and garlic powders, cumin, oregano, and thyme in a small bowl. Sprinkle the mixture over the steaks and rub it in by hand over both sides. Cover the platter and refrigerate for 2 hours, turning the steaks after 1 hour.

3 Cook the steaks on a well-oiled, medium-hot grill for 6 minutes on each side until well browned and medium-rare (also see the cooking chart on page 187). Transfer to a clean platter, cover loosely with foil and leave to rest for 5 minutes before serving.

Crispy Jalapeño Skirt Steaks

Serves **4** | Preparation **11 minutes** | Marinating **8 hours** | Grilling **6–8 minutes**

4 x 8 oz/225 g skirt steaks
¼ cup/½ oz/15 g coarsely chopped cilantro

MARINADE
5 garlic cloves
1 tablespoon coarse sea salt
2 dried bay leaves, crumbled

2 tablespoons dried oregano
1 tablespoon ground coriander
1 teaspoon ground cumin
2 fresh jalapeño peppers, seeded and finely chopped
juice of 2 limes
½ cup/4 fl oz/125 ml olive oil

1 To make the marinade, mash the garlic and salt together in a mortar with a pestle. Add the bay leaves, oregano, coriander, and cumin, and pound the mixture together. Empty the contents of the mortar into a small mixing bowl and stir in the peppers, lime juice, and oil.

2 Place the steaks in a shallow dish and smear the marinade all over them by hand. Cover and refrigerate for 8 hours.

3 Cook the steaks on a well-oiled, medium-hot grill for 3–4 minutes on each side, turning once (also see the cooking chart on page 187). The steaks should be well browned outside and medium inside. Transfer to individual plates and serve sprinkled with the chopped cilantro.

Genius Tip The art of grilling is NOT a precise one. Even on/under an electric or gas grill the times may vary; because many of the grilling times are so short, even a minute's variation will be significant. Many factors can affect the grilling time, such as the starting temperature of the grill, the position of the grill compared to the coals, the state or type of ingredients, and lastly the cook's barbecuing experience. Over time as you become more familiar with your barbecue any mishaps that may throw your grilling off course will be easily resolved with your increased experience.

beef, game & veal

Skirt Steaks in Tarragon Marinade

Serves **4** | Preparation **15 minutes** | Marinating **24 hours** | Grilling **5 minutes**
plus **5 minutes simmering**

1^1/$_2$ **lb/675 g skirt steak**	MARINADE
1 **tablespoon coarse sea salt**	1/$_2$ **cup/4 fl oz/125 ml olive oil**
1 **tablespoon freshly ground**	1/$_4$ **cup/2 fl oz/60 ml dry red wine**
black pepper	1/$_4$ **cup/2 fl oz/60 ml tarragon vinegar**
1/$_4$ **cup/**1/$_2$ **oz/15 g coarsely chopped**	1 **tablespoon Dijon mustard**
fresh tarragon	3 **garlic cloves, crushed**
	3 **dried bay leaves, crumbled**
	1 **tablespoon dried chili flakes**

1 To make the marinade, whisk the oil, wine, vinegar, and mustard together. Stir in the garlic, bay leaves, and chili flakes.

2 Place the steak in a large shallow dish and pour the marinade over it. Turn the meat in the marinade to coat it on both sides. Cover and refrigerate for 24 hours, turning the meat four times.

3 Drain the marinade from the meat and pour it into a small saucepan. Bring to a boil on the stove, reduce the heat and simmer for 5 minutes. Remove from the heat—this is used as a glaze for the meat.

4 Place the steak on a well-oiled medium-hot grill and cook for 5 minutes on each side for a medium-rare result (also see the cooking chart on page 187). Brush the meat frequently with the reduced marinade to keep it moist and glaze it during cooking. Transfer the cooked steak to a cutting board, cover loosely with foil and leave to rest for 5 minutes.

5 Cut the steak into narrow, 1/$_8$ in/3 mm thick slices across the grain. Sprinkle salt, pepper, and chopped tarragon over the steak and serve. Green salad and crusty baguette are delicious accompaniments.

Flank Steak with Adobo Marinade

Serves **4** | Preparation **17 minutes** | Marinating **8 hours** | Grilling **16 minutes**

2 lb/900 g flank steak, about
1¹/₂ in/3.5 cm thick
¹/₄ cup/¹/₂ oz/15 g finely chopped
cilantro

MARINADE
juice of 3 limes
1 onion, coarsely chopped
6 garlic cloves
1 tablespoon coarse sea salt
1 tablespoon dried oregano

1 tablespoon dried thyme
1 tablespoon ground cumin
1 tablespoon freshly ground
black pepper
1 teaspoon chili powder
1 teaspoon ground cinnamon
1 teaspoon cocoa
2 cups/4 oz/100 g fresh cilantro leaves
and stems
¹/₂ cup/4 fl oz/125 ml corn oil

1 To make the marinade, purée the lime juice, onion, garlic, and salt in a food processor to a coarse pulp. Add the oregano, thyme, cumin, pepper, chili powder, cinnamon, cocoa, and cilantro. Pulse to reduce the mixture to an evenly coarse paste. Transfer the paste to a bowl and stir in the oil.

2 Place the steak in a large shallow dish and rub the paste all over it on both sides. Cover and refrigerate for 8 hours, turning three times.

3 Cook the steak on a well-oiled, medium-hot grill for 8 minutes on each side (also see the cooking chart on page 187). Brush the top of the steak with leftover marinade immediately after turning it halfway through cooking.

4 Transfer the steak to a cutting board, cover loosely with foil and allow to rest for 5 minutes. Cut the meat at an angle across the grain into ¹/₄ in/5 mm slices. Transfer to a serving platter and sprinkle with the chopped cilantro.

Steak Rolls Teriyaki

Serves **4** | Preparation **25 minutes** | Marinating **2 hours** | Grilling **14 minutes**

1¹/₂ lb/675 g flank steak
¹/₃ cup/1 oz/25 g fine dry breadcrumbs
¹/₄ cup/1 oz/25 g finely chopped and peeled Granny Smith apple
¹/₄ cup/1 oz/25 g finely minced or chopped sweet red onion
2 tablespoons lightly salted butter, melted
1 tablespoon coarse sea salt
1 tablespoon freshly ground black pepper

MARINADE
¹/₂ cup/4 fl oz/125 ml pineapple juice
3 tablespoons teriyaki sauce
1 tablespoon light molasses
1 tablespoon light sesame oil
3 garlic cloves, crushed
1 tablespoon finely minced or chopped fresh root ginger
2 dried bay leaves, crumbled
¹/₄ teaspoon ground cloves
bamboo skewers, soaked for 1 hour in water

1 Score ¹/₈ in/3 mm deep slashes in a criss-cross pattern across the entire surface on both sides of the steak. Place the steak in a shallow dish.

2 To make the marinade, whisk the pineapple juice with the teriyaki sauce, molasses, and sesame oil. Stir in the garlic, ginger, bay leaves, and ground cloves. Reserve a third of the mixture to use as a glaze while the meat is grilling. Pour the remainder over the meat, cover and refrigerate for 2 hours. Turn the meat over three times during marinating.

3 Drain the steak and lay it on a cutting board. Combine the breadcrumbs, apple, onion, and butter in a mixing bowl. Stir until the ingredients bind together, then spread the mixture in a thin layer over the meat, leaving a 2 in/5 cm border around the edge.

4 Roll up the meat from the longest edge to enclose the stuffing in a roll. Insert skewers at 2 in/5 cm intervals along the length of the meat. Cut the roll of meat at an angle into slices midway between the skewers. Place the skewered rolls on a platter as they are cut.

5 Brush the tops of the rolls with reserved marinade and place, brushed sides down, on a well-oiled, medium-hot grill. Cook for 7 minutes, brush the tops of the rolls and turn them over. Cook for an additional 7 minutes, until well browned and medium-rare. Brush frequently with the reserved marinade to keep the meat moist and caramelize the surface.

6 Transfer the rolls to a serving platter and remove the skewers. Sprinkle with salt and pepper and serve.

Genius Tip As a great flavor enhancer, soak wood, such as apple or mesquite, hickory chips or sprigs of fresh rosemary for 1 hour prior to barbecuing. They impart a marvelous smoky flavor once they are drained of water and placed on top of the burning charcoal embers. Many gas grills come with a smoker box in which you can place the wood chips, or place them in a smoker pouch and follow the manufacturer's instructions.

BBQ London Broil

Serves **4** | Preparation **12 minutes** | Marinating **8 hours** | Grilling **16 minutes**
plus **5 minutes simmering**

2 lb/900 g flank steak
1/2 cup/4 fl oz/125 ml dry red wine
1/4 cup/2 fl oz/60 ml canola oil
1/4 cup/2 fl oz/60 ml dark soy sauce
1 tablespoon light molasses
3 garlic cloves, crushed

2 tablespoons finely minced or chopped fresh root ginger
1 tablespoon freshly ground black pepper
4 dried bay leaves

1 Place the steak in a large shallow dish. Whisk the wine with the oil and soy sauce. Stir in the molasses, garlic, ginger, pepper, and bay leaves until thoroughly combined. Pour the marinade over the meat. Roll and turn the meat in the marinade until it is thoroughly coated. Cover and refrigerate for 8 hours, turning every 2 hours.

2 Drain the meat and pour the marinade into a small saucepan. Bring to a boil, reduce the heat and simmer for 5 minutes. Remove from the heat.

3 Cook the steak on a well-oiled, medium-hot barbecue for 8 minutes on each side, until well browned outside and medium-rare (also see the cooking chart on page 187). Brush frequently with the glaze during grilling. Bring any remaining glaze to the boil, then remove from the heat.

4 Transfer the meat to a cutting board, cover with foil and allow to rest for 5 minutes. Cut the steak at an angle across the grain into 1/4 in/5 mm slices. Place the slices on plates and brush with any remaining glaze.

Filet Mignon with Horseradish Cream

Serves 4 | Preparation **19 minutes** | Marinating **30 minutes** | Grilling **12 minutes**

4 x 6 oz/175 g filet mignon steaks
2 tablespoons olive oil
2 garlic cloves, crushed
1 teaspoon coarse sea salt
1 teaspoon freshly ground
black pepper
1/2 teaspoon chili powder

HORSERADISH CREAM

1 tablespoon grated horseradish
finely grated zest and juice of 1/2 lemon
1/2 cup/1 oz/25 g finely snipped
fresh chives
1 teaspoon coarse sea salt
1/2 teaspoon freshly ground
black pepper
1 cup sour cream
1/2 cup/4 fl oz/125 ml whipping cream

1 Mix the oil, garlic, salt, pepper, and chili powder in a shallow dish just large enough to hold the steaks. Add the steaks to the mixture and turn them and rub the mixture all over the meat by hand. Cover and leave at room temperature for 30 minutes.

2 To make the horseradish cream, stir the horseradish, lemon juice and zest, chives, salt, and pepper into the sour cream. Whip the heavy cream until it stands in stiff peaks, then fold it into the sour cream mixture. Cover and refrigerate until ready to use.

3 Cook the steak on a well-oiled, medium-hot grill for 6 minutes on each side, until well browned and medium-rare (also see the cooking chart on page 187). Transfer to a platter, cover loosely with foil and allow to rest for 5 minutes.

4 Transfer the steaks to serving plates and top each with a dollop of the horseradish cream. Serve the remaining cream separately.

Filet Mignons with Honey Glaze

Serves **4** | Preparation **15 minutes** | Marinating **2 hours** | Grilling **12 minutes** plus **5 minutes simmering**

4 x 6 oz/175 g filet mignon

MARINADE AND GLAZE
$^1/_2$ cup/4 fl oz/125 ml balsamic vinegar
2 tablespoons soy sauce
$^1/_2$ cup red wine

2 tablespoons light liquid honey
1 tablespoon molasses
2 garlic cloves, crushed
1 teaspoon freshly ground black pepper

1 To make the marinade, mix the vinegar with the soy sauce, honey, molasses, garlic, and pepper.

2 Place the steaks in a shallow dish. Pour the marinade over the steaks and turn them a few times until thoroughly coated. Cover and refrigerate for 2 hours, turning the meat twice.

3 Drain the marinade off the steak and pour it into a small saucepan. Bring to a boil, reduce the heat and simmer for 5 minutes until reduced to a thick glaze. Remove from the heat.

4 Cook the steaks on a well-oiled, medium-hot grill for 6 minutes on each side, until well browned and medium-rare (also see the cooking chart on page 187). Brush frequently with the reduced marinade during cooking to give the steaks a delicious glaze.

5 Transfer the steaks to a platter, cover loosely with foil and allow to rest for 5 minutes before serving. Grilled potatoes wedges, tossed with olive oil and fresh rosemary, go well with the steaks.

Genius Tip The position of the grilling rack closest to the coals is best for searing foods quickly at a high temperature. A higher elevation of the rack is necessary for cooking foods at lower temperatures over a longer period of time.

Fillet Steaks with Chinese Cabbage

Serves **4** | Preparation **15 minutes** | Grilling **4 minutes**

**4 x 6 oz/175 g fillet steaks, about
1 in/2.5 cm thick
2 tablespoons freshly ground
black pepper
2 tablespoons crushed dried
chili flakes
1 teaspoon coarse sea salt**

STIR-FRIED CHINESE CABBAGE
**1 cup/8 fl oz/250 ml peanut oil
$^{1}/_{2}$ head of Chinese cabbage,
finely shredded
$^{1}/_{2}$ teaspoon coarse sea salt
$^{1}/_{4}$ cup/2 fl oz/60 ml ketjap manis
(Indonesian sweet soy sauce)
$^{1}/_{2}$ cup/2 oz/50 g finely chopped
green onion**

1 Pound the steaks with a mallet to about $^{1}/_{2}$ in/1 cm thick. Mix the pepper, chili flakes, and salt and use to coat the steaks on both sides.

2 Cook the steaks on a well-oiled, medium-hot grill for 2 minutes on each side, until medium-rare (also see the cooking chart on page 187). Transfer the cooked steaks to a warmed dish, cover loosely with foil and set aside.

3 For the stir-fried Chinese cabbage, heat the oil in a large, non-stick skillet or wok. Add the cabbage and fry for 2 minutes, until golden brown. Drain and toss with salt, ketjap manis, and green onion.

4 Place the steaks on plates. Spoon a small mound of the cabbage on each steak and serve at once.

beef, veal & game

Florentine Porterhouse Steak

Serves **4** | Preparation **9 minutes** | Grilling **22 minutes**

2 lb/900 g porterhouse steak, about
1¹/₂ in/3.5 cm thick
¹/₂ cup/4 fl oz/125 ml extra virgin
olive oil
3 garlic cloves, crushed and chopped
with 1 teaspoon coarse sea salt
1 red chili pepper, seeded and finely
minced or chopped

5 fresh sage leaves, snipped
2 tablespoons coarsely chopped fresh
rosemary leaves
1 teaspoon coarse sea salt
1 tablespoon freshly ground
black pepper

1 Select a shallow dish large enough to hold the steak . Mix the oil, garlic, chili, sage, and rosemary in the dish and set aside.

2 Season the steak on both sides with salt and pepper and cook on a well-oiled, medium-hot grill for 11 minutes on each side, until medium-rare (also see the cooking chart on page 187).

3 Transfer the steak directly from the grill to the seasoned oil in the dish. Turn the steak over a few times to coat both sides well. Cover the dish loosely with foil and set the meat aside to rest for 5 minutes.

4 To serve the steak, cut the sirloin and tenderloin portions away from the bone. Carve the pieces of meat at an angle across the grain into ¹/₄ in/3 mm thick slices. Arrange the slices on a serving platter and spoon some of the seasoned oil over.

Cube Steak Roulade

Serves 4 | Preparation **10 minutes** | Grilling **20 minutes**

8 thin slices cube steak or tenderized steak, uniform in size and thickness, about 1¹/₂ lb/675 g in weight
1 tablespoon coarse sea salt
1 teaspoon hot paprika

1 cup/2 oz/50 g prepared sage and onion breadcrumb stuffing, made with one raw egg
8 thin bacon slices
16 bamboo skewers, soaked in water for 1 hour

1 Lay the slices of steak out flat and sprinkle the salt and paprika evenly on top. Divide the stuffing into eight portions and place one on each slice of steak, then roll up like a jelly roll.

2 Wrap a piece of bacon around each steak roll. Secure the ends of the bacon and the edge of the steak with 2 skewers, inserting them through the rolls at opposite angles (rather like crossed knitting needles through a ball of wool).

3 Place the roulades on a well-oiled, medium-hot grill. Cook for 10 minutes on each side, until the bacon is crisp and the steak is medium-rare inside (also see the cooking chart on page 187).

4 Transfer the roulades to plates and remove the skewers. Serve at once.

beef, veal & game

Asian-style Baby Short Ribs

Serves **4** | Preparation **12 minutes** | Marinating **4 hours** | Grilling **10 minutes**

2 lb/900 g lean baby beef back short ribs

MARINADE

¹/₂ cup/4 fl oz/125 ml ketjap manis (Indonesian sweet soy sauce)

2 tablespoons peanut oil

1 tablespoon light liquid honey

2 tablespoons Indonesian sweet chili sauce

4 garlic cloves, crushed

2 tablespoons finely minced or chopped fresh root ginger

1 tablespoon freshly ground black pepper

1 Cut the meat into sections of four ribs each and lay them flat in a shallow dish.

2 To make the marinade, mix the ketjap manis, peanut oil, honey, chili sauce, garlic, ginger, and pepper. Spoon the marinade over the ribs and massage the mixture into the meat by hand. Cover and refrigerate for 4 hours. Turn the ribs three times during marinating.

3 Drain the ribs, pouring the marinade into a small saucepan. Bring to the boil, reduce the heat and simmer the marinade for 5 minutes, then remove from the heat.

4 Cook the ribs on a well-oiled, medium-hot grill. Cook the meaty side first for 5 minutes. Turn and cook the second side for a further 5 minutes, until the ribs are well browned and cooked through. Brush frequently with the marinade so that the ribs are moist, caramelized, and glazed. Serve at once.

Genius Tip Instead of the usual mayonnaise, make an Asian-style dressing for a standard coleslaw salad with 3 tablespoons light sesame oil, 1 tablespoon Japanese sweet rice vinegar, juice from half a lemon, 1 tablespoon sweet chili sauce, finely minced ginger root, coarsely chopped green onion, pickled radish, and fresh cilantro. Season with salt and freshly ground black pepper before mixing with your coleslaw ingredients.

Chipotle Butter Burger

Serves **4** | Preparation **15 minutes** | Grilling **20 minutes**

1 lb/450 g ground chuck steak | 1 tablespoon coarse sea salt
1 lb/450 g ground sirloin steak | 4 tablespoons lightly salted butter
1 dried chipotle chili, seeded | 4 kaiser or Vienna rolls
$^1/_2$ teaspoon celery seeds |

1 Place both types of steak together in a bowl. Grind the chipotle chili in a spice grinder into a fine powder and mix with the celery seed and salt. Add this seasoning to the meat and knead by hand until thoroughly mixed.

2 Shape the meat into eight equal-sized balls and then flatten these into patties, about $^1/_2$ in/1 cm thick. Using your thumb, mark a hollow in the middle of four patties and place 1 tablespoon butter in each. Top with the remaining patties and press the meat together to seal in the butter in $^3/_4$ in/1.5 cm thick patties.

3 Cook the burgers on a well-oiled, medium-hot grill for 10 minutes on each side, until well browned and cooked through.

4 Heat the rolls on the edge of the grill for 1 minute, turning once. Split the rolls and place a burger in each one. Serve at once. Potato salad and grilled fruit go well with the burgers.

beef, veal & game

Global Burger with Fiery Mayonnaise

Serves **4** | Preparation **25 minutes** | Marinating **1 hour** | Grilling **20 minutes**

2 tablespoons virgin olive oil, plus extra for brushing rolls
2 teaspoon tomato paste
1 teaspoon Dijon mustard
2 garlic cloves, crushed
1½ onions, finely chopped or minced
1 teaspoon finely chopped sweet pickled ginger
4 teaspoons coarsely chopped flat-leaf parsley
2 teaspoons freshly ground black pepper
2 teaspoons coarse salt
1 lb/450 g freshly ground chuck steak
1 lb/450 g freshly ground sirloin steak

4 wholegrain buns or foccacia rolls, split open
1 bunch arugula

LEMON CHILI MAYONNAISE
1 cup/8 oz/225 g mayonnaise
2 tablespoons lemon juice
1 teaspoon grated lemon zest
12 basil leaves, finely shredded
1 chili pepper, seeded and finely chopped
1 teaspoon freshly ground black pepper
1 teaspoon salt

1 Mix the olive oil, tomato paste, mustard, garlic, chopped onions, pickled ginger, parsley, pepper, and salt. Add the both types of ground steak and mix well by hand, kneading and squeezing the ingredients together until thoroughly combined.

2 Divide the mixture into quarters and shape each portion into a ball. Flatten the balls into thick burgers. Place on a plate, cover with plastic wrap, and refrigerate for 1 hour.

3 Meanwhile, make the lemon chili mayonnaise: mix the mayonnaise with the lemon juice, zest, basil, chili, pepper, and salt. Cover and refrigerate until ready to serve.

4 Remove the burgers from the refrigerator to bring them to room temperature about 20 minutes before cooking. Cook on a well-oiled, hot grill for 10 minutes on each side, until well browned and cooked through.

5 Brush the insides of the buns or rolls with olive oil and sprinkle with salt. Toast the cut sides lightly on the grill.

6 Serve the burgers on the rolls or buns, adding a dollop of lemon chili mayonnaise and a few arugula leaves.

Genius Tip When preparing your charcoal barbecue, empty a thick layer of briquettes into the pit, distribute them evenly and douse with fuel. Let stand for 10 minutes, allowing the coal to absorb the fluid. Light the briquettes in the corners furthest away from you first. Wait for 25 minutes or until the embers glow and a gray ash has formed over the majority of the surface. The coals should be at their hottest temperature at this point.

beef, veal & game

Danube Burger

Serves **4** | Preparation **16 minutes** | Grilling **12–16 minutes**

1 lb/450 g ground sirloin steak
1 lb/450 g ground chuck steak
1 onion, finely minced or grated
2 tablespoons canola oil
3 garlic cloves, crushed and then chopped with 1 tablespoon coarse sea salt

$^1/_4$ cup/$^1/_2$ oz/15 g finely chopped flat-leaf parsley
1 teaspoon ground cumin
1 teaspoon grated nutmeg
$^1/_2$ teaspoon hot paprika

1 Place both types of ground steak in a mixing bowl. Add the onion, oil, garlic, parsley, cumin, nutmeg, and paprika. Knead and squeeze the mixture together by hand until thoroughly combined.

2 Divide the mixture into eight equal portions. Roll each portion into a ball and then press these out into neat burgers measuring about 1 in/2.5 cm thick.

3 Cook the burgers on a well-oiled, medium-hot grill for 6–8 minutes on each side, until well browned and cooked through. Serve at once. Mashed potatoes and a tomato salad with some crumbled feta cheese go well with the burgers.

Genius Tip Due to current day concerns regarding meat contamination and particularly salmonella, it is advisable to purchase ground meat from a reliable butcher, rather than attempting to grind it at home. Have meat ground freshly on the spot wherever possible.

Juicy Lucy Burger

Serves **4** | Preparation **20 minutes** | Grilling **20 minutes**

2 tablespoons lightly salted butter
1 coarsely chopped onion
$^1/_2$ cup/2 oz/50 g grated colby or
Cheddar cheese
1 lb/450 g ground chuck steak
1 lb/450 g ground sirloin steak
1 tablespoon coarse sea salt

1 teaspoon freshly ground
black pepper
1 teaspoon chili powder
$^1/_2$ teaspoon garlic powder
4 kaiser or Vienna rolls, split and
buttered

1 First prepare the filling: melt the butter in a skillet or sauté pan. Add the onion and cook, stirring, until golden brown. Scrape the onion and butter into a small bowl. Stir in the cheese.

2 Place both types of steak in a bowl. Add the salt, pepper, and chili powder and knead the ingredients together until thoroughly combined. Shape the mixture into eight equal balls and flatten them into $^3/_4$ in/1.5 cm thick patties.

3 Spread the cheese mixture over four patties, leaving a border around the edge. Place the remaining patties on top and pinch the edges together to seal in the filling. Gently pat the burgers into shape to keep them evenly thick.

4 Cook the burgers on a well-oiled, medium-hot grill for 10 minutes on each side, until well browned and cooked through.

5 Heat the closed rolls on the edge of the grill while cooking the burgers. When they are hot outside, open them flat and toast the buttered sides—this should take about 2 minutes in all.

6 Serve the burgers on the buns. It is a good idea to allow the burgers to cool for a few minutes before serving as the melted cheese filling is extremely hot.

beef, veal & game

Blue Burgers

Serves **4** | Preparation **16 minutes** | Grilling **16–19 minutes**

1 lb/450 g ground sirloin steak
1 lb/450 g ground chuck steak
2 tablespoons Dijon mustard
1 tablespoon Worcestershire sauce
1 teaspoon light soy sauce
1 onion
4 garlic cloves
1 red chili pepper, seeded
1 tablespoon coarse sea salt
2 tablespoons finely chopped
flat-leaf parsley

FILLING
6 oz/175 g blue cheese, crumbled
2 tablespoons lightly salted butter,
 softened
$1/2$ teaspoon chili powder

TO SERVE
2 tablespoons olive oil
4 thick slices large crusty baguette

1 Place both types of ground meat in a bowl. Add the mustard, Worcestershire, and soy sauces, and mix well.

2 Finely mince or chop the onion, 3 garlic cloves, and chili pepper together with the salt. Add to the meat mixture with the parsley and knead the mixture by hand until all the ingredients are evenly mixed. Divide the mixture into eight equal portions and shape each into a 1 in/2.5 cm thick patty.

3 For the filling, mash the cheese, butter, and chili powder together with a fork. Divide this mixture into quarters and place a portion in a neat lump right in the middle of each of four of the patties. Keep the filling in the middle. Top with the remaining patties. Press and seal the edges together with your fingertips. The burgers should be about 2 in/5 cm thick.

4 Prepare the toasted baguette slices as a base on which to serve the burgers. Crush the remaining garlic clove and mix it with the olive oil. Brush this over both sides of the baguette slices.

5 Place the burgers on a well-oiled, medium-hot grill. Cook for 8–9 minutes on each side, or until well cooked. Toast the bread for 1–2 minutes, turning once, until scored golden brown. Serve the burgers on the bread.

Herb-butter Burgers

Serves **4** | Preparation **16 minutes** | Grilling **14 minutes**

1 lb/450 g ground sirloin steak	BUTTER FILLING
1 lb/450 g ground chuck steak	5 tablespoons butter, softened
1 tablespoon freshly ground	4 tablespoons finely chopped mixed
black pepper	fresh herbs, including basil, chives,
1 teaspoon coarse sea salt	oregano, and flat-leaf parsley
4 thick slices sharp Cheddar cheese	2 garlic cloves, crushed and chopped
4 kaiser or Vienna rolls	with 1 teaspoon coarse sea salt
	1 teaspoon chili powder

1 Thoroughly mix both types of ground steak, seasoning it with the pepper, and shape into four large burgers. Make a small cavity in the middle of each burger. Refrigerate while making the butter filling.

2 Cream the butter, herbs, garlic, and chili powder in a small bowl until thoroughly mixed. Reserve 2 tablespoons of the butter at room temperature. Use a spoon to scoop the remaining butter into four small neat portions on a plate, cover and refrigerate for 1 hour or until firm.

3 Place a portion of butter in the cavity in each burger and shape the meat around it to seal it in, making sure that the burgers are neat and even, and about 2 in/5 cm thick.

4 Cook the burgers on a well-oiled, medium-hot grill for 7 minutes. Turn and cook for 3 minutes. Sprinkle with salt and place a slice of cheese on top of each burger. Cook for a further 4 minutes.

5 Meanwhile, slice the kaiser or Vienna rolls open and toast their outsides on the edge of the barbecue until golden. Spread the reserved butter on the cut surfaces of the rolls and toast until golden.

6 Sandwich the burgers in the rolls and serve at once.

beef, veal & game

Hobo Special for One

Serves **1** | Preparation **20 minutes** | Grilling **1 hour**

8 oz/225 g freshly ground beef
1¹/₂ teaspoon coarse salt
1¹/₂ teaspoon freshly ground pepper
1 teaspoon Worcestershire sauce
1 tablespoon coarsely chopped
flat-leaf parsley
¹/₄ cup/1 oz/25 g finely chopped onion
1 tablespoon vegetable oil
1 carrot, cut into strips

1¹/₂ teaspoon ground cumin
2 small whole onions
3 slices potato, cut into
1¹/₂ in/3.5 cm slices
6 mushrooms, cut into
1¹/₂ in/3.5 cm slices
kernels from 1¹/₂ ears fresh
corn-on-the-cob

1 To prepare the hobo special, you will need a cleaned 1 lb/450 g coffee can and foil. Grease the inside of the can with a little vegetable oil.

2 Combine the beef, salt, pepper, Worcestershire sauce, parsley, and chopped onion in a bowl. Shape the meat mixture into a large flat patty and set in the bottom of the can.

3 Lay the carrot strips on top of the burger and sprinkle the cumin over them. Then add the whole onions, potato slices, mushrooms, and finally the corn kernels. Add a little more salt and pepper on the top. Cover the top of the can securely with foil.

4 Nestle the can among the hot barbecue coals, placing them around the side but not directly underneath. Cook for 1 hour, until the vegetables are tender. Eat the meal out of the can with a fork. Be careful not to burn your hands!

O'Leary Corned Beef Hash Patties

Serves **4** | Preparation **10 minutes** | Grilling **10 minutes**

1 lb/450 g corned beef hash | 4 thick bread slices
4 thin bacon slices | 4 bamboo skewers, soaked in
4 eggs | water for 1 hour
canola oil for cooking |

1 Divide the hash into quarters. Shape each portion into a
1 in/2.5 cm thick patty and wrap a slice of bacon around
each one. Secure the bacon with a bamboo skewer.

2 Place the patties on a medium-hot, well-oiled grill
and cook for a total of 10 minutes, turning once,
until the bacon is crisp and well browned, and
the hash is heated through.

3 When the patties are almost cooked,
fry the eggs in a little oil in a skillet on
the stove. Toast the bread on the grill.

4 To serve the patties, transfer the
toasted bread to plates. Arrange the
patties on the plates and remove the
skewers. Top each with an egg and
serve at once.

Genius Tip Use home-made or
good-quality bought corned beef for
the patties. During cooking, move
the patties to the edge of the grill if
the coals flare up and, if appropriate
for the type of grill, extinguish the
flames by spraying them with a
mist of water.

Kosher Hot Dogs with Confetti Relish

Serves **4** | Preparation **11 minutes** | Grilling **8 minutes**

4 jumbo kosher all-beef hot dogs
4 large poppy seed buns

CONFETTI RELISH
2 tablespoons prepared mayonnaise
2 teaspoons hot mustard
2 teaspoons sweet pickle relish
$^1/_2$ sweet red onion, finely chopped

1 tomato, seeded and chopped
1 jalapeño pepper, seeded and
 finely chopped
1 teaspoon capers
1 teaspoon celery salt
1 teaspoon freshly ground
 black pepper

1 To make the relish, mix the mayonnaise, mustard, and relish in a small bowl, then stir in the onion, tomato, pepper, capers, celery salt, and pepper.

2 Cut four slashes at an angle in one side of each hot dog. Turn the hot dogs over and prick their other sides four times with a fork. Place the hot dogs, cut sides down, on a well-oiled, hot grill and cook for 4 minutes on each side, turning once.

3 Meanwhile, slice the buns open and wrap them in foil. Warm them to one side of the barbecue while cooking the hot dogs. Turn the foil packages over when turning the hot dogs. Place the hot dogs in the buns. Spoon the relish over the top and serve at once.

Stuffed Knockwursts

Serves 4 | Preparation **15 minutes** | Grilling **9 minutes**

8 thick knockwursts
1½ cups/6 oz/175 g grated sharp
Cheddar cheese
1 sweet red onion, thinly sliced

6 jalapeño peppers, seeded and each
sliced into 6 strips
1 teaspoon celery salt
8 soft poppy seed hot dog buns

1 Make a ³⁄₄ in/1.5 cm deep slit along the length of each knockwurst. Divide the cheese among the knockwursts, sprinkling it into the slits. Lay the onion rings over the cheese, top with the jalapeño strips and sprinkle with celery salt. Tie the knockwursts loosely shut in two places.

2 Lay the knockwurst on a medium-hot grill, stuffing up, and cook for 9 minutes in total. Turn the knockwurst around and tilt them side to side, but do not fully turn them over (take care to only grill the bottom and sides of the knockwursts). The knockwurst should be browned and cooked through.

3 Meanwhile, slice the buns and toast them on the edge of the grill. Transfer the knockwurst to a platter and snip off the strings. Set the sausages into the buns and serve at once.

Pastrami & Grape-leaf Wraps

Serves **4** | Preparation **15 minutes** | Grilling **8 minutes**

16 brine-packed grape leaves, drained	¹/₂ lb/225 g Swiss cheese, thinly sliced
wholegrain mustard	1 sweet red onion, finely chopped
1 lb/450 g pastrami, thinly sliced	rye bread to serve

1 Blot the grape leaves dry on paper towels. Spread the leaves out flat and smear a thin layer of mustard over each one.

2 Top the leaves with layers of pastrami, cheese, and onion. Arrange three alternate layers of each ingredient in a neat stack in the middle of each leaf. Fold the sides of the leaves over the filling, then fold over the ends. Use a water-soaked tooth pick to skewer through the flaps of the leaves to keep the packet sealed while grilling.

3 Cook the wraps on a medium-hot barbecue for 4 minutes on each side. Use a long flat spatula and turn the packages once only to prevent the leaves and filling from unraveling.

4 Transfer to a serving platter. To eat the wraps, open the packets and scoop out the filling—the grape leaves are not eaten. Serve with rye bread.

Crushed Sage Veal Chops

Serves **4** | Preparation **9 minutes** | Marinade **5 hours** | Grilling **10 minutes**

4 x 12 oz/350 g veal chops, about 1 in/2.5 cm thick
1 teaspoon coarse sea salt

MARINADE
3 tablespoons olive oil
1 tablespoon light molasses

juice of $^1/_2$ lemon
1 tablespoon freshly ground black pepper
2 garlic cloves
1 teaspoon coarse sea salt
$^1/_4$ cup/$^1/_2$ oz/15 g fresh sage leaves

1 To make the marinade, whisk the oil, molasses, lemon juice, and pepper together in a small bowl. Mash the garlic, salt, and sage together in a mortar with a pestle until the mixture is aromatic and pulpy in texture. Stir the garlic and sage mixture into the marinade.

2 Place the chops in a large shallow dish and spoon the marinade over them. Massage the marinade all over the chops by hand. Cover and refrigerate for 5 hours.

3 Sprinkle half the salt over the chops and place them salted sides down on a well-oiled, medium-hot grill. Cook for 5 minutes. Turn, sprinkle with the remaining salt and cook for a further 5 minutes until well browned and medium cooked. Baste with leftover marinade throughout cooking (up until the last 3 minutes of cooking) to keep the meat moist. Transfer to plates let the veal chops rest for 3 minutes loosely covered with aluminum foil.

> **Genius Tip** Always ensure your grill is cleaned and free of grease or remaining dried food bits. Use a wire brush to scrub the surface before and after each use.

beef, veal & game

Herb-brushed Veal Chops

Serves **4** | Preparation **17 minutes** | Marinating **5 hours** | Grilling **10 minutes**

**4 x 12 oz/350 g veal chops, about
1 in/2.5 cm thick
1 teaspoon coarse sea salt
1 teaspoon freshly ground
black pepper
1/2 teaspoon chili powder
1 teaspoon finely snipped chives**

MARINADE
**3 tablespoons olive oil
2 tablespoon Dijon mustard**

**grated zest and juice of 1/2 lemon
1 onion, finely grated
3 garlic cloves, crushed and chopped
with 1 teaspoon coarse sea salt
1 tablespoon dried thyme**

BASTING OIL
**1/4 cup/2 fl oz/60 ml olive oil
6 long fresh rosemary sprigs, tied
together to form a brush**

1 To make the marinade, whisk the oil, mustard, and lemon juice together in a small mixing bowl. Stir in the zest, onion, garlic, salt, and thyme to make a coarse paste.

2 Place the veal chops in a shallow dish. Spoon the paste over the chops, then rub it in all over them by hand. Cover and refrigerate for 5 hours. Turn the chops three times during marinating.

3 At the same time as putting the chops to marinate, pour the olive oil for basting into a shallow dish and add the bundle of rosemary sprigs. Cover and leave at room temperature.

4 Combine the salt, pepper, and chili powder. Sprinkle half this seasoning over the chops and place them, seasoned sides down, on a well-oiled, medium-hot grill. Sprinkle the remaining seasoning on top of the chops.

5 Cook the chops for 5 minutes on each side for a medium result. Dip the rosemary brush in the olive oil and use to baste the chops throughout the grilling process.

6 Transfer the chops to plates and sprinkle with snipped chives. Grilled tomatoes and steam-grilled fennel go well with the chops.

Veal Chop Naranja

Serves **4** | Preparation **10 minutes** | Marinating **30 minutes** | Grilling **14 minutes**

4 x 12 oz/350 g veal chops, about
1 in/2.5 cm thick
1 teaspoon coarse sea salt
1 teaspoon freshly ground
black pepper

MARINADE
grated zest of $^1/_2$ orange and
juice of 1 orange
2 tablespoons olive oil
2 garlic cloves, crushed
1 tablespoon fresh thyme leaves

1 Place the veal chops flat in a shallow dish. Mix the orange zest and juice, olive oil, garlic, and thyme for the marinade, and pour it over the chops. Rub the mixture over the meat by hand. Cover and leave to marinate for 30 minutes at room temperature.

2 Drain the chops and place on a well-oiled, medium hot grill. Cook for 7 minutes on each side for a medium result. Brush the meat with the leftover marinade up until the last 3 minutes of cooking.

3 Transfer the chops to a platter, sprinkle with salt and pepper and allow to rest for 5 minutes before serving.

beef, veal & game

Grilled Veal Saltimbocca

Serves **4** | Preparation **15 minutes** | Grilling **8 minutes**

4 x 6 oz/175 g veal tenderloin fillets	4 slices of prosciutto
2 tablespoons olive oil	12 large fresh sage leaves
1 teaspoon coarse sea salt	¹/₂ lemon
1 teaspoon freshly ground black pepper	shaved Parmesan cheese to serve

1 Place the pieces of veal between two sheets of baking parchment or wax paper and beat them out thinly and evenly using a meat mallet or rolling pin. The slices should be about ¹/₄ in/5 mm thick. Brush with oil and sprinkle with salt and pepper.

2 Cook the veal on a well-oiled, medium-hot grill for 4 minutes. While the veal is cooking, toast the sage leaves on the grill until slightly crisp, turning once—this will take less than a minute in total. Turn the veal and lay 3 sage leaves on each piece. Top with a slice of prosciutto and cook for a further 4 minutes.

3 Transfer the veal to plates. Squeeze a few drops of lemon juice over the each portion and top with curly Parmesan cheese shavings. Serve at once.

Genius Tip When setting up your barbecue, begin by choosing a location that is free of wind movement and far from buildings and flammable matter. The barbecue should be set level on a flat, inflammable surface and away from inflammable matter.

Veal Scallops in Lemon Caper Butter

Serves **4** | Preparation **15 minutes** | Marinating **30 minutes** | Grilling **8 minutes**

4 x 6 oz/175 g veal tenderloin fillets
2 tablespoons oil
finely grated zest and juice of $^1/_2$ **lemon**
1 teaspoon Dijon mustard
1 teaspoon dried thyme

LEMON CAPER BUTTER
3 tablespoons lightly salted butter
juice of $^1/_2$ **lemon**
1 tablespoon capers
1 teaspoon coarse sea salt
1 teaspoon freshly ground
black pepper

1 Place the pieces of veal between two sheets of baking parchment or wax paper and beat them out thinly and evenly using a meat mallet or rolling pin. The slices—known as scallops or escalopes in French—should be about $^1/_4$ in/5 mm thick. Place flat in a shallow dish.

2 Whisk the oil and lemon juice together. Stir in the zest, mustard, and thyme, then pour this marinade over the veal slices. Cover and marinate for 30 minutes at room temperature.

3 Mix the butter, lemon juice, capers, salt, and pepper for the sauce in a small saucepan ready to cook on the grill at the same time as the veal.

4 Drain the veal scallops and cook them on a well-oiled, medium-hot grill for 4 minutes on each side. Meanwhile, heat the mixture for the lemon caper sauce until the butter has browned slightly.

5 Transfer the veal scallops to plates and pour the lemon caper sauce over them. Serve at once. An arugula salad goes well with the veal.

Stuffed Veal Birds

Serves 4 | Preparation **20 minutes** | Grilling **25 minutes**

1 $^1/_2$ lb/675 g veal tenderloin	1 celery stalk, finely chopped
8 oz coarse liver pâté	$^1/_4$ cup/$^1/_2$ oz/15 g finely chopped
1 egg, lightly beaten	flat-leaf parsley
$^1/_2$ cup dry breadcrumbs	1 tablespoon coarse sea salt
2 tablespoons finely minced or	1 teaspoon freshly ground
chopped shallot	black pepper
2 tablespoons finely chopped	olive oil for cooking
green pepper	

1 Slice the veal tenderloin horizontally in half and place the pieces between sheets of baking parchment or waxed paper. Use a meat mallet or rolling pin to pound the meat out thinly until it is even and about $^1/_8$ in/3 mm thick. Cut the thinned veal pieces into eight 8 in/20 cm long strips.

2 Mash the pâté with a fork in a mixing bowl. Add the egg, breadcrumbs, shallot, pepper, celery, parsley, salt, and pepper. Stir until thoroughly mixed.

3 Spread a slice of veal with a thin layer of the pâté mixture. Roll up from the narrow end like a jelly roll. Tie the roll neatly with string, around the middle and 2 in/5 cm from each end. Brush the surfaces with olive oil. Repeat with the remaining veal and filling.

4 To grill the veal, brush the rolls with oil and cook on a medium-hot grill for 25 minutes. Brush frequently with oil and turn often so that the rolls are evenly browned and cooked through.

5 Transfer the veal birds to a cutting board and cover loosely with foil. Allow to rest for 5 minutes. Remove the string and arrange on a serving platter.

Veal Loaf Burgers

Serves **4** | Preparation **25 minutes** | Grilling **20 minutes**

1 lb/450 g lean ground veal round	2 tablespoons finely chopped green olives
6 oz/175 g lean ground smoked ham	1 tablespoon finely chopped flat-leaf parsley
4 oz/100 g liver pâté	
1 tablespoon fresh breadcrumbs	1 tablespoon coarse sea salt
1 cup/8 fl oz/250 ml heavy cream	1 tablespoon freshly ground black pepper
2 egg yolks	
$^1/_2$ teaspoon Dijon mustard	
1 teaspoon Worcestershire sauce	

1 Mix the ground veal with the ham, pâté, and breadcrumbs until thoroughly combined. The best method is to knead the mixture by hand. Gradually work in the cream, kneading it in evenly, then work in the egg yolks one at a time.

2 Mix in the mustard, Worcestershire sauce, olives, parsley, salt, and pepper until evenly combined. Divide the meat into eight equal portions and shape these into $1^1/_2$ in/3.5 cm thick oval burgers. Be sure to knead and compress the mixture together firmly so that the burgers hold their shape well during cooking.

3 Cook the burgers on a well-oiled, medium-hot grill for 10 minutes on each side, turning once. Serve freshly cooked.

Genius Tip Remember—always preheat gas barbecues at the desired cooking temperature with the cover down. When 10 minutes has passed you will be ready to start grilling.

beef, veal & game

221

Wallen-burgers

Serves **4** | Preparation **10 minutes** | Grilling **20 minutes**

1 lb/450 g ground veal round
1 cup/8 fl oz/250 ml heavy cream
4 egg yolks
1 tablespoon coarse sea salt

1 tablespoon freshly ground
black pepper
$^1/_2$ teaspoon freshly grated nutmeg

1 Place the veal in a bowl. Gradually work the cream into the ground meat, either using a mixing spoon or kneading it in by hand. Work in the egg yolks, one at a time, in the same way. Mix in the salt, pepper, and nutmeg until thoroughly combined.

2 Divide the meat into eight equal portions. Wet your hands and shape the meat into small $1^1/_2$ in/3.5 cm thick burgers.

3 Cook the burgers on a well-oiled, medium-hot grill for 10 minutes on each side, until firm, well browned and cooked through. Serve at once. Creamy mashed potatoes and peas are good, simple accompaniments for the burgers.

Grilled Veal Polpette Patties

Serves **4** | Preparation **18 minutes** | Marinating **1 hour** | Grilling **8 minutes**

3 tablespoons olive oil
1 onion, finely minced or chopped
1/4 cup/1 oz/25 g pine nuts
3 garlic cloves, crushed and chopped
with 1 teaspoon coarse sea salt
1/4 cup/1/2 oz/15 g fresh breadcrumbs
3 tablespoons finely chopped
flat-leaf parsley

2 tablespoons shredded basil
1 tablespoon ground fennel seeds
3/4 cup/6oz/175 g ricotta cheese
3 tablespoons grated Parmesan cheese
2 tablespoons grated lemon zest
1 lb/450 g ground veal

1 Heat the oil in a saucepan. Add the onion and pine nuts, and cook for 5 minutes, stirring frequently, until the onion is soft and translucent and the pine nuts are golden brown. Add the garlic and salt, stir and remove from the heat, then set aside to cool.

2 Mix the breadcrumbs, parsley, basil, ground fennel, ricotta cheese, and lemon zest in a large bowl. Stir in the onion mixture, then add the veal and knead it with the other ingredients by hand until thoroughly combined. Cover and refrigerate for 1 hour.

3 Rinse your hands in cold water and roll the mixture into eight small oval patties about 1/2 in/1 cm thick. Cook the patties on a well-oiled, medium-hot grill for 4 minutes on each side. Transfer to a platter, cover loosely with foil and leave to rest for 2 minutes before serving.

beef, veal & game

Wild Boar in Juniper Marinade

Serves **4** | Preparation **28 minutes** | Marinating **24 hour** | Grilling **15 minutes**
plus **5 minutes simmering**

4 x 6 oz/175 g wild boar fillets
1 tablespoon coarse sea salt
fruit conserve, such as cranberry,
redcurrant, lingonberry or crab
apple jelly, to serve

MARINADE
1 cup/8 fl oz/250 ml dry red wine
1/2 cup/4 fl oz/125 ml Calvados
or brandy
3 tablespoons olive oil

1 apple, peeled, cored and grated
1 carrot, grated
1 onion, finely grated
4 garlic cloves, crushed
1 red chili, seeded and finely minced
or chopped
4 bay leaves, crumbled
1 tablespoon juniper berries
1 teaspoon black peppercorns
1 teaspoon dried thyme

1 Rinse the meat fillets under cold running water and pat dry on paper towels, then lay them flat in a shallow dish.

2 To make the marinade, whisk the wine, Calvados, and oil together. Stir in the apple, carrot, onion, garlic, chili, bay leaves, juniper, peppercorns, and thyme. Spoon the marinade over the meat to coat all surfaces thoroughly. Cover and refrigerate for 24 hours, turning the meat four times during marinating.

3 Drain off the liquid and pour it into a saucepan. Bring to a boil, reduce the heat and simmer for 5 minutes. Remove from the heat and use to glaze the meat during cooking.

4 To grill the meat, place the fillets on a well-oiled medium-hot grill. Cook for 6 minutes on each side until well browned and medium rare. Turn the fillets on their sides and cook for an additional 3 minutes to brown the meat all over.

5 Transfer the fillets to a platter, sprinkle with salt and cover loosely with foil. Allow to rest for 5 minutes before serving. Serve a fruit conserve or jelly, such as cranberry, redcurrant, lingonberry, or crab apple jelly, with the boar.

Gressholmen Grilled Rabbit

Serves **4** | Preparation **25 minutes** | Marinating **48 hour** | Grilling **20 minutes**

2 x 3 lb/1.4 kg rabbits, each cut into 6 portions
3 tablespoons bacon fat , melted

MARINADE
$^1/_4$ cup/2 fl oz/60 ml olive oil
3 cups/1$^1/_4$ pints/750 ml dry white wine
1 tablespoon Dijon mustard
3 garlic cloves, crushed

$^1/_2$ red chili pepper, seeded and finely minced or chopped
$^1/_2$ cup/1 oz/25 g chopped fresh rosemary
$^1/_4$ cup/$^1/_2$ oz/15 g chopped fresh marjoram
$^1/_4$ cup/$^1/_2$ oz/15 g fresh thyme leaves
1 tablespoon coarse sea salt
1 tablespoon freshly ground black pepper

1 Rinse the rabbit portions thoroughly under cold running water and pat the pieces dry with paper towel.

2 To make the marinade, whisk the olive oil, wine, and mustard together. Stir in the garlic, chili, rosemary, marjoram, thyme, salt, and pepper. Pour this marinade over the rabbit and turn the portions until thoroughly coated. Cover and refrigerate for 48 hours, turning four times during marinating.

3 Bring the rabbit to room temperature while the barbecue is heating up. Drain the rabbit and place the portions on a well-oiled, hot grill. Cook the leg and shoulder portions for 10 minutes on each side; cook the loin portions for 8 minutes on each side, so as not to overcook these smaller pieces. Baste the rabbit with the bacon fat during cooking, until well browned and cooked through.

4 Transfer the rabbit portions to a platter and cover with foil. Then leave to rest for 5 minutes before serving.

Genius Tip It is recommended that you purchase rabbit already butchered into portions, i.e. hind legs, back, and forelegs, into halves.

Venison with Pomegranate Sauce

Serves **4** | Preparation **35 minutes** | Marinating **24 hours** | Grilling **24 minutes**

3 lb/1.4 kg venison tenderloin
rosemary sprigs for the barbecue
olive oil

MARINADE
12 dried sage leaves
6 allspice berries
6 juniper berries
3 tablespoons black peppercorns
5 tablespoons dried rosemary
3 tablespoons coarse salt
$^1/_4$ cup/2 fl oz/60 ml olive oil
$1^1/_2$ cup/12 fl oz/350 ml
pomegranate juice
6 garlic cloves, finely chopped

POMEGRANATE SAUCE
5 cups/1 quart/2 pints venison or
game stock
3 oz dried porcini mushrooms
3 garlic cloves, crushed
1 jalapeño chili, seeded and finely
chopped or minced
bunch of fresh thyme
4 dried sage leaves
1 tablespoon sweet rice vinegar
$1^1/_2$ cup/12 fl oz/350 ml pomegranate
juice
1 cup/8 fl oz/250 ml tomato
marmalade

1 Trim off any fat or membrane from the venison. Avoid using the narrow end of the tenderloin. Place in a dish.

2 To make the marinade, roast the sage, allspice, juniper, peppercorns, rosemary, salt, and pepper in a dry, non-stick pan until the ingredients release their aromas. Remove from the heat immediately to prevent the ingredients from burning.

3 Grind the herbs and spices in a mortar with a pestle and transfer to a bowl. Add the olive oil, pomegranate juice, and fresh garlic.

4 Rub the marinade into the venison, cover and marinate at room temperature for 3 hours. Transfer to the refrigerator and leave to marinate overnight. Remove from the refrigerator and bring to room temperature about 1 hour before grilling.

5 To make the sauce, pour the stock into a saucepan and add the dried porcini. Add the garlic, jalapeño chili, thyme, and sage. Bring to a boil and reduce the heat to low. Simmer for about 1 hour or until the liquid is reduced by half.

6 Add the rice vinegar, pomegranate juice, and tomato marmalade. Bring to a boil and then remove from the heat. Strain the sauce.

7 To cook the venison, throw some rosemary sprigs on the coals to give off an aromatic smoke. Brush the grill with oil. Cook the venison for about 9 minutes on each side. Then grill the two edges for about 3 minutes each, using tongs to keep the meat standing on edge. The meat should be browned outside and medium-rare inside.

8 Transfer the venison to a platter, cover with foil and leave to rest for 8 minutes.

9 Meanwhile, reheat the sauce. Cut the venison into $1/2$ in/1 cm thick slices and arrange on plates. Spoon a little of the sauce over and serve the rest separately.

Genius Tip Polenta and grilled orange slices are a delicious combination to serve with the venison and its sauce.

chapter 4
lamb

Barbecued Five-spice Chops

Serves **4** | Preparation **16 minutes** | Marinating **15 minutes** | Grilling **16 minutes**

8 double rib lamb chops, about 2 in/ 5 cm thick and 5oz/150 g each
3 tablespoons light sesame oil
1 teaspoon Thai sweet chili sauce
3 garlic cloves, crushed
1 tablespoon finely minced fresh root ginger

1 red chili pepper, seeded and finely minced or chopped
$^1/_2$ cup/1 oz/25 g coarsely chopped fresh cilantro
1 teaspoon Chinese five-spice powder
1 tablespoon coarse sea salt

1 Trim the fat on the chops to $^1/_4$ in/5 mm and clean the bones down to the medallions of meat. Place the chops in a shallow dish.

2 Mix the sesame oil with the chili sauce, garlic, ginger, chili, cilantro, five-spice powder, and salt to form a coarse paste. Spread the mixture over the chops and rub it in thoroughly. Cover and allow to stand at room temperature for 15 minutes.

3 Cook the chops on a well-oiled, medium-hot grill for 8 minutes on each side until well browned and cooked through. Serve freshly cooked.

Genius Tip If your barbecue does not have a built in shelf, a small waist high table is advised to provide extra workspace. Ideally you should have all of the ingredients and utensils available at your fingertips. One exception is the food, which requires refrigeration up until the last minute.

Lamb with Chipotle & Fennel Seed Rub

Serves **4** | Preparation **14 minutes** | Marinating **2 hours** | Grilling **16 minutes**

**8 double rib lamb chops, about 2 in/
5 cm thick and 5oz/150 g each
3 tablespoons olive oil
1 tablespoon coarse sea salt**

CHIPOTLE AND FENNEL SEED RUB
**1 dried chipotle chili, seeded
 and chopped
2 tablespoons fennel seeds
1 tablespoon mustard seeds
1 tablespoon cumin seeds
1 teaspoon garlic powder
1 teaspoon onion powder**

1 Trim off any excess fat from the chops, leaving a $^1/_4$ in/5 mm edge on the meat. Snip into the fat at 3 in/7.5 cm intervals, then place the chops in a shallow dish.

2 To prepare the dry rub, toast the chili with the fennel, mustard, and cumin seeds in a dry non-stick skillet over a medium heat for 3 minutes. Take care not to burn the spices. Place the mixture in a spice mill and grind to a powder. Mix in the garlic and onion powder.

3 Rub the spice mixture over the chops and into the scored fat. Cover and refrigerate for 2 hours.

4 Brush the chops with olive oil and cook on a well-oiled, medium-hot grill for 8 minutes on each side, until well browned and medium or medium-rare. Serve freshly cooked.

lamb

231

Lamb Chops in Saffron Marinade

Serves **4** | Preparation **18 minutes** | Marinating **24 hours** | Grilling **10 minutes**

8 double rib lamb chops, about 2 in/
5 cm thick and 5 oz/150 g each

MARINADE
1 onion, cut in chunks
6 garlic cloves
1 teaspoon finely ground saffron
1 tablespoon freshly ground
black pepper
2 cups/16 fl oz/475 ml whole-fat
plain yogurt

juice of ¹/₂ lemon
grated zest and juice of ¹/₂ orange

BASTING SAUCE
¹/₂ cup/4 fl oz/125 ml butter, melted
juice of ¹/₂ lemon
juice of ¹/₂ orange
¹/₂ teaspoon finely ground saffron
1 tablespoon coarse sea salt

1 Trim the fat on the chops to ¹/₄ in/5 mm and clean the bones down to the medallions of meat. Place the chops in a shallow dish.

2 To make the marinade, process the onion, garlic, saffron, and pepper in a food processor until finely chopped. Add the yogurt, lemon juice, and orange zest and juice. Process until smooth, then pour the mixture over the lamb and make sure they are thoroughly coated. Cover the dish and refrigerate for 24 hours.

3 Make the basting sauce just before grilling the chops. Melt the butter and mix it with the lemon and orange juices, saffron, and salt with the remaining ingredients in a small bowl just before use.

4 Cook the chops on a well-oiled, medium-hot grill for 5 minutes on each side. Brush frequently with the basting mixture during cooking. Serve freshly cooked.

Ginger-spiced Loin Chops

Serves **4** | Preparation **17 minutes** | Marinating **8 hours** | Grilling **16 minutes**

8 T-bone lamb loin chops, about 2 in/
5 cm thick and 7oz/200 g each
1 tablespoon coarse sea salt

MARINADE
3 tablespoons finely minced or
chopped fresh root ginger
4 garlic cloves, crushed
1 red chili pepper, seeded and
finely chopped

$^1/_2$ cup/4 fl oz/125 ml ketjap manis
(Indonesian sweet soy sauce)
$^1/_2$ cup/4 fl oz/125 ml sake
2 tablespoons dark sesame oil
2 tablespoons light molasses

BASTING GLAZE
3 tablespoons light molasses
1 tablespoon dark sesame oil

1 Trim the fat to $^1/_4$ in/5 mm around the edge of the loin meat and remove it completely from the edge of the tenderloin, then place the chops in a shallow dish in single layer.

2 To make the marinade, mix the ginger, garlic, chili, ketjap manis, sake, sesame oil, and molasses, then pour the mixture over the chops. Rub the marinade all over the meat, cover and refrigerate for 8 hours, turning four times during marinating.

3 Stir the molasses and sesame oil together for the basting glaze. Place the chops on a well-oiled, medium-hot grill and cook for 8 minutes on each side, brushing frequently with the glaze. The chops should be well browned and cooked through. Serve sprinkled with salt.

Tandoori-Style Lamb Chops

Serves **4** | Preparation **21 minutes** | Marinating **4 hours** | Grilling **16 minutes**

8 T-bone lamb loin chops, about 2 in/
5 cm thick and 7oz/200 g each
1 tablespoon coarse sea salt
1 cup/2 oz/50 g coarsely chopped
cilantro

MARINADE
2 cups/16 fl oz/475 ml whole-milk
plain yogurt
juice of 1 lemon

5 garlic cloves, crushed
2 tablespoons finely minced or
chopped fresh root ginger
1 tablespoon saffron threads
1 tablespoon freshly ground
black pepper
1 teaspoon ground turmeric
1 teaspoon ground coriander
1 teaspoon cayenne pepper
½ teaspoon ground cumin

1 Trim the fat to ¼ in/5 mm around the edge of the loin meat and remove it completely from the edge of the tenderloin, then place the chops in a shallow dish in a single layer.

2 To make the marinade, stir the yogurt, lemon juice, garlic, ginger, saffron, pepper, turmeric, coriander, cayenne, and cumin together until thoroughly combined. Pour this over the chops and massage it into the meat by hand. Cover and refrigerate for 4 hours, turning the chops over four times.

3 Cook the chops on a well-oiled, medium-hot grill for 8 minutes on each side, until well browned and cooked through. Transfer to a serving platter. Sprinkle with the salt and cilantro.

Genius Tip Basmati rice dressed with melted butter and scented with saffron is an excellent accompaniment for these tandoori-style lamb chops.

Lamb Chops with Greek Relish

Serves **4** | Preparation **20 minutes** | Marinating **2 hours** | Grilling **10 minutes**

16 lamb chops, weighing about 2 lb/900 g
$^1/_2$ cup/4 fl oz/125 ml olive oil
grated zest and juice of 1 lemon
6 garlic cloves, crushed
1 tablespoon dried oregano
1 tablespoon freshly ground black pepper
1 tablespoon coarse sea salt

RELISH
2 tomatoes, peeled and seeded
1 red bell pepper, peeled and seeded
$^1/_2$ cup/2 oz/50 g pitted kalamata olives
2 tablespoons capers
$^1/_2$ cup/1 oz/ 25 g roughly chopped basil
1 tablespoon Greek extra virgin olive oil
1 teaspoon balsamic vinegar
1 tablespoon freshly ground black pepper
1 teaspoon coarse sea salt

1 Clean the bones of the chops as far as the main portion of meat. Lay the chops flat in a shallow dish.

2 Whisk the oil, lemon juice, garlic, oregano, and pepper together and pour this over the chops. Rub the mixture into the meat, cover and refrigerate for 2 hours.

3 To make the relish, place the tomatoes, bell pepper, olives, capers, basil, oil, vinegar, pepper, and salt in a food processor. Reduce to an evenly coarse mixture. Transfer to a bowl, cover and leave at room temperature.

4 Cook the chops on a well-oiled, medium-hot grill, laying the bones towards the edge or cooler part of the grill. Cook for 5 minutes on each side, until well browned and medium to medium-rare.

5 Fan four chops per portion on plates, with their bones in the middle. Sprinkle with salt. Spoon some of the relish over each medallion of meat. Serve at once, offering the remaining relish separately.

lamb

Minted Lamb Chops

Serves **4** | Preparation **15 minutes** | Marinating **2 hours** | Grilling **10–12 minutes**

**8 T-bone lamb loin chops, about 2 in/
5 cm thick and 7oz/200 g each
1 teaspoon coarse sea salt
1 teaspoon freshly ground
black pepper**

MARINADE
**1 cup/8 fl oz/250 ml mint sauce
$^1/_2$ teaspoon ground ginger
$^1/_4$ teaspoon cayenne pepper
$^1/_2$ cup/4 fl oz/125 ml olive oil**

1 Trim the fat to $^1/_4$ in/5 mm around the edge of the loin meat and remove it completely from the edge of the tenderloin, then place the chops in a shallow dish in a single layer.

2 To make the marinade, whisk the mint sauce with the ginger, cayenne, and oil until thoroughly mixed. Pour this over the chops. Cover the dish and refrigerate for 2 hours.

3 Cook the chops on a medium-hot grill for 5–6 minutes on each side, until well browned and medium-rare. Baste the chops up until the last 5 minutes of cooking time with the leftover marinade.

4 Transfer the chops to plates, arranging two per portion. Sprinkle the salt and pepper over and serve.

Genius Tip When cooking thick chops or other cuts of meat with a rim of fat, use long-handled tongs to hold the meat on its side briefly to brown the fat well. This can be done at any stage in the cooking—it is usual to work around the grill, browning the edges of the items in turn during cooking.

Lamb Steaks with Chili Currant Glaze

Serves **4** | Preparation **15 minutes** | Marinating **15 minutes** | Grilling **12–14 minutes**

4 x 8 oz/225 g shoulder steaks, 1 in/
2.5 cm thick
1 garlic clove, crushed
2 tablespoons sesame oil
1 teaspoon Chinese five-spice powder
¾ cup/7 oz/200 g red currant jelly

1 red chili pepper, seeded and finely
minced or chopped
1 tablespoon coarse sea salt
1 teaspoon freshly ground
black pepper

1 Place the lamb steaks in a large shallow dish. Rub the garlic and oil over the lamb. Sprinkle the five-spice over, then smooth it lightly over the meat. Cover and leave at room temperature for 15 minutes.

2 Warm the red currant jelly with the chili pepper in a small saucepan until the jelly has melted.

3 Brush the melted jelly over the steaks and place face down on a well-oiled, medium-hot grill. Brush the top with jelly. Cook the steaks for 6–7 minutes on each side, brushing with more jelly as necessary, until caramelized outside and cooked to a medium result. Transfer to plates and serve.

Downtown Beirut Souvlaki

Serves **4** | Preparation **10 minutes** | Marinating **2 hours** | Grilling **20 minutes**

1¹/₂ lb/675 g lamb fillet, 1 in/ 2.5 cm thick	MARINADE
4 lavash, softened, or pita bread	3 tablespoons olive oil
1 tablespoon coarse sea salt	juice of ¹/₂ lemon
1 tablespoon freshly ground black pepper	4 garlic cloves, crushed
¹/₄ cup/¹/₂ oz/15 g finely chopped flat-leaf parsley	1 tablespoon dried oregano
3-4 tablespoons hummus	

1 Lay the lamb flat in a shallow dish. To make the marinade, whisk the oil and lemon juice together. Stir in the garlic and oregano. Spoon the marinade over the lamb and rub it all over the meat. Cover and refrigerate for 2 hours.

2 Drain the marinade off the lamb and pour it into a small saucepan. Bring to a boil, then remove from the heat.

3 Cook the lamb fillet on a well-oiled, medium-hot grill for 10 minutes on each side, brushing with the marinade, until well browned and cooked through. Warm and lightly toast the flat bread on the grill.

4 Transfer the meat to a cutting board and cover loosely, then leave to rest for 5 minutes. Sprinkle the lamb with salt and pepper and cut it across the grain at an angle into ¹/₈ in/3 mm thick slices.

5 Serve the lamb in the flat bread, sprinkled with parsley and topped with a little hummus.

Chili-mint Lamb Tenderloin

Serves **4** | Preparation **15 minutes** | Marinating **24 hours** | Grilling **14 minutes**

2 lb/900 g lamb tenderloin
1 tablespoon coarse sea salt
1 tablespoon freshly ground black pepper

MARINADE

2 red chili peppers, seeded
4 garlic cloves, crushed

1 tablespoon peeled and chopped fresh root ginger
1 cup/2 oz/50 g mint leaves
2 tablespoons Dijon mustard
$^{1}/_{4}$ cup/2 fl oz/60 ml olive oil
$^{1}/_{4}$ cup/2 fl oz/60 ml fruity red wine
2 tablespoons balsamic vinegar

1 Trim any fat and membrane from the lamb tenderloin and place the meat in a shallow dish.

2 To make the marinade, chop the chilies with the garlic, ginger, and mint in a food processor, then add the mustard, oil, wine and vinegar and process briefly to combine all the ingredients in a coarse paste. Pour the marinade over the lamb and rub it in well. Cover and refrigerate for 24 hours, turning the meat four times.

3 Drain the lamb, sprinkle with the salt and pepper and place towards the edge of a well-oiled, medium-hot grill. Cook for 2 minutes on each side—top, bottom, and both sides. Brush the top with leftover marinade, turn the meat over and brush with more marinade. Cook for a further 3 minutes on the top and bottom, until the meat is well browned and medium-rare.

4 Transfer the lamb to a cutting board. Cover loosely with a piece of foil and leave to rest for 5 minutes. Cut the lamb at an angle across the grain into $^{1}/_{2}$ in/1 cm slices. Fan the slices out on plates and serve at once. Celeriac, boiled and mashed with butter and garlic, and a potato purée or creamy mashed potatoes are delicious with the lamb.

lamb

239

Thai-spiced Lamb Loin Salad

Serves **4** | Preparation **30 minutes** | Marinating **4 hours** | Grilling **16 minutes**

1¹/₂ lb/675 g boneless lamb loin
1 tablespoon coarse sea salt
6 oz/175 g dry rice vermicelli
1 cup/8 oz/225 g fresh bean sprouts
1 red chili pepper, seeded and thinly sliced
1 cup/4 oz/100 g coarsely chopped green onion
1 cup/2 oz/50 g fresh cilantro leaves
1 cup/2 oz/50 g fresh purple basil leaves

MARINADE AND DRESSING
1¹/₂ cups/12 fl oz/350 ml coconut milk
3 tablespoons peanut oil
2 tablespoons light liquid honey
juice of 1 fresh lime
2 tablespoons red curry paste
3 garlic cloves, crushed
2 tablespoons finely minced or chopped fresh root ginger
1 tablespoon Thai fish sauce (nam pla)

1 Trim excess fat and membrane off the lamb and place the meat in a shallow dish.

2 To make the marinade and dressing, whisk the coconut milk, oil, honey, lime juice, and curry paste together. Stir in the garlic, ginger, and fish sauce until thoroughly combined. Pour half the mixture over the lamb and reserve the other half for salad dressing. Rub the marinade over the meat, cover the dish, and refrigerate for 4 hours. Turn the meat three times during marinating.

3 To make the salad, place the vermicelli in a bowl and cover with freshly boiling water. Cover and leave to soak for 30 minutes or for the time suggested on the packet, stirring twice. Drain the vermicelli and set aside.

4 Drain the lamb and sprinkle with the salt. Cook on a well-oiled, medium-hot grill for 16 minutes, turning the meat frequently so that it is well browned on all sides. Transfer the meat to a cutting board. Cover loosely with foil and leave to rest for 5 minutes.

5 Mix the vermicelli with the bean sprouts, chili and green onion in a large serving bowl. Pour the reserved dressing over the salad and toss gently.

6 Cut the lamb at an angle across the grain into ¹/₄ in/5 mm slices. Fan the warm lamb slices over the salad. Sprinkle with the cilantro and basil, and serve.

Cumin Lamb Loin with Grilled Eggplant

Serves **4** | Preparation **30 minutes** | Marinating **30 minutes** | Grilling **16 minutes**

1½ lb/675 g boneless lamb loin
2 tablespoons ground cumin
3 teaspoons coarse sea salt
1 tablespoon freshly ground black pepper

1 teaspoon garlic powder
1 teaspoon ground ginger
1 eggplant
¼ cup/2 fl oz/60 ml olive oil
coarsely chopped cilantro to garnish

1 Trim off any excess fat and membrane from the lamb. Place the meat in a shallow dish. Mix the cumin, 3 teaspoons of the salt, pepper, garlic powder, and ginger, and rub this all over the lamb. Cover and refrigerate for 30 minutes.

2 Rinse the eggplant under cold running water and pat dry, then cut into 1 in/2.5 cm thick slices.

3 Brush the lamb and eggplant with olive oil. Cook the lamb first: place it on a well-oiled, medium-hot grill and sear the meat for 2 minutes on each of its four sides.

4 Move the lamb to the edge of the grill where the heat is not as fierce and continue to cook for 3 minutes on each side, until medium or medium-rare. Transfer the lamb to a cutting board, loosely cover with foil and leave to rest for 5 minutes.

5 Cook the eggplant slices around the edge of the grill for 4 minutes on each side, until tender and scored with dark brown marks.

6 Cut the lamb at an angle across the grain into ¼ in/5 mm slices. Divide the eggplant slices among four plates. Fan a layer of lamb loin slices over the top. Sprinkle with cilantro and serve at once.

Souvlakia with Tzatziki

Serves **4** | Preparation **25 minutes** | Marinating **18 hours** | Grilling **12 minutes**

¹/₃ cup/3 fl oz/75 ml virgin olive oil
juice of 1 lemon
¹/₃ cup/3 fl oz/75 ml dry red wine
3 garlic cloves, crushed
1 tablespoon dried oregano
1 teaspoon coarse salt
1 teaspoon freshly ground
black pepper
2 lb/900 g lamb shoulder, cut into
1 in/2.5 cm cubes
1 onion, cut into 1 in/2.5 cm chunks
4 large pita bread

TZATZIKI
1 large English cucumber, peeled
1¹/₂ tablespoons salt
3³/₄ cups/1¹/₂ pints/950 ml whole-fat
plain yogurt
1 tablespoon lemon juice
2 garlic cloves, crushed
2 tablespoons dried mint or
6 tablespoons coarsely chopped
fresh mint
1¹/₂ teaspoons freshly ground
black pepper

1 Whisk the olive oil, lemon, and wine together in a bowl large enough to hold the lamb. Then add the garlic, oregano, salt, and pepper. Add the lamb cubes and toss until coated with the mixture. Cover and refrigerate for 18 hours.

2 To make the tzatziki, cut the cucumber into very thin julienne pieces and place in a sieve or colander. Sprinkle with the salt and place over a bowl. Leave to stand for 1 hour to draw out the moisture.

3 Mix the yogurt, lemon juice and garlic in a bowl. Cover and refrigerate. Just before serving the sauce, turn the cucumber out onto double-thick paper towels and mop dry with more paper towels. Add the cucumber to the yogurt mixture with the fresh mint and pepper.

Genius Tip Remember to trim the majority of fat from meat before cooking. A little fat provides flavor, whereas too much may be prone to catching fire. Banish the temptation to stick and stab meat when turning. Unnecessary loss of juices means loss of flavor to the dish.

4 Thread the lamb and chunks of onion alternately onto long metal skewers. The lamb should be at room temperature before it is placed on the grill, so allow to stand for 15 minutes if necessary.

5 Cook the souvlakia on a well-oiled, hot grill for 12 minutes or until the lamb is well browned and cooked. Turn often and brush with the marinade remaining in the bowl for the first 8 minutes.

6 Warm the pita bread on the side of the grill, until soft and lightly browned. Slit the pita bread open down one side. Remove the lamb and onions from the skewers and place in the pita. Spoon in some tzatziki and serve.

lamb

Market-place Lamb Kabobs

Serves **4** | Preparation **13 minutes** | Marinating **4 hours** | Grilling **12 minutes**

2 lb/900 g lean boneless lamb shoulder, cut into 1¹/₂ in/3.5 cm cubes
2 tablespoons olive oil
4 garlic cloves, crushed
1 red chili pepper, seeded and finely chopped
¹/₄ cup/¹/₂ oz/15 g coarsely chopped cilantro

1 tablespoon ground cumin
1 tablespoon coarse sea salt
1 teaspoon freshly ground black pepper
4 large pita bread

1 Place the meat in a shallow dish. Mix the olive oil, garlic, chili, cilantro, cumin, salt, and pepper, then pour the mixture over the lamb and mix well. Cover and refrigerate for 4 hours, turning the meat four times.

2 Thread the lamb on 4 long metal skewers, leaving ¹/₄ in/5 mm space between each piece. Cook the kabobs on a well-oiled, medium-hot grill for 3 minutes on each side, until well browned all over.

3 Warm the pita bread on the grill until slightly toasted. To serve the kabobs, fold a piece of pita around the meat on one skewer and pull the skewer out firmly to leave the lamb in the bread.

Genius Tip Remember—charcoal briquettes take longer to heat to the desired temperature, but last longer than easy light charcoal.

Persian Lamb Kabobs

Serves 4 | Preparation **14 minutes** | Marinating **30 minutes** | Grilling **7 minutes**

2 lb/900 g boneless lamb shoulder, trimmed	MARINADE
8 pita bread or soft flat bread or wraps	**1 large onion**
8 green onions, trimmed	**$^1/_2$ cup/4 fl oz/125 ml olive oil**
handful of cilantro sprigs	**juice of 2 limes**
handful of flat-leaf parsley sprigs	**1 tablespoon coarse sea salt**
	1 tablespoon freshly ground black pepper

1 Cut the lamb into strips about 2 in/5 cm wide and $^1/_2$ in/1 cm thick. Place the meat in a shallow dish.

2 To make the marinade, place the onion, oil, lime juice, salt, and pepper in a food processor and pulse until the onion is finely chopped and mixed with the other ingredients. Pour the mixture over the meat and mix thoroughly. Cover the dish and refrigerate for 30 minutes.

3 Thread the lamb onto eight long metal skewers, pushing them through the middle of each piece. Cook on a well-oiled, medium-hot grill for 7–10 minutes, turning once, until well browned and cooked through.

4 Warm and slightly toast the lavash or other soft bread to one side off the grill. Slide the meat off the skewers directly onto the flat bread. Top each with a green onion and a few sprigs of cilantro and parsley. Roll up and serve at once.

Mediterranean Minced Lamb Kabobs

Serves **4** | Preparation **17 minutes** | Marinating **1 hour** | Grilling **8 minutes**

2 lb/900 g ground lamb shoulder
1 onion, finely minced or chopped
4 garlic cloves, crushed and chopped
with 1 tablespoon coarse sea salt
1 red chili pepper, seeded and finely
minced or chopped
1 cup/2 oz/50 g finely chopped cilantro
1 cup/2 oz/50 g finely chopped
flat-leaf parsley
$^1/_2$ cup/1 oz/25 g finely chopped mint
1 tablespoon freshly ground
black pepper
3 tablespoons olive oil

TO SERVE
lavash, softened, or pita bread
4 large lettuce leaves, shredded
1 small red onion, chopped
4 tomatoes, diced
handful of tender basil sprigs
handful of cilantro sprigs

1 Mix the lamb with the onion, garlic, chili, cilantro, parsley, mint, and pepper. Knead and squeeze the mixture until all the ingredients are thoroughly combined with the meat. Cover and refrigerate for 1 hour.

2 Divide the meat into quarters. Wet your hands and roll each portion of meat into a ball. Roll each ball into a sausage, about 10 in/25 cm long and 1 in/2.5 cm thick. Lightly oil eight metal skewers and thread the sausages gently onto the skewers. Brush with the oil.

3 Cook the lamb skewers on a well-oiled, medium-hot grill for 8 minutes. Turn the skewers frequently so that the meat is evenly cooked and well browned all over. Brush with more oil occasionally during grilling.

4 Warm the lavash or pita bread on the grill while the kabobs are grilling. Scrape the meat directly from the skewer into warm flat bread. Top with lettuce, onion, tomato, basil, and cilantro. Fold the bread around the filling and serve.

Orange & Saffron Lamb Kabobs

Serves **4** | Preparation **26 minutes** | Marinating **8 hours** | Grilling **12 minutes**

2 lb/900 g boneless lamb shoulder,
cut into 1¹/₂ in/3.5 cm cubes
1 large red bell pepper, seeded and cut
into 1¹/₂ in/3.5 cm pieces
1 large zucchini, thickly sliced
1 large sweet red onion, cut
into wedges
1 tablespoon coarse sea salt

MARINADE
¹/₂ cup/4 fl oz/125 ml olive oil
1 tablespoon molasses
grated zest of 1 orange and juice
of 2 oranges
1 teaspoon saffron threads
1 teaspoon freshly ground
black pepper
4 garlic cloves, crushed
1 red chili pepper, seeded and finely
minced or chopped
3 dried bay leaves, crumbled

1 To make the marinade, mix the oil, molasses, orange zest and juice, saffron, pepper, garlic, chili, and bay leaves in a large mixing bowl. Add the lamb and mix thoroughly to coat all the cubes. Cover and refrigerate for 8 hours, tossing the lamb in the marinade four times.

2 Drain the lamb and pour the marinade into a small saucepan. Bring to a boil, reduce the heat and simmer for 5 minutes. Remove from the heat.

3 Thread the lamb on eight long metal skewers, alternating the meat with the pieces of pepper, zucchini, and onion.

4 Cook the kabobs on a well-oiled, medium-hot grill for 3 minutes on each of the four sides, until well browned and medium-rare. Brush the meat liberally with the reduced marinade during grilling. Transfer the kabobs to a serving platter and sprinkle with salt.

Lamb Kabobs with Hot Tomato Relish

Serves **4** | Preparation **23 minutes** | Marinating **2 hours** | Grilling **12 minutes**

1 cup/8 fl oz/250 ml red wine
$^1/_2$ cup/4 fl oz/125 ml olive oil
1 teaspoon ground cumin
1 teaspoon freshly ground
black pepper
2 lb/900 g boneless lamb shoulder,
cut into $1^1/_2$ in/3.5 cm cubes
1 tablespoon coarse sea salt

RELISH
2 tomatoes, peeled, seeded and
finely chopped

1 tablespoon extra virgin olive oil
1 teaspoon soft light brown sugar
1 small sweet red onion, finely minced
or chopped
1 red chili pepper, seeded and finely
minced or chopped
$^1/_2$ cup/1 oz/25 g coarsely chopped
fresh cilantro
$^1/_2$ cup/1 oz/25 g fresh chopped
flat-leaf parsley
2 garlic cloves, crushed and chopped
with 1 teaspoon coarse sea salt

1 Mix the wine, oil, cumin and pepper in a large bowl. Add the lamb and mix well to coat all the cubes in the wine marinade. Cover the dish with plastic wrap and refrigerate for 2 hours.

2 To make the relish, mix the tomatoes with the olive oil in a mixing bowl, stir in the sugar, onion, chili, cilantro, parsley, and garlic until all the ingredients are thoroughly combined. Cover and leave at room temperature while the lamb is marinating and cooking.

3 Thread the lamb on long metal skewers. Cook on a well-oiled, medium-hot grill for 3 minutes on each of the four sides until the meat is well browned and cooked through.

4 Transfer the skewers to a platter and sprinkle with salt. Scrape the meat off the skewers with a fork onto plates. Spoon the relish over the meat and serve.

Ouzo Shish Kabobs

Serves 4 | Preparation **25 minutes** | Marinating **12 hours** | Grilling **8 minutes**

2 lb/900 g boneless lamb shoulder, trimmed and cut into 1 in/ 2.5 cm cubes
2 tablespoons dried oregano
1 tablespoon dried marjoram
1 teaspoon coarse sea salt

1 teaspoon freshly ground black pepper
$^{1}/_{2}$ cup/4 fl oz/125 ml ouzo
juice of $^{1}/_{2}$ lemon
4 garlic cloves, crushed

1 Place the lamb in a shallow dish. Mix the oregano, marjoram, salt, and pepper, and sprinkle over the lamb. Rub the seasonings into the cubes of meat until they are thoroughly coated.

2 Mix the ouzo, lemon juice, and garlic, then pour this over the lamb and turn the meat in the liquids until evenly coated. Cover and refrigerate for 12 hours.

3 Drain the lamb and thread the pieces on long metal skewers. Cook on a well-oiled, medium-hot grill for 8 minutes, turning four times so that the meat is evenly browned and cooked through. Serve freshly cooked. Pita bread and a Greek salad are suitable accompaniments.

Cumin-Laced Rack of Lamb

Serves **4** | Preparation **19 minutes** | Marinating **4 hours** | Grilling **22 minutes**

2 racks of lamb, 8 chops and
about 2 lb/900 g each
$^1/_2$ cup/4 fl oz/125 ml olive oil
2 tablespoons light molasses
grated zest and juice of 1 lemon
4 garlic cloves, crushed
2 tablespoons ground cumin

1 tablespoon ground coriander
1 tablespoon freshly ground
black pepper
1 teaspoon ground ginger
1 teaspoon ground cardamom
1 tablespoon coarse sea salt

1 Clean the bones and trim the thin layer of fat and membrane from the surface
of the meaty portion of the racks of lamb. Lay the racks in a shallow dish.

2 Mix the oil with the molasses, lemon zest and
juice, garlic, cumin, coriander, pepper, ginger,
and cardamom to make a thick paste. Smear
some paste over the outside of the racks of
lamb and lay them in the dish with the meaty
portions curling upwards. Spoon the remainder
of the paste over the meaty areas. Cover the
dish and refrigerate for 4 hours.

3 Wrap foil around the cleaned, exposed bones to protect them during grilling, taking care to leave the meat uncovered. This should prevent the bones from charring. Place the racks on a well-oiled, medium-hot grill, meaty sides down. Cook for 12 minutes, turn and cook for a further 10 minutes. Transfer the cooked racks of lamb to a cutting board, cover loosely with foil and leave to rest for 10 minutes.

4 Carve between the bones to cut the racks into single or double chops. Arrange on plates, fanning single chops or crossing the bones of double chops. Sprinkle with salt and serve at once.

Genius Tip Couscous would be delicious with the racks of lamb—gently cook a handful of white raisins and 4 chopped green onions in 2 tablespoons butter with 2 tablespoons olive oil until the fruit is slightly plump. Toss this into the couscous. Add some chopped mint and cilantro, and serve.

Rosemary & Mustard Rack of Lamb

Serves **4** | Preparation **19 minutes** | Marinating **8 hours** | Grilling **24 minutes**

2 racks of lamb, 8 chops and about 2 lb/900 g each
1/2 cup/4 fl oz/125 ml olive oil
2 tablespoons Dijon mustard
2 tablespoons light molasses
2 tablespoons apple cider vinegar

2 tablespoons crushed dried rosemary
2 tablespoons freshly ground black pepper
1 teaspoon crushed dried thyme
4 garlic cloves, crushed
1 tablespoon coarse sea salt

1 Clean the bones and trim the thin layer of fat and membrane from the surface of the meaty portion of the racks of lamb. Lay the racks in a shallow dish, bones down so that they curve upwards.

2 Whisk the olive oil with the mustard, molasses, and vinegar. Stir in the rosemary, pepper, thyme, and garlic, then spoon this over the lamb to thoroughly coat both racks. Cover and refrigerate for 8 hours.

3 Wrap foil around the cleaned, exposed bones to protect them during grilling, taking care to leave the meat uncovered. This should prevent the bones from charring. Place the racks on a well-oiled, medium-hot grill, meaty sides down. Cook for 12 minutes on each side. Transfer the lamb to a cutting board, cover loosely with foil and leave to rest for 10 minutes.

4 Carve between the bones to cut the racks into single or double chops. Arrange on plates, fanning single chops or crossing the bones of double chops. Sprinkle with salt and serve.

Athenian Leg of Lamb

Serves **4** | Preparation **19 minutes** | Marinating **24 hours** | Grilling **30 minutes**

4 lb/1.8 kg leg of lamb, boned and butterflied (see Genius Tip)
1 cup/8 fl oz/250 ml red wine
juice of $^1/_2$ lemon
$^1/_2$ cup/4 fl oz/125 ml Greek olive oil
4 garlic cloves, crushed
2 tablespoons dried oregano
4 dried bay leaves, crumbled
2 tablespoons coarse sea salt
2 tablespoons whole black peppercorns

BASTING DRESSING
$^1/_2$ cup/4 fl oz/125 ml Greek olive oil
juice of $^1/_2$ lemon
4 garlic cloves, crushed
2 tablespoons dried oregano
1 tablespoon freshly ground black pepper

1 Open out the lamb flat in a shallow dish. Stir the wine, lemon juice, oil, garlic, oregano, bay leaves, salt, and peppercorns together, then pour this mixture over the lamb. Cover the dish and refrigerate for 24 hours.

2 When you are ready to cook the lamb, whisk the oil and lemon juice with the garlic, oregano, and ground black pepper to make the basting dressing.

3 Place the lamb on a well-oiled, medium-hot grill. Cook for 15 minutes on each side, brushing frequently with the basting dressing. If the grill flares up, move the meat to the cooler edge of the barbecue until the flames die down. Transfer the lamb to a cutting board and allow to rest for 10 minutes. Cut the meat at an angle against the grain into $^1/_2$ in/1 cm thick slices.

Genius Tip To bone a leg of lamb hold the leg steady on a cutting board, tear the outer skin off, and slice away the outer fat. Loosen the pelvic bone from the socket of the leg by freeing it at the joint using the knife and cutting through the tendons which attach it to the leg bone. Grasp the shank bone at the other end and scrape away the tendons and flesh at the base, leaving the bone virtually clean. Cut the shank bone away from the knee, just at the point where it is connected to the meaty part of the leg. To remove the remaining bone at both ends dislodge it with a sharp knife and scrape the meat away from the bone as you twist it out.

Grilled Leg of Lamb Provençal

Serves **4** | Preparation **14 minutes** | Marinating **24 hours** | Grilling **30 minutes**

$^{1}/_{2}$ **cup/4 fl oz/125 ml olive oil**
1 tablespoon Dijon mustard
grated zest and juice of 1 lemon
4 garlic cloves, crushed
1 teaspoon each of dried basil, fennel,
marjoram, rosemary, sage,
and thyme
3 dried bay leaves, crumbled
1 tablespoon coarse sea salt

1 tablespoon freshly ground
black pepper
4 lb/1.8 kg leg of lamb, boned
and butterflied

BASTING LIQUID
$^{1}/_{2}$ **cup/4 fl oz/125 ml olive oil**
1 tablespoon red wine vinegar

1 Whisk the oil, mustard, lemon zest and juice together until well mixed. Stir in the garlic, dried herbs, bay leaves, salt, and pepper. Open out the lamb in a shallow dish. Spread the mixture over the lamb and rub it in well. Cover the dish and refrigerate for 24 hours.

2 Mix the oil and vinegar for basting. Cook the lamb on a well-oiled, medium-hot grill for 15 minutes on each side, until well browned, brushing frequently with the basting liquid. Move the lamb to one side if the grill flares and replace it when the flames have died down.

3 Transfer the lamb to a cutting board, cover loosely with foil and leave to rest for 10 minutes. Cut the meat at an angle against the grain into $^{1}/_{2}$ in/1 cm thick slices and serve at once.

Genius Tip The process of butterflying meat cuts down on the cooking time. Lay the boned lamb flat and slice horizontally through the portion, where the bone cavity has been created. Don't slice entirely through, but just to the point, which allows turning the flap of meat over like the page of a book. Return to the meaty opposite side, slice horizontally and lay it out flat in a similar fashion.

Fez-style Leg of Lamb

Serves **4** | Preparation **15 minutes** | Marinating **24 hours** | Grilling **30 minutes**

4 lb/1.8 kg leg of lamb, boned
and butterflied
$1/2$ cup/4 fl oz/125 ml olive oil
1 tablespoon light liquid honey
grated zest and juice of 1 lemon
6 garlic cloves, crushed
1 red chili pepper, seeded and
finely chopped

1 cup/2 oz/50 g finely chopped mint
1 tablespoon dried coriander
1 teaspoon dried cumin
1 tablespoon coarse sea salt
1 tablespoon freshly ground
black pepper
harissa to serve (optional)

1 Lay the lamb in a shallow dish and open it out flat. Whisk the oil, honey, and lemon zest and juice together. Stir in the garlic, chili, mint, coriander, cumin, salt, and pepper and pour the mixture over the lamb. Rub the mixture into the meat, cover and refrigerate for 24 hours.

2 Drain the marinade off the meat and pour it into a small saucepan. Bring to the boil on the stove, reduce the heat and simmer for 5 minutes. Remove from the heat and use as a basting liquid.

3 Cook the lamb on a well-oiled, medium-hot grill for 15 minutes on each side, brushing frequently with the reduced marinade, until well browned. Move the lamb to one side if the grill flares and replace it over the hot coals when the flames have died down.

4 Transfer the lamb to a board, cover loosely with foil and leave to rest for 10 minutes. Cut the meat at an angle against the grain into $1/2$ in/1 cm thick slices. Offer harissa as a condiment, if liked; couscous goes well with the lamb.

kasbah Lamb Brochettes

Serves **4** | Preparation **17 minutes** | Marinating **8 hours** | Grilling **8 minutes**

1/4 **cup/2 fl oz/60 ml olive oil**
juice of 1/2 **lemon**
1 onion, grated
3 garlic cloves, crushed
1 teaspoon hot paprika
1 teaspoon crushed saffron threads
1 teaspoon dried oregano

1/2 **teaspoon ground cumin**
1 teaspoon ground turmeric
11/2 **lb/675 g boneless leg of lamb, cut**
into 1 in/2.5 cm cubes
1 tablespoon coarse sea salt
1 tablespoon freshly ground
black pepper

1 Whisk the oil and lemon juice together in a large mixing bowl. Stir in the onion, garlic, paprika, saffron, oregano, cumin, and turmeric until thoroughly combined in a coarse paste. Add the lamb cubes to the bowl of paste and mix well. Cover and refrigerate for 8 hours.

2 Thread the lamb cubes onto eight long metal skewers. Season the meat well all over with the salt and pepper, then place on a well-oiled, medium-hot grill. Cook for 2 minutes on each of the four sides for a medium result.

3 Serve the lamb on the skewers or scrape the meat off the skewers and onto individual plates.

Martini Leg of Lamb

Serves **4** | Preparation **16 minutes** | Marinating **24 hours** | Grilling **30 minutes**

1 cup/8 fl oz/250 ml dry white vermouth	4 dried bay leaves, crumbled
½ cup/4 fl oz/125 ml gin	1 teaspoon dried thyme
½ cup/4 fl oz/125 ml olive oil	4 lb/1.8 kg leg of lamb, boned and butterflied
5 garlic cloves, crushed	1 tablespoon coarse sea salt
1 tablespoon juniper berries	cranberry or lingonberry sauce or conserve to serve
1 teaspoon black peppercorns	
1 teaspoon whole cloves	

1 To make a marinade, mix the vermouth, gin, oil, garlic, juniper berries, peppercorns, cloves, bay leaves and thyme. Spread out the lamb in a dish and pour the marinade over. Cover and refrigerate for 24 hours, turning the lamb four times.

2 Drain the lamb and pour the marinade into a saucepan. Bring to a boil, reduce the heat and simmer for 5 minutes. Remove from the heat.

3 Cook the lamb on a well-oiled, medium-hot grill for 15 minutes on each side, until well browned and medium-rare. Brush frequently with the reduced marinade during cooking.

4 Transfer the meat to a cutting board. Cover loosely with foil and leave to rest for 10 minutes. Cut the meat at an angle against the grain into ½ in/1 cm thick slices. Season with salt and serve with cranberry or lingonberry sauce or conserve.

Genius Tip Nutty, wild rice and delicious barbecued squash are excellent accompaniments for this succulent lamb dish.

Mrs Twomey's Barbecued Lamb

Serves **4** | Preparation **30 minutes** | Grilling **30 minutes**

4 lb/1.8 kg leg of lamb, boned and
butterflied (see Genius Tip page 254)
3 large garlic cloves, cut into
thin slivers
¹/₂ teaspoon ground ginger
1 teaspoon freshly ground
black pepper
1 teaspoon salt
2 teaspoons English mustard powder
2 tablespoons all-purpose flour

BASTING SAUCE
2 tablespoons soy sauce
3 tablespoons Worcestershire sauce
1 cup/8 fl oz/250 ml dry red wine
2 tablespoons tomato paste
1 tablespoon brown sugar
¹/₄ teaspoon cayenne pepper
4 tablespoons mild sweet chutney
1 onion, finely chopped
3 tablespoons melted butter

1 Trim excess fat from the lamb. Make small, deep incisions all over the lamb and insert the slivers of garlic into them. Mix the ginger, pepper, salt, mustard powder, and flour, then rub this mixture all over the lamb.

2 Prepare the basting sauce in a saucepan: whisk the soy sauce, Worcestershire sauce, wine, tomato paste, sugar, and cayenne pepper together until the sugar has dissolved and the tomato paste is thoroughly combined with the liquids. Stir in the chutney, onion, and butter. Bring to the boil on the stove, then reduce the heat and simmer for 5 minutes. Remove from the heat.

3 Brush the lamb with basting sauce and cook indirectly on a covered barbecue over a low to medium grill, placing it well away from the heat source. Allow about 30 minutes hours gentle grilling. Turn the lamb every 10–15 minutes so that it cooks evenly and move it to the cooler edge of the grill if it begins to brown too much on one side. Brush with the basting sauce to keep the meat moist during the long cooking.

4 Transfer the meat to a board, cover loosely with foil and leave to rest for 10 minutes before carving. Meanwhile, bring the remaining basting sauce to the boil, simmer for 3–5 minutes to reduce the mixture to a syrupy glaze, and remove from the heat.

5 Carve the lamb into thick slices, transfer to a serving platter and drizzle the glaze over them before serving.

Genius Tips A covered grill or kettle barbecue is ideal for cooking a large cut of meat as keeping the lid closed retains the heat to cook the meat evenly and prevents flare-ups. Alternatively, the meat can be cooked in the oven as Mrs Twomey did originally in Leixlip, County Kildare, Ireland, where she roasted lamb in the oven with this delicious barbecue glaze. She prepared this dish for our family on special occasions. Place in a roasting pan and pour over the basting sauce. Cook in a preheated oven at 200°C/400°F/gas 6 for 1 hour, basting every 15 minutes. Reduce the temperature to 160°C/325°F/gas 3 and cook for a further 1 hour, basting as before.

Kofta Kabobs

Serves **4** | Preparation **20 minute** | Marinating **45 minutes** | Grilling **10 minutes**

2 lb/900 g ground lamb
1 egg
1 large onion, finely chopped
1 cup/2 oz/50 g finely chopped
flat-leaf parsley
$^2/_3$ cup/1$^1/_2$ oz/35 g finely chopped
fresh mint
1 teaspoon ground cinnamon
1 tablespoon olive oil

1 tablespoon coarse sea salt
1 tablespoon freshly ground
black pepper

ACCOMPANIMENTS
4 large pita bread
4 tablespoons strained plain yogurt
$^1/_2$ English cucumber, diced
4 tomatoes, diced

1 Place the lamb, egg, onion, parsley, mint, cinnamon, oil, salt, and pepper in a bowl. Mix all the ingredients until thoroughly combined. This can be done with a mixing spoon or by kneading the ingredients into the meat by hand.

2 Divide the meat into quarters. Wet your hands and roll each portion of meat into a ball. Roll each ball into a sausage, about 11 in/28 cm long and 1$^1/_2$ in/3.5 cm in diameter. Lightly oil four metal skewers and thread the sausages gently onto the skewers. There should be about 1 in/2.5 cm skewer uncovered at each end. Rest the ends of the skewers on the edges of a shallow dish so as not to flatten the sausage. Cover loosely with plastic wrap and refrigerate for 45 minutes.

3 Cook the lamb skewers on a well-oiled, medium-hot grill for 10 minutes. Turn the skewers frequently so that the meat is evenly cooked and well browned.

4 Warm the pita bread on the grill for a few seconds on each side. Slit each piece of pita lengthwise and slide a portion of lamb straight off a skewer into each piece of bread. Drizzle with yogurt and sprinkle with cucumber and tomato. Serve at once.

Cilantro-mint Lamb Kabobs

Serves **4** | Preparation **26 minutes** | Grilling **12 minutes**

1½ lb/675 g ground lamb
1 finely chopped sweet red onion
4 garlic cloves, crushed and chopped
with 1 tablespoon coarse sea salt
1 red chili pepper, seeded and finely
minced or chopped
1 cup/2 oz/50 g finely chopped fresh
cilantro
1 cup/2 oz/50 g finely chopped fresh
mint leaves

1 teaspoon finely minced ginger
2 tablespoons olive oil

TO SERVE
4 large pita bread
4 tablespoons plain yogurt
juice of ½ lemon
coarse sea salt

1 Mix the lamb with the onion, garlic, chili, cilantro, mint, ginger, and oil. Knead and squeeze the mixture until all the ingredients are thoroughly and evenly combined with the meat.

2 Divide the meat into quarters. Wet your hands and roll each portion of meat into a ball. Roll each ball into a long sausage about 2 in/5 cm thick. Lightly oil four metal skewers and thread the sausages gently onto the skewers. There should be about 1 in/2.5 cm skewer free at each of the sausages.

3 Cook the lamb skewers on a well-oiled medium-hot grill for 12 minutes. Turn the skewers frequently so that the meat is evenly cooked and well browned.

4 Meanwhile, warm and lightly toast the pita bread on the side of the grill as the kabobs are cooking. To serve, wrap a piece of pita around a kabob and pull the meat firmly away from the skewer. Drizzle a little yogurt and lemon juice over the meat and sprinkle with a little salt, then fold the pita firmly around the meat. Repeat with the remaining kabobs.

Grilled Lambfurters

Serves **4** | Preparation **15 minutes** | Grilling **15 minutes**

2 lb/900 g ground lamb shoulder	1 teaspoon coarse sea salt
2 garlic cloves, crushed	$^1/_2$ teaspoon freshly ground
$^1/_4$ cup/$^1/_2$ oz/15 g fine dry	black pepper
bread crumbs	$^1/_4$ teaspoon cayenne pepper
$^1/_3$ cup/1$^1/_2$ oz/40 g pine nuts, toasted	2 eggs, lightly beaten
$^1/_4$ cup/$^1/_2$ oz/15 g finely chopped	8 hot dog rolls, split open
flat-leaf parsley	mango chutney to serve (optional)

1 Mix the lamb with the garlic, bread crumbs, pine nuts, parsley, salt, pepper, cayenne, and eggs. Knead and squeeze the mixture until all the ingredients are thoroughly combined.

2 Divide the meat into eight equal portions. Wet your hands and roll each portion of meat into a ball. Shape each ball into a sausage about the same length as the hot dog rolls.

3 Cook the lambfurters on a well-oiled, medium-hot grill for a total of 15 minutes for a medium result. Turn the lambfurters frequently so that they brown and cook through evenly.

4 Meanwhile warm and lightly toast the buns on the side of the grill. Serve the lambfurters in the buns, adding a little mango chutney if liked.

Middle-Eastern Lamb Burgers

Serves **4** | Preparation **11 minutes** | Grilling **8 minutes**

2 lb/900 g ground lamb	1 teaspoon light sesame oil
1 onion, finely chopped	1 tablespoon coarse sea salt
1 egg	1 teaspoon freshly ground
1 tablespoon sesame seeds	black pepper
$^1/_4$ cup/$^1/_2$ oz/15 g finely chopped mint	4 lavash, softened, or other
$^1/_4$ cup/$^1/_2$ oz/15 g finely chopped flat-leaf parsley	flat bread to serve

1 Mix the lamb with the onion, egg, sesame seeds, mint, parsley, sesame oil, salt, and pepper. Knead and squeeze the mixture until all the ingredients are thoroughly combined with the meat, then divide it into eight equal portions.

2 Roll the portions of meat into balls, then flatten them into neat round burgers measuring about $^3/_4$ in/1.5 cm thick.

3 Cook the burgers on a well-oiled, medium-hot grill for 4 minutes on each side, until well browned and cooked through.

4 Warm the flat breads on the grill until lightly toasted. Place two burgers on each piece of bread and fold the bread around the burgers to enclose them in a neat pocket.

Genius Tip Remember—always keep your barbecue at least 10 ft/3 m away from combustible items. This includes the house, garage, any fences, and gates. Never use your barbecue indoors or under a covered patio or open garage door.

Turkish Lamb & Pistachio Burgers

Serves **4** | Preparation **15 minutes** | Marinating **15 minutes** | Grilling **8 minutes**

1¹/₂ lb/675 g ground lamb
1 red onion, finely minced or chopped
2 garlic cloves, crushed
1 red chili pepper, seeded and finely minced or chopped
1 cup/4 oz/100 g coarsely ground pistachio nuts

1 teaspoon light liquid honey
¹/₂ cup/1 oz/25 g coarsely chopped flat-leaf parsley
1 teaspoon ground cumin
1 teaspoon coarsely ground black pepper
4 pita bread to serve

1 Mix the lamb with the onion, garlic, chili, pistachio nuts, honey, parsley, cumin, and pepper. Knead and squeeze the mixture until all the ingredients are thoroughly combined with the meat, then divide it into four equal portions.

2 Roll the portions of meat into balls, then flatten them into neat round burgers measuring about ¹/₂ in/1 cm thick. Place on a platter, cover and leave at room temperature for 15 minutes.

3 Cook the burgers on a well-oiled, medium-hot grill for 4 minutes on each side, until well browned and cooked through.

4 Warm the pita bread on the grill until lightly toasted on each side. Split the pita and transfer the burgers directly from the grill into the pita. Serve at once.

Kabul Lamb Burgers

Serves **4** | Preparation **17 minutes** | Grilling **10 minutes**

$1^1/_2$ **lb/675 g ground lamb**
1 onion, finely minced or chopped
$^1/_2$ **cup/l oz/25 g fresh bread crumbs**
2 garlic cloves, crushed and chopped
with 1 tablespoon coarse sea salt
1 tablespoon freshly ground
black pepper
1 large egg

$^1/_2$ **cup/l oz/25 g finely chopped dill**
$^1/_2$ **cup/l oz/25 g finely chopped**
cilantro
1 teaspoon ground cumin
1 teaspoon ground coriander
$^1/_2$ **teaspoon ground turmeric**
4 pita bread
4 tablespoons aioli or mayonnaise

1 Mix the lamb with the onion, bread crumbs, garlic, pepper, egg, dill, cilantro, cumin, coriander, and turmeric. Knead and squeeze the mixture until all the ingredients are thoroughly combined with the meat.

2 Divide the meat into quarters. Wet your hands and roll each portion of meat into a ball. Shape each ball into a 1 in/2.5 cm thick burger.

3 Cook the burgers on a well-oiled, medium-hot grill for 5 minutes on each side, for a well browned and medium result. Warm and lightly toast the pita bread towards the edge of the barbecue as the burgers are cooking.

4 Serve the burgers on the pita, topped with a dollop of aioli or mayonnaise. A simple tomato and cucumber salad complements the burgers.

chapter **5**

pork

Indonesian-style Pork Tenderloin

Serves **4** | Preparation **45 minutes** | Marinating **24 hours** | Grilling **10 minutes**

2 lb/900 g pork tenderloin
$^2/_3$ cup/5 fl oz/175 ml ketjap manis (Indonesian sweet soy sauce)
$^1/_4$ cup/2 fl oz/60 ml peanut oil
1 tablespoon sesame oil
1 teaspoon chili oil or hot chili sauce

PEANUT SAUCE
4 tablespoon peanut oil
1 cup/8 oz/225 g crunchy peanut butter
4 green onions, minced or finely chopped

3 garlic cloves, crushed
3 tablespoons minced or grated fresh root ginger
2 red chili peppers, seeded and minced or finely chopped
2 tablespoons brown sugar
juice of 2 fresh limes
12 oz/350 g can coconut milk
1 cup/2 oz/50 g chopped cilantro

GARNISH
$^1/_2$ cup/1 oz/25 g chopped cilantro
$^1/_2$ cup/2 oz/50 g chopped peanuts

1 Trim any fat and membrane off the pork and cut it into eight equal portions. Mix the ketjap manis, peanut oil, sesame oil, and chili oil or sauce together in a large bowl. Add the pieces of pork fillet, turning each one to coat it completely in the mixture. Cover the bowl with plastic wrap and refrigerate for at least 3 hours or overnight if possible.

2 Make the peanut sauce just before grilling the pork. Heat the oil in a saucepan, add the peanut butter, green onions, garlic, ginger, chilies, sugar, lime juice, coconut milk, and cilantro, stirring to combine the ingredients. Bring to a boil, stirring, then reduce the heat to low and simmer for 10–15 minutes. The sauce should be reduced to a thick pouring consistency. Remove from the heat, cover and set aside.

3 Cook the pork on a well-oiled, medium-hot grill for about 5 minutes on each side, for a well-browned medium result.

4 Serve each portion whole or sliced. Drizzle some sauce over the meat and sprinkle with cilantro and chopped peanuts. Serve the remaining sauce separately.

Genius Tip Before using your barbecue make sure that it is safely situated and on sturdy ground. If it wobbles, leans or seems in any way unstable move it to a more suitable location on a level surface.

Bamboo Pen Pork Tenderloin Jerk

Serves **4** | Preparation **23 minutes** | Marinating **4 hours** | Grilling **16 minutes**

2 lb/900 g pork tenderloin
1 tablespoon coarse sea salt
$^1/_2$ cup/1 oz/25 g coarsely chopped cilantro

JERK RUB
4 habañero chili peppers, halved and seeded
1 onion, coarsely chopped
4 garlic cloves, chopped
2 tablespoons chopped fresh root ginger

3 tablespoons coarse sea salt
2 tablespoons ground cloves
1 tablespoon dried thyme
1 tablespoon cayenne pepper
$^1/_2$ teaspoon freshly grated nutmeg
$^1/_2$ teaspoon ground cinnamon
3 tablespoons peanut oil
2 tablespoons light molasses
4 tablespoons apple cider vinegar

1 Slice the tenderloin in half lengthwise. The pieces of meat should be about 1 in/2.5 cm thick—if they are thicker, place them between two sheets of baking parchment or waxed paper and pound them out to 1 in/2.5 cm. Lay the meat in a shallow dish.

2 To make the jerk rub, place the chilies, onion, garlic, ginger, salt, cloves, thyme, cayenne, nutmeg, and cinnamon in a food processor. Pulse to a coarse paste. Add the oil, molasses, and vinegar and process to a paste.

3 Spread the paste over the pork, cover the dish, and refrigerate for 4 hours, turning the meat four times.

4 Cook the pork on a medium-hot, well-oiled grill. Allow 9 minutes on the first side and 7 minutes on the second side until the meat is cooked through and browned on both sides. Transfer the pork to a cutting board, cover loosely with foil and allow to rest for 5 minutes.

5 Cut the pork across at an angle into thin slices and arrange on a serving platter. Sprinkle with salt and cilantro and serve.

Pork Tenderloin in Plum Sauce

Serves **4** | Preparation **17 minutes** | Marinating **24 hours** | Grilling **20 minutes**

2 lb/900 g pork tenderloin
1 cup/8 fl oz/250 ml plum sauce
1 tablespoon light sesame oil
$^1/_2$ cup/4 fl oz/125 ml sake
2 tablespoon sweet Japanese vinegar

grated zest and juice of 1 orange
2 garlic cloves, crushed
2 tablespoons minced or grated fresh
root ginger
1 tablespoon ground white pepper

1 Trim off any fat and thin membrane from the pork and lay it in a shallow dish.

2 Whisk the plum sauce with the sesame oil, sake, rice vinegar, and orange rind and juice. Stir in the garlic, ginger, and pepper. Set aside a third of this mixture for basting the meat during cooking and pour the rest over the pork as a marinade. Cover the dish and refrigerate for 24 hours, turning four times.

3 Cook the pork on a medium-hot, well-oiled grill for 8 minutes each on the top and bottom, and for 2 minutes on each side. Brush with the reserved marinade mixture during cooking. The pork should be well browned and cooked through.

4 Transfer the pork to a cutting board, cover with foil, and leave to rest for 5 minutes. Cut the pork at an angle into $^3/_4$ in/1.5 cm thick slices and fan out on a serving platter.

Genius Tip A dish of rice noodles tossed with stir-fried shiitake mushrooms and chopped green onion goes well with the pork.

pork

Grilled Pork Tenderloin Mediterraneo

Serves **4** | Preparation **19 minutes** | Marinating **2 hours** | Grilling **18 minutes**

2 lb/900 g pork tenderloin	¹⁄₄ cup/¹⁄₂ oz/15 g coarsely chopped basil
5 tablespoons olive oil	
2 tablespoons dry white wine	¹⁄₄ cup/¹⁄₂ oz/15 g coarsely chopped thyme
grated zest and juice of 1 lemon	
4 garlic cloves, crushed	2 tablespoons dried oregano
¹⁄₄ cup/¹⁄₂ oz/15 g coarsely chopped fresh cilantro	1 teaspoon English mustard powder
	1 teaspoon ground fennel
¹⁄₄ cup/¹⁄₂ oz/15 g coarsely chopped flat-leaf parsley	1 teaspoon dried chili flakes
	1 tablespoon coarse sea salt

1 Slice the tenderloin in half lengthwise. The pieces of meat should be about 1 in/2.5 cm thick—if they are thicker, place them between two sheets of baking parchment or waxed paper and pound them out to 1 in/2.5 cm. Lay the meat in a shallow dish.

2 Whisk the oil, wine, and lemon rind and juice together in a mixing bowl. Stir in the garlic, cilantro, parsley, basil, thyme, oregano, mustard, fennel, and chili flakes. Spoon this mixture over the meat and rub it in well, then cover the dish and refrigerate for 2 hours.

3 Cook the tenderloins on a medium-hot, well-oiled grill for 9 minutes on each side. Transfer to a board and cover loosely with foil. Leave to rest for 5 minutes.

4 Cut the tenderloin at an angle into ¹⁄₂ in/1 cm thick slices. Arrange the slices on plates, fanning them out neatly, and sprinkle with salt.

Pork Loin Strips in Paprika Marinade

Serves **4** | Preparation **20 minutes** | Marinating **24 hours** | Grilling **8 minutes**

1¹/₂ lb/675 g pork tenderloin	MARINADE

$1^1/_2$ **lb/675 g pork tenderloin**
1 tablespoon coarse sea salt
$^1/_2$ **cup/2 oz/50 g finely chopped green onion**
bibb lettuce leaves

MARINADE
3 tablespoons olive oil
$^1/_2$ **cup/4 fl oz/125 ml dry white wine**
4 garlic cloves, crushed
2 tablespoons paprika
1 teaspoon dried oregano
$^1/_2$ **teaspoon dried chili flakes**

1 Cut the pork into $^1/_4$ in/5 mm thick slices measuring about 4 x 2 in/10 x 5 cm. Lay the pieces flat in a shallow dish.

2 To make the marinade, whisk the oil and wine together. Stir in the garlic, paprika, oregano, and chili flakes, then pour the marinade over the pork and mix well. Cover and refrigerate for 24 hours.

3 Cook the pork on a well-oiled, medium-hot grill for 4 minutes on each side, until well browned and cooked through.

4 Transfer the pork to a serving platter. Sprinkle with the salt and onion. Serve with the lettuce leaves—the meat is rolled in the leaves and eaten as finger food.

Genius Tip Always remember to situate your barbecue within proximity of the garden hose or have a bucket of sand on standby. Try to never leave your barbecue unattended.

Soy-sauce Roulades with Plums

Serves 4　|　Preparation **30 minutes**　|　Grilling **16 minutes**

2 lb/900 g pork tenderloin
2 tablespoons Chinese
 five-spice powder
sesame oil for cooking
bamboo skewers, soaked in water
 for 1 hour

FILLING
2 tablespoons olive oil
2 tablespoons soy sauce

2 tablespoons soft brown sugar
6 fresh plums, skinned, pitted and
 thinly sliced
1 tablespoon finely minced or grated
 fresh root ginger
2 finely minced or chopped
 green onion
$^1/_4$ cup/$^1/_2$ oz/15 g coarsely chopped
 cilantro leaves

1 Cut the tenderloin into $^1/_2$ in/1 cm thick strips, measuring about 4 x 8 in/10 x 20 cm. Sprinkle with the five-spice powder. Lay each piece of pork between two sheets of baking parchment or wax paper and pound out thinly with a meat mallet or rolling pin.

2 To make the filling, heat the oil, soy, and sugar in a saucepan, stirring, until the sugar has dissolved. Add the plums, ginger, and green onion. Cook, stirring, for about 10 minutes, until the plums and onions are tender. Continue to cook, stirring frequently, until the mixture is reduced to a paste. This will take about 5 minutes. Stir in the cilantro, remove from the heat, and cool slightly.

3 Lay out the pork slices and spread the filling over them. Roll up firmly from their short edges to enclose the filling without squeezing it out. Secure each roulade with two bamboo skewers, crossing them to keep the edges of the meat securely in place.

4 Brush the roulades with sesame oil and cook on a well-oiled, medium-hot grill for 8 minutes on each side, until well browned and cooked through. Transfer to a platter and remove the skewers before serving.

Pork Tacos

Serves **4** | Preparation **25 minutes** | Marinating **24 hours** | Grilling **16 minutes**

1½ lb/675 g pork tenderloin
¼ cup/2 fl oz/60 ml peanut oil
1 cup/8 fl oz/250 ml apple cider vinegar
½ cup/4 oz/100 g soft brown sugar
1 tablespoon dried thyme
1 tablespoon dried oregano
1½ teaspoons ground cumin
3 dried bay leaves, crumbled
1 teaspoon freshly ground black pepper

½ teaspoon chipotle chili powder
½ teaspoon ground cinnamon
4 cloves
1 teaspoon coarse sea salt

ACCOMPANIMENTS
12 soft flour tortillas
guacamole
red salsa

1 Place the pork tenderloin in a shallow dish. Stir the oil, vinegar, and sugar together until the sugar has dissolved. Stir in the thyme, oregano, cumin, bay leaves, pepper, chili powder, cinnamon, and cloves to make a thick marinade. Spoon the marinade over the pork and rub it in well. Cover the dish with plastic wrap and refrigerate for 24 hours.

2 Cook the pork on a well-oiled, medium-hot grill. Allow 4 minutes on each of the four sides, until well browned and cooked through.

3 Transfer the pork to a cutting board. Cover loosely with foil and leave to rest for 5 minutes. Toast the tortillas briefly on the grill, turning to brown both sides, until they are golden brown but still soft. Wrap the toasted tortillas in foil to keep them warm.

4 Cut the pork across at an angle into ¼ in/5 mm thick slices. Arrange on a platter and sprinkle with salt. Serve with the tortillas. Offer guacamole and red salsa as accompaniments.

Grama Samba Pork Tenderloin

Serves **4** | Preparation **20 minutes** | Marinating **24 hours** | Grilling **16 minutes**

2 lb/900 g pork tenderloin
3 tablespoons olive oil
juice of 3 oranges
2 tablespoons light molasses
1 tablespoon soft brown sugar
1/4 cup/1 oz/25 g grated fresh root ginger

4 garlic cloves, crushed
1 tablespoon chipotle chili powder
6 whole cloves
1/2 teaspoon cumin
1 tablespoon coarse sea salt

1 Place the pork in a dish. Whisk the oil, orange juice and molasses together. Add the sugar and stir until it has dissolved. Stir in the ginger, garlic, chili powder, cloves, and cumin. Reserve a third of this marinade to use as a glaze during grilling. Pour the remainder over the pork and rub it in well. Cover and refrigerate for 24 hours.

2 Cook the pork on a well-oiled, medium-hot grill for 4 minutes on each of the four sides. Brush with the reserved marinade during cooking. The pork should be well browned and glazed, and cooked through. Transfer to a board, cover loosely with foil, and leave to rest for 5 minutes.

3 Cut the pork across at an angle into 1/4 in/5 mm thick slices. Fan out the slices on plates and sprinkle with salt. Black beans and barbecued plantain are a delicious accompaniment to the pork.

Pork Tenderloin with Burmese Rub

Serves **4** | Preparation **20 minutes** | Marinating **1 hour** | Grilling **16 minutes**

2 lb/900 g pork tenderloin
$^{1}/_{2}$ cup/4 fl oz/125 ml coconut milk
2 tablespoons peanut oil
4 garlic cloves, crushed
1 red chili pepper, seeded and finely minced or chopped
1 teaspoon chili powder

1 teaspoon ground coriander
1 teaspoon ground turmeric
$^{1}/_{2}$ teaspoon ground cardamom
$^{1}/_{2}$ teaspoon ground cumin
$^{1}/_{2}$ teaspoon onion powder
1 tablespoon coarse sea salt

1 Lay the pork in a shallow dish. Whisk the coconut milk and oil together. Stir in the garlic, chili pepper and powder, coriander, turmeric, cardamom, cumin, and onion powder to make a thick paste. Spread the paste over the pork and rub it in well. Cover and refrigerate for 1 hour.

2 Cook the pork on a well-oiled, medium-hot grill for 4 minutes on each of the four sides, until evenly browned all over and cooked right through.

3 Transfer the meat to a cutting board and cover loosely with foil. Leave to rest for 5 minutes before carving.

4 Cut the pork across at an angle into $^{1}/_{4}$ in/5 mm thick slices. Fan out the slices on a serving platter and sprinkle with salt.

Pork Tenderloin with Curry Rub

Serves **4** | Preparation **25 minutes** | Marinating **1 hour** | Grilling **16 minutes**

2 lb/900 g pork tenderloin
1 tablespoon tomato ketchup
1 tablespoon tomato paste
2 tablespoons peanut oil
juice of 1/2 lemon
1 small onion, finely grated
4 garlic cloves, crushed
1 red chili pepper, seeded and finely minced or chopped
1 tablespoon fresh root ginger, finely minced or grated

1 tablespoon garam masala
1 teaspoon ground fenugreek
1 teaspoon ground coriander
1 teaspoon ground cumin
1 tablespoon coarse sea salt

ACCOMPANIMENTS

sweet mango chutney
fresh coriander and mint chutney
 (see genius tip)

1 Place the pork in a shallow dish. Stir the ketchup, tomato paste, oil, and lemon juice together, then mix in the onion, garlic, chili, ginger, garam masala, fenugreek, coriander, and cumin. Smear this paste all over the meat. Cover and refrigerate for 1 hour.

2 Cook the meat on a well-oiled, medium-hot grill for 4 minutes on each of the four sides, until well browned and cooked through. Transfer the pork to a board and cover loosely with foil. Leave to rest for 5 minutes.

3 Cut the pork across at an angle into 1/4 in/5 mm thick slices. Fan out the slices on a serving platter and sprinkle with salt. Serve with sweet mango chutney and fresh coriander mint chutney.

Genius Tip Make this simply prepared chutney by placing the following ingredients in the blender: 1/4 cup/1 oz/25 g fresh mint and cilantro; 2 garlic cloves; 3 rough chopped green onions; 1 fresh hot green chili pepper (jalapeño); juice from 1 whole lime; 1 teaspoon of superfine sugar; salt and freshly ground black pepper. First pulse, and then purée the ingredients into a thick pulp. Thin with a little water if desired.

Pork Tenderloin with Ceylonese Paste

Serves **4** | Preparation **25 minutes** | Marinating **1 hour** | Grilling **16 minutes**

2 lb/900 g pork tenderloin	1 teaspoon hot chili powder
$^1/_2$ cup/4 fl oz/125 ml coconut milk	1 teaspoon ground coriander
2 tablespoons peanut oil	1 teaspoon ground cumin
1 tablespoon apple cider vinegar	1 teaspoon ground fennel
1 tablespoon soft brown sugar	$^1/_2$ teaspoon ground fenugreek
1 small onion, grated	$^1/_2$ teaspoon ground cloves
4 garlic cloves, crushed	$^1/_2$ teaspoon ground cardamom
1 tablespoon finely minced or grated fresh root ginger	1 tablespoon coarse sea salt

1 Place the pork in a shallow dish. Whisk the coconut milk, oil, and vinegar together. Stir in the sugar until it has dissolved. Stir in the onion, garlic, ginger, chili powder, coriander, cumin, fennel, fenugreek, ground cloves, and cardamom. Spread this mixture over the meat and rub it in well. Cover and refrigerate for 1 hour.

2 Cook the meat on a well-oiled, medium-hot grill for 4 minutes on each of the four sides, until browned all over and cooked through.

3 Transfer to a cutting board and cover loosely with foil. Leave to rest for 5 minutes. Cut the meat at an angle into $^1/_4$ in/5 mm thick slices. Fan out the slices on a serving platter and sprinkle with salt. Serve at once.

Pork Roulades Dijonnaise

Serves **4** | Preparation **27 minutes** | Grilling **12 minutes**

2 x 1 lb/450 g pork tenderloin fillets, trimmed of any fat and membrane

1 tablespoon coarse sea salt

1 tablespoon freshly ground black pepper

3 tablespoons olive oil

FILLING

2 tablespoons Dijon mustard

1 tablespoon liquid honey

$^1/_2$ cup/1$^1/_2$ oz/50 g grated Parmesan cheese

$^1/_2$ cup/3 oz/75 g fine julienne of Westphalian ham

$^1/_4$ cup/$^1/_2$ oz/15 g coarsely chopped flat-leaf parsley

$^1/_4$ cup/$^1/_2$ oz/15 g coarsely chopped tarragon

2 tablespoons snipped chives

$^1/_2$ teaspoon cayenne pepper

1 Slice each tenderloin in half lengthwise. Lay a portion of pork between two sheets of baking parchment or wax paper and beat out thinly with a meat mallet or rolling pin to $^1/_4$ in/5 mm thick. Repeat with the remaining portions of pork. Lay out the slices of pork on a board and season with the salt and pepper.

2 For the filling, mix the mustard, honey, and Parmesan cheese in a small bowl. Add the ham, parsley, tarragon, chives, and cayenne, and stir to a thick paste.

3 Divide the mixture among the pork slices and spread it evenly over them. Roll up firmly and evenly to compact, but not squeeze out, the filling. Tie each roll in four places without pulling the string too tightly—it should not indent the rolls.

4 Brush the roulades with the olive oil and cook on a medium-hot, well-oiled grill, turning frequently, for 12 minutes, until well browned and cooked through. Transfer to a board, cover loosely with foil, and leave to rest for 5 minutes.

5 Remove the string and cut the roulades into 1 in/2.5 cm thick slices. Fan the slices out on plates and serve. Garlic-seasoned mashed potatoes and broccoli go well with the pork

Shelly's Barrier Island Mustard BBQ

Serves **4** | Preparation **13 minutes** | Marinating **3 hours** | Grilling **16 minutes**

4 x 8 oz/225 g pork loin chops
2 tablespoons canola oil
$^1/_2$ cup/4 oz/100 g honey mustard
1 tablespoon molasses
1 tablespoon corn syrup
1 tablespoon apple cider vinegar

3 garlic cloves, finely chopped
1 red chili pepper, seeded and
 finely chopped
$^1/_2$ teaspoon cayenne pepper
1 teaspoon coarse sea salt

1 Trim the fat on the meat to a $^1/_4$ in/5 mm rim. Place the chops in a shallow dish.

2 Mix the oil, mustard, molasses, corn syrup, vinegar, garlic, chili, and cayenne to make a marinade. Pour this over the meat and turn the pieces over several times to coat them thoroughly. Cover and refrigerate for 3 hours. Turn the meat over once every hour.

3 Cook the meat on a medium-hot, well-oiled grill for 8 minutes on each side, until browned and cooked through. Sprinkle with salt and serve.

Kramer's Honey Mustard Pork

Serves **4** | Preparation **11 minutes** | Marinating **45 minutes** | Grilling **16 minutes**

4 x 8 oz/225 g pork chops	1 tablespoon light liquid honey
2 tablespoons olive oil	3 garlic cloves, crushed
1 tablespoon Dijon mustard	1 tablespoon freshly ground
1 tablespoon soy sauce	black pepper
1 tablespoon light molasses	1 tablespoon coarse sea salt

1 Trim the fat on the chops to a $^1/_4$ in/5 mm rim. Place the chops in a shallow dish.

2 Whisk the olive oil, mustard, soy sauce, molasses, honey, garlic, and pepper together to make a marinade. Spoon this over the chops and turn them in the mixture to coat all sides evenly. Cover and leave to stand at room temperature for 45 minutes.

3 Cook the chops on a medium-hot, well-oiled grill for 8 minutes on each side, until well browned and cooked through. Transfer to plates and sprinkle with salt before serving. Fried potatoes (with onion and bacon, if liked) and steamed baby spinach go well with the chops.

> **Genius Tip** Glazes may be used to baste and coat foods before grilling and be brushed on while grilling. They may produce a crisp outer texture and enhance the gloss. Apply the glaze in several coats to form a dense thick outer layer. The sugar content in ingredients, such as honey, molasses, ketchup, syrup, and other prepared sauces, help to form a crust. A glaze must be thick enough to cling to food, so as not to drip onto coals and encourage shooting flames.

grilling genius

Barbecued Pork in Guinness Marinade

Serves **4** | Preparation **15 minutes** | Marinating **2 hours** | Grilling **16 minutes**

4 x 8 oz/225 g pork chops	1 tablespoon freshly ground
2 cups/16 fl oz/475 ml Guinness stout	black pepper
1 tablespoon canola oil	1 tablespoon crushed caraway seeds
1 tablespoon English mustard powder	1 tablespoon hot paprika
1 tablespoon light molasses	1 tablespoon coarse sea salt
3 garlic cloves, crushed	$^{1}/_{2}$ cup/1 oz/25 g coarsely chopped
1 tablespoon finely minced or grated	flat-leaf parsley
fresh root ginger	

1 Trim the fat on the chops to a $^{1}/_{4}$ in/5 mm rim. Place the chops in a shallow dish large enough to hold them in a single layer.

2 To make a marinade, whisk the stout, oil, mustard, and molasses together. Stir in the garlic, ginger, pepper, caraway seeds, and paprika.

3 Spoon the marinade over the chops and turn them to coat them thoroughly. Cover and refrigerate for 2 hours. Turn the chops over 3 times during this time.

4 Cook the chops on a medium-hot, well-oiled grill for 8 minutes on each side, until well browned and cooked through. Transfer to plates and sprinkle with salt and parsley. Mashed rutabaga and peas go well with the chops.

Currant-glazed Pork

Serves **4** | Preparation **10 minutes** | Grilling **16 minutes**

4 x 8 oz/225 g pork chops, about
1 in/2.5 cm thick
3 tablespoons peanut oil

CURRANT GLAZE
³/₄ cup/7 oz/200 g red currant jelly

2 tablespoons apple cider vinegar
2 tablespoons freshly grated or
 prepared horseradish
1 tablespoon coarse sea salt
1 tablespoon freshly ground
 black pepper

1 Score the surfaces of the chops with ¹/₈ in/3 mm deep slash marks to prevent them from curling while grilling. Brush the surfaces with the oil and place in a shallow dish.

2 Warm the jelly in a saucepan with the vinegar until the jelly has melted. Remove from the heat and stir in the horseradish, salt, and pepper.

3 Brush the tops of the chops with glaze and place glaze down on a well-oiled, medium-hot grill. Cook for 8 minutes on each side, brushing frequently with glaze, until evenly browned and caramelized, and cooked through.

Genius Tip Lightly cooked baby carrots or julienne of large carrots, tossed with a little ground cumin and briefly cooked in butter, and new potatoes go well with the chops.

Grilled Pork in Brine

Serves **4** | Preparation **30 minutes** | Marinating **12 hours** | Grilling **16 minutes**

4 x 8 oz/225 g pork chops, about	**3 tablespoons soft brown sugar**
1 in/2.5 cm thick	**4 bay leaves**
3 tablespoons olive oil	**4 cloves**
	1 teaspoon allspice berries
BRINE	**1 teaspoon chopped fresh root ginger**
8 cups/3¹/₂ pints/2 liters water	**1 cinnamon stick**
¹/₄ cup/2 oz/50 g sea salt	**1 tablespoon whole black peppercorns**

1 To make the brine, bring the water, salt, and sugar to a boil in a saucepan. Add the bay leaves, cloves, allspice, ginger, cinnamon stick, and peppercorns. Reduce the heat, stir, and simmer for 20 minutes. Remove from the heat, cover, and leave to cool to room temperature.

2 Score the surfaces of the chops with ¹/₈ in/3 mm deep slash marks to absorb the brine and prevent them from curling while grilling. Place in a dish deep enough to hold the brine. Pour the brine over the chops to immerse them completely. Cover and refrigerate for 12 hours.

3 Drain the chops and pat them dry with paper towel. Brush with oil and cook on a well-oiled, medium-hot grill for 8 minutes on each side, until browned and cooked through.

Grilled Pork in Mississippi Mud

Serves **4** | Preparation **15 minutes** | Marinating **2 hours** | Grilling **16 minutes**

4 x 8 oz/225 g pork chops, about
1 in/2.5 cm thick
2 tablespoons peanut oil
1 tablespoon apple cider vinegar
1 cup/8 fl oz/250 ml tomato ketchup
1 teaspoon coarse sea salt

1 teaspoon soft brown sugar
$^1/_2$ teaspoon cayenne pepper
$^1/_2$ teaspoon freshly grated nutmeg
$^1/_2$ teaspoon dried sage
$^1/_4$ teaspoon dried chili flakes

1 Score the surfaces of the chops with $^1/_8$ in/3 mm deep slash marks to prevent them from curling while grilling. Place in a shallow dish.

2 Whisk the oil, vinegar, and ketchup together. Add the salt and sugar and stir until dissolved. Stir in the cayenne, nutmeg, sage, and chili flakes. Spread this marinade over the meat and rub it in well. Cover and refrigerate for 2 hours, turning once.

3 Cook the chops on a well-oiled, medium-hot grill for 8 minutes on each side, brushing frequently with the marinade up until the last 5 minutes of the grilling time. The chops should be well browned and cooked through.

Barbecued Pork with Tropical Rub

Serves **4** | Preparation **20 minutes** | Marinating **1 hour** | Grilling **16 minutes**

4 x 8 oz/225 g pork chops, about 1 in/2.5 cm thick	**1 teaspoon dried oregano**
grated zest and juice of 2 limes	**3 dried bay leaves, crumbled**
3 tablespoons peanut oil	**$^1/_2$ teaspoon dried marjoram**
1 teaspoon freshly ground black pepper	**$^1/_2$ teaspoon ground cloves**
	$^1/_2$ teaspoon ground cinnamon
	$^1/_2$ teaspoon ground allspice
1 teaspoon ground cumin	**1 teaspoon coarse sea salt**

1 Score the surfaces of the chops with $^1/_8$ in/3 mm deep slash marks to prevent them from curling while grilling. Place in a shallow dish.

2 Whisk the lime zest and juice and oil together. Stir in the pepper, cumin, oregano, bay leaves, marjoram, cloves, cinnamon, and allspice. Smear the mixture over and into the slashes. Cover and refrigerate for 1 hour.

3 Cook the pork on a well-oiled, medium-hot grill for 8 minutes on each side, until browned and cooked through. Serve at once, sprinkled with salt.

Sweet 'n' Sour Pork Chops

Serves **4** | Preparation **10 minutes** | Marinating **2 hours** | Grilling **16 minutes**

4 x 8 oz/225 g pork chops	4 garlic cloves, crushed
2 tablespoons corn oil	1 tablespoon minced or grated fresh
2 tablespoons light sesame oil	root ginger
2 tablespoons light liquid honey	1 red chili pepper, seeded and minced
1 tablespoon light molasses	or finely chopped
juice of 2 limes	

1 Trim the fat on the chops to a $^1/_4$ in/5 mm rim. Place the chops in a shallow dish large enough to hold them in a single layer.

2 Whisk the corn and sesame oils with the honey and molasses. Stir in the lime juice, garlic, ginger, and chili. Spoon half of this mixture over the chops and rub it in well. Reserve the remainder for basting the meat during grilling. Cover the dish and place in the refrigerator for 2 hours, turning the meat three times.

3 Cook the chops on a medium-hot, well-oiled grill for 8 minutes on each side, until cooked through. Brush with the reserved mixture during grilling. The glaze should caramelize, browning the meat and giving it a crisp texture. Transfer to plates and serve.

Santa Fe Pork Chops

Serves **4** | Preparation **10 minutes** | Marinating **3 hours** | Grilling **16 minutes**

4 x 8 oz/225 g pork chops
1 tablespoon soft brown sugar
1 tablespoon garlic powder
1 tablespoon onion powder
1 teaspoon chipotle chili powder

1 teaspoon ground cumin
1 teaspoon ground fennel
1 teaspoon paprika
1 teaspoon of salt

1 Trim the fat on the chops to a $^1/_4$ in/5 mm rim. Place the chops in a shallow dish. Mix the sugar, garlic powder, onion powder, powdered chipotle chili, cumin, fennel, and paprika. Rub this mixture all over the meat. Cover and refrigerate for 3 hours.

2 Cook the chops on a medium-hot, well-oiled grill for 8 minutes on each side, until well browned and cooked through. Transfer to plates, sprinkle with the salt, and serve.

Genius Tip Boil and mash a mixture of potatoes and sweet potatoes to go with the chops. You could also offer a fruit chutney as an accompaniment.

Chipotle Smoked Pork

Serves **4** | Preparation **15 minutes** | Marinating **2 hours** | Grilling **16 minutes**

4 x 8 oz/225 g pork chops	1 tablespoon chipotle chili powder
3 tablespoons tomato paste	1 teaspoon dried oregano
3 garlic cloves, crushed	2 tablespoons light liquid honey
1 teaspoon English mustard powder	1 tablespoon light molasses
1 teaspoon ground cumin	juice of 1 orange

1 Trim the fat on the chops to a $^{1}/_{4}$ in/5 mm rim. Place the chops in a shallow dish large enough to hold them in a single layer.

2 Mix the tomato paste with the garlic, mustard powder, cumin, chili powder, and oregano. When thoroughly combined, gradually stir in the honey, molasses and, finally, the orange juice to make a smooth mixture.

3 Reserve a quarter of the paste for basting the meat during cooking. Pour the rest over the meat and rub it all over the chops. Cover and refrigerate for 2 hours.

4 Cook the chops on a medium-hot, well-oiled grill for 8 minutes on each side, until well browned and cooked through. Brush with the reserved paste during cooking to keep the meat moist and give it a caramelized crust. Transfer the chops to plates and serve. Grilled squash kabobs and fried plantain chips go well with the chops.

Maudie's Bourbon-boosted Pork

Serves **4** | Preparation **9 minutes** | Marinating **24 hours** | Grilling **16 minutes**

4 x 8 oz/225 g pork chops
$^1/_2$ cup/4 fl oz/125 ml bourbon
2 tablespoons canola oil
1 tablespoon molasses
1 tablespoon maple syrup

juice of $^1/_2$ orange
4 bay leaves, crumbled
3 tablespoons coarse sea salt
2 tablespoons freshly ground
 black pepper

1 Trim the fat on the chops to a $^1/_4$ in/5 mm rim. Place the chops in a shallow dish large enough to hold them in a single layer.

2 Mix the bourbon with the oil, molasses, maple syrup, orange juice, bay leaves, salt, and pepper in a bowl. Stir until thoroughly combined, then set aside a quarter of the mixture for basting the meat during cooking.

3 Pour the remaining mixture over the chops, turning them to coat them evenly. Cover the dish and refrigerate for 24 hours. Store the reserved marinade in a covered container in the refrigerator.

4 Drain the chops and cook them on a medium-hot, well-oiled grill for about 8 minutes on each side, until well browned and cooked through. Brush the meat frequently with the reserved marinade while grilling. Transfer to plates and serve at once.

Smoky Cinnamon 'n' Clove Pork

Serves **4** | Preparation **10 minutes** | Marinating **2 hours** | Grilling **16 minutes**

4 x 8 oz/225 g pork chops	1 tablespoon ground cinnamon
3 tablespoons canola oil	1 tablespoon ground cloves
3 tablespoons apple cider vinegar	1 teaspoon chipotle chili powder
1 tablespoon light molasses	4 bay leaves, crumbled
1 tablespoon light liquid honey	1 tablespoon coarse sea salt

1 Trim the fat on the chops to a $^1/_4$ in/5 mm rim. Place the chops in a shallow dish large enough to hold them in a single layer.

2 Whisk the oil, vinegar, molasses, and honey together in a mixing bowl. Stir in the cinnamon, cloves, chili powder, and bay leaves. Pour this marinade over the chops and turn them a few times to coat them thoroughly. Cover and refrigerate for 2 hours, turning three times.

3 Cook the chops on a medium-hot, well-oiled grill for 8 minutes on each side, until well browned and cooked through. Transfer the chops to plates, sprinkle with salt and serve.

Genius Tip Remember to trim the majority of fat from meat before cooking. A little fat provides flavor, whereas too much may be prone to catching fire. Banish the temptation to stick and stab meat when turning. Unnecessary loss of juices means loss of flavor to the dish.

Mesquite Grilled Pork

Serves 4 | Preparation **20 minutes** | Marinating **1 hour** | Grilling **16 minutes**

4 x 8 oz/225 g pork chops,
1 in/2.5 cm thick
3 tablespoons olive oil
grated zest and juice of 1 lemon
1 teaspoon soft brown sugar
4 garlic cloves, crushed
1 teaspoon freshly ground
black pepper
1 teaspoon chili powder

1 teaspoon onion powder
1 teaspoon dried oregano
1 teaspoon dried thyme
$\frac{1}{2}$ teaspoon dried rosemary
$\frac{1}{2}$ teaspoon dried dill
1 teaspoon coarse sea salt
mesquite chips, soaked in water for 1
hour, drained

1 Score the surfaces of the chops with $\frac{1}{8}$ in/3 mm deep slash marks to prevent them from curling while grilling. Place in a shallow dish.

2 Whisk the oil and lemon zest and juice together. Stir in the sugar until it has dissolved, then stir in the garlic, pepper, chili powder, onion powder, oregano, thyme, rosemary, and dill. Smear this mixture over the pork and into the slashes. Cover and refrigerate for 1 hour.

3 Sprinkle the drained mesquite chips over the hot coals about 10 minutes before cooking the chops so that they have enough time to start giving off their smoke before grilling.

4 Cook the chops on the well-oiled, medium-hot grill for 8 minutes on each side, until well browned all over and cooked through. Transfer to plates and sprinkle with salt.

Gressholmen Pork Shoulder Chops

Serves **4** | Preparation **11 minutes** | Marinating **1 hour** | Grilling **14 minutes**

2 lb/900 g pork cutlets	4 garlic cloves, crushed
3 tablespoons soy sauce	1 tablespoon minced or grated fresh
3 tablespoons ketchup	root ginger
2 tablespoons light sesame oil	1 tablespoon freshly ground
2 tablespoons apple cider vinegar	black pepper
2 tablespoons soft brown sugar	1 tablespoon coarse sea salt

1 Place the cutlets in a shallow dish. To make a marinade, whisk the soy sauce, ketchup, oil, and vinegar together. Stir in the sugar until it has dissolved, then stir in the garlic, ginger, and pepper.

2 Reserve a third of the marinade and pour the rest over the cutlets. Turn them in the mixture to coat all sides, the cover and leave to marinate at room temperature for 1 hour.

3 Cook the cutlets on a medium-hot, well-oiled grill for 7 minutes on each side, until well browned, caramelized, and cooked through. Brush with the reserved marinade during cooking. Transfer to a serving platter and sprinkle with salt.

Genius Tip The position of the grilling rack closest to the coals is best for searing foods quickly at a high temperature. A higher elevation of the rack is necessary for cooking foods at lower temperatures over a longer period of time.

Javanese Pork Sate

Serves **4** | Preparation **26 minutes** | Marinating **2 hours** | Grilling **8 minutes**

1¹/₂ **cups/12 fl oz/350 ml ketjap manis**
(Indonesian sweet soy sauce)
1 **tablespoon peanut oil**
juice of 2 limes
5 **garlic cloves, crushed**
3 **tablespoons minced or grated fresh**
root ginger

1 **red chili pepper, seeded and minced**
or finely chopped
1 **tablespoon ground coriander**
5 **kaffir lime leaves, crumbled**
2 **lb/900 g boneless pork loin, cut into**
1 **in/2.5 cm cubes**
bamboo skewers, soaked in water
for 1 hour

1 Mix the ketjap manis, peanut oil, lime juice, garlic, ginger, chili, coriander, and lime leaves in a bowl. Remove ¹/₂ cup/4 fl oz/125 ml of this mixture and reserve it for basting the meat during cooking.

2 Add the meat to the mixture in the bowl and mix well to coat all the cubes in the marinade. Cover and refrigerate for 2 hours, turning four times.

3 Thread 3 cubes of meat on each bamboo skewer, leaving at least ¹/₂ in/1 cm free at each end of each bamboo skewer. Fold two pieces of foil into strips three-layers thick and lay these on a well-oiled, medium-hot grill, positioning them so that they will protect the ends of the bamboo skewers and prevent them from burning.

4 Rest the skewers on the foil and cook the pork for 8 minutes in total, or 2 minutes on each side. Brush the sate with the reserved glaze every time the skewers are turned. Arrange the sate on a platter and serve.

Nader's Pork Loin Kabobs

Serves **4** | Preparation **24 minutes** | Marinating **24 hours** | Grilling **10 minutes**

4 tablespoons olive oil

1 cup/8 fl oz/250 ml fruity dry red wine

4 garlic cloves, crushed

1 tablespoon dried chili flakes

1 teaspoon dried oregano

1 teaspoon ground cumin

1 teaspoon ground coriander

1 teaspoon ground turmeric

4 bay leaves, crumbled

1 teaspoon freshly ground black pepper

2 lb/900 g boneless pork loin, cut into 1 in/1 cm cubes

HERB SALAD

2 cups/4 oz/100 g flat-leaf parsley leaves

1 cup/2 oz/50 g cilantro leaves

1 cup/2 oz/50 g basil leaves

1 cup/2 oz/50 g tender dill sprigs

1 cup/2 oz/50 g snipped chives

1 Whisk the oil and wine together in a large bowl. Stir in the garlic, chili flakes, oregano, cumin, coriander, turmeric, bay leaves, and pepper. Add the meat and mix well to coat all the cubes. Cover the dish and refrigerate for 24 hours.

2 Drain the meat, pouring the marinade into a small saucepan. Bring the marinade to the boil, reduce the heat, and simmer for 5 minutes, then remove from the heat.

3 Thread the meat onto long metal skewers and cook on a medium-hot, well-oiled grill until well browned and cooked through. Allow $2^1/_2$ minutes on each side, making 10 minutes total cooking, and brush frequently with the boiled marinade to keep the meat moist.

4 Meanwhile, mix the parsley, cilantro, basil, dill, and chives for the salad. Divide the herb mixture between four plates. Scrape the piece of meat off the skewers with a fork onto the bed of herbs. Serve at once.

Tamarind Chipotle Pork Spareribs

Serves **4** | Preparation **25 minutes** | Marinating **24 hours** | Grilling **55 minutes**

2 large racks of baby back pork spare ribs, about 4 lb/1.8 kg weight
2 cups/16 fl oz/475 ml olive oil
juice of 3 limes
8 garlic cloves, crushed
1 tablespoon chipotle chili powder
1 tablespoon soft light brown sugar

GLAZE
1 cup/8 fl oz/250 ml tamarind sauce
juice of 2 limes
3 garlic cloves, crushed
1 tablespoon chipotle chili powder
1 tablespoon molasses

1 Place the ribs in a shallow dish—the dish should be large enough for the ribs not to overlap.

2 To make a marinade, mix the olive oil with the lime juice, garlic, chipotle chili powder, and sugar. Spoon this evenly over the ribs and rub it in well. Cover and refrigerate for 24 hours.

3 To make the glaze, mix the tamarind sauce with the lime juice, garlic, chipotle chili powder, and molasses. Cover and refrigerate ready for use.

4 Wrap the ribs in heavy duty foil. Place the packets over slow-burning coals on a medium-hot grill. Cook for 20 minutes on each side with the barbecue covered. Remove the racks from the foil, brush them with glaze and cook on direct heat for an additional 15 minutes on each side with the barbecue uncovered. Brush with the glaze after turning to form a well-browned, crispy outer texture. Take care to avoid shooting flames caused by the glaze.

Genius Tip If tamarind sauce is not available to buy, look for tamarind pulp. To prepare the pulp, take an 8 oz/225 g piece of tamarind and break it up into 1 in/2.5 cm pieces. Place the pieces in a blender with 1 cup/ 8 fl oz/250 ml boiling water. Leave to rest for 2 minutes. Pulse for 30 seconds into a thick dark liquid. Do not pulverize the seeds, if possible. Allow to cool to room temperature. Sieve the mixture into a bowl, using a wooden spoon to extract the juice from the pulp.

Guava-glazed Country-Style Ribs

Serves **4** | Preparation **10 minutes** | Grilling **1 hour**

4 lb/1.8 kg meaty baby back
pork ribs
1 cup/8 fl oz/250 ml barbecue sauce
8 oz/225 g guava jelly
juice of $^1\!/_2$ lime

1 red chili pepper, seeded and finely
minced or chopped
$^1\!/_2$ teaspoon ground cumin
hickory chips, soaked in water for
1 hour, drained

1 Wrap the ribs in heavy duty foil. Place the foil packets over slow burning coals on a medium-hot grill. Cook for 20 minutes on each side with the barbecue covered.

2 Meanwhile, mix the barbecue sauce, guava jelly, lime juice, chili, and cumin in a small saucepan. Heat gently, stirring, until the jelly melts and mixes with the other ingredients. Remove from the heat.

3 Place the drained hickory chips on the barbecue. Remove the racks from the foil, brush them with the glaze, and cook on direct heat for an additional 15 minutes on each side with the barbecue uncovered. Brush with the glaze after turning to form a well-browned, crispy outer texture. Take care to avoid any shooting flames caused by the glaze.

Grilled Bahian Meatloaf Burgers

Serves **4** | Preparation **30 minutes** plus **30 minutes chilling** | Grilling **16 minutes**

1 beef bouillon cube	**$^1/_4$ cup/2 fl oz/60 ml heavy cream**
$^1/_2$ cup/4 fl oz/125 ml boiling water	**2 tablespoons port**
1 cup/2 oz/50 g roughly chopped dry bread	**1 tablespoon Worcestershire sauce**
	$^1/_4$ cup/1$^1/_2$ oz/40 g white raisins
1 lb/450 g roast pork	**1 egg**
$^1/_2$ lb/225 g coarse pork sausage meat	**2 tablespoons corn oil**
$^1/_3$ cup/1 oz/25 g grated Parmesan cheese	**1$^1/_2$ teaspoons coarse sea salt**

1 Dissolve the bouillon cube in the boiling water in a small bowl. Add the bread, mix well, and cover the bowl. Leave to soak until the bread is soft and the liquid has cooled—about 20 minutes.

2 Process the pork in a food processor until it is finely minced. Transfer to a bowl and mix in the sausage meat until thoroughly combined

3 Squeeze out the bread and add it to the meat mixture. Add the Parmesan cheese, cream, port, Worcestershire sauce, white raisins, and egg. Mix until all the ingredients are thoroughly blended. Shape the mixture into a ball, cover, and refrigerate for 30 minutes.

4 Knead the mixture firmly, then divide it into eight equal portions and shape these into 1$^1/_2$ in/3.5 cm thick oval burgers.

5 Brush the burgers with oil and cook on a medium-hot grill for 8 minutes on each side, turning only once, until well browned and cooked through. Transfer to plates and sprinkle with salt.

Albert's Ground Pork Burger

Serves 4 | Preparation **10 minutes** | Grilling **20 minutes**

1 teaspoon garlic powder	$^1/_2$ teaspoon dried basil
1 teaspoon onion powder	$^1/_4$ teaspoon dried sage
1 teaspoon grated orange zest	$^1/_4$ teaspoon dried rosemary
1 teaspoon chili powder	$1^1/_2$ lb/675 g ground pork
$^1/_2$ teaspoon cayenne pepper	4 kaiser or Vienna rolls, split
$^1/_2$ teaspoon dried oregano	2 tablespoons lightly salted butter
$^1/_2$ teaspoon dried thyme	1 teaspoon coarse sea salt

1 Mix the garlic and onion powders with the orange zest, chili powder, cayenne, oregano, thyme, basil, sage and rosemary in a large bowl. Add the pork and mix well until all the seasonings are thoroughly blended with the meat.

2 Divide the mixture into quarters and shape each portion into a large round burger, about $1^1/_2$ in/3.5 cm thick.

3 Cook the burgers on a well-oiled, medium-hot grill for 10 minutes on each side, until well browned all over and cooked through.

4 Spread the cut sides of the rolls with butter. Place on the edge of the grill to warm the crust sides first and then toast the cut sides until golden brown. Serve the burgers in the rolls.

Jupp's BBQ Fricadeller

Serves **4** | Preparation **20 minutes** | Grilling **14 minutes**

1 cup/2 oz/50 g fresh bread crumbs
1 cup/8 fl oz/250 ml boiling water
1$^{1}/_{2}$ lb/675 g ground pork
$^{1}/_{4}$ cup/$^{1}/_{2}$ oz/10 g chopped flat-leaf parsley
1 small onion, finely grated
1 tablespoon bacon fat or butter, melted

$^{1}/_{2}$ tablespoon freshly grated nutmeg
1 tablespoon freshly ground black pepper
$^{1}/_{2}$ teaspoon hot paprika
$^{1}/_{2}$ teaspoon dried sage
1 egg
1 teaspoon coarse sea salt

1 Place the bread crumbs in a bowl and pour the boiling water over them. Leave to soak for 10 minutes, then drain them in a fine sieve. Squeeze out any additional moisture from the crumbs and place them in a large mixing bowl.

2 Add the pork to the bread crumbs. Add the parsley, onion, bacon fat or butter, nutmeg, pepper, paprika, sage, and egg. Knead and squeeze the mixture until all the ingredients are thoroughly combined.

3 Divide the mixture into eight equal portions and shape each into an oval fricadeller about 1$^{1}/_{2}$ in/3.5 cm thick.

4 Cook the fricadeller on a well-oiled, medium-hot grill for 9–10 minutes on each side, until well browned and cooked through. Transfer to plates and sprinkle with salt.

pork

Beer-marinated Bratwurst

Serves **4** | Preparation **10 minutes** | Marinating **24 hours** | Grilling **10 minutes**

8 bratwurst	8 allspice berries
2 cups/16 fl oz/475 ml pilsner beer	3 dried bay leaves, crumbled
2 tablespoons apple cider vinegar	8 hot dog buns
8 black peppercorns	German mustard to serve

1 Prick the bratwurst all over with a fork and place in a shallow dish large enough to hold them in a single layer.

2 Mix the beer, vinegar, peppercorns, allspice berries, and bay leaves. Pour this marinade over the bratwurst, cover, and refrigerate for 24 hours. Turn the sausages four times in the mixture during marinating.

3 Drain the sausages and cook on a well-oiled, medium-hot grill for 10 minutes, turning frequently, until well browned on all sides. Lightly toast the inside and outside of the buns. Serve the bratwurst in the buns, offering spicy German mustard with these hot dogs.

Genius Tip Play it safe and always make sure that poultry, sausages, and pre-packaged hamburger patties are cooked through thoroughly before serving.

Rioja Marinated Chorizo

Serves **4** | Preparation **10 minutes** | Marinating **24 hours** | Grilling **12 minutes**

$1^1/2$ **lb/675 g chorizo sausage**
1 cup/8 fl oz/250 ml rioja wine

5 black peppercorns
3 dried bay leaves, crumbled

1 Prick the sausages all over and place in a dish. Pour the wine over the sausages, add the peppercorns and bay leaves, then cover and refrigerate for 24 hours.

2 Drain the chorizo and cook them on a well-oiled, medium-hot grill for 6 minutes on each side, until evenly browned. Move the sausages to the cooler edge of the grill, if necessary, to prevent them from burning.

3 Thickly slice the chorizo and serve it as part of a selection of other tapas dishes, such as olives, cubes of Spanish cheese, and crusty rustic bread.

Smoked Pork with Hoisin Sauce

Serves **4** | Preparation **5 minutes** | Grilling **8 minutes**

4 x 12 oz/350 g cooked smoked pork chops, about $1^1/2$ **in/3.5 cm thick**
juice of $^1/2$ **lemon**

$^1/2$ **cup/4 fl oz/125 ml hoisin sauce**
$^1/4$ **cup/1 oz/25 g finely chopped green onion**

1 Score the chops with $^1/8$ in/3.5 cm deep slashes to prevent them from curling during grilling. Place in a shallow dish. Sprinkle lemon juice over both sides of the chops and brush with the hoisin sauce.

2 Cook the chops on a well-oiled, medium-hot grill for 4 minutes on each side, brushing with hoisin sauce once after the chop has been turned over. The chops should be well browned with a moist, glazed crust. Transfer to plates and sprinkle with green onion.

pork

Ham Steaks with Ginger Glaze

Serves **4** | Preparation **10 minutes** | Grilling **6 minutes**

**4 x 12 oz/350 g cooked ham steaks,
about** $^1/_2$ **in/1 cm thick**
$^1/_4$ **cup/2 fl oz/60 ml peanut oil**

GLAZE
$^1/_4$ **cup/2 fl oz/60 ml tomato sauce**
2 tablespoons dark soy sauce

2 tablespoons soft light brown sugar
**1 tablespoon finely minced or grated
fresh root ginger**
2 garlic cloves, crushed
**1 tablespoon freshly ground
black pepper**

1 Score the surfaces of the steaks with $^1/_8$ in/3 mm deep slash marks to prevent them from curling while grilling. Brush the surfaces with the oil and place on a platter large enough to hold them in one layer.

2 To make the glaze, whisk the tomato and soy sauces and sugar together until the sugar has dissolved. Stir in the ginger, garlic, and pepper.

3 Brush one side of the meat with the glaze and place the steaks glazed sides down on a well-oiled, medium-hot grill. Cook for 3 minutes on each side, turning once and brushing with the glaze throughout grilling. The steaks should be well browned and caramelized. Grilled fresh pineapple goes well with the steaks.

Mustard-glazed Ham Steaks

Serves **4** | Preparation **15 minutes** | Marinating **30 minutes** | Grilling **6 minutes**

4 x 12 oz/350 g cooked ham steaks, about ¹/₂ in/1 cm thick

GLAZE
3 tablespoons peanut oil
2 tablespoons apple cider vinegar

2 tablespoons wholegrain mustard
2 tablespoons light liquid molasses
2 tablespoons bacon fat or butter, melted
1 teaspoon freshly ground black pepper

1 Score the surfaces of the steaks with ¹/₂ in/1 cm deep slash marks to prevent them from curling. Brush the surfaces with the oil and place in a shallow dish.

2 For the glaze, whisk the oil, vinegar, mustard, molasses, and butter together and stir in the pepper. Pour the mixture over the ham steaks and rub it into the slashes, then cover the dish and refrigerate for 30 minutes.

3 Drain the steaks, reserving the marinade. Cook the ham on a well-oiled, medium-hot grill for 3 minutes on each side, until caramelized and moist.

Sweet Mustard-glazed Ham Steaks

Serves **4** | Preparation **15 minutes** | Grilling **6 minutes**

**4 x 12 oz/350 g cooked ham steaks,
2 in/5 cm thick
¹/₄ cup/2 oz/50 g Dijon mustard
2 tablespoons corn oil
2 tablespoons dark rum
juice of ¹/₂ lemon**

**2 tablespoons soft dark brown sugar
1 teaspoon freshly ground
black pepper
1 teaspoon chili powder
¹/₂ teaspoon ground cloves**

1 Score the surfaces of the steaks with ¹/₂ in/1 cm deep slash marks to prevent them from curling. Brush the surfaces with the oil and place in a shallow dish.

2 Stir the mustard, oil, rum, and lemon juice together. Add the sugar and stir until it has dissolved, then mix in the pepper, chili powder, and cloves. Smear this mixture all over the ham steaks, especially into the slashes.

3 Cook the ham steaks on a well-oiled, medium-hot grill for 3 minutes on each side, brushing continuously with any remaining glaze from the dish. The ham should be moist and well caramelized.

Genius Tip If your barbecue does not have a built in shelf, a small waist high table is advised to provide extra workspace. Ideally you should have all of the ingredients and utensils available at your fingertips. One exception is the food, which requires refrigeration up until the last minute.

Caribbean-style Ham Steaks

Serves **4** | Preparation **20 minutes** | Marinating **1 hour** | Grilling **6 minutes**

**4 x 12 oz/350 g pre-cooked ham steaks,
about $^1/_2$ in/1 cm thick
2 tablespoons peanut oil
2 tablespoons dark rum
grated zest and juice of $^1/_2$ lime
grated zest and juice of $^1/_2$ orange**

**1 teaspoon soft brown sugar
1 garlic clove, crushed
1 tablespoon finely chopped fresh
thyme leaves
2 oranges, peeled and sliced, to garnish**

1 Score the surfaces of the steaks with $^1/_8$ in/3 mm deep slash marks to prevent them from curling. Brush the surfaces with the oil and place in a shallow dish.

2 Whisk the oil, rum, and citrus juices together in a small bowl. Stir in the sugar, garlic, and thyme until the sugar has dissolved. Pour this mixture over the ham steaks and rub it all over them. Cover and refrigerate for 1 hour.

3 Drain the ham steaks, reserving the marinade, and cook on a well-oiled, medium-hot grill for 3 minutes on each side until evenly browned. Brush with the reserved marinade during cooking to keep the meat moist. Transfer the steaks to plates and garnish with orange slices.

pork

chapter 6

vegetables & side salads

Caramelized Tofu

Serves **4** | Preparation **14 minutes** | Marinating **2 hours** | Grilling **10 minutes**

2 lb/900 g extra firm tofu, cut into
1 in/2.5 cm thick slices
¹/₂ cup/4 fl oz/125 ml ketjap manis
(Indonesian sweet soy sauce)
1 tablespoon liquid honey
1 tablespoon light sesame oil
finely grated zest and juice of 1 orange
2 garlic cloves, crushed

¹/₂ red chili pepper, seeded and finely
chopped or minced
1 tablespoon finely minced or grated
fresh root ginger
1 teaspoon coarse sea salt
¹/₂ cup/2 oz/50 g chopped green onion
2 tablespoons toasted sesame seeds
bamboo skewers, soaked in water
for 1 hour

1 Lay the slices of tofu in a large shallow dish. Whisk the ketjap manis, honey, sesame oil, orange zest, and juice together, then stir in the garlic, chili, and ginger. Spoon this marinade over the tofu and turn the slices gently to coat both sides. Cover and refrigerate for 2 hours, turning twice.

2 Thread a skewer lengthwise through the center of each piece of tofu. There should be about 1 in/2.5 cm of bamboo skewer protruding at each end.

3 Fold two double-thick bands of foil to protect the ends of the bamboo skewers and place these on a well-oiled, medium-hot grill, spacing them far enough apart to prevent the ends of the skewers from burning. Place the skewers on the grill, resting their ends on the foil.

4 Cook the tofu for 5 minutes on each side, brushing frequently with the remaining marinade from the dish. Use a long-handled flat spatula to support the skewers when turning the tofu.

5 Slide the tofu off the skewers with a fork straight onto a serving platter. Sprinkle with salt, chopped green onion and toasted sesame seeds.

Pita with Spinach & Feta

Serves **4** | Preparation **20 minutes** | Grilling **4 minutes**

1 cup/8 fl oz/250 ml water	¹/₄ cup/1 ¹/₂ oz/40 g white raisins
¹/₂ lb/450 g spinach leaves	¹/₄ cup/2 oz/50 g crumbled feta cheese
2 tablespoons olive oil	1 teaspoon coarse sea salt
1 shallot, finely chopped or minced	4 large pita bread
¹/₄ cup/1 oz/25 g pine nuts, toasted	

1 Bring the water to the boil in a saucepan. Add the spinach and boil for 4 minutes. Drain in a fine sieve, pressing out all the water with the back of a spoon. Squeeze the spinach by hand to dry it.

2 Heat the oil in a small saucepan. Add the shallot, pine nuts, and white raisins and cook for about 5 minutes, until the shallot is translucent and the white raisins are tender. Add the spinach and cook over a low heat for 2 minutes, stirring frequently. Remove from the heat and cool slightly.

3 Stir the feta and salt into the spinach mixture. Slit the pita bread across the top and divide the spinach mixture among them, spooning it into the middle. Work the filling into an even layer by squeezing it out by hand, leaving at least 1 in/2.5 cm unfilled at the open end.

4 Cook the pita around the edge of a medium-hot grill for 2 minutes on each side, until hot and lightly browned. Serve at once.

Masala Spinach Burgers

Serves 4 | Preparation 24 **minutes** | Marinating 3 **hours** | Grilling 8 **minutes**

3 cups/1 lb/450 g well-drained cooked spinach
$^1/_4$ cup/1 oz/25 g lightly salted cashew nuts
$^1/_4$ cup/1 oz/25 g whole-wheat flour
1 teaspoon garam masala
$^1/_2$ teaspoon ground cumin
$^1/_2$ cup/4 oz/100 g drained and sieved cottage cheese or ricotta cheese
$^1/_2$ cup/2 oz/50 g grated Cheddar cheese

1 red chili pepper, seeded and finely chopped or minced
$^1/_4$ cup/$^1/_2$ oz/15 g coarsely chopped cilantro
2 tablespoons finely chopped mint
2 tablespoons coarsely chopped white raisins
1 tablespoon coarse sea salt
juice of $^1/_2$ lemon
$^1/_4$ cup/2 oz/50 g lightly salted butter, melted

1 Hold the squeezed-out spinach in a bundle and chop it finely. Place in a bowl.

2 Roast the cashews in a dry non-stick skillet for about 3 minutes, shaking the pan occasionally until they are golden brown in places. Leave the nuts to cool, then coarsely grind them in a mortar with a pestle. Alternatively, use a food processor for this. Add to the spinach.

3 Mix the flour, garam masala, and cumin in the dry skillet and roast over a medium heat for about 3 minutes, stirring continuously, until the flour is lightly browned and the spices are aromatic. Tip the flour mixture into the bowl as soon as it is cooked.

4 Stir the spinach mixture until all the ingredients are thoroughly combined. Add the cottage cheese or ricotta and stir until well mixed. Then mix in the Cheddar cheese, chili, cilantro, mint, white raisins, salt, and lemon juice. Roll the mixture into a ball in the bowl, cover and refrigerate for 4 hours.

5 Divide the mixture into eight equal portions and shape each into a 1 in/2.5 cm thick oval burger. Cook the burgers on a well-oiled medium-hot grill for 4 minutes on each side, until browned. Brush with melted butter before and after turning the burgers. Serve two burgers per portion. Mango chutney, nan or other flat bread, and saffron rice are suitable accompaniments.

Herb Jack Stuffed Mushrooms

Serves **4** | Preparation **11 minutes** | Grilling **6–8 minutes**

12 large brown mushrooms, stalks discarded and wiped
2 tablespoons extra virgin olive oil
1 cup/4 oz/100 g grated Monterey Jack cheese
2 garlic cloves, crushed and chopped with 1 teaspoon coarse sea salt
1 red chili pepper, seeded and finely chopped or minced

$^1/_4$ cup/$^1/_2$ oz/15 g finely chopped cilantro
$^1/_4$ cup/$^1/_2$ oz/15 g finely chopped mint
$^1/_4$ cup/$^1/_2$ oz/15 g finely chopped flat-leaf parsley
$^1/_2$ teaspoon ground cumin

1 Make six $^1/_2$ in/1 cm score marks into the thickest part of the mushrooms on the gills side of the caps.

2 Mix the oil with the cheese, garlic, chili, cilantro, mint, parsley, and cumin to form a coarse paste. Divide this mixture among the mushrooms, pressing it into them and smoothing the top.

3 Cook the mushrooms around the edge of a well-oiled, low-heat grill for 6–8 minutes. The mushrooms should be well browned underneath and the filling should be hot, with the cheese melted. Serve at once.

Genius Tip Flat bread sandwiches, quesadillas, and many desserts can be handled more efficiently with use of large metal baskets with clasps. There is a big advantage to using this apparatus when there may be multiple layers to the food and it is necessary to keep the composition together at all times, particularly when turning.

Chevre in Grape Leaves

Serves **4** | Preparation **15 minutes** | Grilling **4 minutes**

12 oz/350 g chevre, crumbled
2 tablespoons chopped fresh Provençal
herbs, such as oregano, rosemary,
and thyme
1 teaspoon freshly ground
black pepper

8 brined grape leaves, drained
8 wooden toothpicks, soaked in water
for 10 minutes
2 tablespoons olive oil
warm bread to serve

1 Place the chevre in a bowl. Sprinkle in the herbs and pepper, and mix thoroughly without mashing the cheese.

2 Lay the grape leaves on a flat surface. Divide the chevre mixture equally among them, spooning it into the middle of each leaf. Fold the ends and sides over the filling to form an envelope and keep these in place with a toothpick. Brush the parcels with olive oil.

3 Grill the parcels over the low heat of slow-burning, ashen coals. Place the parcels with toothpick sides down on the grill. Cook for 2 minutes and then turn the parcels. Cook for a further 2 minutes.

4 Serve two parcels per plate. Each person cuts open his or her own parcel and scoops out the chevre, which is eaten spread on warm bread. The leafy wrapping is discarded.

Eggplant & Mozzarella Panini

Serves **4** | Preparation **10 minutes** plus **20 minutes salting** | Grilling **8 minutes**

2 eggplant, cut into $^1/_2$ in/1 cm slices
2 tablespoons coarse sea salt
$^1/_2$ teaspoon dried chili flakes
4 tablespoons olive oil
4 crusty Italian rolls

10 oz/250 g buffalo mozzarella, cut into 12 slices
$^1/_2$ cup/1 oz/25 g finely shredded basil
2 tablespoons extra virgin olive oil

1 Layer the eggplant slices in a colander or sieve, sprinkling them with the salt. Place over a bowl to catch any juices and leave to stand for 20 minutes. Rinse the slices and pat them dry on paper towel.

2 Stir the chili flakes into half the oil and use to brush the eggplant slices on both sides. Cook the eggplant on a well-oiled, medium-hot grill for 4 minutes on each side, until scored brown and tender.

3 Slit the rolls and fold them open, then brush their insides with the remaining olive oil. Open out on the edge of the grill to lightly toast the insides, then close the rolls and grill for a few seconds on each side to crisp the crust.

4 Divide the eggplant among the rolls. Add the mozzarella, sprinkle with the basil, and drizzle with extra virgin olive oil before closing the rolls.

vegetables & side salads

315

Grilled Pear Halves with Blue Cheese

Serves 4 | Preparation **12 minutes** | Marinating **2 hours** | Grilling **4 minutes**

4 firm ripe pears, halved and cored
8 oz/225 g blue cheese, sliced into
thin 1 in/2.5 cm strips

MARINADE
$^1/_2$ **cup/4 fl oz/125 ml fresh orange**
juice
$^1/_4$ **cup/2 fl oz/60 ml raspberry vinegar**
$^1/_4$ **cup/2 $^1/_2$ oz/40 g apricot preserve**
3 tablespoons walnut oil
$^1/_2$ **teaspoon pure vanilla extract**

1 To make the marinade, whisk the orange juice, vinegar, and apricot preserve together, then whisk in the oil and vanilla until well mixed. Pour this mixture into a shallow dish.

2 Score eight 1 in/2.5 cm slashes into the skin side of each pear. Place in the marinade and rub the mixture all over the fruit, particularly into the slash marks. Turn the pears cut sides down in the dish, cover, and refrigerate for 2 hours.

3 Cook the pear halves skin sides down around the cooler edge of a well-oiled, medium-hot grill. Cook for 2 minutes on each side, until the outside is scored dark brown. Brush with the marinade during grilling to keep the fruit moist and give it an even glaze.

4 Transfer the pears to plates. Lay slices of blue cheese over the edge of each pear half so that the fruit is part covered. Serve at once.

Spicy Papaya with Chili & Lime

Serves **4** | Preparation **9 minutes** | Marinating **15 minutes** | Grilling **3 minutes**

1 tablespoon light sesame oil
1 teaspoon light liquid honey
juice of 2 limes
1 red chili pepper, finely chopped
or minced

4 papayas, about 1lb/450 g total
weight, peeled, seeded, and cut into
2 in/5 cm cubes
bamboo skewers, soaked in water
for 1 hour

1 Whisk the sesame oil, honey, lime juice and chili together and pour into a shallow dish. Add the papaya and toss gently, then cover and leave at room temperature for 15 minutes.

2 Lay the fruit in the marinade and toss gently. Leave to marinate for 15 minutes at room temperature.

3 Thread the cubes onto the bamboo skewers, leaving 3 in/7.5 cm free at one end and 1 in/2.5 cm at the other. Lay two double-thick lengths of folded foil on a medium-hot grill to protect the ends of the skewers. Place the skewers on the grill with the ends protected by the foil. Cook for 3 minutes in total, turning once, until evenly browned. Brush with leftover marinade from the dish during cooking. Serve at once.

Genius Tip The papaya brochettes are delicious with grilled halloumi cheese. Halloumi is a Greek cheese that becomes crisp outside when grilled and slightly soft inside, but it does not melt and run. To grill halloumi, cut 8 x 1 in/2.5 cm thick slices, brush with olive oil, and cook on a well-oiled, medium-hot grill for about 3 minutes on each side, until crisp and well browned. Serve at once, with the papaya brochettes.

vegetables & side salads

Flame-blackened Tomatoes

Serves **4** | Preparation **5 minutes** | Grilling **12 minutes**

8 large tomatoes

1 Rinse the tomatoes but do not puncture or cut them. Cook on a well-oiled, hot grill for 12 minutes, turning frequently until they are charred all over.

2 Transfer to a plate and leave to rest for 10 minutes, then scrape off the charred skin with a knife. Cut off the tops of the tomatoes and slice them thickly. Serve at room temperature as an accompaniment. Alternatively, remove their seeds and dice the tomatoes, then use them as the base for a smoky salsa.

Cherry Tomato Kabob Salad

Serves **4** | Preparation **11 minutes** | Grilling **4 minutes**

24 cherry tomatoes	$^1/_2$ **teaspoon soft brown sugar**
	$^1/_4$ **cup/$^1/_2$ oz/15 g finely chopped dill**
DRESSING	**2 tablespoons finely snipped chives**
2 tablespoons extra virgin olive oil	**1 teaspoon coarse sea salt**
1 teaspoon balsamic vinegar	**1 teaspoon freshly ground black pepper**

1 Thread the tomatoes on long metal skewers. To make the dressing, whisk the oil, vinegar, and sugar together until the sugar has dissolved. Stir in the dill, chives, salt, and pepper. Cover and set aside at room temperature while you grill the kabobs.

2 Cook the kabobs on a well-oiled, medium-hot grill for 4 minutes, until the tomatoes are brown and the skin begins to blister. Turn the skewers frequently.

3 Gently ease the tomatoes off the skewers into a bowl. Add the dressing and toss gently. This salad is delicious with fish, meat, poultry, and rice dishes.

Grilled Tomatoes Parmesan

Serves **4** | Preparation **12 minutes** | Grilling **8 minutes**

6 firm ripe tomatoes
$^1/_4$ cup/2 fl oz/125 ml virgin olive oil
6 garlic cloves, crushed and chopped
with 1 $^1/_2$ teaspoons coarse sea salt
1 shallot, finely chopped or minced
1 tablespoon chopped fresh oregano
1 tablespoon finely chopped
flat-leaf parsley

1 teaspoon freshly ground
black pepper
$^1/_2$ cup/1$^1/_2$ oz/40 g finely shaved
Parmesan cheese
$^1/_2$ teaspoon cayenne pepper

1 Rinse and dry the tomatoes and slice them across in half (so that the stalk end is on top).

2 Heat the oil in a small saucepan. Add the garlic and shallot, and cook gently for about 10 minutes, until the shallot is tender and translucent but not browned. Remove from the heat and stir in the oregano, parsley, and black pepper. Set aside.

3 Cook the tomatoes cut sides down on a well-oiled medium-hot grill for 4 minutes. Turn them over and top with the shallot mixture. Add the Parmesan shavings and sprinkle with cayenne, then cook for a further 4 minutes.

4 Transfer gently to a platter and serve at once. The tomatoes are delicious with all types of main courses or as an appetizer; they are especially good with prosciutto, crusty bread, and an arugula salad.

Barbecued Sweet Potato Slices

Serves **4** | Preparation **14 minutes** | Marinating **1 hour** | Grilling **8 minutes**

$1^{1}/_{2}$ **lb/675 g sweet potatoes**
$^{1}/_{2}$ **cup/4 oz/100 g lightly salted butter**
3 tablespoons pure light maple syrup
juice of $^{1}/_{2}$ **orange**
3 tablespoons finely snipped chives

1 red chili pepper, seeded and finely chopped or minced
1 tablespoon coarse sea salt
$^{1}/_{4}$ **cup/$^{1}/_{2}$ oz/15 g finely chopped flat-leaf parsley**

1 Scrub the sweet potatoes and place in a saucepan. Cover with water and bring to the boil. Reduce the heat slightly, if necessary, and boil the potatoes steadily for 8 minutes, until half cooked. Drain the potatoes and cut them into $^{1}/_{2}$ in/1 cm thick slices. Place in a shallow dish.

2 Melt the butter in a small saucepan. Remove from the heat and stir in the maple syrup, orange juice, chives, and chili. Pour the butter mixture over the potatoes and turn the slices in it to coat them on both sides. Leave to stand at room temperature for 1 hour, turning the potato slices twice.

3 Cook the sweet potato slices on a well-oiled, medium-hot grill for 4 minutes on each side, until the skin is crisp and the flesh tender and well browned. Brush with the butter mixture during cooking.

4 Transfer the slices to a serving dish and spoon any remaining butter mixture over them. Sprinkle with salt and parsley and serve.

Grilled Jerusalem Artichoke Salad

Serves **4** | Preparation **15 minutes** | Marinating **15 minutes** | Grilling **8 minutes**

2 lb/900 g Jerusalem artichokes
3 tablespoons olive oil
juice of $^1/_2$ lemon

DRESSING
$^1/_2$ cup/4 fl oz/125 ml extra virgin
olive oil
1 tablespoon apple cider vinegar
1 teaspoon balsamic vinegar

1 teaspoon Dijon mustard
2 garlic cloves, crushed and chopped
with 1 tablespoon coarse sea salt
3 tablespoons finely chopped
fresh chives
2 tablespoons finely minced or
chopped shallots
1 tablespoon freshly ground
black pepper

1 Scrub the artichokes and cook in boiling water for about 6 minutes, or until they are half cooked and still firm, rather than tender. Drain and place in a bowl. Add the olive oil and lemon juice, and toss the artichokes gently to coat them evenly. Leave to cool for 15 minutes.

2 Meanwhile, to make the dressing, whisk the oil, vinegars, and mustard together in a heatproof serving bowl. Stir in the garlic, chives, shallots, and pepper. Set aside at room temperature until the artichokes are cooked.

3 Thread the artichokes onto long metal skewers and cook on a well-oiled, medium-hot grill for 8 minutes, until they are browned and tender. Turn the skewers frequently so that the vegetables brown evenly.

4 Scrape the artichokes off the skewers onto a board. Cool slightly and then cut lengthwise into $^1/_2$ in/1 cm thick slices. Add the hot slices to the dressing in the bowl. Toss gently and leave to stand at room temperature for 15 minutes before serving.

Barbecued Garlic

Serves **4** | Preparation **6 minutes** | Marinating **10 minutes** | Grilling **12 minutes**

24 garlic cloves, peeled
2 tablespoons olive oil
¹/₂ teaspoon chili powder

¹/₂ teaspoon coarse sea salt
4 bamboo skewers, soaked in
water for 1 hour

1 Place the garlic cloves in a bowl with the oil, chili powder, and salt. Mix well and leave to marinate for 10 minutes.

2 Thread six garlic cloves on each skewer, leaving 1 in/2.5 cm free at each end. Lay the skewers on the middle of a sheet of cooking foil large enough to wrap over and enclose them.

3 Scrape all the marinade from the bowl over the garlic and fold the foil around the skewers, taking care not to puncture the foil. Fold the edges together to seal in the garlic and its marinade and place the packet on a hot grill. Cook for 5 minutes on each side.

4 Remove the packet from the grill. Carefully remove the skewers and place them back on the barbecue. Cook for 1 minute on each side to lightly brown the garlic. Serve the garlic as an accompaniment or toss the cloves with salad.

Corn with Tequila Lime Butter

Serves **4** | Preparation **12 minutes** | Grilling **10 minutes**

4 corn-on-the-cob ears with husks
$^{1}/_{2}$ cup/4 oz/100 g lightly salted
butter
finely grated zest and juice of
1 fresh lime
2 tablespoons white tequila

$^{1}/_{2}$ red chili pepper, seeded and
minced or finely chopped
$^{1}/_{4}$ cup/$^{1}/_{2}$ oz/15 g finely chopped
cilantro
$1^{1}/_{2}$ teaspoons coarse sea salt

1 Pull the husk away from the corn, folding it back over the stem end of each cob. Remove the silk and tie the husk in place with string. Place the tied corn bundles on a platter.

2 Melt the butter in a small saucepan. Remove from the heat and stir in the lime zest and juice, tequila, chili, cilantro, and salt. Brush the corn with the butter mixture.

3 Fold double thick pieces of foil to protect the husk from burning. Place these on a medium-hot grill and lay the corn on the grill, with the husks on the foil. Cook for 10 minutes, until slightly charred on the surface with tender kernels. Turn and brush frequently with the butter. Serve at once, with any remaining butter poured over.

vegetables & side salads

Barbecued Corn in Wet Newspaper

Serves **4** | Preparation **5 minutes** | Soaking **30 minutes** | Grilling **25 minutes**

4 tender corn-on-the-cob ears with husks	**3 tablespoons lightly salted butter, melted** **1½ teaspoons coarse sea salt** **1 teaspoon chili powder**

1 Strip the husks back from the corn, leaving them attached at the stems. Remove the silk from the inside. Soak the corn in a large bowl of lightly salted ice-cold water for 30 minutes. Soak 16 sheets of newspaper in a separate bowl of water.

2 Drain and pat dry the ears of corn with a towel. Mix the butter, salt, and chili powder together. Brush the butter over the corn kernels, then pull the husks back over them. Wrap each cob in four layers of wet newspaper, allowing one sheet per layer.

3 Have a water spray ready to keep the paper moist during cooking. Set the wrapped corn on a bed of hot ashes. Cook for 25 minutes, turning the corn packages frequently. Lightly spray the newspaper with a mist of water to keep the outer layer moist at all times.

4 Transfer the packets to a platter and leave to rest for 5 minutes—this allows the corn to continue steaming gently. Carefully unwrap the newspaper and snip off the husks with scissors.

Genius Tip Always remember to situate your barbecue within proximity of the garden hose or have a bucket of sand on standby. Try to never leave your barbecue unattended.

Bahamian Butternut Squash Mash

Serves **4** | Preparation **15 minutes** | Grilling **1 hour**

2 butternut squash
4 garlic cloves, peeled
4 tablespoons butter
1 teaspoon freshly grated nutmeg
1 teaspoon coarse sea salt

$^1/_2$ teaspoon ground allspice
$^1/_2$ teaspoon chili powder
1 cup/18 fl oz/250 ml heavy cream
$^1/_2$ cup/1 oz/25 g finely chopped
 flat-leaf parsley

1 Cut the squash in half lengthwise and trim a thin sliver off the curved bottom so that each half stands steadily and flat. Scoop out and discard the seeds, then place a clove of garlic and 1 tablespoon butter in each hollow left by the seeds.

2 Mix the nutmeg, salt, allspice, and chili powder and divide this among the squash halves, sprinkling it into the hollows on top of the butter.

3 Cover the cut surfaces of the squash halves with foil and place on a medium-hot grill. Cover the barbecue and cook for 1 hour until tender. Remove from the barbecue and allow to rest for 10 minutes.

4 Scoop out the flesh, butter, and seasonings from the squash shells and place in a bowl. Mash until smooth and velvety in texture. Fold in the cream and lightly mix in the parsley.

vegetables & side salads

Grilled Squash a la Grecque

Serves **4** | Preparation **11 minutes** | Grilling **10 minutes**

2 medium yellow or crookneck squash
3 medium zucchini squash
$^1/_4$ cup/2 fl oz/60 ml Greek olive oil
juice of $^1/_2$ lemon
4 garlic cloves, crushed and chopped
with 1 teaspoon coarse sea salt

1 tablespoon finely chopped cilantro
1 teaspoon finely chopped mint
1 teaspoon dried oregano
$^1/_4$ teaspoon cayenne pepper

1 Rinse the squash, trim off their ends and cut them lengthwise into $^1/_4$ in/5 mm thick slices. Lay the slices flat in a shallow dish.

2 Whisk the oil and lemon juice together in a small bowl. Stir in the garlic, cilantro, mint, oregano, and cayenne. Pour the oil mixture over the squash and rub it all over the slices by hand.

3 Cook the squash slices on a well-oiled, medium-hot grill for 5 minutes on each side, until tender and scored dark brown. Transfer to a serving platter, fanning out the yellow and green slices attractively. The squash slices go very well with lamb dishes.

Squash with Cinnamon-apple Stuffing

Serves **4** | Preparation **15 minutes** | Grilling **40 minutes**

1 medium acorn squash
1 Granny Smith apple
2 tablespoons soft brown sugar
2 tablespoons lightly salted butter, softened

$^1/_2$ teaspoon lemon juice
$^1/_2$ teaspoon cinnamon
$^1/_4$ teaspoon coarse sea salt

1 Halve the squash lengthwise and scoop out the seeds. Peel, core, and dice the apple and place in a bowl.

2 Add the sugar, butter, lemon juice, cinnamon, and salt to the apple. Stir until thoroughly combined, then spoon the mixture into the cavities in the squash halves. Wrap the stuffed squash halves securely in foil.

3 Heat the coals until they are beginning to turn white on top. Set the packets directly on the coals, stuffed sides uppermost, and cook for 40 minutes or until the squash are tender. Test the surfaces by pressing the packets gently with an oven mitt.

4 Remove the packets from the coals and protect your hand with an oven mitt when opening the foil. Transfer the stuffed squash halves to a serving platter and slice each half into four. The stuffed squash go particularly well with pork or ham dishes.

Genius Tip For a delicious vegetarian main dish, add roughly chopped walnuts or cashew nuts to the apple stuffing. Serve sprinkled with fine shavings of pecorino or manchego cheese.

vegetables & side salads

Fresh Corn, Okra & Red Bell Salad

Serves **4** | Preparation **16 minutes** | Marinating **1¼ hours** | Grilling **20 minutes**

2 corn-on-the-cob ears, husks removed
1 lb/450 g fresh okra
¼ cup/2 oz/50 g lightly salted butter, melted
juice of ½ lemon
1 teaspoon chili powder
2 red bell peppers
1 cup/1 oz/25 g shredded basil leaves

DRESSING
¼ cup/2 fl oz/60 ml extra virgin olive oil
grated zest and juice of ½ lemon
½ red chili pepper, seeded and finely chopped or minced
1½ teaspoons coarse sea salt

1 Place the corn and okra in a shallow dish. Whisk the butter, lemon juice, and chili powder together, then pour this over the corn and okra. Turn the vegetables in the mixture until they are thoroughly coated. Cover and refrigerate for 1 hour.

2 To make the dressing, whisk the oil and lemon zest and juice together. Stir in the chili and salt. Cover and set aside at room temperature.

3 Cook the whole peppers on a well-oiled, medium-hot grill for 20 minutes, turning often, until charred all over. Place them in a self-sealing plastic bag and set aside to cool for 20 minutes.

4 Place the corn directly on the grill and cook for 10 minutes, turning frequently, until golden brown all over. Brush with leftover marinade during cooking.

Genius Tip The position of the grilling rack closest to the coals is best for searing foods quickly at a higher temperature. A higher elevation of the rack is necessary for cooking foods at lower temperature for a longer period of time.

5 Thread the okra widthwise onto metal skewers and cook on the grill for 8 minutes, until evenly browned, brushing with leftover marinade and turning frequently.

6 Scrape the charred skin from the peppers. Cut off their tops, remove the cores and seeds, and slice the flesh into thin strips. Place in a serving bowl.

7 Hold a cob of corn upright and slice off the kernels from top to bottom. Repeat with the remaining cob and add the kernels to the peppers. Cut the tops off the okra and slice the pods into $1/2$ in/1 cm thick rings. Add to the peppers and corn.

8 Pour the salad dressing over the vegetables and toss lightly. Leave to marinate at room temperature for 15 minutes. Sprinkle in the basil and toss the mixture just before serving.

Tandoori Cauliflower & Broccoli

Serves **4** | Preparation **18 minutes** | Marinating **2 hours** | Grilling **18 minutes**

1 lb/450 g cauliflower	1 teaspoon finely minced or grated
1 lb/450 g broccoli	fresh root ginger
1 cup/8 fl oz/250 ml whole-fat plain	1 teaspoon cayenne pepper
yogurt	$^{1}/_{2}$ teaspoon ground turmeric
2 tablespoons peanut oil	$^{1}/_{2}$ teaspoon ground cumin
juice of $^{1}/_{2}$ lemon	$^{1}/_{2}$ cup/1 oz/25 g finely chopped
3 garlic cloves	cilantro
1 teaspoon coarse sea salt	

1 Break the cauliflower and broccoli into florets and trim their stems to 3 in/7.5 cm. Cut the trimmings into $^{1}/_{4}$ in/5 mm slices. Place the vegetables in a bowl.

2 Purée the yogurt, oil, lemon juice, garlic, salt, ginger, cayenne, turmeric, and cumin until smooth in a blender or food processor. Pour the spice mixture over the vegetables and toss until they are completely coated. Cover and refrigerate for 2 hours.

3 Cut a piece of foil large enough to completely enclose the vegetables in a single layer. Pile the vegetables on the middle of the foil and spoon the spice paste over them. Fold the foil over the vegetables to enclose them completely. Bring the foil edges together and fold them over to seal the packet.

4 Gently shuffle the vegetables flat in the packet, taking care not to puncture the foil. Cook on a medium-hot grill for 10 minutes. Turn the packet gently using long, flat-tipped tongs and a spatula. Be particularly careful not to puncture the foil. Make sure the contents of the package lay flat on the grill. Cook for an additional 8 minutes on the other side.

5 Remove the packet from the grill and take it to the table closed. To serve the vegetables, protect your hand with an oven mitt and hold the packet over a serving bowl. Snip the foil, taking care to avoid burning yourself with hot steam or cooking liquor, and empty the vegetables and their cooking juices into the bowl. Sprinkle with cilantro and serve. The cauliflower and broccoli go well with plain or spiced main dishes, fish, meat, or vegetarian.

Herb-grilled Leeks

Serves **4** | Preparation **9 minutes** | Marinating **1 hour** | Grilling **8 minutes**

8 small leeks	**¹/₄ cup/¹/₂ oz/15 g finely chopped basil**
¹/₄ cup/4 fl oz/125 ml olive oil	**¹/₄ cup/¹/₂ oz/15 g fresh thyme leaves**
juice of ¹/₂ lemon	**1 teaspoon coarse sea salt**
2 garlic cloves, crushed	**¹/₄ teaspoon cayenne pepper**

1 Trim ¹/₄ in/5 mm from the root ends of the leeks and trim the dark green part of each leek to 2 in/5 cm. Slice each leek lengthwise in half and remove the outer layer from each piece. Rinse thoroughly under cold running water, keeping the pieces intact. Place the leeks in a shallow dish.

2 Whisk the oil with the lemon juice, garlic, basil, thyme, salt, and cayenne. Pour this marinade over the leeks and rub it into their cut sides, then lay them face down in the dish. Cover and leave at room temperature for 1 hour.

3 Drain the leeks, reserving the marinade, and cook on a well-oiled, medium-hot grill for 4 minutes on each side, until tender and evenly scored with dark brown stripes.

4 Transfer the leeks to a platter and pour over the reserved marinade. Serve hot or leave to cool to room temperature. The leeks make a good first course or side dish.

vegetables & side salads

Latin-style Barbecued Eggplant

Serves **4** | Preparation **13 minutes** | Marinating **15 minutes** | Grilling **8 minutes**

2 large eggplant
¹/₂ cup/4 fl oz/125 ml olive oil
juice of ¹/₂ lemon
4 cloves garlic, crushed and chopped
with 1 tablespoon coarse sea salt
¹/₂ red chili pepper, seeded and finely
minced or chopped

1 teaspoon dried oregano
¹/₂ teaspoon dried marjoram
¹/₂ teaspoon fresh thyme leaves
¹/₂ teaspoon chili powder
¹/₂ teaspoon freshly ground
black pepper

1 Rinse the eggplant and trim off their stems, then cut them lengthwise into ¹/₂ in/1 cm thick slices. Place in a shallow dish.

2 Whisk the oil and lemon juice together. Stir in the garlic, chili, oregano, marjoram, thyme, chili powder, and pepper. Pour this marinade over the eggplant slices and turn them to coat both sides. Cover and leave to stand at room temperature for 15 minutes.

3 Place the eggplant slices, undersides down, on a well-oiled, medium-hot grill. Brush the tops with leftover marinade and cook for 4 minutes. Turn the slices, brush with marinade, and cook for 4 minutes, until tender with well-browned score marks. Transfer to a serving platter.

Genius Tip For a delicious light meal or first course, serve the eggplant with aioli, a simple salad of arugula, and crusty bread.

Baba Ghanoush

Serves **4** | Preparation **8 minutes** | Grilling **1 hour**

4 eggplant	2 tablespoons extra virgin olive oil
6 garlic cloves, crushed and chopped with 1 tablespoon coarse sea salt	juice of 1 lemon
1 red chili pepper, seeded and finely chopped or minced	$^{1}/_{2}$ cup/1 oz/25 g finely chopped flat-leaf parsley

1 Cook the whole eggplant on a medium-hot grill for 1 hour, turning frequently, until charred black all over and collapsed. The flesh should feel very soft under the skin. Remove from the grill and leave to rest for 20 minutes.

2 Split the eggplant and scoop out the flesh from inside the skin. Place in a mixing bowl and stir in the garlic, chili, olive oil, lemon juice, and parsley. Cover and leave to stand at room temperature for 30 minutes before serving. Baba ghanoush may be served as a spread or dip, with flat bread or vegetable crudité, or as an accompaniment for grilled lamb.

vegetables & side salads

Grilled Japanese Eggplant

Serves **4** | Preparation **15 minutes** | Grilling **8 minutes**

4 Japanese eggplant	**1 garlic clove, crushed**
1 tablespoon soy sauce	**1 teaspoon finely grated fresh**
1 tablespoon olive oil	**root ginger**
1 tablespoon balsamic vinegar	

1 Cut off the stems from the eggplant and cut each in half lengthwise. Score a series of $1/8$ in/3 mm deep slashes into the skin side of each eggplant half and place in a shallow dish.

2 Mix the soy sauce, oil, vinegar, garlic, and ginger, then pour this over the eggplant and rub it in well, especially into the slashes.

3 Place the eggplant halves skin-sides down on a well-oiled medium-hot grill. Cook for 4 minutes on each side until slightly charred and tender. Brush with the soy sauce mixture from the dish during cooking. Serve freshly cooked.

Asian-style Baby Eggplant

Serves **4** | Preparation **13 minutes** | Marinating **15 minutes** | Grilling **8 minutes**

6 baby eggplant, about 5 oz/150 g each, halved lengthwise
$\frac{1}{2}$ cup/4 fl oz/125 ml ketjap manis (Indonesian sweet soy sauce)
1 tablespoon light sesame oil
1 tablespoon light molasses
1 tablespoon mirin (Japanese sweet wine)
1 tablespoon sake
1 tablespoon mayonnaise
1 tablespoon toasted sesame seeds

1 Prick the eggplant all over with a fork, both the cut surfaces and the skin. Place in a shallow dish.

2 Mix the ketjap manis, sesame oil, molasses, mirin, sake, and mayonnaise. Pour the mixture over the eggplant and rub it all over them. Cover and leave to stand at room temperature for 15 minutes.

3 Cook the eggplant on a well-oiled, medium-hot grill. Place the skin sides down and cook for 4 minutes, until the flesh feels tender and the skin is evenly dark brown. Turn and cook for a further 4 minutes.

4 Transfer to a serving platter, skin-sides down and sprinkle with the sesame seeds. Serve as an accompaniment or with steamed sushi rice.

Riviera Vegetable Array

Serves **4** | Preparation **22 minutes** | Marinating **15 minutes** | Grilling **12–18 minutes**

2 red bell pepper, seeded and cut into eight wedges

1 yellow bell pepper, seeded and cut into eight wedges

1 green zucchini, quartered lengthways

1 yellow zucchini, quartered lengthways

2 heads of Belgian endive, quartered lengthways

1 small head of long radicchio, quartered lengthways

2 small sweet red onions, halved

4 large porcini mushrooms, stems discarded

4 plum tomatoes

$^1/_2$ cup/4 fl oz/125 ml olive oil

juice of $^1/_2$ lemon

1 tablespoon balsamic vinegar

1 tablespoon coarse sea salt

1 Place all the vegetables in separate piles on a large platter, leaving the mushrooms and tomatoes whole.

2 Whisk the oil and lemon juice together and spoon this over the vegetables. Toss by hand, keeping the vegetables in their separate types. Cover and leave at room temperature for 15 minutes.

3 Cook the vegetables in batches by type to ensure they are all evenly cooked. Cook only as many pieces as you can watch and turn easily. Place on a well-oiled, medium-hot grill and allow between 4–6 minutes, turning once. Brush with the remaining marinade during cooking, until tender with browned score marks on the surface.

4 Arrange the cooked vegetables on a platter and pour over any remaining marinade. If the marinade has been used up completely, drizzle 2 tablespoons olive oil over the vegetables. Drizzle with the balsamic vinegar and sprinkle with salt. Serve as an accompaniment for fish, meat, poultry, or vegetarian main dishes, or serve with saffron rice and aioli.

Steamed-grilled Fennel Parmesan

Serves **4** | Preparation **17 minutes** | Marinating **1 hour** | Grilling **10 minutes**

2 large bulbs of fennel
$^1/_2$ cup/1$^1/_2$ oz/40 g shaved Parmesan
cheese

MARINADE
2 tablespoons olive oil
1 tablespoon lemon juice
1 tablespoon Pernod

1 tablespoon freshly ground
black pepper
2 garlic cloves, crushed and chopped
with 1 teaspoon coarse sea salt
$^1/_4$ teaspoon cayenne pepper
2 tablespoons fresh thyme leaves
1 tablespoon lightly salted
butter, melted

1 Trim off the stalks from the fennel, chop and reserve these. Thoroughly rinse the fennel and cut the bulbs lengthwise into $^1/_4$ in/5 mm thick slices. Add the fennel slices to a pan of boiling salted water and simmer for 8 minutes, until half cooked. Drain well.

2 Meanwhile, whisk the oil with the lemon juice, Pernod, pepper, garlic, cayenne, and thyme to make the marinade. Stir in the reserved chopped fennel trimmings.

3 Cut a large piece of foil, 24 x 12 in/ 60 x 30 cm, and fold it in half to make a double-thick square. Lay the fennel between the folded foil. Fold two opposite sides of the foil over twice to seal them.

4 Stir the melted butter into the marinade and pour it into the foil packet. Fold the foil over twice along the remaining side. Fold all three sides over once more to ensure that they are sealed and carefully shake the liquid around the fennel in the packet. Refrigerate for 1 hour.

5 Place the packet of fennel on a medium-hot grill and cook for 5 minutes. Turn the foil packet using flat-tipped metal tongs and a spatula, being careful not to puncture it, and cook for a further 5 minutes.

6 Transfer the packet of fennel to a large plate and puncture the top carefully with a fork to allow steam to escape. Open the packet at the table, taking care not to burn yourself with hot steam or liquor. Serve the fennel sprinkled with Parmesan cheese shavings.

vegetables & side salads

Grilled Zucchini & Mozzarella Salad

Serves **4** | Preparation **14 minutes** | Grilling **10 minutes**

4 zucchini	**2 garlic cloves, crushed and chopped**
6 oz/175 g buffalo mozzarella	**with 1 teaspoon coarse sea salt**
	1 red chili pepper, seeded and
DRESSING	**finely chopped**
$^1\!/_4$ cup/2 fl oz/60 ml extra virgin	**$^1\!/_4$ cup/$^1\!/_2$ oz/15 g coarsely chopped**
olive oil	**fresh mint**
juice of $^1\!/_2$ lemon	**1 teaspoon freshly ground**
	black pepper

1 Trim the ends off the zucchini and cut them thinly lengthwise into strips about $^1\!/_8$ in/3 mm thick (a mandolin is ideal for cutting very thin slices).

2 To make the dressing, whisk the oil and lemon juice together in a small bowl. Stir in the garlic, chili, mint, and pepper. Reserve the mixture for later.

3 Cook the zucchini strips on a well-oiled, medium-hot grill, for 1 minute on each side until scored with well-browned marks.

4 Prepare the mozzarella by slicing it to about $^1\!/_8$ in/3 mm thick. Place the mozzarella cheese in the middle of a serving dish and arrange the zucchini strips loosely around it. Drizzle the dressing over the top and serve.

Asian Vegetable Medley

Serves **4** | Preparation **30 minutes** | Marinating **1 hour** | Grilling **10 minutes**

1 bok choy, cut across into $^1/_4$ in/ 5 mm slices

3 carrots, cut into $^1/_8$ in/3 mm slices

16 snow peas, quartered lengthwise

16 shiitake mushrooms, cut into $^1/_4$ in/5 mm slices

1 red bell pepper, seeded and cut lengthwise into $^1/_4$ in/5 mm strips

1 leek, white part only, cut into julienne strips

3 garlic cloves, thinly sliced

$^1/_2$ red chili pepper, seeded and thinly sliced

2 tablespoons fine thin sliced ginger

$^1/_4$ cup/2 fl oz/60 ml light soy sauce

2 tablespoons hoisin sauce

1 tablespoon sake

1 tablespoon light sesame oil

1 teaspoon coarse sea salt

$^1/_2$ cup/1 oz/25 g coarsely chopped cilantro

$^1/_4$ cup/$^1/_2$ oz/15 g toasted sesame seeds

1 Place the bok choy, carrots, snow peas, shiitake mushrooms, pepper, and leek in a large bowl. Add the garlic, chili, and ginger.

2 In a small bowl, whisk the soy and hoisin sauces together with the sake, oil, and salt. Pour this mixture over the vegetables and toss them until they are thoroughly coated.

3 Cut a piece of foil large enough to enclose the vegetables—it should be about 24 in/60 cm long. Heap the vegetables with their dressing on the foil and fold it around them to enclose them completely. Fold over the edges of the foil three times to seal them. Take care not to puncture the foil. Place in the refrigerator for 1 hour.

4 Make sure the vegetables are evenly distributed in the foil packet by gently shuffling them, taking care not to puncture or open the foil. Place the packet on a medium-hot grill for 10 minutes.

5 Carefully transfer the packet of vegetables to a serving platter using long-handled, flat-tipped tongs and protecting your hands with oven mitts. Puncture the top of the foil with a fork and then open the packet, taking care not to burn yourself on the steam or liquid. Sprinkle the vegetables with chopped cilantro and sesame seeds.

vegetables & side salads

Cumin & Thyme Carrots

Serves 4 | Preparation **10 minutes** | Grilling **30 minutes**

3 tablespoons olive oil
2 tablespoons apple cider vinegar
$^{1}/_{2}$ teaspoon soft light brown sugar
$^{1}/_{2}$ teaspoon ground cumin

$^{1}/_{2}$ teaspoon dried thyme
$^{1}/_{2}$ teaspoon coarse sea salt
$^{1}/_{2}$ teaspoon freshly ground
 black pepper
24 baby carrots

1 Whisk the oil, vinegar, and sugar in a small bowl until the sugar has dissolved completely. Stir in the cumin, thyme, salt and pepper.

2 Cut a piece of foil 24 x 12 in/60 x 30 cm. Fold the foil in half, then place the carrots between the folded foil. Fold two sides of the packet over three times to seal them. Spoon the oil and vinegar mixture in through the open side and then fold that over three times to seal the packet. Be careful not to puncture the foil at any time.

3 Gently spread the carrots flat within the packet and place on a medium-hot grill. Cook for 15 minutes on each side. Remove from the grill, transfer to a plate and allow to rest for 10 minutes to complete the cooking process before serving. Open the packet with care to avoid burning yourself on escaping steam and liquid.

Steam-grilled Savannah Green Beans

Serves **4** | Preparation **15 minutes** | Grilling **15 minutes**

juice of $^1/_2$ **orange**	$^1/_2$ **teaspoon soft light brown sugar**
2 tablespoons lightly salted butter, softened	**1 lb/450 g green beans, trimmed**
1 teaspoon coarse sea salt	**1 red bell pepper, seeded and cut into $^1/_4$ in/5 mm strips**
1 teaspoon freshly ground black pepper	$^1/_2$ **cup/2 oz/50 g chopped pecan nuts**

1 Whisk the orange juice, butter, salt, pepper, and sugar together in a large bowl until the sugar has dissolved and the ingredients are well mixed. Add the beans, pepper, and pecan nuts and stir until the vegetables are well coated in the dressing.

2 Cut a piece of foil 24 x 12 in/60 x 30 cm. Fold the foil in half. Fold two sides of the packet over three times to seal them, then place the vegetable mixture in the packet. Fold the remaining side over three times to seal the packet. Be careful not to puncture the foil at any time.

3 Spread the beans flat within the foil and place the packet on a medium-hot grill. Cook for 15 minutes, turning the package over halfway through.

4 Transfer the packet to a platter and leave it to stand for 5 minutes so that the beans finish cooking. Puncture with a fork to allow some of the steam to escape before slitting the packet cautiously to avoid burning yourself on escaping steam and liquid.

Genius Tip Avoid overcooking foods such as fruits and vegetables that require gentler heat by placing them on the outer perimeter of the grill. Fruits and vegetables that are cut into cubes or smaller pieces may be grilled in metal kebab baskets to avoid falling off the skewers and provide even browning on all sides.

vegetables & side salads

Steam-Grilled Baby Beets

Serves **4** | Preparation **15 minutes** | Grilling **40 minutes**

16 even-sized baby beets	1 teaspoon coarse sea salt
$^1/_4$ cup/2 fl oz/60 ml apple cider vinegar	$^1/_2$ teaspoon dill seeds
	6 whole allspice berries
2 tablespoons lightly salted butter, softened	2 bay leaves, crumbled
	$^1/_4$ cup/$^1/_2$ oz/15 g chopped dill
1 teaspoon soft brown sugar	

1 Leave the peel on the beets and snip off their tops, leaving 1 in/2.5 cm of leaf stem in place. Rinse gently under cold running water, so as not to bruise or puncture the skin. Pat the beets dry on paper towel.

2 Whisk the vinegar, butter, and sugar together until the sugar has dissolved. Stir in the salt, dill seeds, allspice berries, and bay leaves.

3 Cut a piece of heavy duty foil 24 x 12 in/60 x 30 cm. Fold the foil in half. Fold two sides of the packet over three times to seal them, then place the beets and vinegar mixture in the packet. Fold the remaining side over three times to seal the packet. Be careful not to puncture the foil at any time.

4 Make sure the beets are lying flat in the packet, taking care not to puncture the foil. Lay the packet directly on the burning coals and cook for 20 minutes on each side. Remove from the coals and place on a platter, then leave to stand for 5 minutes during which time the beets will finish cooking.

5 Prick the foil to allow steam to escape, then leave the beets until they are cool enough to handle. Slice the root ends off and peel the beets using a small knife. Transfer to a serving platter and sprinkle with dill.

Vegetable Medley

Serves **4** | Preparation **15 minutes** | Grilling **20 minutes**

1 green zucchini, trimmed and cut into ¹/₄ in/5 mm slices

1 yellow zucchini, trimmed and cut into ¹/₄ in/5 mm slices

1 tomato, diced

2 celery stalks, cut into ¹/₄ in/ 5 mm slices

1 sweet red onion, thinly sliced

2 tablespoons olive oil

2 tablespoons lightly salted butter

1 teaspoon coarse sea salt

1 teaspoon freshly ground black pepper

¹/₂ teaspoon fresh thyme leaves

¹/₂ teaspoon hot paprika

1 Cut a piece of heavy duty foil 24 x 12 in/60 x 30 cm. Fold the foil in half and fold two sides of the packet over three times to seal them. Place the zucchini, tomato, celery, and onion in the packet. Add the oil, butter, salt, pepper, thyme, and paprika. Fold the remaining side over three times to seal the packet. Be careful not to puncture the foil at any time.

2 Place the packet on a medium-hot grill. Cook for 10 minutes on each side and then transfer the packet to a platter. Prick the foil with a fork to allow some steam to escape before tearing the top open. Take care to avoid burning yourself with steam or hot cooking juices.

Grilled Radicchio Tarator

Serves **4** | Preparation **15 minutes** | Grilling **5 minutes**

4 small heads of radicchio	DRESSING
3 tablespoons olive oil	3 tablespoons extra virgin olive oil
1 garlic clove, crushed	1 tablespoon balsamic vinegar
1 tablespoon fresh marjoram leaves	$^1/_4$ cup/1 oz/25 g pine nuts, toasted
$^1/_2$ teaspoon coarse sea salt	
$^1/_2$ teaspoon freshly ground black pepper	

1 Rinse the radicchio and pat dry on paper towel. Remove the outer leaves, which are usually more bitter than the heart, but leave the core in place to hold the leaves together. Cut the heads into quarters, giving four wedges, and place these wedges in a bowl.

2 Mix the oil, garlic, marjoram, salt, and pepper together with a fork and pour this mixture over the radicchio. Toss gently until the wedges are evenly coated.

3 Cook the radicchio on a well-oiled grill over low heat for a total of 5 minutes, until lightly browned. Turn the radicchio frequently, taking care not to burn the leaves as this make them intensely bitter.

4 Transfer the radicchio wedges to a platter. Drizzle the olive oil and balsamic vinegar over the and toss gently. Sprinkle with the pine nuts and serve. The radicchio can be served as part of a mixed appetizer, for example with olives, pecorino cheese, and crusty bread.

Genius Tip The pine nuts can be toasted in a dry, non-stick pan on the barbecue: shake the pan frequently and cook for 5 minutes or until the pine nuts are golden brown.

Rosemary's Baby Potatoes

Serves **4** | Preparation **20 minutes** | Grilling **5 minutes**

8 waxy baby new potatoes
¹/₄ cup/2 fl oz/60 ml olive oil
2 garlic cloves, crushed

1 red chili pepper, finely chopped
or minced
1 teaspoon coarse sea salt
12 long fresh rosemary sprigs

1 Halve the potatoes and cook them in boiling water for about 8 minutes or until they are half cooked—not quite tender. Drain and return to the hot pan, then leave to dry, off the heat, for 2 minutes. Transfer to a shallow dish.

2 Whisk the oil, garlic, chili, and salt together in a small mixing bowl. Pour the dressing over the potatoes and toss them very gently. Thread the potato halves onto the rosemary sprigs.

3 Cook the potatoes on a well-oiled, medium-hot grill for 5 minutes, turning frequently, until the potatoes are crisp and golden. Brush with the remaining oil from the dish during cooking. Serve freshly cooked.

Caramelized Plantains

Serves **4** | Grilling **15 minutes**

4 ripe plantains |

1 Place the plantains in their skins on a hot grill. Cook for 15 minutes, turning frequently, until the skin is charred and the flesh feels tender to the touch. Remove from the grill and allow to rest for 5 minutes.

2 Slit the skins and eat the flesh directly from the shell—the natural sugars should be caramelized and the plantain should be tender and sweet. Grilled plantains are good with Caribbean fish or meat dishes.

Grilled Spring Asparagus

Serves **4** | Preparation **15 minutes** | Grilling **4 minutes**

20 asparagus spears	**1 teaspoon coarse sea salt**
3 tablespoons olive oil	**1 teaspoon chopped fresh**
juice of 1/2 lemon	**marjoram leaves**
1 garlic clove, crushed	

1 Rinse and dry the asparagus. Cut off the woody ends of the spears and peel off the bottom 2 in/5 cm of the tender green part. Plunge the asparagus into boiling water and cook for 1 minute, then drain and dry the spears on paper towels.

2 Mix the oil, lemon juice, garlic, salt, and marjoram in a large shallow dish. Add the asparagus spears and roll them in the oil mixture until thoroughly coated.

3 Cook the asparagus spears on a well-oiled, medium-hot grill for 4 minutes, turning once, until tender and lightly charred in places. Brush with the oil mixture from the dish during cooking.

Charred Peppers with Anchovies

Serves 4 | Preparation **25 minutes** | Grilling **20 minutes**

3 red bell peppers
3 yellow bell peppers
6 oz/175 g can anchovies in olive oil
4 oz/100 g brine-packed jumbo
 capers, drained
2 tablespoons extra virgin olive oil
2 garlic cloves, crushed and chopped
 with 1 teaspoon coarse sea salt

1 teaspoon freshly ground
 black pepper
$^1/_4$ cup/$^1/_2$ oz/15 g finely shredded
 fresh basil
1 cup/3 oz/75 g Parmesan cheese
 shavings

1 Cook the whole red and yellow bell peppers on a medium-hot grill for about 20 minutes, turning frequently, until they are charred all over. Transfer the charred peppers to one or two self-sealing plastic bags. Seal and leave to stand for 15 minutes.

2 Remove the peppers from the bags. Halve them and remove their seeds, then peel off the charred skin by hand and using a small sharp knife. Slice the peppers into 1 in/2.5 cm wide strips.

3 Arrange the pepper strips, anchovies, and capers on a serving platter. Mix the oil, garlic, and pepper together in a small bowl. Pour this dressing over the pepper salad. Sprinkle with the basil and Parmesan.

vegetables & side salads

Hot Chili Pepper Quesadillas

Serves **4** | Preparation **9 minutes** | Grilling **4 minutes**

2 jalapeño peppers, seeded and sliced into thin rings
2 red chili peppers, seeded and sliced into rings
1 small sweet red onion, finely chopped
1 tablespoon olive oil
juice of $^{1}/_{2}$ lime
1 teaspoon coarse sea salt

$^{3}/_{4}$ cup/1$^{1}/_{2}$ oz/40 g coarsely chopped cilantro
8 soft flour tortillas
2 cups/8 oz/225 g grated sharp Cheddar cheese

ACCOMPANIMENTS
1 cup/8 fl oz/250 ml sour cream
tomato salsa

1 Mix the jalapeño and red chili peppers, onion, oil, lime juice, salt, and cilantro in a small bowl. Stir until thoroughly combined.

2 Divide the mixture among four tortillas and spread it out, leaving a 2 in/5 cm rim around the edge of each one. Sprinkle the cheese evenly over the filling and onto the rim but not right up to the edge. Top each with a second tortilla and press down gently with your fingertips.

3 Cook the quesadillas on a well-oiled, medium-hot grill for 2 minutes on each side, until the tortillas are golden brown and the cheese has started to melt and seal the tortillas together. Use a wide and flat, long-handled spatula to turn the quesadillas.

4 Transfer the quesadillas to a cutting board. Cut each into four wedges and fan these out on plates. Add a dollop of sour cream and tomato salsa.

Grilled Bell Pepper Salad

Serves **4** | Preparation **20 minutes** | Marinating **1 hour** | Grilling **10 minutes**

2 red bell peppers
2 yellow bell peppers
1¹/₂ cups/4 oz/100 g shaved pecorino
or Parmesan cheese

DRESSING
3 tablespoons extra virgin olive oil
juice of 1¹/₂ of lemons
1 garlic clove, crushed
3 tablespoons coarsely chopped flat-
leaf parsley
3 tablespoons finely shredded basil
1¹/₂ teaspoons coarse salt

1 Cook the whole red and yellow bell peppers on a hot grill for about 10 minutes, turning frequently, until they are charred all over. Transfer the charred peppers to one or two self-sealing plastic bags. Seal at once and leave to stand for 20–25 minutes.

2 Remove the peppers from the bags. Halve them and remove their seeds, then peel off the charred skin by hand and using a small sharp knife. Do not worry if a few bits of charred skin remain—they will add character to the salad. Cut the peppers into quarters.

3 To make the dressing, whisk the oil, lemon and garlic together in a bowl. Stir in the parsley and basil. Add the salt, adjusting the amount to taste.

4 Toss the peppers in the dressing, cover and marinate for 1 hour at room temperature. Fan the peppers on a serving plate and top with the pecorino or Parmesan cheese.

Genius Tip The pepper salad may be served as an accompaniment for poultry, as part of a selection of antipasti dishes, or on its own, with plenty of crusty bread.

vegetables & side salads

Palm Hearts with Zucchini Salsa

Serves **4** | Preparation **25 minutes** | Marinating **15 minutes** | Grilling **5 minutes**

8 palm hearts (fresh or canned, drained)
3 tablespoons olive oil
1 tablespoon apple cider vinegar
1 garlic clove, crushed and chopped with 1 teaspoon coarse sea salt
1 shallot, finely chopped or minced
1 jalapeño pepper, seeded and finely chopped or minced

ZUCCHINI SALSA
1 zucchini, diced
2 tomatoes, peeled, seeded and diced
$^1/_2$ sweet red onion, finely chopped
1 garlic clove, crushed and chopped with 1 teaspoon coarse sea salt
1 jalapeño pepper, seeded and finely chopped or minced
3 tablespoons olive oil
1 tablespoon lemon juice
$^1/_4$ cup/$^1/_2$ oz/15 g finely chopped fresh cilantro

1 Quarter the palm hearts and place them in a shallow dish.

2 Whisk the oil and vinegar together, then stir in the garlic, shallot and jalapeño pepper. Pour this mixture over the palm hearts, turn them in the marinade and cover the dish. Leave to marinate for 15 minutes at room temperature.

3 For the salsa, mix the zucchini with the tomatoes, onion, garlic, jalapeño pepper, oil, lemon juice, and cilantro until thoroughly combined. Cover and leave at room temperature.

4 Drain the palm hearts and cook them on a well-oiled medium-hot grill for 5 minutes, turning and brushing with the marinade, until lightly browned.

5 Spoon pools of the salsa on four plates and arrange the grilled palm hearts on top. Offer warm bread with the palm hearts.

Spinach Salad with Red Onion & Feta

Serves **4** | Preparation **20 minutes** | Grilling **4 minutes**

1lb/450 g spinach, stems removed, washed and dried
1 sweet red onion, sliced
2 oranges, peeled and sliced
2¹/₂ cups/12 oz/350 g crumbled feta cheese
¹/₄ cup/1 oz/25 g pine nuts, toasted

DRESSING
3 tablespoons extra virgin olive oil
1 tablespoon balsamic vinegar
1 teaspoon Dijon mustard
1 teaspoon coarse sea salt
1 teaspoon freshly ground black pepper
1 tablespoon snipped chives

1 Place the spinach in a large salad bowl. To make the dressing, whisk the oil, vinegar, mustard, salt, pepper, and chives together and set aside.

2 Cook the onion and orange slices on a well-oiled, medium-hot grill for 2 minutes on each side until slightly charred. Transfer to a platter and allow to cool slightly.

3 Add the onion and orange to the spinach and toss lightly. Pour the dressing over the salad, top with the feta, and toss again gently. Sprinkle the toasted pine nuts over the top and serve. Warm crusty bread goes well with the salad.

Grilled Baby Lettuce Salad

Serves **4** | Preparation **13 minutes** | Grilling **5 minutes**

1 head of baby radicchio
2 heads of baby endive
2 heads of baby romaine
3 tablespoons olive oil
$^1/_2$ cup/4 oz/100 g crumbled blue cheese
$^1/_2$ cup/2 oz/50 g finely chopped green onion
$^1/_4$ cup/1 oz/25 g toasted pine nuts
$^1/_4$ cup/1 oz/25 g pomegranate seeds or sun-dried cranberries

DRESSING
$^1/_4$ cup/2 fl oz/60 ml extra virgin olive oil
1 tablespoon apple cider vinegar
1 teaspoon balsamic vinegar
1 tablespoon light liquid honey
$^1/_4$ cup/$^1/_2$ oz/15 g finely chopped flat-leaf parsley
1 teaspoon coarse sea salt
1 teaspoon freshly ground black pepper

1 Cut the radicchio into quarters and the romaine and endive in half, leaving the cores in tact. Rinse thoroughly under cold running water, particularly between the leaves (without separating them from the core). Dry the wedges of leaves in a salad spinner or pat with paper towel. Rub the olive oil over the vegetables and place in a bowl.

2 To make the dressing, whisk the oil, vinegars, and honey together. Stir in the parsley, salt, and pepper. Set aside at room temperature.

3 Cook the leaves, outer surfaces down, on a medium-hot grill, until wilting underneath. When the underneath is scored brown, turn the leaves carefully and cook the other sides. The cooking time should be about 5 minutes.

4 Transfer the leaves to a board. Cut out the cores and fan the radicchio and romaine leaves on a platter. Cut the endive halves into thin wedges and sprinkle these over the leaves.

5 Spoon the dressing evenly over the lettuces. Sprinkle with the blue cheese, green onion, and pomegranate seeds or cranberries and serve at once. The salad makes an excellent first course, light main course, or side dish for poultry.

Stuffed Portobello Mushrooms

Serves 4 | Preparation **7 minutes** | Grilling **7 minutes**

4 large portobello mushrooms, wiped or brushed and stalks discarded
2 tablespoons extra virgin olive oil
1 tablespoon fresh bread crumbs
2 garlic cloves, crushed and chopped with 1 teaspoon coarse sea salt

$^1/_2$ red chili pepper, seeded and finely chopped or minced
2 tablespoons snipped fresh basil
1 cup/4 oz/100 g finely grated pecorino cheese

1 Brush the mushrooms all over with 1 tablespoon of the oil. Mix the remaining oil with the bread crumbs, garlic, chili, basil, and pecorino until all the ingredients are thoroughly combined.

2 Place the mushrooms gills down on a well-oiled, medium-hot grill. Cook for 3 minutes, then transfer to a platter or board.

3 Divide the filling among the mushrooms, pressing it together well and mounding it up slightly if necessary. Place the mushrooms on the grill, stuffing uppermost, and cook for 4 minutes. The mushrooms should be well browned underneath and the filling should be heated through. Serve freshly cooked.

chapter 7

brunch on the grill

Bacon-wrapped Prunes

Serves **4** | Preparation **6 minutes** | Grilling **4 minutes**

16 plump and moist prunes, pitted
8 large unsalted almonds, split

4 lean bacon slices, quartered

1 Split the prunes, if necessary, or open along the slit made to remove the pit. Place a piece of almond in each prune. Wrap a piece of bacon around each prune, pressing gently so that the bacon clings to the fruit.

2 Thread the bacon-wrapped prunes onto long metal skewers, taking care to keep the bacon strips in place. Leave a gap of 1 in/2.5 cm between each prune to allow space for them to cook.

3 Cook around the edge of a medium-hot grill for 2 minutes on each side until the bacon is crisp and well cooked. Slide the prunes off the skewers onto a serving platter. Provide toothpicks to pick up the prunes and serve hot.

Genius Tip Place netted wire or perforated metal plates directly onto the grate when cooking smaller pieces of food, such as mushrooms or eggplant slices or those, which are more fragile, like delicate, flaky fish. Pre-heat the plate and spray or brush with a fine layer of oil before setting the food on top.

Pancetta-wrapped Dates

Serves **4** | Preparation **9 minutes** plus **30 minutes soaking** | Grilling **6 minutes**

12 dried dates, pitted	12 fresh sage leaves
1 cup/8 fl oz/250 ml port	6 thin slices pancetta, halved
1 cup/8 fl oz/250 ml water	lengthwise

1 Bring the port and water to a boil in a small saucepan. Close the dates and add them to the liquid. Remove from the stove and leave to soak for 30 minutes. Use a draining spoon to lift the dates from the liquid and pat them dry with paper towel. Place a sage leaf in each date and wrap in a piece of pancetta. Gently squeeze the pancetta so that it clings to the dates.

2 Thread the pancetta-wrapped dates on long metal skewers. Place the skewers around the edge of a medium-hot grill. Cook for 3 minutes on each side until the pancetta is brown and crisp. Scrape the dates off the skewers onto a platter.

Fresh Figs with Prosciutto & Basil

Serves **4** | Preparation **7 minutes** | Grilling **4 minutes**

8 firm ripe figs	16 large fresh basil leaves
16 thin slices prosciutto	$^{1}/_{4}$ cup/2 fl oz/60 ml olive oil

1 Rinse and dry the figs on paper towel. Cut off their stems and halve the figs. Place a basil leaf on the cut surface of each fig half and roll in a slice of prosciutto. Thread the wrapped figs on metal skewers, keeping the ends of the prosciutto firmly in place.

2 Cook around the edge of a well-oiled, medium-hot grill for 2 minutes on each side, until the prosciutto is crisp. Transfer to serving plates and serve at once. A simple salad—of arugula or other leaves—and crisp bread go well with the figs.

brunch on the grill

Lumpa Roll

Serves 4 | Preparation **20 minutes** | Grilling **13 minutes**

10 eggs	8 oz/225 g smoked salmon,
1 teaspoon coarse sea salt	thinly sliced
1 teaspoon freshly ground	4 tablespoons sour cream
black pepper	4 tablespoons fresh dill sprigs,
2 tablespoons lightly salted butter	stems removed
8 pieces lumpa or lefse (Scandinavian	4 tablespoons finely chopped
potato flat bread)	green onion

1 Beat the eggs with the salt and pepper until frothy. Melt the butter in a non-stick saucepan or skillet. Add the eggs and cook, stirring continuously, until they are scrambled and lightly set. Remove from the heat at once, cover, and set aside—the heat of the pan will finish cooking the eggs.

2 Place the lumpa or lefse on the grill briefly to warm and soften the bread. Remove from the grill and lay on a flat surface.

3 Spoon the scrambled eggs evenly in the middle of the bread. Top with smoked salmon, a drizzle of sour cream, dill sprigs, and a sprinkle of green onion. Roll up the flat bread and serve.

Italian Sausage & Garlic Baguette

Serves **4** | Preparation **10 minutes** | Grilling **8 minutes**

2 lb/900 g Italian sausage links
2 baguettes
1 cup/8 fl oz/250 ml extra virgin olive oil
2 tablespoons Dijon mustard
3 garlic cloves, crushed, and chopped with 1 teaspoon coarse sea salt

$^1/_2$ cup/1 oz/25 g finely chopped fresh basil
$^1/_2$ cup/1 oz/25 g finely snipped chives
1 tablespoon dried Greek oregano
1 teaspoon freshly ground black pepper

1 Make six 1 in/2.5 cm score marks at an angle along the length of each sausage and prick the other sides with a fork.

2 Slice the baguettes in half lengthwise, then cut each loaf across in half, making eight pieces in all.

3 Whisk the oil with the mustard, garlic, basil, chives, oregano, and pepper. Brush this over the cut surfaces of the bread.

4 Cook the sausages, scored sides down first, on a well-oiled, medium-hot grill for 4 minutes on each side. Turn the sausages until well browned all over.

5 Place the bread, oiled sides down around the edge of the grill to toast until golden brown. Turn and lightly brown the crust sides. This should take about 2 minutes in total. Serve the sausages on the bread.

Sausage on Toasted Baguette

Serves **4** | Preparation **9 minutes** | Grilling **10 minutes**

$1^{1}/_{2}$ **lb/675 g sausage links,**
2 each of Italian, chorizo and
bratwurst of equal size
1 baguette
2 tablespoons Dijon mustard

1 tablespoon olive oil
$^{1}/_{4}$ **cup/2 oz/50 g thinly sliced sweet**
red onion
$^{1}/_{4}$ **cup/1 oz/25 g thinly sliced pickled**
jalapeño pepper rings

1 Score six $^{1}/_{4}$ in/5 mm deep diagonal slash marks on one side of the sausages and prick the other sides in six places at an angle. Cook around the edge of a medium-hot grill for 5 minutes on each side, beginning with the slash-marked sides down on the grill.

2 Slice the baguette lengthwise in half. Mix the mustard with the oil and brush this over the cut sides of the bread. Toast the cut sides on the grill, then turn and crush the toast lightly.

3 Slice each sausage in half lengthwise. Arrange the sausages on the bottom of the baguette, top with a layer of onion and jalapeño peppers, then replace the top of the baguette. Cut into four and serve.

Waffles with Breakfast Sausage

Serves **4** | Preparation **10 minutes** | Grilling **10 minutes**

8 frozen waffles
8 country pork sausage links

4 tablespoons sweet butter, melted
real maple syrup

1 Prick the sausages and cook on a well-oiled, medium-hot grill for 5 minutes on each side, until cooked through and thoroughly browned.

2 Meanwhile, cook the frozen waffles for about 3 minutes on each side. When they are ready, move the hot waffles to the edge of the grill to keep warm without overcooking.

3 Place the waffles on warm plates and drizzle the butter over them. Add the sausages and serve at once, with maple syrup on the side.

Genius Tip Fruit preserves or jelly may be served instead of the maple syrup, and bacon rashers may be cooked instead of the sausages. If using cooked waffles that are not frozen, warm them very briefly on the grill.

Ham 'n' Cheese Waffle Sandwiches

Serves **4** | Preparation **10 minutes** | Grilling **10 minutes**

8 frozen waffles
2 tablespoons Dijon mustard
2 tablespoons sweet pickle relish,
drained
8 thin slices Westphalian ham

¹/₂ cup/2 oz/50 g grated Gruyére
cheese
2 tablespoons lightly salted butter,
melted

1 Spread the waffles thinly with mustard and pickle relish. Lay a slice of ham on each of four waffles and divide the Gruyére cheese among them. Add a second slice of ham and top with the remaining waffles, relish sides down.

2 Press the waffle sandwiches together and brush with melted butter. Place buttered sides down on a medium-hot grill and cook for 3 minutes, until browned. Brush the tops with the remaining butter and turn the waffles, then cook for a further 3 minutes.

3 Transfer the waffles to the cooler edge of the grill and check that the cheese has melted inside them. Warm for a further 1 minute on each side before cutting the waffle sandwiches diagonally in half and serving.

Polenta on the Grill

Serves **4** | Preparation **39 minutes** plus **24 hours chilling** | Grilling **6 minutes**

2 cups/12 oz/350 g coarse ground
yellow cornmeal
6 cups water
1 tablespoon coarse sea salt
1$^1/_2$ teaspoons freshly ground
black pepper
$^1/_4$ teaspoon cayenne pepper

$^1/_2$ cup/4 fl oz/125 ml light cream
4 tablespoons extra virgin olive oil
$^1/_2$ cup/1$^1/_2$ oz/40 g finely grated
Parmesan cheese
$^1/_4$ cup/$^1/_2$ oz/15 g finely chopped
flat-leaf parsley

1 To make the polenta, place the cornmeal in a saucepan. Whisk in the water, salt, 1 teaspoon of the pepper, and the cayenne. Bring to a boil, stirring or whisking continuously, and boil for 3 minutes.

2 Reduce the heat and stir in the cream, half the oil, and half the Parmesan. Simmer the polenta for 35 minutes, stirring continuously until thick and creamy. Pour the polenta into a shallow ungreased dish to a depth of $^1/_2$ in/1 cm. Cover with plastic wrap and cool, then refrigerate for 24 hours.

3 Use a sharp wetted knife to cut the polenta into 4 in/10 cm squares. Wipe and rinse the blade occasionally so that it cuts the mixture cleanly. Use a spatula and the knife to remove the squares from the dish, taking care to keep them in shape. Brush both sides of the squares with olive oil and place on a small platter.

4 Cook the polenta on a well-oiled, medium-hot grill for 3 minutes on each side, until well browned and crisp. Transfer to a serving platter. Dust with the remaining Parmesan, remaining pepper, and chopped parsley. A rich tomato sauce or ratatouille go well with the polenta.

brunch on the grill

Peppers with Arugula & Olives

Serves **4** | Preparation **14 minutes** plus **20 minutes standing** | Grilling **20 minutes**

1 red bell pepper
1 yellow bell pepper
2 cups/3 oz/175 g arugula leaves
2 tablespoon extra virgin olive oil
1 teaspoon balsamic vinegar
1 teaspoon coarse sea salt

$^1/_2$ teaspoon freshly ground
black pepper
4 focaccia rolls, halved horizontally
16 large kalamata olives, pitted
and sliced

1 Cook the whole peppers on a medium-hot grill for about 20 minute, until charred all over, turning frequently. Place the peppers in a self-sealing plastic bag and leave to sweat for 20 minutes.

2 Scrape off the charred skin from the peppers using your fingers and a small sharp knife. Halve the peppers, remove their cores and seeds and cut into $^1/_2$ in/1 cm wide strips.

3 Toss the arugula with the half the oil, the vinegar, salt, and pepper. Brush the remaining oil on the cut sides of the focaccia. Layer the peppers, dressed arugula, and olives on the bread and serve at once.

Toasted Mozzarella Pesto Tramezzino

Serves 4 | Preparation **15 minutes** | Grilling **4 minutes**

8 x ¹/₂ in/1 cm slices good white bread, crusts removed
12 oz/350 g mozzarella cheese, cut into 8 thin slices
3 tablespoons olive oil

PARSLEY PESTO
1 cup/4 oz/100 g black olives, pitted
2 garlic cloves, crushed
¹/₂ teaspoon coarse sea salt
1 tablespoon lemon juice
1 tablespoon finely grated lemon zest
1 tablespoon capers
¹/₄ cup/¹/₂ oz/15 g finely chopped flat-leaf parsley
1 teaspoon freshly ground black pepper

1 To make the pesto, pulse the olives in a food processor until they are reduced to a coarse paste. Add the garlic, salt, lemon juice, lemon zest, capers, parsley, and pepper and pulse until combined in a paste.

2 Spread the pesto on the bread and use to make four mozzarella sandwiches. Press the sandwiches gently together and brush their tops with oil. Place oiled sides down on a medium-hot grill and cook for 2 minutes until lightly toasted.

3 Brush the tops with oil and turn the sandwiches, then toast the second sides for 2 minutes, until the cheese is lightly melted. Transfer to a board and cut diagonally in half, then transfer to plates and serve at once.

Focaccia with Spinach & Chili Ricotta

Serves **4** | Preparation **20 minutes** | Grilling **5 minutes**

$^{1}/_{2}$ **cup/4 fl oz/125 ml water**
1 lb/450 g spinach leaves, shredded
3 tablespoons olive oil
2 garlic cloves, crushed
1 large shallot, finely minced
1 red chili pepper, seeded and finely chopped or minced

4 sun-dried tomatoes, roughly chopped
1 cup/8 oz/225 g ricotta cheese
$^{1}/_{4}$ **cup/$^{3}/_{4}$ oz/20 g grated Parmesan cheese**
1 teaspoon coarse sea salt
4 individual foccacia rolls or squares, halved horizontally

1 Bring the water to the boil in a saucepan. Add the spinach and boil for 4 minutes. Drain in a fine sieve, pressing out all the water with the back of a spoon. Squeeze the spinach by hand to dry it.

2 Heat the olive oil in a saucepan. Add the garlic, shallot, chili and tomatoes, and cook for about 5 minutes, until the shallot is translucent. Add the spinach, stir and heat for 3 minutes. Remove from the heat.

3 Mix the ricotta, Parmesan and salt in a bowl. Toast the cut sides of the bread for 1 minute on a medium-hot grill. Remove the rolls from the grill and fill with the cheese and spinach mixtures.

4 Press the rolls closed and warm them on the grill for about 2 minutes on each side. Transfer to a cutting board, cut the rolls in half and serve at once.

Bruschetta with Olive Tapenade

Serves **4** | Preparation **15 minutes** | Grilling **2 minutes**

1 garlic clove, crushed
3 tablespoons extra virgin olive oil
8 x ³/₄ in/1.5 cm slices rustic Italian
bread

TAPENADE
1 cup/4 oz/100 g mixed green and
black olives, pitted
1 tablespoon extra virgin olive oil

1 tablespoon lemon juice
1 garlic clove, crushed
¹/₂ red chili pepper, seeded and finely
chopped or minced
¹/₄ cup/¹/₂ oz/15 g coarsely chopped
flat-leaf parsley
1 teaspoon freshly ground
black pepper

1 Mix the garlic and oil and brush this over both sides of the bread.

2 To make the tapenade, process the olives, oil, lemon juice, garlic, chili, parsley, and pepper in a food processor to make a coarse paste.

3 Toast the bread on a medium-hot grill until browned and crisp on both sides—about 2 minutes total time. Spread with a thin layer of tapenade and serve. The bruschetta makes a tasty snack or accompaniment.

Avocado Bruschetta

Serves **4** | Preparation **15 minutes** | Grilling **2 minutes**

1 garlic clove, crushed
3 tablespoons extra virgin olive oil
8 x ³/₄ in/1.5 cm slices rustic Italian
bread

AVOCADO SPREAD
2 ripe avocados, halved,
pitted and peeled

1 garlic clove, crushed
juice of ¹/₂ lemon
1 tablespoon extra virgin olive oil
1 teaspoon coarse sea salt
1 teaspoon freshly ground
black pepper
1 teaspoon dried oregano
1 teaspoon capers

1 Mix the garlic and oil and brush this over both sides of the bread.

2 To make the avocado spread, mash the avocados with the garlic, lemon juice, oil, salt, pepper, oregano, and capers.

3 Toast the bread on a medium-hot grill until browned and crisp on both sides—about 2 minutes total time. Spread with a thick layer of avocado spread and serve as an appetizer or accompaniment.

Bruschetta with Warm Basil Ricotta

Serves **4** | Preparation **15 minutes** | Grilling **7 minutes**

1 garlic clove, crushed
3 tablespoons extra virgin olive oil
8 x ¾ in/1.5 cm slices rustic Italian
bread

RICOTTA SPREAD
¾ cup/6oz/175 g ricotta cheese
1 tablespoon finely grated
Parmesan cheese

1 tablespoon lightly salted
butter, melted
1 tablespoon lemon juice
4 tablespoons shredded basil
1 teaspoon coarse sea salt
1 teaspoon freshly ground
black pepper

1 Mix the garlic and oil and brush this over both sides of the bread.

2 To make the ricotta spread, mix the ricotta with the Parmesan, butter, lemon juice, basil, salt, and pepper.

3 Toast the bread on a medium-hot grill until browned and crisp on both sides—about 2 minutes total time.

4 Spread the ricotta mixture on the toasted bread. Lay a piece of foil on the grill and place the bruschetta on the foil. Heat through for 5 minutes before serving as an accompaniment or snack.

Genius Tip Always ensure your grill is cleaned and free of grease or remaining dried food bits. Use a wire brush to scrub the surface before and after each use.

Sicilian-style Bruschetta

Serves **4** | Preparation **10 minutes** | Grilling **2 minutes**

3 tablespoons extra virgin olive oil | $^1/_2$ teaspoon dried chili flakes
juice of $^1/_2$ lemon | 2 garlic cloves, crushed
1 tablespoon dried oregano | 8 x $^3/_4$ in/1.5 cm slices rustic Italian
$^1/_2$ teaspoon coarse sea salt | bread

1 Whisk the oil, lemon juice, oregano, salt, chili, and garlic together. Toast the bread for 1 minute on each side, until lightly browned.

2 Brush the oil mixture over the bread and serve. The bruschetta goes well with antipasti or with most grilled foods.

• •

Fontina & Marinated Vegetable Toasts

Serves **4** | Preparation **10 minutes** | Grilling **4 minutes**

8 x $^1/_2$ in/1 cm slices good white bread, | 12 strips marinated red bell pepper
crusts removed | 1 teaspoon coarse sea salt
12 thin slices fontina cheese | 1 teaspoon freshly ground
4 marinated whole baby artichokes, | black pepper
finely sliced | 3 tablespoons olive oil

1 Make four sandwiches using the bread and dividing the cheese, artichokes, and peppers evenly among them. Season with salt and pepper.

2 Brush the tops of the sandwiches with olive oil and cook, oiled sides down, on a medium-hot grill for 2 minutes. Brush the tops of the sandwiches with olive oil before turning them. Toast for 2 minutes until well browned on the second side.

3 Transfer to a board, cut in half diagonally and serve at once.

Pizza Snack on the Grill

Serves **4** | Preparation **20 minutes** | Grilling **6–8 minutes**

fine ground cornmeal
4 pita bread or lavash, softened
virgin olive oil

TOPPING
2 tablespoons virgin olive oil
1 cup/2 oz/50 g soft sun-dried tomatoes packed in oil
1 teaspoon tomato paste

2 garlic cloves , crushed
1 teaspoon salt
1 teaspoon dried chili flakes
3 teaspoons dried oregano
2 teaspoons ground fennel
20 slices pepperoni or salami
1$^{1}/_{2}$ lb/675 g mozzarella cheese, diced
20 basil leaves, finely shredded

1 Sprinkle a layer of cornmeal on a platter or sheet of baking parchment. Brush the pita or lavash with oil on one side and place oiled side down in the cornmeal to lightly coat the bread.

2 For the topping, process the oil, sun-dried tomatoes, tomato paste, garlic, salt and chili flakes in a food processor to a paste. Spread this paste on the uncoated sides of the breads.

3 Divide the pepperoni or salami among the pizza snacks. Add the mozzarella and sprinkle with basil.

4 Cover the barbecue before the coals become completely white. Continue heating until the coals are white and then place the pizzas on the lightly oiled grill and cover the barbecue. Cook for 6–8 minutes, checking occasionally to make sure that the pizzas do not burn underneath.

chapter 8
sweet grills

Campfire Oatmeal S'mores

Serves **4** | Preparation **5 minutes** | Grilling **4 minutes**

4 large marshmallows
8 large flat and chewy oatmeal cookies

4 x 4 in/10 cm squares thin dark chocolate

1 Thread the marshmallows on long metal skewers. Cook on the grill over low-heat for 4 minutes, turning often, until the marshmallows are browned outside and soft inside.

2 Meanwhile, warm the cookies flat sides down for 1 minute. Place a piece of the chocolate on the hot, flat sides of half the cookies. Remove the marshmallows and place one on top of each piece of chocolate.

3 Top with the remaining cookies, flat sides down, and press down lightly. Allow the marshmallows to cool for a few moments before serving the cookie sandwiches as they are too hot to eat right away.

• •

Toasted Chocolate Panini

Serves **4** | Preparation **5 minutes** | Grilling **2 minutes**

8 x ¹⁄₂ in/1 cm slices brioche
4 squares good bittersweet chocolate

3 tablespoons sweet butter, melted

1 Cut the brioche into ¹⁄₂ in/1 cm slices and trim the slices into neat rounds. Sandwich the rounds together with chocolate squares, making four sandwiches. Brush all over with the melted butter.

2 Toast the panini on a medium-hot grill for 1 minute on each side until golden brown outside with the chocolate beginning to melt inside. Serve at once—take care when eating as the melted chocolate may be very hot.

grilling genius

French Toast

Serves **4** | Preparation **15 minutes** | Grilling **6 minutes**

12 x 1 in/1 cm slices white sourdough loaf	1 teaspoon pure vanilla extract
4 eggs, at room temperature	1 tablespoon ground cinnamon
2 cups/16 fl oz/475 ml milk, at room temperature	3 tablespoons caster sugar
6 tablespoons lightly salted butter, melted	pure maple syrup or fruit preserve to serve

1 Lay the slices of bread flat in one or two large shallow dishes. Prick the slices all over with a fork so that they absorb as much liquid as possible.

2 Beat the eggs and milk together. Beat in the butter, vanilla, and cinnamon until thoroughly combined. Pour the mixture over the bread and turn the pieces over until the liquid is absorbed. The bread should still be firm in texture, not soggy. Sprinkle a little of the sugar over the bread.

3 Prepare a double-thick sheet of foil and lay it to one side on a medium-hot grill— this is to keep the French toast hot when it is cooked. Place the soaked bread, sugared sides down on the grill. Sprinkle the remaining sugar over the tops of the bread. Cook for 3 minutes, turning once, until browned on both sides.

4 Transfer the French toasts to the foil as they are cooked, and heat for a further 3 minutes, turning once, to ensure they are set right through. Brush with extra butter to keep the toast moist. Serve at once, with maple syrup or fruit preserve.

Grilled Pound Cake

Serves **4** | Preparation **5 minutes** | Grilling **4 minutes**

3 tablespoons butter, melted
1 tablespoon lemon juice
1 teaspoon grated lemon zest
$^1/_2$ teaspoon ground cinnamon
4 x $^1/_2$ in/1 cm thick slices pound cake

$^1/_2$ cup/4 fl oz/125 ml heavy cream, whipped
$^1/_2$ lb/225 g strawberries, hulled (optional)

1 Place the butter in a small saucepan and add the lemon zest and juice and the cinnamon. Heat until the butter melts.

2 Brush the top of each slice of cake with butter mixture. Place buttered sides down on a medium-hot grill. Brush the top with more butter and toast for 2 minutes. Turn and toast for a further 2 minutes.

3 Transfer to plates and top with whipped cream. Add strawberries, if liked, and serve at once.

Genius Tip Always use heat-resistant mitts or gloves and long-handled tools when barbecuing to ensure that your hands are kept well away from the flames.

Grilled Coconut Ipanema

Serves 4 | Preparation **13 minutes** | Marinating **15 minutes** | Grilling **8 minutes**

½ cup/4 fl oz/125 ml cachaca
(Brazilian sugar cane liquor)
grated zest and juice of 1 lime

2 tablespoons soft brown sugar
1 fresh coconut

1 Whisk the cachaca and the lime zest and juice together in a bowl. Add the sugar and stir until it has dissolved completely.

2 Pierce two of the eyes in the top of the coconut and drain off the juice or water. Break the nut and scoop out the white meat. Break the coconut into uniform chunks, about 4 in/10 cm square. Place in the cachaca mixture and toss to coat completely. Cover and marinate at room temperature for 15 minutes.

3 Cook the coconut around the edge of a well-oiled, low-heat grill. Cook for 8 minutes in total until evenly browned all over, brushing frequently with the soaking liquor.

4 Transfer the coconut to plates and pour the remaining liquor over the pieces. Serve at once.

Bananas in Coconut Milk Glaze

Serves **4** | Preparation **8 minutes** | Marinating **30 minutes** | Grilling **3 minutes**

1 cup/8 fl oz/250 ml coconut milk	1 lemon grass stalk
juice of $1/2$ orange	4 firm ripe bananas
1 tablespoon liquid molasses	$1/4$ cup/3 oz/75 g sweetened coconut
2 kefir lime leaves, snipped into thin strips	flakes, toasted

1 Whisk the coconut milk, orange juice, molasses, and lime leaves together in a fairly large bowl. Trim the lemon grass and crush the bulb end by pressing it under the blade of a wide knife or hitting it with a pestle. Add the lemon grass to the coconut milk mixture. Cover and leave at room temperature for 30 minutes.

2 Peel the bananas and cut them at an angle into chunks. Add the chunks to the coconut milk mixture as they are cut and roll them in the liquid to coat them evenly—this will prevent discoloration.

3 Cook the chunks of banana on the perimeter of a well-oiled, medium-hot grill for a total of 3 minutes, until well browned. Turn the bananas frequently and brush with the coconut glaze.

4 Transfer the bananas to plates and sprinkle the coconut over them. Serve at once.

Genius Tip The bananas are versatile—serve them with grilled spiced poultry or pork, or with Caribbean-style savory dishes. Alternatively, add dollops of cream, yogurt, or ice cream to make a tempting dessert.

Orange & Banana Nut Kabobs

Serves **4** | Preparation **10 minutes** | Grilling **8 minutes**

2 navel oranges	**1 tablespoon finely shredded coconut**
$^1/_4$ cup/1 oz/25 g finely chopped walnuts	**2 firm ripe bananas**
	2 tablespoons light liquid honey

1 Cut a thin slice off the top and bottom of an orange—just enough to expose the top of the fruit. Stand the fruit on the board, then cut off the peel and all the pith in strips down the outside of the fruit. Work around the fruit, then trim off any bits of pith that remain. Repeat with the second orange and cut both into $^1/_2$ in/1 cm thick slices.

2 Mix the walnuts and coconut on a plate. Peel the bananas and cut them into $1^1/_2$ in/3.5 cm chunks. Roll the banana chunks in the honey and immediately coat them in the nut mixture. Thread the orange slices and banana chunks alternately on long metal skewers.

3 Place the skewers directly on a well-oiled, medium-hot grill. Cook for 4 minutes on each side, until the banana coating is toasted and the orange slices are scored dark brown. Serve at once, scraping the fruit off the skewers onto plates.

sweet grills

Bananas with Chocolate Ganache

Serves **4** | Preparation **20 minutes** | Grilling **8 minutes**

4 vanilla pods	**4 firm ripe bananas**
6 squares bittersweet chocolate	**¹⁄₄ cup/4 fl oz/125 ml heavy cream**

1 Slice each vanilla pod in half lengthwise. Scrape the seeds from the vanilla pods into a heatproof bowl, add the chocolate, and set aside.

2 Push a skewer into the end of a banana to make a hole equal in length to a vanilla pod. Push the halved pods into the holes in the bananas.

3 Cook the bananas on a medium-hot grill for 4 minutes on each side, until the skins are blackened. Transfer to a cutting board and leave to rest for 10 minutes.

4 While the bananas rest, make the ganache: place the bowl of chocolate over a pan of hot, but not boiling, water. Stir until the chocolate melts. Pour in the cream and whisk the mixture until is becomes velvety in texture.

5 Gently peel the bananas and remove the vanilla pods. Cut each banana at an angle into six pieces and place in a bowl. Spoon the chocolate ganache over the bananas and serve.

Genius Tip Remember to clean your grate before grilling fruits and desserts. The lingering remains from past meat drippings, marinades and bastes will not exactly enhance the sweet flavors. Grilling of fruits should be limited to the amount of time it takes to caramelize their natural sugars and create the aesthetic dark brown score marks.

Pecan Peach Tortilla Pie

Serves 4 | Preparation **15 minutes** | Grilling **10 minutes**

3 ripe peaches	$^1/_2$ teaspoon ground cinnamon
2 dates, pitted and finely chopped	4 large flour tortillas
$^1/_4$ cup/1 oz/25 g finely chopped pecans	2 tablespoons sweet butter, melted
1 tablespoon corn syrup	1 tablespoon confectioners' sugar
juice of $^1/_2$ lemon	whipped cream or peach ice cream to serve
1 teaspoon soft light brown sugar	

1 Peel and pit the peaches, and cut into $^1/_4$ in/5 mm slices. Place in a bowl. Stir in the dates, pecans, corn syrup, lemon, sugar, and cinnamon until all the ingredients are well combined.

2 Divide the fruit mixture evenly among two tortillas and spread it out, leaving a small space around the edge. Top with the remaining tortillas and press them down gently.

3 Cut a piece of heavy foil and use to cover a medium-hot grill. Brush the tortillas with butter and invert them carefully onto the foil. Cook for 5 minutes, brush the tops with butter, and carefully turn the tortillas to cook the other sides. Cook for an additional 5 minutes.

4 Transfer to a cutting board and cut each into four wedges. Serve the wedges in pairs, with points meeting in the middle of large plates. Sift confectioners' sugar over the tops and serve with a large dollop of cream or a scoop of peach ice cream in the middle.

Peach Halves with Bittersweet Melt

Serves **4** | Preparation **5 minutes** | Grilling **21 minutes**

4 large peaches, halved and pitted
1 cup/6 oz/175 g bittersweet
chocolate chips

4 scoops vanilla ice cream

1 Cook the peaches cut sides down on a medium-hot grill for 3 minutes until browned. Turn and cook for a further 3 minutes on the skin-side. Remove the peach halves from the grill.

2 Fold a piece of foil in half and lay this on the grill. Place the peaches on the foil, skin-sides down. Fill the cavity in each peach half with chocolate chips. Cook for 15 minutes, until the chocolate has melted. Transfer the peach halves to bowls. Add a scoop of vanilla ice cream to each and serve at once.

- -

Grilled Amaretto Peaches

Serves **4** | Preparation **10 minutes** | Grilling **21 minutes**

6 firm ripe peaches, halved and pitted
2 tablespoons vanilla sugar

$1/2$ cup/4 fl oz/125 ml Amaretto liqueur

1 Cook the peaches cut sides down on a medium-hot grill for 3 minutes until slightly charred. Turn and cook for 3 minutes on the skin-side. Remove the peaches from the grill.

2 Fold a piece of foil in half and lay this on the grill. Place the peaches on the foil. Spoon a small amount of Amaretto into the cavity in each peach half. Sprinkle the vanilla sugar over the top and cook for a 15 minutes or until very tender. Serve at once, arranging three peach halves per portion. Serve with sour cream or vanilla ice cream.

Grilled Fresh Pineapple

Serves **4** | Preparation **18 minutes** | Marinating **1 hour** | Grilling **15 minutes**

1 large ripe pineapple
2 tablespoons liquid lavender honey
2 tablespoons vegetable oil

juice of $^1/_2$ lime
1 dried piri piri chili pepper, left whole

1 Cut off the top and bottom of the pineapple. Cut off the peel in thick strips down the outside, working around the fruit. Cut out any remaining eyes and quarter the fruit lengthwise. Cut off the tough core at the point of each wedge. Place the pineapple in a shallow dish.

2 Mix the honey with the oil and lime juice, then add the dried chili when the liquids are thoroughly combined. Spoon this mixture over the pineapple, making sure all the pieces are evenly coated. Cover and leave to marinate at room temperature for 1 hour.

3 Cook the pineapple over the last slow burning coals, when the barbecue is really hot, for about 15 minutes. Make sure the pineapple is scored deep brown before turning. Brush with the marinade from the dish during cooking. Serve the pineapple as whole wedges or cut them into $^1/_2$ in/1 cm slices.

Melon Wedge Trio

Serves **4** | Preparation **10 minutes** | Marinating **15 minutes** | Grilling **4 minutes**

1 cup/8 fl oz/250 ml fresh orange juice | 1 small cantaloupe melon, halved
1 tablespoon apricot preserve | ½ honeydew melon
1 teaspoon liquid honey | ½ Crenshaw melon
1 teaspoon walnut oil

1 Whisk the orange juice, preserve, honey, and walnut oil together in a large shallow dish.

2 Discard the seeds from the melons, cut them into thick wedges, and remove the peel. Place the melon wedges in the orange juice mixture, turning them to coat them on all sides. Cover the dish with plastic wrap and leave to marinate at room temperature for 15 minutes.

3 Thread the melon wedges onto long metal skewers and place on the edge of a well-oiled, medium-hot grill. Cook for 2 minutes on each side until scored brown. Brush the wedges with the marinade from the dish during cooking.

4 Scrape the melon off the skewers onto plates and serve at once. Vanilla ice cream or sherbet, such as a fresh melon sherbet, go well with the melon.

Pear & Mascarpone Brioche

Serves **4** | Preparation **20 minutes** | Grilling **2 minutes**

4 firm comice pears
2 tablespoons soft brown sugar
4 x $^1/_2$ in/1 cm slices day-old brioche
1 cup/8 fl oz/250 ml mascarpone

grated zest and juice of 1 large or
2 small limes
$^1/_4$ cup/1 oz/25 g confectioners' sugar

1 Wash and dry the pears, then cut them lengthwise into $^1/_4$ in/1 cm slices. Roll the slices in the brown sugar until lightly coated.

2 Mix the mascarpone, lime zest and juice, and confectioners' sugar with a fork.

3 Cook the pear slices on a medium-hot grill for 1 minute on each side. Lightly toast both sides of the brioche slices at the same time—this should also take about 1 minute.

4 Transfer the pear slices to a cutting board. Cut off the core and stem. Lay a slice of brioche on a plate and spoon the mascarpone mixture evenly on top. Lay the pear slices over the mascarpone and serve.

Genius Tip The pears are versatile for both savory and sweet courses. They make an excellent accompaniment for grilled lamb kabobs or chops. Topped with whipped cream or crème fraîche they make a tempting dessert, especially when decorated with crystallized mint leaves and served with thin crisp cookies.

Minted Pears

Serves **4** | Preparation **10 minutes** | Grilling **15 minutes**

2 large firm comice pears　|　**1 teaspoon ground ginger**
2 tablespoons mint jelly

1 Cut four pieces of foil each large enough to wrap up a pear. Wash and dry the pears, then halve them, and scoop out their cores. Place a pear half on each piece of foil. Fill the hollows left by the cores with mint jelly and sprinkle with ground ginger.

2 Fold the foil around the fruit and fold over the edges to seal the packets. Crumple the foil slightly underneath the pear halves, if necessary, so that they stand neatly. Take care not to puncture the foil.

3 Place the pear packets on a medium-hot grill and cook for 15 minutes without turning. Remove the packs from the grill and open them carefully to avoid burning your hands on escaping steam. Transfer the fruit to plates and serve.

Sauterne-glazed Nectarine Brochettes

Serves **4** | Preparation **8 minutes** | Marinating **15 minutes** | Grilling **3 minutes**

1 cup/8 fl oz/250 ml Sauterne (sweet white wine)
juice of ½ lemon
1 tablespoon light liquid honey

1 teaspoon ground cinnamon
8 firm ripe nectarines
½ cup/1 oz/25 g slivered almonds

1 Whisk the wine, lemon juice, honey, and cinnamon together in a shallow dish.

2 Peel, halve, and pit the nectarines. Place the fruit in the wine mixture as it is prepared and bathe the pieces in the liquid to coat them completely. Cover the dish and leave the fruit to marinate for 15 minutes.

3 Thread the nectarine halves on metal skewers, pushing the skewers lengthwise through the fruit in line with the stone cavity (not the shortest way through the middle). Pour the remaining marinade into a small saucepan and bring to the boil. Remove from the heat.

4 Cook the nectarines around the edge of a well-oiled medium-hot grill for a total of 3 minutes. Brush with the marinade and turn to brown both sides.

5 Transfer the nectarines to plates and pour the remaining glaze over the top. Sprinkle with the almonds and serve at once.

Genius Tips To peel nectarines or peaches, place them in a large bowl and cover with freshly boiling water. Leave to stand for about 1 minute—the skin on ripe fruit is loosened in less than 1 minute but on firm or under-ripe fruit the standing time is longer. Drain and slit the skin, then peel it off with a small knife. It should come away cleanly and easily. When peeling more than four fruit, do them in two batches to avoid soaking some for too long while peeling the first fruit. If the fruit is allowed to stand for too long after draining, and become cold, the peel does not come off easily.

Grand Marnier Orange Segments

Serves **4** | Preparation **15 minutes** | Grilling **12 minutes**

3 navel oranges	1 tablespoon soft brown sugar
finely grated zest of $^1/_2$ orange	$^1/_2$ teaspoon ground cinnamon
$^1/_2$ cup/4 fl oz/125 ml Grand Marnier	ice cream, sherbet, waffles, pancakes,
2 tablespoons butter, melted	crêpes, or cream to serve

1 Grate the zest from half an orange and place it in a small bowl. Cut a thin slice off the top and bottom of the orange—just enough to expose the top of the fruit. Stand the fruit on the board, then cut off the peel and all the pith in strips down the outside of the fruit. Work around the fruit, then trim off any bits of pith that remain.

2 Hold the fruit over a bowl and cut out the segments from between the membranes, then place them in the bowl. Repeat with the remaining oranges (but without grating off the zest).

3 Add the Grand Marnier and butter to the zest and whisk the ingredients together. Stir in the sugar and cinnamon until the sugar has dissolved. Pour this mixture over the orange segments and toss gently.

4 Cut a 24 x12 in/60 x 30 cm piece of foil and fold it in half. Fold the edges together three times along the sides to make a pouch. Spoon the orange segments and liquid into the foil pouch and triple-fold the remaining pair of edges together to seal in the fruit.

5 Carefully flatten the package and place on a medium-hot grill. Cook for 6 minutes on each side.

6 To serve, using an oven mitt to hold the pouch, snip off one of the folded edges with a pair of scissors. Taking care not to burn yourself on escaping hot steam and liquid, empty the oranges into a serving dish. Serve at once, spooned over ice cream or sherbet; with pancakes, crêpes or waffles; or very simply drizzled with a little cream.

Blueberry-filled Nectarines

Serves **4** | Preparation **10 minutes** | Grilling **20 minutes**

**4 large firm ripe nectarines,
halved and pitted
3 tablespoons blueberries**

**1 tablespoon light liquid honey
juice of ¹/₂ lemon
cream, mascarpone or yogurt to serve**

1 Cut eight pieces of foil large enough to enclose a nectarine with plenty of foil for folding the edges over and sealing the packets.

2 Place a nectarine half on each piece of foil. Drizzle honey into the cavities and divide the blueberries among the nectarines. Drizzle a little lemon over the top of each filled nectarine half.

3 Fold the foil around the fruit and fold the edges over to seal in the juices. Press the foil closely around the underneath and sides of the nectarines to keep the blueberries in place on top.

4 Place the packages on a medium-hot grill and cook for 20 minutes without turning. Transfer to plates and allow to stand for a few minutes before serving. The packets should be opened at the table, taking care to avoid being burnt by steam or hot liquor. Offer cream, mascarpone, or yogurt with the fruit.

Berry Brioche with Mascarpone

Serves **4** | Preparation **10 minutes** | Grilling **3 minutes**

$^1/_2$ **cup/4 oz/100 g mascarpone** | **8 tablespoons raspberries**
2 teaspoons lemon juice | $^1/_2$ **teaspoon ground cinnamon**
1 tablespoon light liquid honey | **3 tablespoons butter**
8 x $^1/_2$ **in/1 cm slices brioche** |

1 Mix the mascarpone, lemon juice, and honey. Toast the brioche slices on one side on a medium-hot grill for about 1 minute. Spread the toasted sides with the mascarpone to $^1/_2$ in/1 cm from the edge. Top four slices with raspberries and top with the remaining brioche, mascarpone down.

2 Stir the cinnamon in the melted butter and brush this over the outside of the sandwiches. Toast for 1 minute on each side and serve at once.

Apple Lefse Rolls

Serves **4** | Preparation **15 minutes** | Grilling **7 minutes**

2 tablespoons lightly salted | **1 Granny Smith apple, peeled, cored**
butter, softened | **and finely diced**
1 tablespoon lemon juice | **4 pieces lumpa or lefse (Scandinavian**
1 tablespoon soft brown sugar | **potato flat bread)**
$^1/_2$ **teaspoon ground cinnamon** |

1 Mix the butter, lemon juice, sugar, and cinnamon together in a bowl. Stir in the apple. Divide the mixture among the lumpa or lefse and roll up.

2 Cook the rolls for 2 minutes on a medium-hot grill. Meanwhile, lay a piece of foil to one side on the grill. Transfer the rolls to the foil and continue to cook for a further 5 minutes. Serve at once—the rolls go well with grilled sausages or bacon for breakfast, or with ice cream as a dessert.

Cinnamon Apple Sticks

Serves 4 | Preparation **15 minutes** | Grilling **30 minutes**

4 Granny Smith apples | ¹⁄₄ cup/2 oz/50 g soft brown sugar
¹⁄₄ cup/2 oz/50 g sweet butter | 1 teaspoon ground cinnamon

1 Wash and dry the apples. Run a long metal skewer through the middle of each apple.

2 Cook the apples on a medium-hot grill for 20 minutes, turning occasionally, until browned outside with tender flesh. Remove from the grill and leave to cool for 5 minutes.

3 Melt the butter in a small, shallow skillet. Mix the sugar and cinnamon together on a plate. Peel the apples, leaving them on the skewers, and roll them in the butter. Spoon the butter over the fruit, if necessary, while holding them over the skillet. Immediately roll the apples in the sugar mixture to coat them completely.

4 Replace the apples on the grill and cook for 10 minutes, rotating the skewers so that the apples are evenly caramelized. Transfer the apples to a plate, leaving the skewers in place, and leave to cool.

5 The apples can be served on the skewers or sliced and cored.

Summer Fruits with Yogurt Sauce

Serves **4** | Preparation **17 minutes** | Marinating **15 minutes** | Grilling **3 minutes**

juice of 1 orange
1 teaspoon light liquid honey
1 small cantaloupe melon,
halved and seeded
2 firm ripe peaches, peeled,
halved and pitted
2 firm ripe plums, peeled,
halved and pitted

2 firm kiwi, peeled and halved
8 large strawberries, hulled

YOGURT SAUCE
1 cup/8 oz/225 g whole-fat plain yogurt
2 tablespoons apricot preserve
grated zest and juice of $1/2$ orange
1 teaspoon finely chopped mint

1 First make the yogurt sauce: whisk the yogurt and apricot preserve together. Stir in the juice and mint. Cover and refrigerate until the fruit is served.

2 Whisk the orange juice and honey together in a shallow dish. Slice the cantaloupe into wedges, peel these and cut them across in half into pieces of similar size to the other portions of fruit.

3 Place the cut fruit and the strawberries in the orange and honey mixture as they are prepared. Toss the fruit gently, cover, and leave to marinate at room temperature for 15 minutes.

4 Thread the fruit on long metal skewers. Cook around the edge of a well-oiled, medium-hot grill for 3 minutes, until scored dark brown in places. Turn the brochettes once and brush with the marinade remaining in the dish so that the fruit is evenly glazed.

5 Scrape the fruit off the skewers with a fork onto plates. Add a dollop of yogurt sauce to each plate and serve any remaining sauce separately.

Grilled Breakfast Fruit Kabob

Serves **4** | Preparation **20 minutes** | Grilling **8 minutes**

8 prunes, pitted	1 firm ripe banana
8 dried apricots	1 Granny Smith apple
2 cups/16 fl oz/475 ml boiling water	juice of 1 orange
1 fresh pineapple	1 tablespoon light liquid honey

1 Place the prunes and apricots in a bowl and pour in the boiling water. Cover and leave to stand at room temperature for 15 minutes.

2 Meanwhile, cut off the top and bottom of the pineapple. Cut off the peel in thick strips down the outside, working around the fruit. Cut out any remaining eyes and quarter the fruit lengthwise. Cut off the tough core at the point of each wedge. Cut the fruit into $1\frac{1}{2}$ in/3.5 cm chunks.

3 Peel the banana and slice into $1\frac{1}{2}$ in/3.5 cm chunks. Peel and core the apple and cut it into similar-sized chunks.

4 Mix the orange juice and honey together. Drain the dried fruit and pat dry with a paper towel. Thread the fresh and dried fruit on four long metal skewers. Brush the orange mixture over the kabobs.

5 Cook the kabobs on a well-oiled, medium-hot grill for 8 minutes, turning four times and brushing with the orange mixture each time. Serve at once.

index

The author would like to give special thanks to:

Anneke & Lourens Amerlaan, Carlos & Sandra de Araujo, Philip Bardin, Rosemary Barron, Fritz Braker, Barbara Jo Davis, Rene Dubon, Nader Faridjoo, Froilan Fresneda, Sandy Givot, Steven Givot, Summer Guri Liv Heftye, Jimkey, Linda Kang, Sien Lemke, Simon Majumdar, Bo Masser, Mary Mateer, Kate McGhie, Maudie McGillicuddy, Sven-Erik Mill, Nasse Mou, Hiroko Nakayama, Margarida Nogueira, Mette Marit II, Juarez Oliveira, Evgenia & Stamatios Pothos, Shelly Rogers, Greta Røtterud, Lars Røtterud, JP Samuelson, Tim Schneider, Thea Strikos, Jupp Thoennes, Mrs Twomey, Emmett Williams, Nadia Zerouali

I wish to extend special thanks to Bridget Jones who has reviewed my work brilliantly and checked its content for accuracy.